SILK & STONE

THE THIRD HALI ANNUAL
Published by Hali Publications Limited

© Worldwide, Hali Publications Limited
London 1996

A catalogue record for this book is available
from The British Library

ISBN 1-898113-20-3

Hali Publications Limited are the publishers of
HALI, *The International Magazine of Antique
Carpet and Textile Art,* which appears bi-monthly

Hali Publications Limited
Kingsgate House
Kingsgate Place
London NW6 4TA
United Kingdom
Tel: (44 171) 328 9341
Fax: (44 171) 372 5924
E-mail: hali@centaur.co.uk

Hali Publications Limited is a member of the
Centaur Communications Limited Group

Editor
Jill Tilden

Associate Editors
Daniel Shaffer
Sheila Scott

Picture Research
Rachel Evans

Design
Anderida Hatch
Liz Dixon

Publisher
Sebastian Ghandchi

Promotion & Marketing
Piers Clemett
Ashley Spinks

Advertisement Sales
Christiane Di Re
Conrad Shouldice
Mark Harbour

Advertisement Co-ordinator
Angharad Britton

With thanks to Nicholas Purdon, Joan A. Spears
and Imogen Tilden for their editorial assistance

Imagesetting
Disc to Print
London, United Kingdom

Colour Origination
Vision Reproductions Limited
Milton Keynes, United Kingdom

Printing & Binding
Snoeck, Ducaju & Zoon
Ghent, Belgium

Front cover pictures courtesy
Spink & Son; Private collection
Spine picture courtesy
Pierre-Alain Ferrazzini
Back cover pictures courtesy
DPA Images of India
The Shōsōin Treasure Repository
The Chester Beatty Library

SILK & STONE

THE ART OF ASIA

Hali Publications Limited

CONTENTS

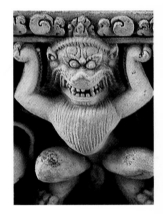

INTRODUCTION

In his *Art of Poetry* of 1674, the French writer Nicolas Boileau stated that the aim of literature should be at once to please and to instruct. He claimed no credit for this idea. In a period of high classical revival Boileau's source was the Roman poet Horace, whose own fascinating and sharply observed handbook of literary praxis, the *Ars Poetica*, was written around 20BC. The editorial intention in producing this second volume of essays on Asian art can fairly be summed up by the same precepts, even if we have long since left behind a world of classical truths. These studies are offered in the hope that they may please and instruct in a number of ways: through the marrying of idea and image, through the choice of unusual and beautiful objects, and through the opportunity they present of gaining insight into the aesthetic and intellectual delights of looking at a range of different media, geographical areas and periods of Asian art.

Some of the articles are introductory, some are focused scholarly investigations of specific issues. They have not been forced into any shape or made to fulfil any premise, but are laid before the reader in a Taoist spirit, allowing an overall balance and harmony to emerge along the way. Similarly, on an intellectual level, while diversity is very evident in the themes treated in these pages, the pervasive undertow is always back towards fundamental encounters: the impact of Indian culture and ideas of hegemony, diffused along the Southeast Asian trade routes in the first centuries of the common era; the peaceful flow of aesthetic, religious and political ideas, commerce and craft skills along the Silk Roads; the cultural conjunctions that followed the violent upheavals of Mongol and Timurid conquests in the thirteenth and fourteenth centuries, and in more recent times the trading and diplomatic links established between Europe and both the Near and Far East.

The studies in this book, as will immediately be evident, represent the approach of Western art historical scholarship to Asian art. A fundamental concern of this approach is the defining and refining of stylistic categories. This has proved very useful in structuring our understanding of all kinds of art, but it may be worth observing that abstract stylistic taxonomies are largely a post-Renaissance phenomenon in the West and traditionally not part of discourse on the products of artists/craftsmen in the East. There are signs, however, of a return to a more balanced approach among Western scholars in which *rasa* (Sanskrit: essence) – affective response – can be considered among the terms of the discussion.

In this volume Robert Hillenbrand's essay on the relationship of words and images in a fifteenth century Persian manuscript balances scholarly rigour with aesthetic intuition. As Arabist and Islamic art historian he is unusually well placed to examine the roles of calligrapher and illuminator within the court workshop. He focuses on the subtlety and artistry of the painter's response to the text, qualities exercised within the strict craft disciplines of those who knew themselves to be valued servants of the ruling group.

The delicate, domestic paintings examined by Joachim Bautze ultimately owe much to the Persian miniaturists. Some were certainly the work, albeit on an entirely different scale, of Rajput miniature painters of the period. From the seventeenth century the tradition developed among ruling families in Rajasthan of setting aside an interior room in the palace as a picture gallery or *chitrashala*. Hardly known in the West, most of these will never enter the art historical record as they are rapidly being destroyed by vandalism and neglect.

An Islamic courtly context – the court of the Mughal emperor Akbar, around 1600 – is proposed as the key to the conundrum of the mysterious red-ground grotesque carpet fragments examined in Steven Cohen's extended essay. The study looks at past scholarly attempts to identify the fragments, following a trail which suggests the machinations of a so-far unmasked Moriarty. In the second part of the essay, the sources of the grotesque itself are examined, a quest that leads back into antiquity, taking in the 'talking tree' of Alexander, mythical composite beasts and the 'face of glory' on temple arches.

Several millennia earlier than the first recognisably grotesque use of distorted or composite forms, Neolithic cultures in several parts of China were already producing ritual jades which included abstract forms decorated with mysterious monster masks, clearly related to the familiar *Tao T'ieh* mask. Carol Michaelson traces the evidence of archaeological jades from 2500BC to the first centuries of the present era, when, in a quest for incorruptibility, the richest and most powerful Han nobles conceived the ultimate luxury of the jade burial suit.

The entwined destinies of gods, demons, monkeys and mortals are worked out in the

Sanskrit epic the *Ramayana*. Product of an oral tradition that is believed to have been written down for the first time in the second century AD, it began early on to be transmitted beyond the borders of India. Thierry Zéphir looks at two great *Ramayana* interpretations in Khmer art, in the bas-relief sculptures of Banteay Srei and Ankor Wat.

Like Zéphir, Kalpana Kartik turns to epigraphy in her reconstruction of Southeast Asian traditions – in this case the ritual use of gold. Inscriptions from as early as the seventh century provide evidence for the ritual function of gold in ancient Java. Finds such as the famous Wonoboyo treasure show the great sophistication of both form and technique of the early goldsmiths of the Indonesian islands, in whose work Hindu and Buddhist elements combine with local animistic beliefs, particularly those relating to ancestral traditions.

Many of the authors in this volume describe the synthesis that results from such encounters. George Michell discusses the way in which Persian architectural forms, previously unknown in the Indian subcontinent, impacted on the local architecture of the Deccan. Following the arrival of Muslim invaders in the twelfth century, ambitious rulers reinterpreted their formal and decorative vocabulary to create monumental forts and palaces which, while speaking clearly of their Iranian antecedents, are conceived and articulated in terms that are wholly Indian.

India is the endpoint of Yolande Crowe's essay on the influence exerted on western Asian Islamic art of the deep chiselled designs found in Yuan and early Ming lacquer. In the ornament of the sandstone pavilion of Fatehpur-Sikri, she sees the final echo of an innovative lacquer technique introduced three centuries earlier. Its reverberations in the carved marble and woodwork of the splendid new buildings of Beijing would certainly have struck the members of the visiting Persian embassy as they arrived in the city in December 1420.

Three of the papers included in this year's *Annual* focus on little known aspects of Far Eastern textiles. The notorious difficulty of access to the Shōsōin Repository in Nara, Japan, has limited study of the immensely important collection of objects, including many textiles, originally deposited there by the Japanese imperial family in the eighth century. Alan Kennedy's study identifies the function of a number of early textile types and discusses the evidence for assigning a Japanese provenance to some, while others have demonstrably been imported from China, Central Asia or even the East Mediterranean.

Textiles traded to Japan from the Mediterranean countries, India, Persia and China reappear, often with the patina of revered old age, in the Tea Ceremony. Covers for the tiny bowls and caddies that were ritually handled and admired in one of Japan's most esoteric Zen ceremonials are discussed by Susan-Marie Best.

Textile fragments found in Chinese temples and pagodas provide material evidence for the importance of silk in the culture of the Northern Song. Shelagh Vainker places the few textiles securely datable to this eleventh century dynasty alongside the evidence provided by contemporary chronicles, paintings and the records of silk production and use. The picture that emerges is of a commodity of major economic importance, and held in the highest esteem at the top levels of society, up to and including the imperial family.

If it is true that prior to the twentieth century a philosophical gulf separated the naturalistic, constructionist philosophies of the West and the pervasive mysticism of the East, then to observe the ways in which each interprets the art of the other can be particularly instructive. Sheila Canby traces the gradual assimilation of Western artistic ideas in Persian painting, as trade and diplomacy intensified contact between Persians and Europeans throughout the seventeenth century. Such ideas were never wholly embraced but were transmuted and reinterpreted within the traditional aesthetic parameters of the Persian artists.

The story of Chinese export porcelain is something else altogether. A quiet social revolution in seventeenth and eighteenth century Europe meant that nouveau riche industrialists and merchants aspired to standards of fashionable behaviour exemplified, then as now, in styles of eating and entertaining. To meet the demands of this growing market the Chinese porcelain factories produced a range of wares that in many instances provided entirely Western designs, from which the admired and sought after 'exotic' was itself completely absent. Are these objects Chinese, Western, or neither? Established categories may prove of little help in defining increasingly cosmopolitan forms of culture.

Jill Tilden

1

MONUMENTS OF THE DECCAN

Islamic Architecture of the Central Indian Plateau

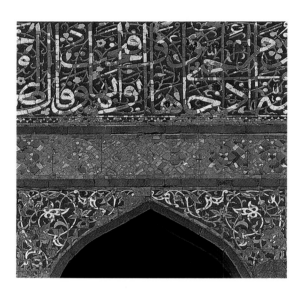

GEORGE MICHELL WITH PHOTOGRAPHS BY ANTONIO MARTINELLI

The forts, palaces, mosques and tombs erected by Muslim rulers in India between the thirteenth and eighteenth centuries constitute a significant chapter in the story of Islamic architecture as a whole. Both religious and royal Muslim monuments are found in almost all regions of the Indian subcontinent, from Bihar and Bengal in the east to Gujarat and Sindh in the west, from the Gangetic plain and Kashmir in the north to the central plateau known as the Deccan. These buildings testify to the ambitions of the sultans and the long and complicated histories of their kingdoms.

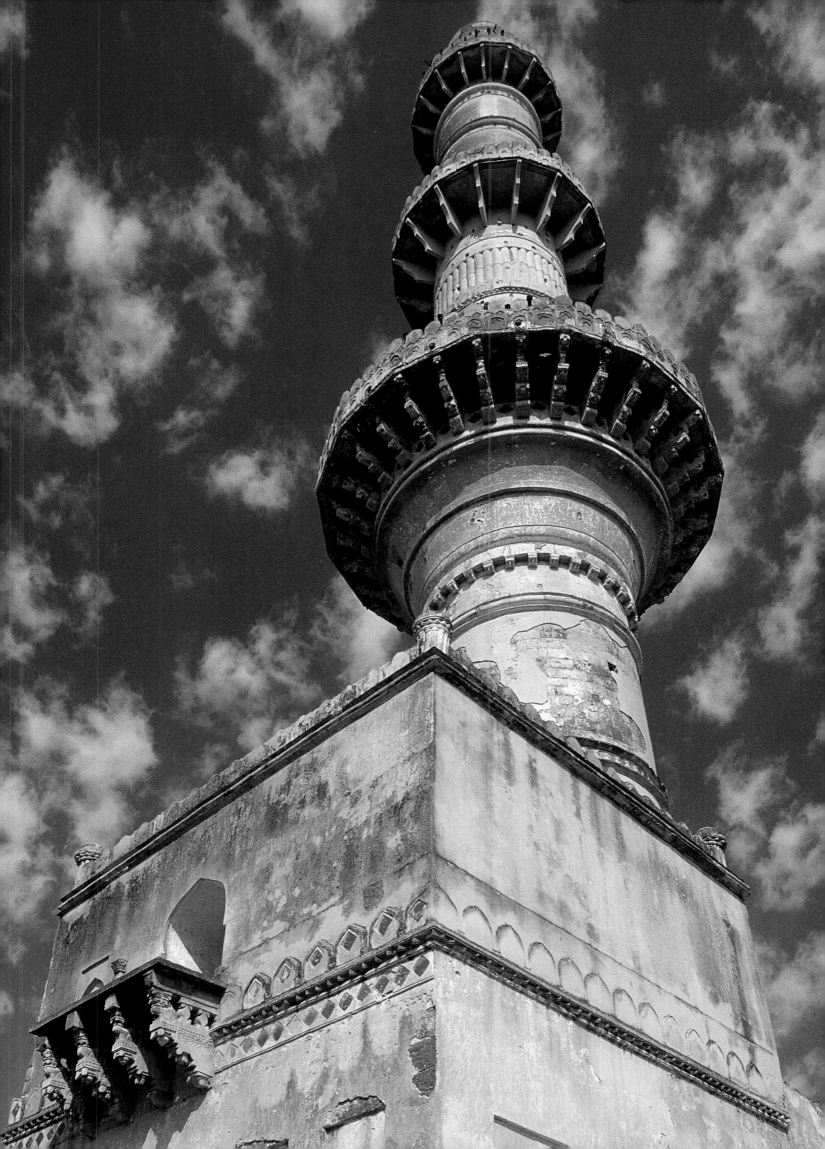

1. Title page: Tilework on the Madrasa of Mahmud Gawan, Bidar.

2. Previous page: Tower of the Chand Minar, Daulatabad.

Islamic buildings in India derive their immediate inspiration from the Persian lands of the Middle East, where an architecture had developed with forms and techniques unknown to the Subcontinent. This foreign tradition arrived in India together with the first Muslim invaders, who established their headquarters at Delhi. The imported architecture was, however, substantially altered by Indian craftsmen who introduced local techniques, forms and decorative motifs. As a result, the citadels, audience halls and places of prayer commissioned for the various sultans, their commanders and governors, took on a distinctly Indian appearance. This essentially subcontinental Islamic manner was expressed most characteristically in finely worked stone. There were constant references to earlier Indian practice; columns and brackets, also eaves and parapets, for instance, often imitated those in Hindu and Jain temples. Ornamental motifs focused on typical Indian themes such as the ubiquitous lotus. Such elements assumed a local expression with the development of distinct regional styles, and nowhere is this more apparent than in the Deccan.

The elevated plateau of peninsular India is traversed by abrupt basalt escarpments, the sites of Buddhist and Hindu rock-cut sanctuaries and monasteries, as well as by great rivers such as the Tapti, Godavari and Krishna. Though arid, the open plains of the Deccan are the setting of immense agricultural and mineral resources, attracting conquerors throughout the centuries. The first Muslim raid on this region occurred less than one hundred years after the first sultanate was established at Delhi in 1192. Some four expeditions were mounted in all, three under the able leadership of Malik Kafur. With their superior cavalry and arms, the Delhi army had little difficulty in overwhelming the Yadava kings of Devagiri, the Kakatiyas of Warangal and the Hoysalas of Dorasamudra, the most important Hindu dynasties of the Deccan at the time. By 1312 the citadels of these rulers had all been occupied and the history of Islamic architecture in this part of India had begun.

Devagiri is the most impressive stronghold in the Deccan. The great cone-shaped hill that rises almost two hundred metres above the plain was patiently chiselled away by the

3. Gateway to the fort, Bidar.

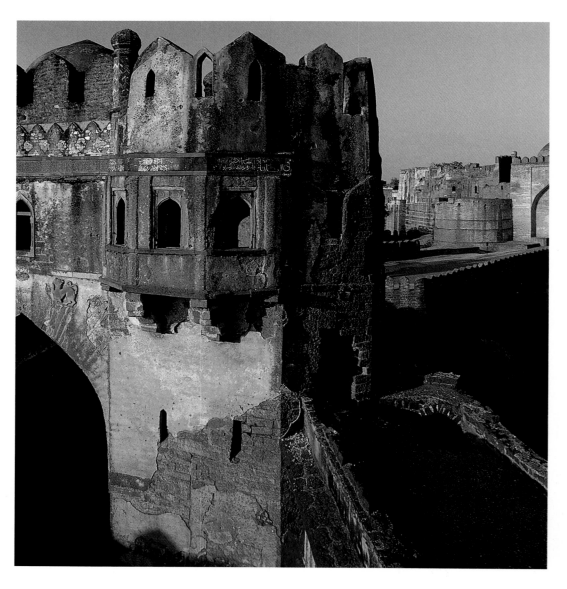

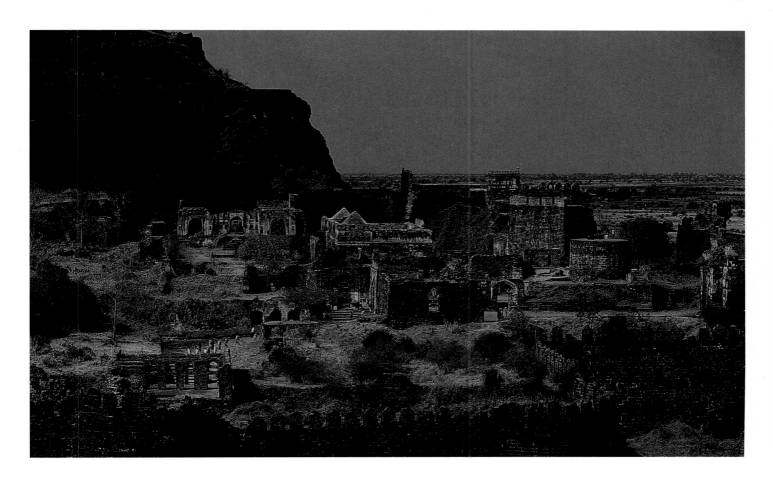

4. *Palace within the fort, Daulatabad.*

Yadavas to create an impregnable rock with sheer faces. On making his headquarters at Devagiri, which he renamed Daulatabad, Malik Kafur ordered new ramparts to be laid out enclosing a vast area fanning out from the rock on three sides. The Jami (Friday) mosque – the name given to the main mosque in Indian towns – was erected here in 1318. It is provided with a vast court intended to accommodate contingents of soldiers involved in the Deccan campaigns. The prayer hall is of interest for the domed chambers that front the colonnades and for the many instances of reused temple columns.

Dynastic turmoil in Delhi led to the rise of the Tughluqs after 1320. The Deccan was proclaimed a Tughluq province and in 1327 Sultan Muhammad Tughluq took the unprecedented step of shifting the entire Delhi court to Daulatabad. Though in the end this move proved unsuccessful, it served as an excuse for the construction of a victory monument in the manner of the Qutb Minar at Delhi. The thirty metre high cylindrical shaft of the Chand Minar (Moon Tower) at Daulatabad soars over the city (2). It is divided into four stages by diminishing circular balconies, the lowest of which is carried on brackets sculpted with pendant lotuses. The central fluted section was added in 1346 by Alauddin Bahman to signify his declaration of independence from Delhi. This commander emerges as the founder of the first autonomous sultanate of the Deccan.

Known as the Bahmanis in homage to Alauddin, these rulers continued to expand the Daulatabad citadel. The residence that they built in the shadow of the rock survives in a dilapidated condition (4). The angled arches, shallow domes and pyramidal vaults are derived from contemporary Tughluq architecture in Delhi. These same features characterise the monuments of Gulbarga, some 350 kilometres south, where the Bahmanis moved in the middle of the fourteenth century. The circular fort erected at Gulbarga by these sultans still stands; so, too, does the impressive Jami mosque within the ramparts. This unique structure consists of a rectangular prayer hall without any associated court. The interior is divided into aisles by low arches, creating perspectives of receding planes with side lighting. The bays are roofed with flat domes alternating with pyramidal vaults. The larger dome in front of the mihrab in the rear wall is carried by corner squinches filled with long cusps, a distinctive Bahmani feature.

The austere manner of Gulbarga's mosque is echoed in the many tombs dotted around the city. The Tughluq manner of these buildings is evident from the sloping walls, angled arched openings and cut-plaster decoration, the last with stylised arabesques and lotus medallions. Battlemented parapets run along the tops of the walls, ending in squat finials

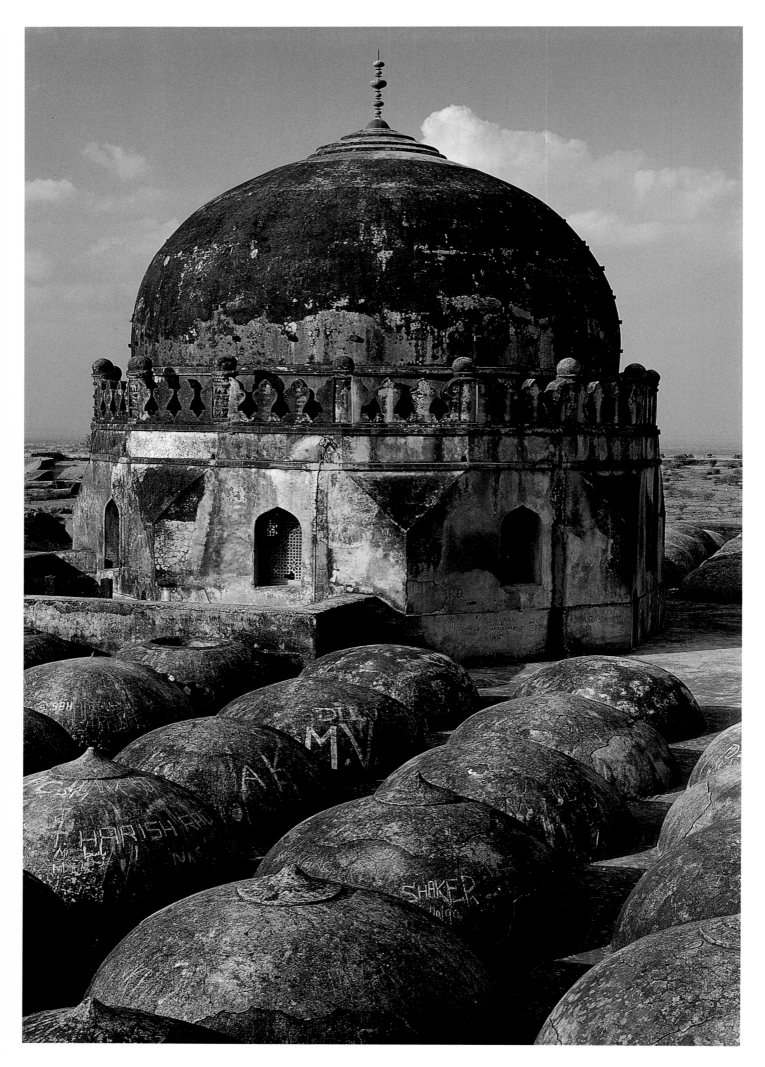

with domical tops. Domes swell upwards but rarely attain a complete hemispherical profile. The grandest of Gulbarga's royal tombs is that of Firuz Shah (ruled 1397-1422). This consists of twin domed chambers, the outer walls divided into two tiers of arched recesses, a characteristic found in the mature Bahmani style. Doorways are sheltered by angled eaves on brackets, the first of many temple-like features to be absorbed into Deccan Islamic architecture. Another important funerary monument is the Dargah of Gesu Daraz, a famous Chishti saint who settled in Gulbarga, dying there in the same year as Firuz. The spiritual authority of Gesu Daraz has not diminished over the centuries and the tomb continues to be visited by crowds of pilgrims. The palace city of Firuzabad, named after its royal founder, lies about thirty kilometres south of Gulbarga. The remnants of audience halls, residential suites, hammams and monumental portals throw light on Deccan courtly life in the early fifteenth century.

More impressive still is the royal complex at Bidar, some hundred kilometres northeast of Gulbarga, to which the Bahmani capital was moved by Firuz's successor, Ahmad I (ruled 1422-36). This city is situated on a rising shelf of rock, surveying a vast plain to the north. The palace area at Bidar is contained within an approximately circular citadel, the walls of which are strengthened by polygonal bastions topped with battlements. A sequence of three gates provides access from the city on the south (3). Their pointed arched openings are characteristic of later Bahmani architecture; so, too, are the heraldic lions in carved stone and the bands of coloured tiles. In the middle of Bidar's royal citadel stands the Solah Kambha mosque, the private place of worship for the king and his courtiers. Its prayer hall is divided into multiple aisles by massive circular columns, reminiscent of contemporary Persian practice. An imposing dome rises above the structure (5). This architectural link with Iran parallels the increasing influence of warriors, merchants, teachers and pious personalities from the Middle East who had settled in the Deccan by this time. The conflict between these newcomers, known as Afaqis, and the older established Dakhnis, was to become a disruptive feature of the Bahmani era.

The Iranian quality of Bidar's palace architecture is evident in the various residential and ceremonial structures. The Diwan-i Am, the hall or court of public audience, comprises a columned hall facing north towards an internal court. Today, only the stone footings of the timber columns survive. Chambers opening off this hall are enlivened with polychrome tile mosaic forming geometric and floral patterns essentially Iranian in style. The entrance to the nearby Takht Mahal, which once housed the throne of the Bahmani sultan, is marked by a lofty portal with pointed arched recesses outlined in grey-green stone. Hexagonal tiles illustrating regal lions and sunburst motifs once filled the spandrels. One of the rooms to the rear is charmingly adorned with a stone-lined lotus pond set into the floor (6).

The most complete royal structure at Bidar is the Rangin Mahal, an ensemble of halls and chambers forming a private apartment.

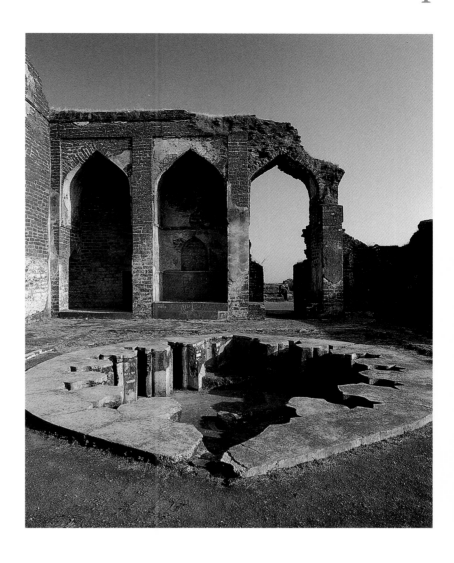

6. Ornamental pond in the Takht Mahal, Bidar.

5. Dome of the Solah Kambha mosque, Bidar.

7. Dome of the mosque in the Ibrahim Rauza, Bijapur.

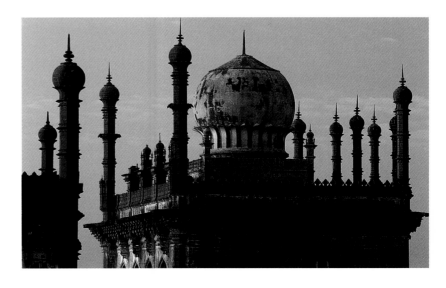

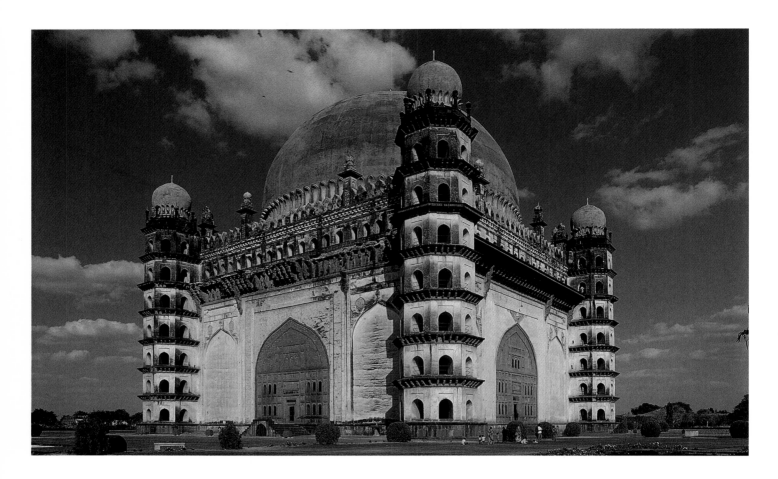

8. The Gol Gumbad, Bijapur.

The building was renovated under the Baridis, successors to the Bahmanis in the sixteenth century. The decorative scheme of the Rangin Mahal demonstrates the skilful use of different materials and techniques, including carved wooden columns and brackets, tile mosaic in arabesque and calligraphic designs, and delicate inlays of mother-of-pearl shell set into polished stone. The last resemble the patterns of the silver-inlaid gunmetal *bidri* work for which Bidar is famous.

This emphasis on architectural ornamentation is sustained in both educational and funerary buildings at Bidar. The imposing madrasa erected in 1472 by Mahmud Gawan, influential prime minister of the later Bahmani sultans, is the outstanding monument of the era. The madrasa is modelled closely on theological colleges in Khorasan and Transoxania. It consists of a square court onto which face deep portals surmounted by domes on circular or octagonal drums. The portals are flanked by ranges of small chambers intended for students. Two cylindrical minarets originally framed the main facade, but one collapsed in an explosion of 1696. The surviving example has three stages separated by cantilevering balconies. Fragments of sumptuous polychrome tilework in brilliant blue, turquoise, green and yellow cloak the facade (1). The calligraphic bands and arabesque patterns reflect Iranian decoration at its finest.

That the Bidar kings were also great tomb builders is evident in the necropolis at Ashtur, 2.5 kilometres northeast of the city. The tomb of Ahmad I, earliest of the group, presents an imposing square domed chamber with its outer walls divided into triple tiers of arched recesses. The pointed profiles of the arches are typical of the later Bahmani period; so, too, the ornate parapet of merlons with corner finials, repeated on the sixteen-sided drum of the dome above. Faded paintings on the walls and inside the dome give tantalising hints of the original sumptuous ornamentation. The facade of the adjacent tomb of Ahmad II (ruled 1436-58) employs five recesses of unequal height, with the largest in the middle. The arched tops have gently curved profiles outlined in stone bands; diagonal square panels are placed above the outer niches.

A short distance from the Ashtur cemetery is the tomb of Khalil Allah, a Persian holy figure who arrived at Bidar in 1431. Known as Chaukandi, this mausoleum consists of a square domed chamber standing freely within a two-storeyed octagon. The unusual screen wall is enlivened with arched recesses and diagonal squares, all outlined in masonry bands. The south doorway is graced by a Qur'anic inscription dated 1450, one of the finest examples of monumental calligraphy in the Deccan. The sculpted letters in overlapping

thulth are animated by swirls of foliation delicately incised into the background.

Increasing feuds between the Afaqis and Dakhnis in the later decades of the fifteenth century did much to erode the authority of the Bahmanis. Meanwhile, there were external threats from the emperors of Vijayanagara, the Hindu kingdom that lay immediately to the south, with whom the sultans had been at war almost from the beginning of their careers. The disintegration of the Bidar kingdom provided an opportunity for local governors to break away from Bidar. By the turn of the sixteenth century five new states had been founded, the most important at Ahmadnagar, Bijapur and Golconda.

The architecture of the Nizam Shahis, monarchs of the Marathi-speaking provinces of the former Bahmani kingdom, can only be noted briefly here. The palaces erected by these sultans on the outskirts of their capital at Ahmadnagar are more Persian in design and decoration than those of the Bahmanis. The Farh Bagh completed in 1583, for instance, is a grandiose royal complex with a central domed building standing in the middle of a large pool. Each facade displays a double-height arched portal flanked symmetrically by two tiers of arched recesses, repeated on the angled corner faces. The half-domes of the portals and recesses are filled with faceted plasterwork in a refined Iranian manner. The overall composition anticipates that of the Taj Mahal by more than fifty years, except for the double dome that rises over the Agra monument.

The Adil Shahis who took over most of the Kannada-speaking provinces of the Bahmanis made their headquarters at Bijapur, which they furnished with magnificent monuments. Adil Shahi architecture is remarkable for its technical inventiveness and rich decorative repertoire. More than the Bahmanis and Nizam Shahis, the Adil Shahis sponsored a style that drew heavily on indigenous sculptural traditions.

Building activity at Bijapur, as also at Ahmadnagar and Golconda, was greatly stimulated by the victory over Vijayanagara in 1565. Only after the elimination of the Hindu threat to sultanate supremacy did the Adil Shahis embark upon their most ambitious projects. The

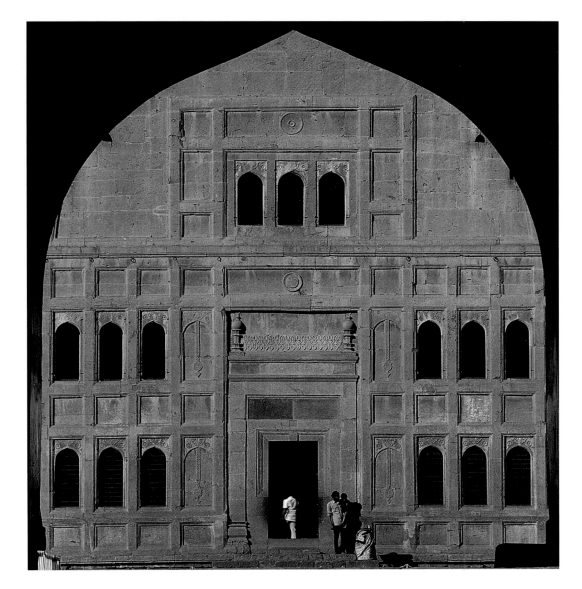

9. One of the four central recesses of the Gol Gumbad, Bijapur.

Jami mosque at Bijapur, begun by Ali I (ruled 1558-80) soon after this battle, presents an austere facade of nine arches, with the central arch distinguished by small cusps with medallion-on-bracket motifs in the spandrels. The space occupied by the nine central bays of the interior is roofed with a single dome. This is supported on a net of intersecting arches with intermediate pendentives, a structural device to be repeated on a larger scale in the later Gol Gumbad (see below). The treatment of the stone mihrab is sumptuous, with bands of stylised foliation framing the central arch.

The long reign of Ibrahim I (ruled 1580-1627) is marked by an elaborate architectural style. Malika Jahan Begum's mosque erected by Ibrahim in 1586 in honour of his wife has its three-arched facade sheltered by angled eaves. These are carried on cut-out brackets with triple sets of curving elements adorned with arabesque ornament. The pierced parapet above combines interlocking merlons with stylised palmettes; intermediate pinnacles are conceived as diminutive pavilions with domical tops. The Mihtar-i Mahal, another work of Ibrahim's reign, consists of a small mosque and a free-standing gate. The latter is exceptional for the projecting balconies with arched openings overhung by projecting eaves on angled struts. These angled supports are enlivened with stylised lions, geese and foliation in shallow relief, sometimes cut out in imitation of timberwork. Slender finials with domical tops flank the facade.

This emphasis on delicately worked brackets, parapets and finials culminates in Ibrahim's masterpiece, the Ibrahim Rauza (7). Completed in 1626, this glorious complex consists of a paired tomb and mosque elevated on a common plinth set in the middle of a formal garden. The tomb has a central chamber, some thirteen metres square, roofed by a flat vault with curved sides divided into nine squares. The outer walls are covered with superbly executed panels of geometric and calligraphic designs, both as relief panels and

10. The Sat Manzil, Bijapur.

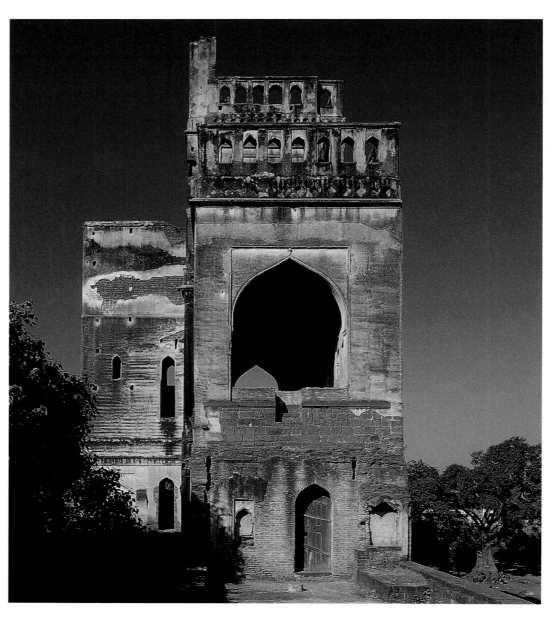

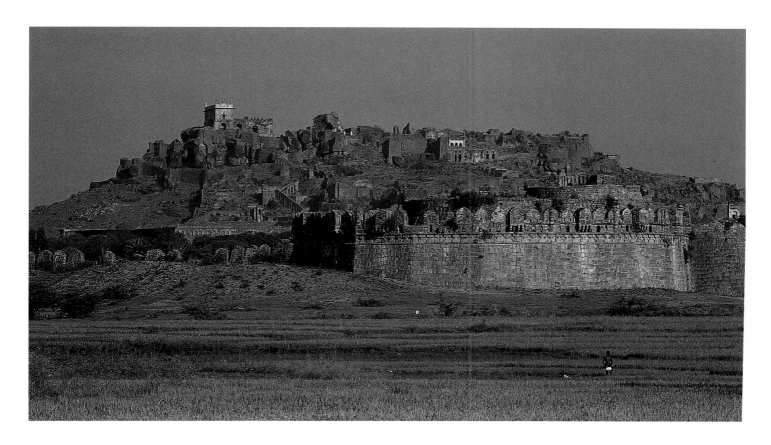

as cut-out screens. Arches of uneven spacing with corbels support the flat roof of the verandah on four sides. The exterior is conceived as a veritable pyramid of turrets and finials, crowned with a three-quarters sphere raised high on a frieze of petals. The mosque facing towards the tomb repeats many of these features. As in the tomb, corner buttresses are carried beyond the roof to create slender minarets.

If Ibrahim Rauza is the most exquisite monument at Bijapur, then the noblest is the mausoleum of Muhammad Ali Shah (ruled 1627-56), known as Gol Gumbad. In spite of its huge scale, the tomb is impressively simple in design, with a hemispherical dome, nearly 44 metres in external diameter, resting on a cubical chamber (**8**). The dome is supported internally by arches in overlapping squares with interlocking pendentives, a technique first noticed in the Jami mosque. The severe quality of the interior helps to emphasise this structural system. The tomb's exterior is majestic, with triple sets of arched recesses on three sides. Medallions on brackets are etched into the plasterwork in the spandrels. The central recesses are filled with stone screens pierced by doorways and windows (**9**). The overhang is carried on tiers of sculpted brackets and surmounted by an arcade and a parapet of trefoil merlons. Octagonal corner towers have open stages, each marked by arcades, concealing staircases. They are topped with bulbous domes on petalled bases imitating the great dome that hovers over the central mass, acting as a climax of the whole composition.

Bijapur's architecture is by no means restricted to religious monuments. Remains of the extensive palace of the Adil Shahis can be seen inside the walled citadel. The Sat Manzil is a towered structure, with only four storeys out of the original seven still standing. It marks the northwest corner of the central quadrangle of the citadel, looking out over the surrounding moat (**10**). The Gagan Mahal which stands beyond is an audience hall dominated by a lofty central portal that faces towards an open area intended for public assemblies. Little survives of the chambers that once opened off the main hall. A more complete idea of a typical Adil Shahi palace is given by the Dad Mahal east of the citadel, erected in 1646. Originally intended as a hall of justice, this building was later converted into a sacred reliquary to house two hairs of the Prophet. Its facade presents a double-height portico with slender timber columns carrying a wooden panelled ceiling (**12**). Chambers at the rear are arranged around central rooms on two levels. They are embellished with delicately toned murals set in niches, depicting vases with vines and flowers, and with elaborate inlaid wooden doors and screens.

Contemporaries of the Adil Shahis, the Qutb Shahis were also responsible for an impressive set of royal and religious monuments. It was these rulers who, in the first half of the sixteenth century, transformed the hill fort of Golconda into a thriving and wealthy city,

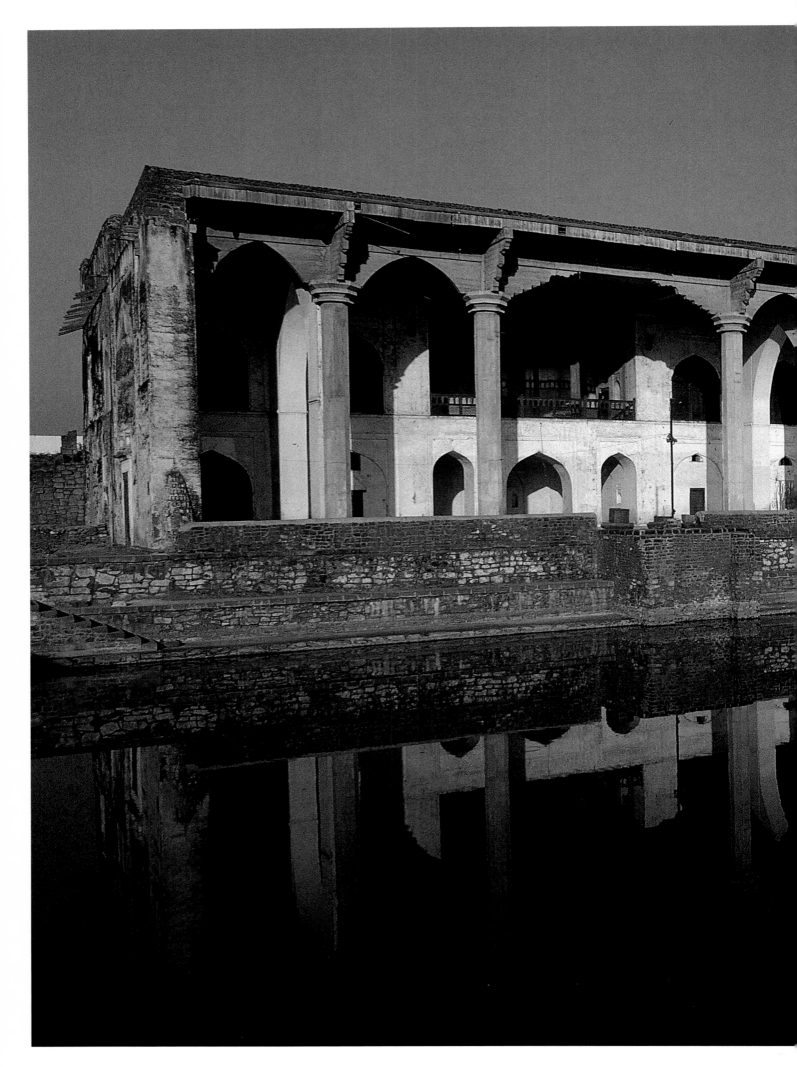

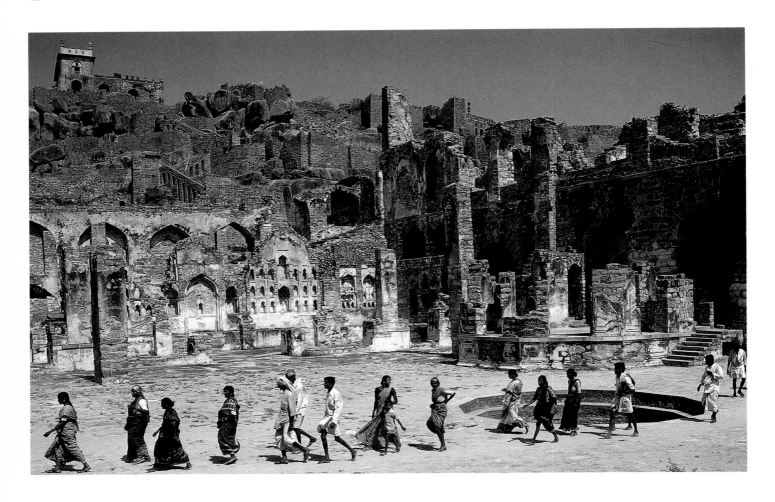

13. The palace and central courtyard, Golconda.

the reputation of which reached Europe, especially because of the diamonds that were sold there. Golconda is protected by concentric rings of strongly built walls, the outer circuit provided with massive bastions, some with unusual bulbous protrusions (**11**). The palace is dominated by a rugged hill overlooking a vast plain. Situated on the eastern flank of the hill, the buildings are now ruinous; even so, its linear arrangement of armoury, barracks, audience halls, reception chambers, private apartments and bath, leading to zones of ever-increasing privacy, is still evident. At the core of the palace is a spacious court with a twelve-sided pond set into the pavement, overlooked by arcaded apartments, possibly for women of the court (**13**). While most of the vaults and roofs have now collapsed, traces of delicate plasterwork are still apparent. A small Hindu shrine and a mosque at the summit of the hill testify to the diverse beliefs of Golconda's population.

The mausoleums in the necropolis six hundred metres north of Golconda are the final resting places of the Qutb Shahi sultans. The tomb of Muhammad Quli (ruled 1580-1611) has a single storey with recessed bays in the middle of each side to take timber porticos imitating entryways to grand mansions (**14**). A hemispherical dome rises on a frieze of petals. The tomb of the next Qutb Shahi king, Muhammad (ruled 1611-26), is more evolved stylistically. This pyramidal composition has receding arcaded storeys culminating in a great dome raised high on a square drum. While the treatment of the pointed arches is simple, the eaves, cornices and parapets are encrusted with plaster and enlivened with coloured tilework. These create richly patterned bands framing arched niches and galleries. Corner buttresses are extended as finials with domical tops. The dome is a plain three-quarter hemisphere with a high relief frieze of petals at the base.

It was Muhammad Quli who took the decision to move the capital from Golconda to a new site six kilometres to the east. By 1591 the plans of Hyderabad were ready and over the next few years the principal monuments and gardens of the new city were laid out on the south bank of the Musi river. Hyderabad is laid out on a grid pattern, with the two main bazaar streets running north-south and east-west and intersecting at right angles. The crossing is marked by the Char Minar, a gigantic four-arched gateway with a mosque on top. This is without doubt the city's most significant urban landmark (**15**). It is a master-piece of Qutb Shahi architecture and conforms to no indigenous or foreign prototype, though it is sometimes believed to have been intended as a copy of the shrine at Kerbala venerated by the Shia sect of Islam to which the Qutb Shahis belonged. The structure is

dominated by four lofty arched portals, each spanning more than thirteen metres. The roof supported by these arches carries a small madrasa and mosque where proclamations were read out on special occasions. The monument takes its name from the quartet of minarets at the corners, which are, at 56 metres, the highest in the Deccan. Conceived as slender round towers, they contain spiral staircases that ascend to triple tiers of balconies.

Immediately north of the Char Minar is the Char Kaman, a quartet of detached arches defining an open square. They date from 1594 when this part of Hyderabad was designated the royal quarter, being the site of the Qutb Shahi palace, now lost, and the Jami mosque. The latter is considerably smaller than the Mecca Mosque begun in 1617 as the major project of Muhammad's reign. Built entirely of dressed stone, its prayer hall is five aisles long and three bays deep. The combination of lofty arches on stone columns and the long narrow cornice gives the facade a comparatively light appearance in spite of its grandiose scale. The circular corner minarets have arcaded octagonal balconies at parapet level, but were only completed under the Mughals.

The careers of the Nizam Shahis, Adil Shahis and Qutb Shahis were all brought to an end

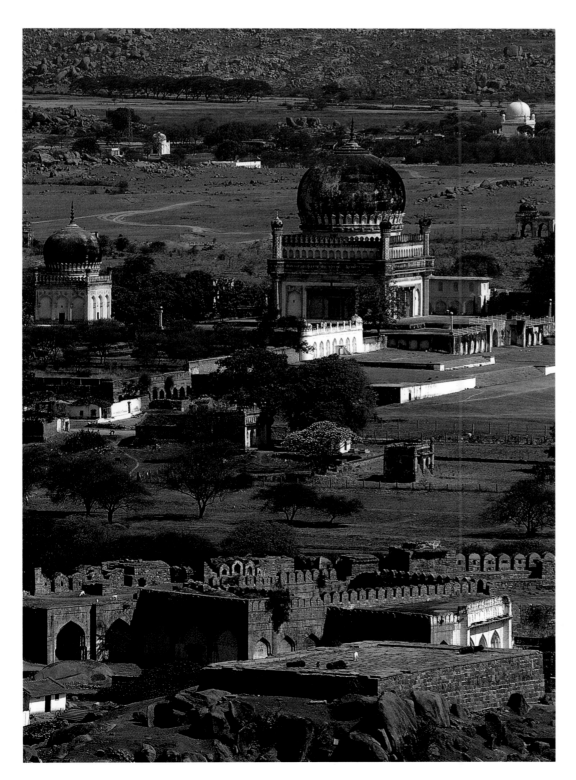

14. The Tomb of Muhammad Quli, Golconda.

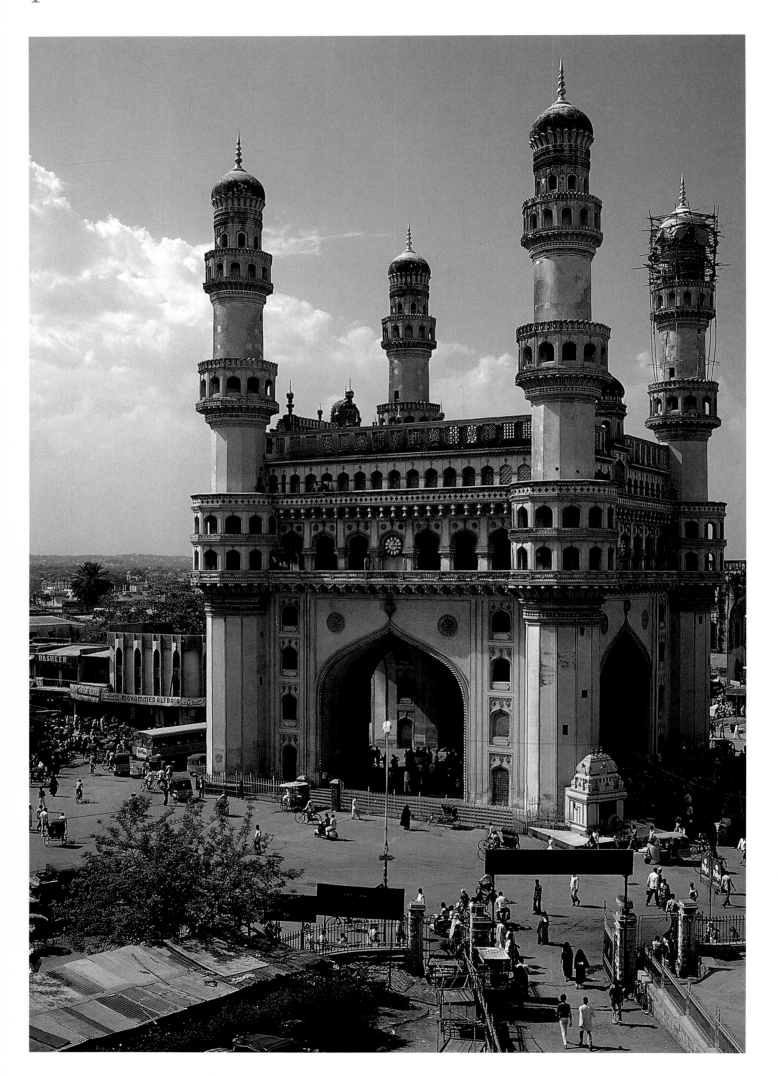

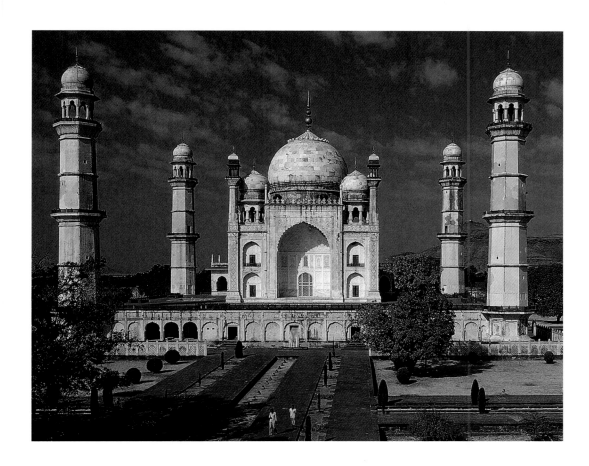

16. *The Bibi-ka Maqbara, Aurangabad.*

by the Mughal invasion of the Deccan which proceeded in stages throughout the first half of the seventeenth century. Ahmadnagar was taken in 1636, whereas Bijapur and Golconda both succumbed in 1668. The Mughals chose Aurangabad, then known as Fatehpur, fourteen kilometres south of Daulatabad, as their Deccan headquarters. The city was renamed after Aurangzeb (ruled 1658-1707), who spent the latter part of his life here campaigning in the Deccan. The walls built by the Mughals to shield Aurangabad from the attacks of the Marathas are provided with monumental gates. These adopt a typical Mughal design, with polygonal bastions capped with domed pavilions.

Military insecurity caused by the unceasing warfare with the Marathas seems to have prevented the Mughals from building on a large scale. An exception is the Bibi-ka Maqbara, the major Mughal monument of the period (**16**). This mausoleum was erected in 1661 by Azam Shah, son of Aurangzeb, to entomb his mother Begum Rabia Durani. The Bibi-ka Maqbara is too often dismissed as an unsatisfactory copy of the Taj Mahal on which it is obviously based. This comparison fails to acknowledge the innovative aspects of its design and the distinguished ornamentation. The tomb stands in the middle of a large walled garden, with axial walkways and water channels, entered through an imposing and finely decorated gate on the south. Brass-clad doors with embossed designs of flowering plants lead to steps that ascend to a broad terrace. This imposing square structure of vertical proportions is dominated by a rigorous symmetry. Each facade has a lofty arched portal flanked by double tiers of smaller arched niches. A great dome with a pronounced bulbous profile crowns the whole composition. The corners are marked by octagonal domed pavilions and tapering finials topped by miniature pavilions. Doorways give access to an octagonal gallery that looks down over the gravestone at the lower level, a feature unknown in any other Mughal tomb. The gravestone is surrounded by perforated marble screens carved with great delicacy. White marble cladding is used in combination with superbly modelled plasterwork. Like the Taj Mahal, the mausoleum is framed by four tapering minarets standing freely at the corners of the terrace. The examples at Aurangabad, however, are octagonal rather than circular.

No building constructed by the Mughals in their later years, either in the Deccan or elsewhere in their dominions, rivals the Aurangabad tomb. As their power dwindled so did their architectural achievements. Later Mughal mosques and tombs at Aurangabad are modest structures with little display of artistic invention. Under the Asaf Jahis, successors to the Mughals, there was no attempt to revive the grand monuments of earlier times. In this way, Deccan Islamic architecture was brought to a close.

15. *The Char Minar, Hyderabad.*

2

THE ROYAL MURALS OF RAJASTHAN

Art in Peril

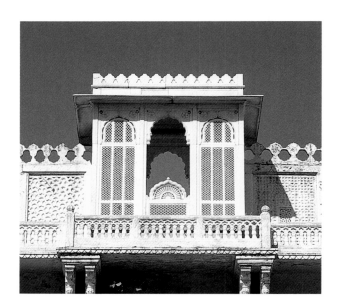

JOACHIM BAUTZE

The *chitrashala* was the private art gallery of the cultivated and wealthy Rajput noble, in which a series of self-contained scenes were painted directly onto the walls. Splendid examples survive from the early seventeenth century onwards, among them those of the Kotah Palace in Rajasthan. Concealed in the inner-most recesses of the palace, these and many similar galleries have remained almost unknown in the West, but are now rapidly disappearing as neglect and vandalism take their toll.

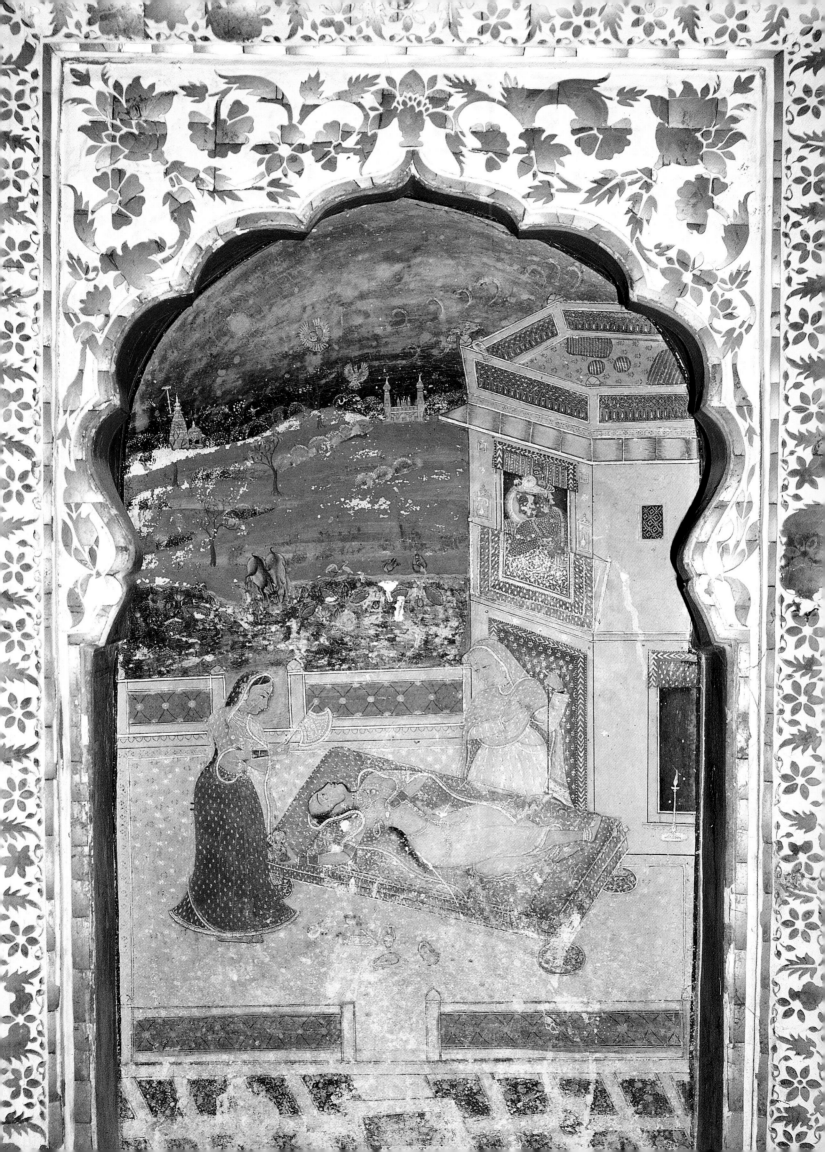

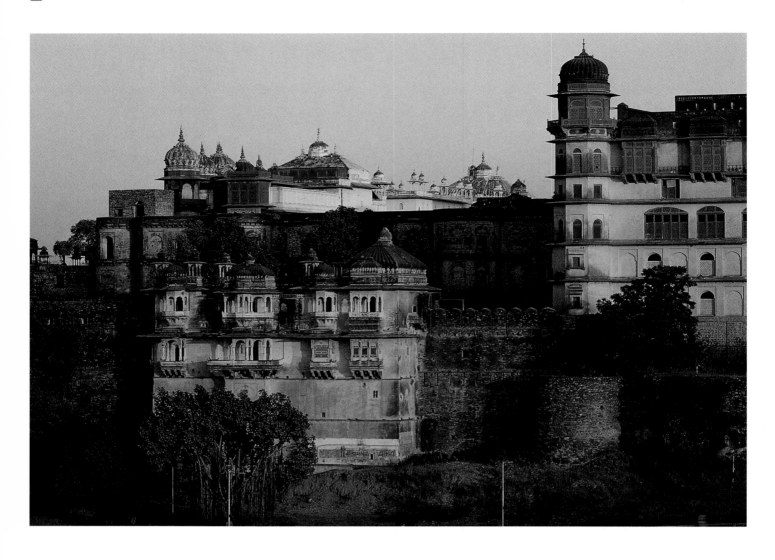

3. *Kotah Palace from the west.*

Art historians distinguish between two very different types of painting in the Indian artistic tradition: murals and manuscript illumination. While paintings in the Buddhist caves at Ajanta in Maharashtra State show that the mural attained a high point as early as the first century of the Christian era, for climatic reasons illustrated manuscripts have not survived from any period prior to around 1000 AD. The earliest of these manuscripts are on palm leaf: paper was not introduced into India before the end of the fourteenth century. In addition, a few paintings on cotton, mostly sponsored by Jains, have come down to us from the fifteenth century onwards, but unlike paintings in the West these were neither mounted in a wooden frame nor hung on the wall.

4. *Interior of the chitrashala in the Jhala ki Haveli, Kotah Palace.*

1. *Title page: Pavilion, Kotah Palace.*

2. *Previous page: A lovesick lady pining for Krishna, her lover. First floor, eastern room, western wall of the Jhala ki Haveli, Kotah Palace. 78 x 45cm (31" x 18"). Photographed in 1983.*

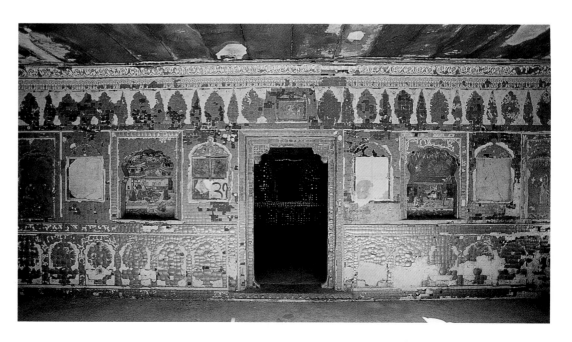

Some of the largest specimens on cloth are from the eighteenth and nineteenth centuries, normal practice being to keep them safely rolled in tubes and to display them only on rare occasions for a few privileged visitors.

Whether on wood, textile, palm leaf or paper, paintings need special care and maintenance to survive the rigours of the tropical Indian climate. The ever-present threat of damage caused by insects poses another serious problem; to combat this many Indian miniatures are surrounded by a border of red lac, which reputedly contains an insect-repelling chemical. Paintings executed in gouache on paper were traditionally kept in bundled stacks and were seldom shown. Due to their comparatively small size, they could in any case only be viewed easily by one person at a time.

In the course of time a third genre of painting developed, which served to bridge the gap between the transportable miniature paintings and the fixed wall paintings. It consists of a thematically self-contained wall painting surrounded by a painted frame, placed at eye level and able to be viewed easily by more than one spectator. It should be distinguished from the more familiar type of Indian wall painting which fills large sections or complete walls with sequential illustrations of a particular story. Although the framed wall paintings occasionally illustrate one legend in a sequence of pictures, they generally represent isolated subjects.

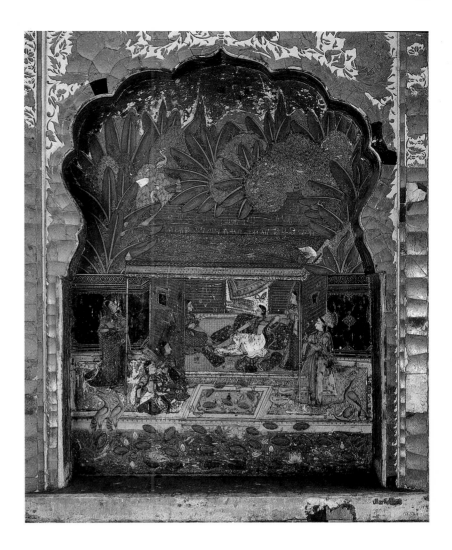

5. A Lady entertained by musicians, eastern verandah, eastern wall, southern niche. 90 x 63cm (36" x 25"). Photographed in 1983.

There is no Western term for this third type of Indian painting, which I will refer to here as 'tableau-mural'. Rooms containing tableau-murals are referred to in secular Indian literature of the sixteenth century as *chitrashala*, literally, 'picture gallery'. Most were commissioned by Hindus of noble descent, and are consequently to be found in the area known today as Rajasthan, the home of many Rajput princes. They formed an integral part of any Rajput palace under the jurisdiction of a cultured ruler, and should not be confused with the better known and more recent frescoes at Shekhawati in northeastern Rajasthan, which were generally commissioned by wealthy merchants, and painted mainly on the outside of houses. The *chitrashala* enabled the Rajput connoisseur to enjoy his paintings in the

6. Lower part of 5 showing severe damage. Photographed in 1993.

same way as his European contemporaries, except that, in contrast to the latter, he could not remove or rearrange the pictures.

Although Rajasthan is by far the most visited area in India, very few tourists are aware of any of these picture galleries. And in spite of the international attention paid to Indian painting in recent years, even the more experienced traveller does not know about them. They have remained unnoticed, hardly mentioned outside the limited context of scientific research. This is perhaps surprising in an age when highly prized artefacts are generally afforded wide publicity through the media of television and illustrated books and journals. It must be remembered, however, that most of the palaces in Rajasthan are still in private hands and are generally inaccessible to the public, and that it is in the private apartments of these palaces that the murals have

7. Two ladies on a swing, eastern verandah, northern wall, central niche. 86 x 53cm (34" x 21"). Photographed in 1983.

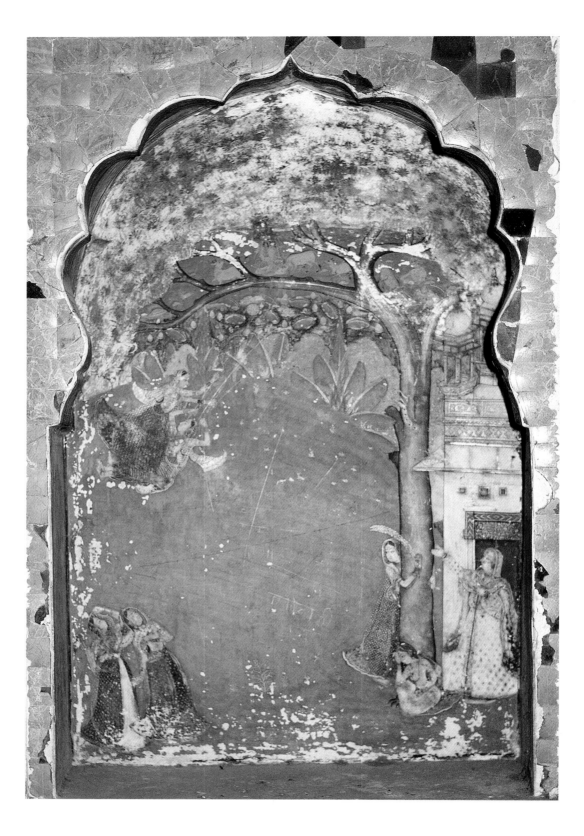

8. Detail of 7, showing destruction of the lefthand side of the mural. Photographed in 1993.

generally survived the ravages of time. A favoured area for the *chitrashala* was in the women's quarters, a part of the palace that is rarely open to the public, even today.

Only a small number of these galleries, like the *chitrashala* of the palace of Bundi, are under the custody of the Archaeological Survey of India. Many others are greatly at risk. The murals discussed here were painted in the Jhala ki Haveli, a fortress-like mansion comprising about eighty rooms forming part of the old *garh* or fortified palace of Kotah, Rajasthan. Also known as the Zalim Singh ki Haveli, it was built for Rajrana Jhala Zalim Singh, referred to as the 'Machiavelli of Rajasthan' by near contemporary historians. Zalim Singh (1740-1823) was the *divan* or chief minister of several Kotah kings and, for a number of years, exercised more power than the official rulers. As well as being the leading states-man of his time, he was also a great art connoisseur.

In about 1780, Zalim Singh ordered two large apartments in his palace to be embellished with tableau-murals. These were set into real niches or painted recesses marked off by

moulded borders. They had ornate frames of glazed tiles painted with stylised floral motifs. Placed at eye level, they measure between 80 and 95 centimetres in height, and between 40 and 70 centimetres in width.

The artistic quality of these murals can be compared to the far better known Rajput miniature paintings. Some are signed, telling us that certain artists worked on both murals and miniatures. A signed fresco also indicates where the named artist worked, thus providing invaluable clues as to the provenance of many famous Rajput miniature paintings, which carry no formal information as to their place of origin.

The frescoes were painted using the same watercolours as the miniatures. First, an outline was drawn in red onto the wet plaster. Once the surface had dried the colours were applied and partially enhanced by gold leaf. The binding medium was probably made of gum arabic.

Developed in the second half of the seventeenth century, the Kotah school of painting contributed much to the fame of Rajput art. Kotah style favoured naive attitudes, with figures represented in profile. Artists tended to paint hunting scenes, as well as lyrical subjects showing ladies in various attitudes, as seen in the Jhala ki Haveli paintings. The rulers of Kotah were devout followers of Sri Nathji, a distinctive image of Krishna, who, as one of Vishnu's avatars, is one of the most important Vaishnavite deities in Northern India. Among the murals originally in the Jhala ki Haveli were the earliest known representations of the 36 festivals dedicated to this god. Following prolonged neglect these have now disappeared entirely and are permanently lost to the art historical record.

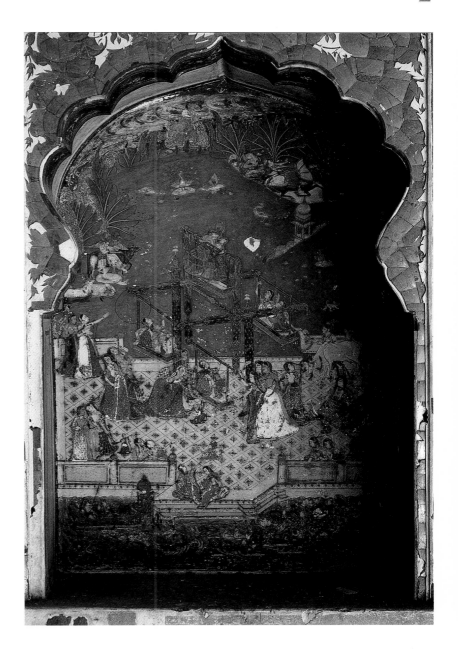

9. *Krishna carousing with ladies on a ferris wheel, eastern verandah, eastern wall, southern extremity. 90 x 56cm (36" x 22"). Photographed in 1983.*

10. *The above, showing extensive scratching to the surface. Photographed in 1993.*

In spite of their importance, other frescoes still in the Kotah Palace have, within the last few years, suffered a similar fate. In 1981 and 1983, at the time when I photographed and measured the murals in the Jhala ki Haveli, they were still almost intact, although by 1983 most of the gold leaf had been scratched off. Following this visit they were further vandalised by children of a nearby school who managed to break into the locked premises. Another blow to the gallery was the removal of a large panel representing a hunting scene, which was taken to the National Museum of India in New Delhi after it had been allowed to fall into a considerable state of decay. In 1993 a student of mine, Dr Horst Metzger, returned to Kotah and rephotographed some of the murals found in the eastern verandah, the eastern and the western rooms of the first floor in the Jhala ki Haveli. At that time the degree of destruction demonstrated by these two sets of photographs became apparent.

One of these murals shows a high ranking woman sheltering from the sun's heat in a hut with an awning (5). She is being entertained by two musicians seated outside the hut in addition to four ladies-in-waiting. The later photograph of the same mural shows that its upper part had completely broken away, with only a small section of the lower part still intact but seriously cracked (6).

A second example shows two ladies on a swing suspended from the branch of a large tree next to a palace structure (7). Two more ladies witness the scene from below the swing, while another woman embraces the trunk of the tree. An old duenna appears through the door of the palace and points at the swing. A kneeling woman at the bottom of the tree looks distressed. The photograph taken in 1993 reveals that the left half of this mural had by then been completely destroyed (8). A third example shows Krishna carousing with ladies

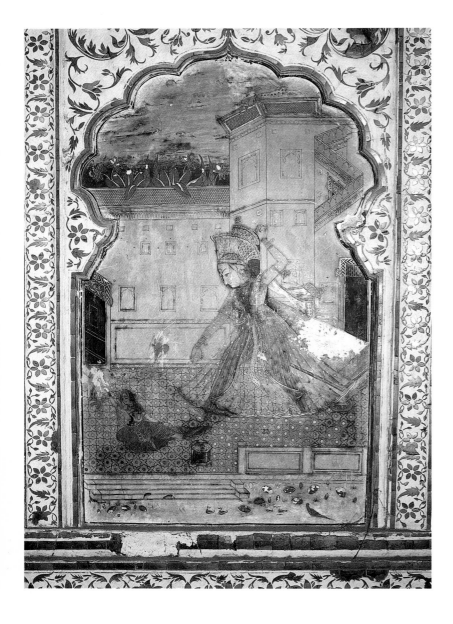

*11. Lady rescuing her parrot
from a cat, eastern room, eastern
wall. 73 x 43cm (28" x 17").
Photographed in 1983.*

*12. Zalim Singh and Salid Singh
on a Lion Hunt (detail),
western room, western wall.
Photographed in 1983.*

on a Ferris wheel which is kept in motion by several of the god's favourites (**9**). While in 1983 the mural showed only a negligible loss of the painted plaster to the right of Krishna and his beloved, the 1993 photograph again shows considerable deterioration, with the surface now badly scratched (**10**).

The earlier photographic record of another example shows a love-sick heroine lying on a bed on a terrace, pining for her divine lover Krishna, who looks down from a palace window apparently unnoticed by the heroine (**2**). A serving-girl waves a fan above her head, while a duenna resting on a long stick tries to talk to her. This night scene is illuminated by a burning candle and the full moon, the light of which is reflected on the minarets of a mosque, and on the gilded top of the *shikara* (tower) of a Hindu temple set against the dark blue sky on the horizon. A decade later the painted plaster had suffered damage both by repeated blows to the surface and by scratching. Gold leaf originally applied to the two birds, the temple and the mosque had been scratched away. The name Ajay had been scrawled on the painting in white chalk.

The fifth case illustrates a subject which is known from a number of miniature paintings (**11**). A cat succeeds in opening the cage of a parrot, the pet of a well-to-do woman. The screeches of the threatened bird alarm the woman who rushes on to the scene brandishing a stick in order to drive the cat away. The cat, which has already started mauling the parrot, has to release his injured prey. The 1993 photograph of the same mural reveals a number of incised graffiti in Nagari script. Damage to the figure of the woman chasing the cat has mainly been caused once again by the scratching away of the applied gold leaf.

The last example is known only from Kotah miniature painting (**13**). It is obviously based on a European model, and shows a white-complexioned, blonde-haired figure, probably a girl, picking fruit from some small trees nearby. The artist may have been copying a

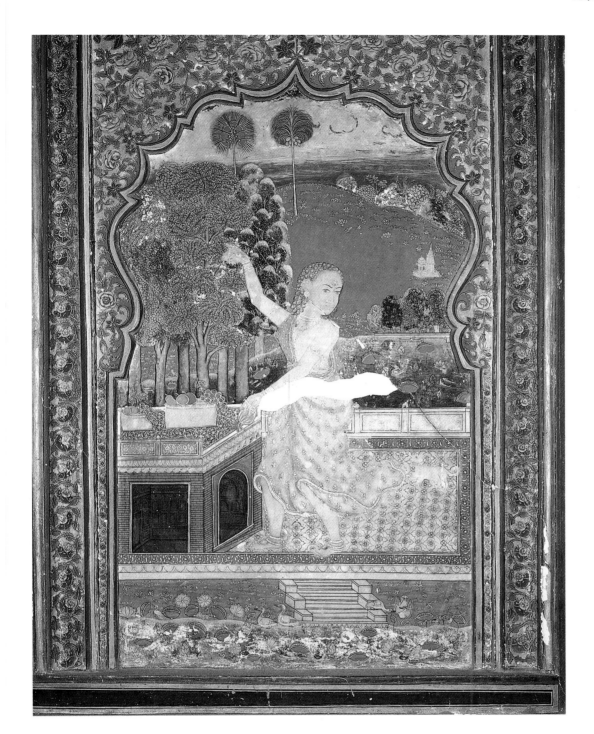

13. *A blonde girl (?) picking fruit, western room, southern wall, eastern niche. 75 x 44cm (29" x 17"). Photographed in 1983.*

14. *Detail of 13 showing extensive surface damage. Photographed in 1993.*

European-inspired Fortuna, without understanding the details. The mural was already partly damaged in 1983 when an area of painted plaster had flaked off. By 1993, however, large areas of the plaster had been damaged (14). In addition, there were signs of recent graffiti and white pigment appeared to have been thrown over the entire wall, leaving extensive streaking.

Similarly damaged galleries can be seen in a number of other palaces in Rajasthan. Indeed, very few are likely to survive. The *chitrashalas* of the Bhao Singhji ki Haveli in Bundi and the Royal palace of Karwar have been converted into police stations with subsequent damage to the murals. In Bundi, they were overpainted with the most gaudy acrylic colours. Even seventeenth century frescoes, like those in the old palace of Indargarh, have been defaced with air-gun pellets.

By the time I returned to the Jhala ki Haveli in October 1995, the frescoes had completely disintegrated. These photographs are therefore the only record that remains of the Kotah Palace gallery. Elsewhere similar murals continue to suffer irreversible damage, during building alterations, for example, when they are frequently overpainted with whitewash or randomly cut into for the insertion of windows. Their neglect arises from a lack of knowledge, funds and interest. One can only hope that the publication of this account of the history and plight of the *chitrashala* may go some way to preventing further destruction.

3

THE MESSAGE OF MISFORTUNE

Words and images in Sa'di's *Gulistan*

ROBERT HILLENBRAND

Persian miniature painting deliberately sets out to create an idealised world. It does so by means of spectacular technique, precise drawing and subtle colour schemes. Yet these paintings, however alluring in themselves, also accompany a text, and frequently contain their own acid commentary on it. A fifteenth century illustrated version of Sa'di's masterpiece, the *Gulistan*, is a case in point.

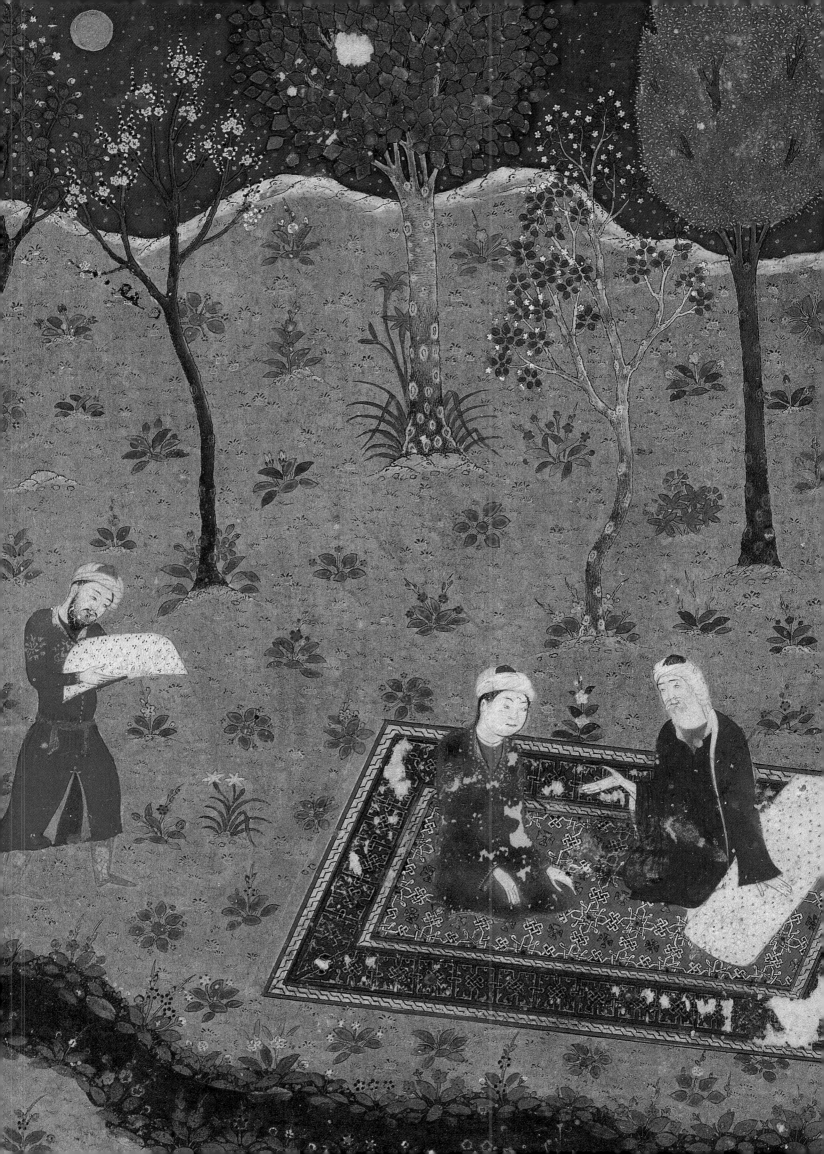

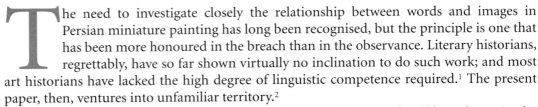

1. Title page: The prince and the dervish (detail of 5).

2. Previous page: The poet Sa'di converses by night with a young friend in a garden, from the Gulistan of Sa'di, Herat, Persia, 830AH (1427AD). Chester Beatty Library, Dublin, inv.no. P.119, f.3r.

3. One brother is rescued, the other drowns, Sa'di, Gulistan, f.15v.

The need to investigate closely the relationship between words and images in Persian miniature painting has long been recognised, but the principle is one that has been more honoured in the breach than in the observance. Literary historians, regrettably, have so far shown virtually no inclination to do such work; and most art historians have lacked the high degree of linguistic competence required.[1] The present paper, then, ventures into unfamiliar territory.[2]

The manuscript to be investigated is an early Timurid copy of Sa'di's *Gulistan* in the Chester Beatty Library, Dublin.[3] It is what reviewers call a slim volume – a mere 56 folios – and its covers measure ten inches by six. The written surface is significantly smaller, being contained within a space of seven inches by four, with some 23 lines per page. The text is written in *nasta'liq*, then a newly fashionable script,[4] and was copied in 830AH (1427AD) by the leading calligrapher of the time, Maulana Ja'far Tabrizi, who took the sobriquet of Baisunghuri after the Timurid prince whose atelier *(kitabkhana)* he ran.[5] This circumstance, together with the dedication to Baisunghur[6] (1397-1433) and the unusual emphasis on illumination, suggests that the painter, too, was one of the outstanding exponents of his craft.

Among its forty artists, the royal atelier counted gilders, gold-sprinklers, musicians, poets, calligraphers, painters, mystics, bone-carvers and singers; and some of them were polymaths who excelled in several of these fields.[7] Thus there is nothing untoward in allowing for the possibility that the illustrator of the Dublin *Gulistan* had wider horizons than painting; that he might, indeed, have had professional views of his own on the text that he was called upon to embellish. Several members of the atelier survived Baisunghur by thirty, fifty, and in one case, seventy years,[8] which suggests that some members of this team of stars were taken on as quite young men, perhaps with young ideas to match.

The manuscript contains eight paintings, spaced very unevenly throughout the book at folios 3, 9, 14, 15, 16, 29, 32 and 36. Thus there are significant gaps of 13 and 20 folios respectively without illustrations.[9] But the sheer plethora and variety of illumination on all the pages which lack paintings ensures that these still make a sumptuous impression.

The illustrator of this manuscript had a number of problems to overcome, and all of them affected his approach to his text. First of all, and most important, the *Gulistan* had apparently not been illustrated before.[10] In this respect the painter was at an obvious disadvantage vis-à-vis his colleagues charged with illustrating the texts of Firdausi or Nizami. There was no established cycle to follow. He himself – at least in theory – had to make up suitable images. And of course the difficulties thus created were not confined to the invention of new scenes. Much of the strength and effectiveness of traditional sequences of illustrations lay in the way that individual images balanced, complemented or enriched each other. Gifted painters knew how to develop leitmotifs so that a given picture would contain resonances, references to other paintings in the cycle, that would be picked up by an attentive observer.[11] To achieve that from scratch was a very tall order, since much of the success of this game depends on familiarity. Accordingly, it is only to be expected that some of the paintings in this *Gulistan* should betray signs that this is a pioneering effort. The repetition of similar scenes, for example the two seascapes (**3, 11**),[12] or the preference for figures in isolation outside a cliff-like facade,[13] is one such sign, and a very marked one given that there are only eight

paintings. Another is the tailoring of familiar iconography to slightly different ends. Thus the scene of the lustful prince lunging at the Chinese maiden (8) owes much to images of amorous encounters between Rustam and Tahmineh, or Khusrau and Shirin.[14]

A second and quite different problem was posed by the prodigal wealth of illumination which this particular manuscript contained. So ubiquitous is it, and so varied, that one wonders what precisely the status of the paintings themselves could have been. Was there a degree of competition in the royal *kitabkhana* about the respective roles of illumination and illustration in a fine manuscript? This *Gulistan* is dated in the early years of Baisunghur's activity as a patron of the arts of the book.[15] Perhaps, then, it documents a transitional stage in the formation of his taste. Eventually, of course, he came to favour books in which paintings, though still relatively few in number, came to dominate, asserting their presence by their sheer density of content.[16] The *Gulistan* has not arrived at this point, but illustrates a different way of creating a luxury book – and one which has unmistakable associations with fine Qur'ans.[17] As it happens, this way proved to be a dead end. But en route it manifestly produced a masterpiece of Timurid ornament.[18] At intervals throughout the fifteenth century, moreover, the odd especially select manuscript was produced in which paintings were subordinated to, or even replaced by, pages tinted mauve or powder blue, sprinkled with gold or silver, with the central panel of text surrounded by scenes in a kind of grisaille.[19] In Baisunghur's *Gulistan* the mix of painting, calligraphy and illumination in markedly different styles may have been intended as a deliberate response to the variety of Sa'di's text, with its lightning alternations of mood and mode as the author switches from verse to rhymed prose, from Arabic to Persian or from narrative to lyric.[20]

A third problem confronting the painter of the 1427 *Gulistan* was the nature of the text which he was charged to illustrate. It is at the opposite pole to the leisurely pace at which the action so often unfolds in Firdausi's *Shahnama* or even in the *Khamsa* of Nizami – the two most familiar illustrated texts of the Timurid period. The *Gulistan* moves swiftly from one tale to the next. For the most part the story is told without factual embellishment. It begins *in medias res* and continues in the same brusque fashion. Sa'di fleshes out the skeletal narrative not by anecdotal detail but by a helter-skelter succession of verses in Arabic and Persian. One aphorism succeeds another. The literary structure is often antithetical or repetitive; thus a moral is drawn by three or four examples. These enrich the texture of the passage and illumine the central theme from a series of different angles.[21] It seems reasonable to look for evidence that the painter attempted to translate some of these devices into visual terms. This would be wholly in accordance with the way that the entirety of the text is presented in the Dublin manuscript, which shows a consistent and lively awareness of how the component elements of the text should be presented – and distinguished from each other.[22] Yet at the same time it would be idle to expect any consistently exact parallelism between the literary and linguistic devices used by the poet and those available to the painter. They speak different languages, and that is in the nature of things. What can be expected is that the painter will try to complement and enrich the text in his own fashion. Sometimes he may embroider upon it so assiduously that the original text is obscured.

So far as the story itself is concerned, then, the painter's marching orders are clear. It is his job to spotlight the moral, which is exactly what the text itself is designed to do. And the nature of Sa'di's text both helps and hinders him. It helps him in that the poet's extremely pithy narrative style – if indeed the word narrative is appropriate for so bald a means of expression – tends to focus unwaveringly on the point of the story. When Sa'di digresses, it is not to pad out the story by telling us, for instance, when and where a king ruled, or his name, or his physical appearance, or what kind of a person he was. Instead he prefers to insert verses which sententiously point the moral and adorn the tale. So the painter can be in no doubt as to the proper object of his attention.

But Sa'di's text is that much more difficult to illustrate precisely because of the absence of supplementary detail. Does the scene take place inside or outside a building? Are the principal actors alone, or is there an audience? What else is happening at the same time?[23] These are matters which the painter has to decide, and he has to tread carefully. If there is too little going on visually, the painting can be in danger of looking trite or disagreeably empty.[24] But at the opposite extreme lies confusion, so much detail that the eye cannot order nor the mind digest it.[25] And in steering a safe course between these poles, any sensitive artist would presumably have sought a means of visual expression that dovetailed not only with the actual words of his text but also with its mood.

The Dublin *Gulistan* clearly possesses that general unity of style which is only to be

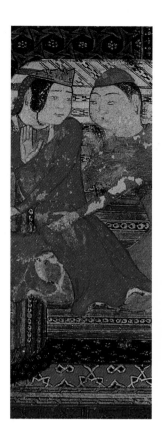

4. A drunken prince assaults a Chinese maiden (detail of 8).

expected in a royal manuscript, and especially in one illustrated by a single painter. But this does not stop the artist developing several quite different approaches to the text chosen for illustration. Sometimes he tells the whole story straightforwardly; at other times he so manages matters that we are left in suspense as to what will happen; and then on occasion he vouchsafes clues as to how the story will end. Each of these three responses to the text involves him in a degree of interpretation, but his intellectual input varies from one to the next. This will become clear as we look at examples of each of these three approaches in turn.

Let us begin with an instance of straightforward exposition. The garden scene on folio 3 (**2**) closely follows the relevant accompanying text and depicts a nocturnal conversation between Sa'di and a friend. His own age is not mentioned in the text,[26] and it may be that the choice of an old man was dictated by an already established model – the youth consulting a sage or Majnun visited in the wilderness – which the artist happily adapted to his purpose.[27] This scene is the odd one out among these eight paintings. Obviously it is intended to depict not action, as do the other seven pictures, but contemplation. The poet's

5. The prince and the dervish, Sa'di, Gulistan, f.9r.

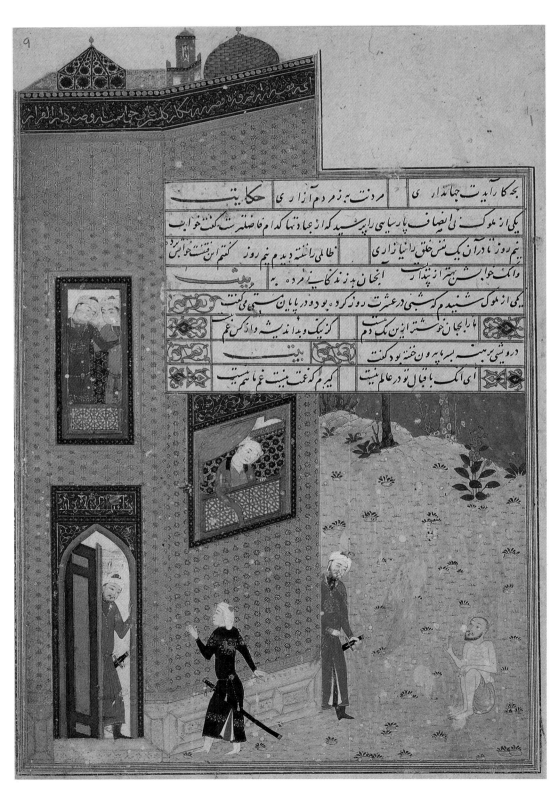

meditations are about to be made still more comfortable by means of the extra pillow which a servant is bringing him.

In some sense this is a display piece intended to show that the painter can manage this kind of composition, which had been popular for at least a generation.[28] The text on the picture page mentions "the dew-fallen pearl on the damask rose" (the reference to the rose, *gul*, is perhaps intended as a pun, as will shortly appear) "heart-gladdening groves" and "clusters of fruit like the pleiades [which] hung aloft from its [the garden's] boughs".[29] This natural abundance finds its ample counterpart in the painting. But on the very next page Sa'di falls to musing that the flowers of such a garden are doomed to fade; and so he determines to "write such a *Kitab-i Gulistan* as neither the rude storm of autumn shall be able to lay the hand of usurpation upon its leaves, nor the revolution of the season convert the serenity of its summer into the gloom of winter... this rose-bower must bloom to all eternity!"[30] Thus the context explains alike the placing and the mood of this picture – although it might be argued that the painting would have fitted more relevantly into the following passage of text. It is a visual preface, an extended pun; and furthermore, it helps to explain the absence of a painted frontispiece. Here on folio 3 is the frontispiece;[31] but it is more than just an author portrait, for its close integration with the content of the text makes it express the *raison d'être* of the manuscript. Thus a hackneyed image has been turned to new account. Given the long history of the author portrait in manuscript painting, this is no mean feat.[32]

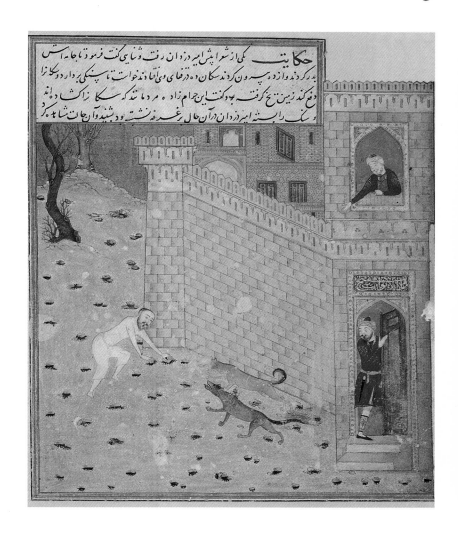

6. *A distressed poet is attacked by dogs, Sa'di, Gulistan, f.32v.*

Let us turn now to the second category, namely scenes in which the artist leaves us guessing. In the pictures depicting the beggar before the king (5) and the distressed poet attacked by dogs (6), the text incorporated into that page ends at a critical point in the story, and the illustration accurately mirrors this state of suspense. This is, incidentally, evidence suggesting that the artist did not necessarily see his task as illustrating the entirety of the story in question. Instead, he seems to have made his own choice of the most appropriate part of the tale to depict. Will the poet escape the fangs of the village curs? Is the courtier opening – or closing – that portal so auspiciously inscribed with the invocation "O Opener of gates!"? Will the shivering dervish receive charity or the royal elbow? The action is finely balanced between triumph and disaster, and the picture itself gives nothing away. For the answer, the reader has to turn to the next page. Let us look at one of these two pictures in more detail to see how the story is told.

Attention focuses on the half-naked dervish who crouches with hunched shoulders, clasping his knees against the cold, his ribcage distressingly visible (7). He is set against a largely barren landscape coloured a frigid blue and relieved by one large and a few tiny red and green flowers. These same two colours are taken up three more times in a diagonal slant marked in turn by the courtier lounging at the corner of the palace, the prince leaning over the balcony and finally a figure at the upper window. One is reminded here, as in the other examples of colour parallelism in these paintings, of the use of rhyme – and, as in literary rhyme, there is room for variety: not only *aabb* but *abab* and other combinations.[33] The russet-hued palace radiates warmth, and vaunts its own beauty in the golden inscription which runs along the cornice:

> *O loftiness higher than the gold-adorned turquoise-blue palace,*
> *Shall I call you the rosebed of the soul or the garden of the Abode of Permanence?*[34]

Elsewhere in the *Gulistan* references may be found to moralising inscriptions, as on the palace of Feridun, the tombstone of Bahram Gur and the crown of Kaikhusrau.[35] This one

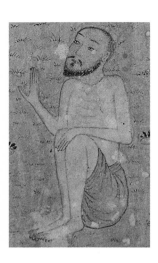

7. *A dervish begs for charity (detail of 5).*

seems somewhat flatulent by contrast, but it too has its purpose when seen from the worm's-eye view of the dervish. It serves to widen the gap between the haves and the have-nots – a leitmotif of the illustrations in this manuscript. As it happens, the ready wit of the dervish wins him a thousand-dinar purse from the monarch, who (on the next page) tells him " 'O dervish! Hold up your skirt!' He replied 'Where can I find a skirt, who have not a garment?' " and was duly given a robe of honour as a bonus.[36] So the story ought to have ended, but it did not. The dervish contrived to squander his thousand dinars in a few days, and rashly came back for more; but his wit had degenerated into chutzpah, and he was sent away empty-handed. Thus his situation at the end of the story is the same as it was at the beginning, and in that sense the message of the picture – which exudes pain rather than comfort – is entirely appropriate.

The third category, in which the painter offers clues as to how the story will end, is the most interesting of all. In the only interior scene of the whole manuscript, a wasp-waisted prince is trying to overpower a Chinese maiden (**8**). Sa'di's language is clinical. "In a state of intoxication he wanted to copulate with her. The damsel resisted. The king flew into a passion" – here the text on the illustrated page ends, and continues on the next page as follows: "...and forced her upon a negro, whose upper lip projected along the sides of his nose, and the lower one doubled down upon his chin. He had such a hideous appearance that the demon Sakhr would have been terrified at seeing him, and fountains of liquid pitch trickled from his armpits." This fearsome character, Sa'di says, "the slave of his libidinous and carnal appetites...gave way to his lust, and deflowered the damsel."[37] These coming events cast their shadow over the painting. The ardour of the prince has pushed the Chinese maiden almost to the limit of the picture frame; she is cornered in the most literal fashion between two bolsters. At the opposite extreme of the painting is the negro lurking in the doorway, a *diabolus ex machina* awaiting his opportunity. This parallelism is, as we shall see, developed further. For the moment it is enough to notice that this visual connection between the girl and the negro, which embraces the entire width of the picture, sets up a tension between the ostensible subject matter and the hidden agenda, between the present and the future. The chamber is lavishly decked out with patterned textiles and tilework, and all this sumptuous decoration offers a poignant contrast to the squalid exercise in sexual politics which is unfolding before us. It acts as a gilded prison for her. The starkly confronted horizontal and vertical lines of the bedding seem to fence her in and may be intended as a visual metaphor of her plight. Outside, and out of reach – as in the scene of Sa'di and the girl (**9**) – is a paradise garden.

Here, very clearly, is a story of two pairs, and this is true not only of the positioning of the two groups. Both the inner figures are seeking to impose their will on the outer ones, the prince assaulting the girl and the courtier restraining the negro with an admonitory gesture. Perhaps the negro is expostulating at being forced to remain outside. The club he carries may be seen as a sinister portent of the impending rape. Finally, the distribution of colour accents is so managed as to create a link and also a diametrical opposition between the girl and the negro, and only between these two. As is the case elsewhere in this manu-script, the colours in question are pale green and vermilion, and here too it seems at least possible that they carry a message, as may the curtains in the selfsame colour, rolled up and down respectively. The lady wears a red outer garment and a green inner one; with the negro the colours are reversed, green outside, red inside. If red can be taken, naturally enough, to connote heat, and green to imply coolness, the relevance of these colours to the action would need no further comment. One might only add that his clothes, masking as they do most of the nature that lurks beneath, also smack of a literary device – litotes: extreme understatement for the sake of effect.[38]

Next, a deceptively simple painting illustrates a brief text describing how the poet, wandering in the noonday heat through the alleys of a town, chanced to encounter a maiden who appeared as if by magic from a doorway and offered him a much-needed drink of iced water (**9**).[39] Sa'di then intimates gracefully and in verse that the sight of her has afflicted him with a profounder thirst which no mere drink could assuage. The lady's reply is not recorded, though no doubt she too quoted verse at him in abundance. This brief and ambiguous encounter is the point of departure for the artist, who builds on it his own commentary, full of wit and sly humour. In a telling reversal of the setting described in the text, with its reference to the poet sheltering against the heat in the shadow of a wall, he sets Sa'di against a pale green ground while the girl comes out of an orange-red building which seems almost to glow with heat. These are the two dominant colours of the painting and can perhaps be seen as appropriate equivalents for the two major themes of passion and

rejection. But why are they so to speak reversed?[40] Closer examination suggests that the painter is playing a kind of cat-and-mouse game in his choice of colours. The warm-hued building has a marble dado of cool violet and the wall above and around the maiden is spangled with pale green stars. The doorway in which she stands, silhouetted against a pure white ground, is framed in tilework of blue and green. She herself is clad, promisingly enough, in orange; but that is her outer garb only, and beneath it can be glimpsed a pale green shift. The iced beverage which she offers the poet is contained in a bowl of the same jade-green colour. His outer robe, in contrast, is the colour of renunciation, blue, and is echoed, as just noted, in the door-frame.

The message of this subtle interplay of colours seems to be that hopes are raised only to be dashed. The body language of the two figures bears this out. The setting conjures up an

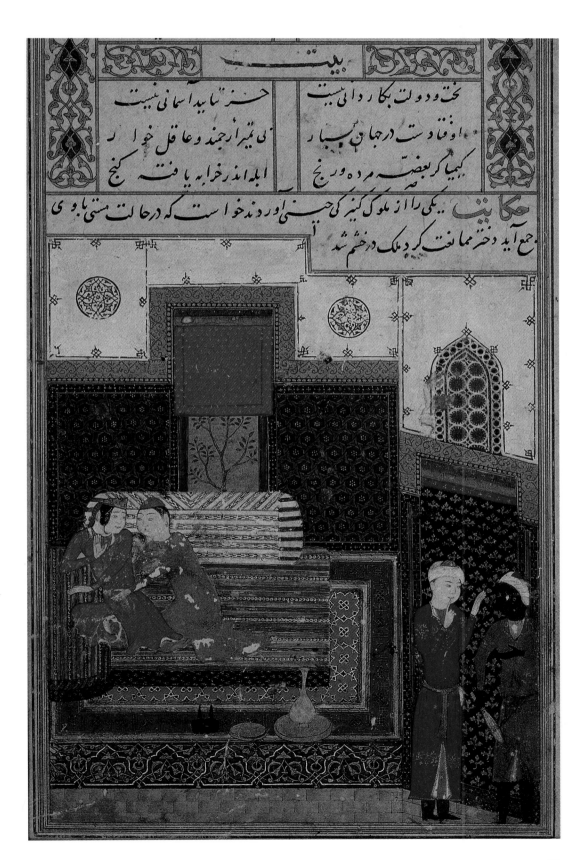

8. A drunken prince assaults a Chinese maiden, Sa'di, Gulistan, f.16r.

ample space, yet this contains only two diminutive figures. In one sense it dwarfs them; but in another, it ensures that attention is focused on them. Their hands almost touch but not quite. She stays just behind the mauve threshold, which thus seems to bar his entry. She proffers the drink but he has not yet received it. Thus gesture reinforces the message of colour.

But it is the contrast between their surroundings that is most explicit: unbroken emptiness for him, but for her a blossoming garden against a golden sky. That garden is sensuously lush in comparison with the starkness outside. And only a tiny, enticing fragment of it, resplendent in gold and bright green, is visible. Even the shutters of her house are firmly closed, so to speak, against him. Thus in his own domain the artist goes decisively beyond his literary source, and does so by means of a visual language every whit as allusive as the text itself.

The third picture which involves a development of the text on the painted page concerns the story of a youth with more brawn than brain who, having no money, tries to beg a passage on a boat (11).[41] The boatman refuses and, for good measure, reviles him, but

9. A chance encounter between a maiden and the young Sa'di, Sa'di, Gulistan, f.36r.

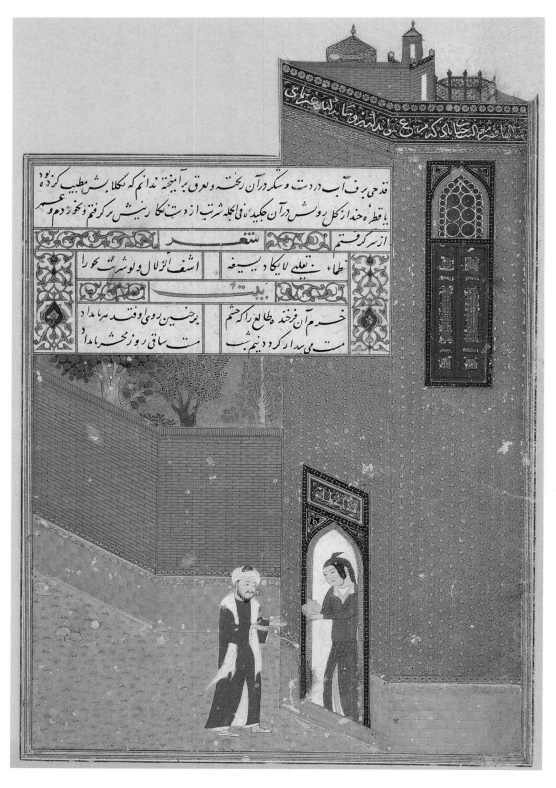

changes his mind when the youth offers him his garment in payment of his fare. Once aboard, the youth beats up both the boatman and his colleague. Worsted, they hypocritically profess amity and peace, and the voyage proceeds. Then they arrive at a pillar which juts out of the waves; here someone must climb up with a hawser so that the boat can be turned round. Sa'di's text continues, at the foot of the text panel, "The youth, in the pride of that courage which was uppermost in his thoughts, disregarded the rancour of an injured rival" – and here we must turn to the next page to learn that he duly shinned up the pillar with the cable. Immediately, says the text "the boatman dragged it from his hand and pushed off the vessel. The deserted wretch stood aghast." It is therefore this next page that is being illustrated, but as we read the text on the picture page we can see well enough where it will all end.

Here again the painter makes colour, gesture and empty space do his work for him. The landscape behind the youth materialises in a bleak palette of white, faded blue, mauve and pale green. The trees are bare of leaves and silhouetted against an unframed sky. The tower, whose hard-edged lines emphasise the sheer drop to the ocean below and seem to seal his fate, is also pale green. This chromatic austerity, with its unmistakable emotional implications, lends extra poignancy to the wide range of bright cheery colours in the boat to which he is denied access.[42]

The message of isolation is equally driven home by placing and gesture. The ten figures in the boat are huddled together, enjoying the privileges of human company and warmth. They are plainly indifferent to his fate and their vigorous hand gestures show them talking animatedly to each other. Only three figures turn towards the marooned youth with triumphant or mocking gestures. In the wordless colloquy between the boatman and the abandoned young man, empty space is made to play its full part.[43] It amplifies the huge gulf fixed between the fortunate and the unfortunate, across which the mute semaphore of the youth's pleading outstretched arms sends its unavailing message.

It would be possible to analyse each of the remaining five pictures in similar terms, but the law of diminishing returns would certainly operate. At this point, therefore, it may be useful to move from the specific to the general in an attempt to discover what principles governed the way the artist responded to his subject matter. Among those that can readily be identified, three stand out: the painter's penchant for drama; his choice of misfortune as a motif; and his concern to make text panels play their full role in the finished picture.

First, then, the painter's taste for drama. Again and again the artist reveals the mainspring of the action, the moment that triggers the denouement. Occasionally it is the denouement itself. It seems natural to use the vocabulary of the theatre – however anachronistic that analogy may be – since so many of the scenes are conceived primarily in dramatic terms. Spectators are ranged tightly packed like an audience; sometimes they even applaud or jeer.[44] The way the composition is organised, too, is often reminiscent of the theatre, with angled facades or diagonal files of onlookers operating like wings to nudge the attention towards centre stage, and a gorgeously decorated palace exterior as the backdrop.[45] Empty space is used in the most calculated manner to isolate the protagonist and focus attention upon him. Indeed, deliberate contrasts of colour – for example, the way the key figure is made to stand out vividly against a monochrome background – function in much the same way as spotlights in the theatre.[46] Gesture is manipulated to the same end.[47]

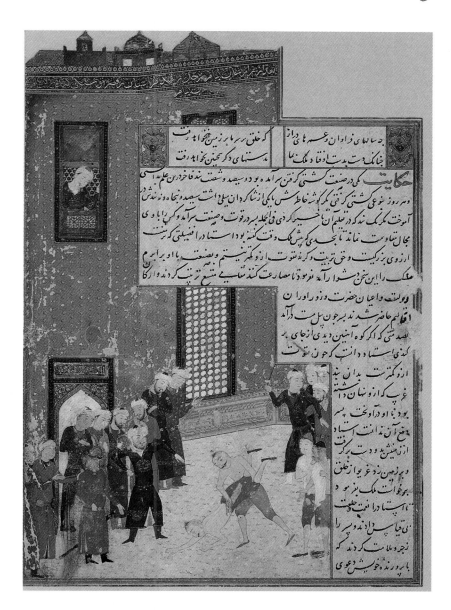

10. The wrestling match, Sa'di, Gulistan, f.14r.

Frequently the artist contrives to load a gesture with meaning by almost literally stretching it out, as in the case of the youth marooned on the pillar. He thus marshals the empty area between the figures linked by the gesture. Dead space comes to life.

The second leitmotif is no less obvious. When the subject matter of these paintings is critically examined, the major theme to emerge is quite plainly misfortune. That is certainly not the lasting impression left by a reading of the *Gulistan* as a whole. It is therefore an emphasis introduced by the artist – unless, indeed, he were following orders from above. The generally ironic and good-humoured tone which permeates the *Gulistan* leaves little trace in these paintings. Instead, scenes of a decidedly black cast have been selected for illustration and impart a downbeat, even pessimistic atmosphere to the book. This creation of a consistent mood at variance with that of the text itself is quite remarkable and no parallels for it suggest themselves. People are drowned, marooned, betrayed, sexually assaulted, attacked by dogs, disappointed, spurned and frustrated. The exceptions are the somewhat anodyne scene at the beginning, which depicts Sa'di conversing with a youth in a garden (2), and the tableau of the wrestlers, where virtue narrowly triumphs over vice (10).[48]

It remains uncertain whether it was the similarity of theme which generated the repetitive compositions or whether, on the contrary, the artist was most at ease with a certain compositional formula which lent itself most readily to scenes depicting victims of misfortune. At all events, our painter left a series of his trademarks on such scenes, and he uses them constantly to put across his message.[49] It may be useful to run through them quickly. All of them express the painter's imaginative response to the story, his desire to develop and intensify the narrative structure.[50] Thus, for example, in every case except that of Sa'di and the girl (9), where privacy is the essence of the encounter, he adds extra people to the scene. They are not mentioned in the text. Their purpose is not mere ballast – they are too carefully placed for that – but to act as a mute commentary on the main theme.[51] And they are not on the victim's side. By this unobtrusive means, then, the painter quietly weights the scales against the disadvantaged, following in this, it seems, his own personal interpretation of the *Gulistan*. Life is not a bed of roses.

In the same spirit Sa'di favours the device of isolating, almost silhouetting, the victim against an unfriendly expanse of plain monochrome background, such as the sea or a barren landscape.[52] The victim's vulnerability is exposed by his pathetic nakedness – the poet, the dervish, the marooned youth – and further emphasised by his feeble physique (7, 13). Even the wrestlers have bodies unworthy of their calling and here again their nakedness and their dun-coloured breeches reflect their lowly status. The unspoken message of these pictures is that it pays to be rich; woe to the poor and the unlucky. "Laugh, and the world laughs with you; weep, and you weep alone". Nothing subversive here,[53] for all that the *Gulistan* would have given ample warrant for it; and that is perhaps as it should be, seeing that the artist depended on a prince for his livelihood. The rich and powerful, secure in their luxurious palaces, look disdainfully down from their windows on the suppliants below, like Roman emperors idly contemplating events in the arena. The gulf between them is an index of the social as well as the spatial distance which separates them. Bright or warm colours are reserved for the privileged; cold greys and blues encompass the unfortunate.

Body language plays its part too. In the scene of the drowning brothers (3), one has only to contrast the phlegmatic posture of the spectators in the boat, safe and snug, with the frantically waving arms of the man sinking below the surface. The dervish vainly trying to warm his naked torso, the poet fumbling desperately to dislodge a stone he can throw at the dogs slinking towards him (6, 13), are both watched with indifference or schadenfreude by courtiers from the shelter of the nearby building. Neither of them is offered any help. Indeed in the case of the poet, even nature conspires against him, for winter has frozen the stones to the ground, prompting him to rail in the text panel "What bastards these men are, for they untie their dogs and tie up their stones!". This witticism, forced out of him by sheer panic, proves his salvation because it amuses the bandit chieftain watching at the window. But the picture itself does not betray the outcome, and the stark juxtapositions in these two paintings typify this cycle of illustrations.

The third constant of our artist's approach is the way that he incorporates blocks of text into the picture space. The pervasive presence of these text boxes creates something akin to the speech bubble in a modern cartoon or comic – though the analogy underlines how crude a device the speech bubble is in comparison with the language of mime.[54] The use of text panels in these pictures marks a new stage in the interplay between text and image in Persian painting. For almost a century – since the time of the so-called Demotte *Shahnama*, probably executed in the 1330s – artists had realised that their options were wider than

11. A youth is marooned by an angry boatman, Sa'di, Gulistan, f.29v.

42

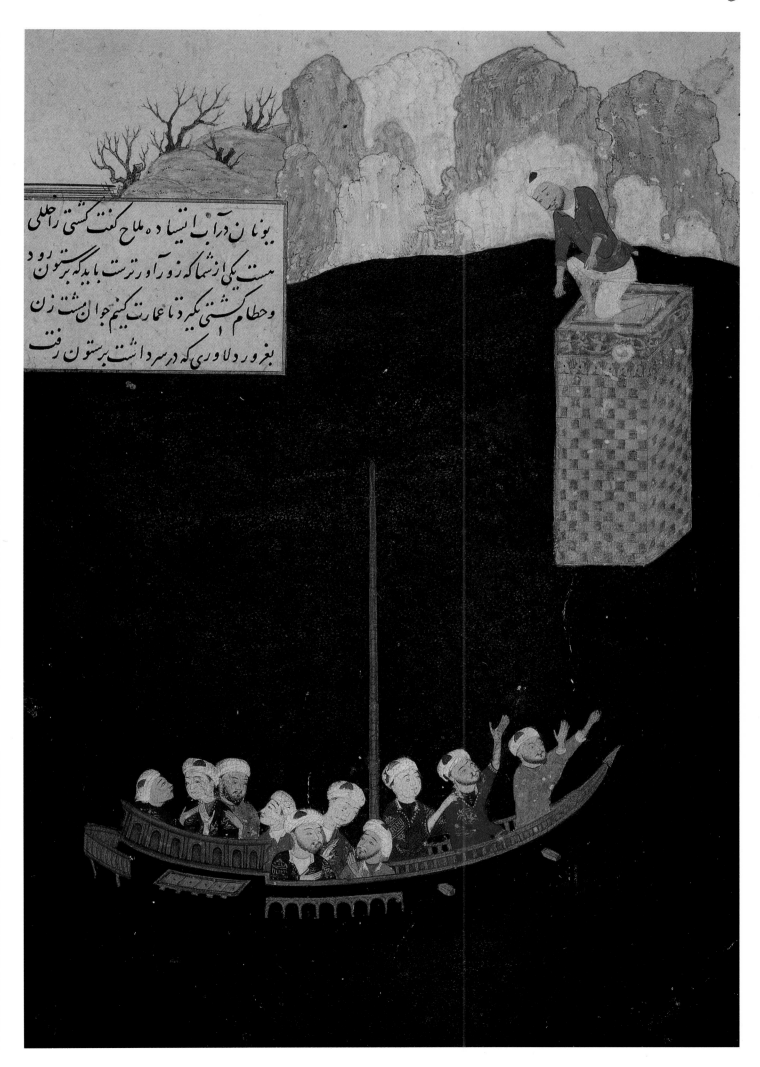

merely varying the breadth of the text panel which was set above or below the picture.[55] But while the more adventurous artists had indeed experimented with flags of text engulfed by the picture,[56] or with paintings banished to the margins while text panels claimed pride of place,[57] the idea of varying the size, the placing and the role of the text panel from one painting to the next in a single manuscript was still unfamiliar. And this is just what is done in the *Gulistan*. Equally striking, and of course intimately related to this phenomenon, is the way that each picture is set on the page differently from the next. Thus in the dimensions and shape of the painted surface and text panel alike, continuous variety is the rule, with a consequent enlivening effect on the entire manuscript.

Nobody should underestimate the sheer professionalism of the artists who together created a fine manuscript of this period. The labours of the bookbinders, leather-workers, paper-cutters and paper-polishers, though integral to the finished product, are not strictly relevant in this context. But the scribe, painter and illuminator had to work in the closest concert if the grand design were not to miscarry. Their interdependence derived from the way the space on the page was parcelled up. The relative emphasis placed on text, illustration and illumination varied dramatically from page to page, but could afford to do so only because policy decisions about the layout of every page were taken early on.

The textbook case of this practice is furnished, as Teresa Fitzherbert has demonstrated, by the Khwaju Kirmani manuscript of 1396 in the British Library, produced a generation before the *Gulistan* under discussion here.[58] Here a poem many thousand *bait*s (couplets) in length has been transcribed with such total control of pace that it finishes on the dot of the last line of the last page of the manuscript. Yet in the process it has managed to integrate into the rhythm of that text – whose number of *bait*s per full page of text remains absolutely even throughout the book – a set of paintings notably uneven both in size and in the amount of text which they incorporate. All this argues the most careful planning in advance. Not only the presence of a text panel in a picture, but the very content of that same panel, had to be fixed before the painter seriously began work. The many examples of unfinished paintings whose text panels remain empty should not be misconstrued. The text that was eventually intended to fill such panels was known in advance, and we have seen that it frequently dictated the precise content of the painting. Even a full-page illustration could only be inserted at a later stage if it fulfilled two conditions; that its verso also contained a full-page painting, and that neither painting incorporated any of the text to be illustrated.[59]

These remarks should make it clear that the underlying concept of an illustrated manuscript, at least in the academy founded and funded by Baisunghur, was emphatically not that of a self-contained text to which an elastic number of illustrations could be added later and at will. Instead, text, illustration and even illumination were intended to form a seamless whole. Ornament, too, is not mere decorative infill because artist or calligrapher have left some visually irksome gaps on the page. It is placed with a finely tuned sense of interval; in musical terms, one might speak of absolute pitch. A destructive domino effect would inevitably result if a painted or illu-

12. Illuminated text page, Sa'di, Gulistan.

minated surface took up too much room on a given page, for the finely wrought balance between text, painting and illumination on subsequent pages would then be displaced. There is only one right place for a given *bait*. In other manuscripts of earlier or later times, or of lesser quality, this is patently not so, because the calligraphy is not of uniform size. But once the decision has been taken to execute a manuscript in a uniform size of script, very precise planning is imperative.[60] Even an untrained eye can detect the signs of a calligrapher cramming words too closely together because he was running out of space, or conversely expanding the space between words and letters because he had too much of it.

What is the precise role of the painter in this situation? There is no certainty about whether he agreed with the patron or the calligrapher on the exact number of pictures for the manuscript. But he must certainly have maintained close liaison with the calligrapher as to the exact shape of the boxes that would hold the paintings; and, in his turn, the calligrapher would have had to know what part of the text would need to be accommodated on such pages. And of course, the less text that appeared on the page, the more constricted did the options of the painter become – not least because that text took on proportionately greater significance as it became less and less.

Most challenging of all were the cases where the flag of text was no more than a *bait* or two. Then the painter was on his mettle to ensure that, while his illustration accurately captured the spirit of the story as told in the adjoining pages, it also carried a special charge of relevance linked to the panel of text in the painting itself. In the case of the *Gulistan*'s wrestling scene, for example, the painter had ample scope since the text panel contained virtually the entire story. As it happens, this *Gulistan* – unlike, say, the Khwaju Kirmani manuscript in the British Library – has no case where the textual presence in the picture has been whittled down to a pair of *baits*, and so there is no opportunity for a final flourish of virtuosity, as there is when a painting is so constructed that it turns on the significance of a few words.

As it happens, there are three cases in the Dublin *Gulistan* where the text panel adjoining the painting, and on the same page, contains a portion of the previous story. Was this a matter of indifference to the makers and reader of the book? Or was it tolerated as just a minor blemish? Or was it, on the contrary, a piece of deliberate planning? The latter seems the most likely explanation, for in all three cases – ff.9r,[61] 14r,[62] and 16r[63] (**5, 10, 8**) – the presence of the immediately preceding episode (which is of course potentially intrusive and distracting) was intended to drive home the moral which the painting expressed. Overlap, then – or, for that matter, its absence[64] – was part of the overall plan.[65]

When the Dublin *Gulistan* is compared with the great Persian manuscripts of earlier or later periods, it can be seen to lack their range of expression, as exemplified, say, in the Demotte *Shahnama* or in the British Library Nizami of 1494.[66] Instead, it adopts a deliberately restricted compass, reworking a single basic idea in several different guises. Hence the repetition of a single figure type – thin, bloodless, narrow-waisted – or of similar architectural facades. Two illustrations – the poet in the garden and the amorous prince – are evidently lifted or adapted from earlier manuscripts. In one sense, then, this manuscript represents a step backwards from the confident full-page pictures of the Khwaju Kirmani manuscript, for even its apparently full-page illustrations prove on closer inspection to be nothing of the kind and they contain significantly less action, çolour, detail. Yet to dismiss it in these terms would be a serious error.

Its true context is in the activity of the entire Baisunghuri atelier over a period of some seven years between 1426 and 1433, the year of his death. Baisunghur clearly ordered copies of many of the major literary masterpieces of Persian literature, and they emphatically do not conform to a single house style. Indeed, even successive versions of the same text, as in the case of the *Kalila wa Dimna* and probably the *Shahnama*, attest significant differences in style.[67] This, then, was not merely a period of experiment in the normal sense, but rather a time when the appropriate style of presentation for a given text, including its page layout, calligraphy, painting and illumination, with the degree of emphasis to be allotted to each of these elements, was a matter for careful thought. It seems likely that different teams were each allotted a manuscript and encouraged to devise a tailor-made solution for the particular problems it posed. It was inevitable that some solutions should be perceived as dead ends – perhaps the *Chahar Maqaleh* was one of these – and others as only partial successes.[68] But their felicities would nevertheless have something to offer towards the formation of the celebrated classical style of Persian painting, traditionally associated with Baisunghur.[69] And in that category the Dublin *Gulistan* deserves a place of honour.

Notes see Appendix

13. The poet is held at bay by dogs (detail of 6).

4

FARANGI SAZ

The Impact of Europe on Safavid Painting

SHEILA CANBY

Following the death of Shah Tahmasp in 1576 the number of European visitors to Iran increased, and with them came new sources of inspiration for Iran's painters. At first, Persian artists borrowed elements from European painting, adapting them to their native style. Then during the course of the seventeenth century, with the influx of European prints and printed books, new subject matter and European pictorial techniques increasingly came into use, resulting in a style that departed radically from the traditional mode used in the fifteenth and sixteenth centuries.

One of the hallmarks of Iranian art of the Safavid period (1501-1722) is the introduction of European elements where previously none were to be found. Although European visitors came to Iran in the fourteenth, fifteenth and sixteenth centuries, their numbers and their impact on the arts were extremely limited. Even when, in 1515, the Portuguese managed to take control of the Persian Gulf port of Hormuz, oddly this neither seriously strained relations with Shah Isma'il I, the founder of the Safavid dynasty, nor resulted in noticeable Portuguese influence on the arts.

The accession of Shah Tahmasp in 1524 ushered in a period of exceptional patronage of the visual arts, especially painting, entirely devoid of European influence. Even when the English traders, Anthony Jenkinson and the Johnson brothers, came to Tahmasp's court at Qazvin in 1561, the visit did not have any measurable impact on the court arts of the Safavids. In fact, by the 1560s Shah Tahmasp had entered a phase of deep superstition and religious fundamentalism. Although he was far from pleased to learn that the English visitors were Christian, they managed to leave Iran unscathed. Over the following thirty years various other Europeans visited the country, but years of political upheaval and a depleted treasury provided infertile ground for sustained European influence on the arts.

The arrival in Iran of the English adventurers Anthony and Robert Sherley in 1599 marked a new stage in European influence. By this time Tahmasp had died, the dynasty had barely survived a decade of civil war and misrule, and Shah 'Abbas I had acceded to the throne. With the help of Robert Sherley, Shah 'Abbas hoped to persuade the kings of Europe to join in a military alliance against the Turks and to engage in trade with Iran. While the military alliance never came about, eventually both the English and Dutch East India Companies established textile factories in Iran. From at least the 1620s, if not earlier, Europeans of all types – merchants, ambassadors, priests and craftsmen – could be found in Iran and especially in the capital, Isfahan.

In addition, Shah Tahmasp, and to a greater extent Shah 'Abbas, had resettled large numbers of Georgians, Circassians and Armenians in Persia. Shah 'Abbas provided the Armenians with their own quarter in Isfahan, New Julfa, and encouraged them to use their mercantile and linguistic abilities by becoming silk traders. With the profits from their trading, the Armenians constructed twenty churches between 1606 and 1728, and in turn these were decorated with tiles, wall paintings and paintings on panel or canvas by European

and local artists of Armenian, Iranian, or European origin.[1] Thus, in the seventeenth century an array of Christian images of European origin or based on European prototypes was available in the Iranian capital.

To three European visual sources for Iranian artists – Europeans themselves, European artists resident in Iran and Christian pictorial models – a fourth should be added: European secular prints and printed books. These were brought to Iran by traders and travellers, who sold or gave them to the local populace. While few prototypes can be identified precisely, the introduction of certain compositional themes, techniques and colours strongly suggests a new influence at work in Persian painting. Increasingly the taste for European methods replaced the Chinese aesthetic which had informed much of fourteenth and fifteenth century Persian painting.

Spearheaded by Riza, the leading artist at the court of Shah 'Abbas I, Persian painting

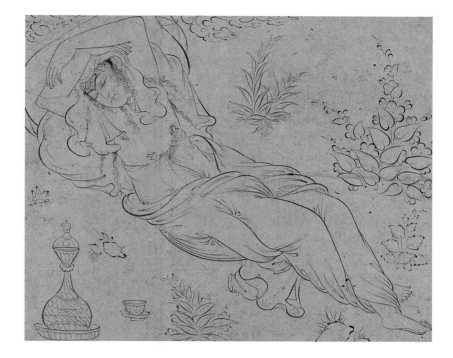

made the transition from the prevailing Qazvin style of the second half of the sixteenth century to one exhibiting European influence in the early seventeenth century. The works of Riza, also known as Aqa Riza and Riza-yi 'Abbasi, and of his contemporaries from the late 1580s, continued to incorporate the saturated colours, scattered landscape elements painted in wispy gold, and the delicately rendered, idealised faces associated with the Qazvin style (3). Such European preoccupations as recession in space, chiaroscuro, and, to a certain extent, modelling, are foreign to such works. Moreover, the palette emphasises the purity and brightness of each colour represented, rather than tonal transitions.

Following the move of the Safavid capital to Isfahan in 1598, aspects of the prevailing court painting style had begun to change in a way that may suggest European influence. Primary colours gave way to purples, greens and browns. Forms became more rounded and the use of line less delicate. By the 1620s, Riza and his school had entirely abandoned the palette and physical types represented in his earlier portraits of young men. Even allowing for changes in fashions of dress, these figures were now heavier with larger heads, lower waists, more pronounced facial features, and thick ovoid thighs. In many paintings of this period, drapery forms weighty folds that resemble toffee oozing across the page.

The reasons for these stylistic developments are of course numerous and are not limited to foreign influence. The taste of patrons, the development of new modes of dress, and the rise of a nouveau riche social class all contributed to the new ways of depicting the

4. Sleeping woman, attributed to Riza, Qazvin, ca. 1595. Ink on paper, 11.8 x 14.4cm (4¹/₂" x 6"). Sackler Museum, Harvard University, inv.no. 275.1983.

1. Title page: Flowers in a jug, signed Shafi' 'Abbasi, Isfahan, dated 1081AH (1672AD). Ink on paper, 27.9 x 18cm (11" x 7"). British Museum, London, inv.no. 1988 4-23 056, f.2v.

2. Facing title page: Prince in the countryside, attributed to Muhammad Qasim, Isfahan, ca. 1650. Gouache, ink and gold on paper, 25 x 17cm (10" x 7"). British Museum, London, inv.no. 1920 9-17 0275.

5. Cleopatra, Marcantonio Raimondi after an original by Raphael, Rome, ca. 1520-25. Engraving, 11 x 17.5cm (4¹/₂" x 7"). British Museum, London, inv.no. 1910 2-213 332.

3. Young man in a blue cloak, signed Riza, Qazvin, ca. 1587. Gouache on paper, 13 x 7.5cm (5" x 3"). Arthur M. Sackler Museum, Harvard University Art Museums, Cambridge Massachusetts, Sarah C. Sears Collection, inv.no. 1936.27.

Safavids. One of the main challenges to understanding early seventeenth century Persian painting is that of disentangling internal developments from those elements adapted from foreign sources.

The most probable source of European influence was of course works of art or printed illustrated books themselves. Even before Persian artists started to portray figures in European dress in the 1620s (6), they had begun to depict some European subjects, such as nudes, in Persian style. Portraits of reclining nude women did not exactly abound in earlier sixteenth century Persian painting. Even if artists observed such figures from life, they might not have thought them fit subjects for portraits had there not been pre-existing European examples.

The earliest documented Persian seminude figure based on a European prototype is a drawing attributed to Riza (4) after a print by Marcantonio Raimondi (5) which I have discussed at length elsewhere.[2] Were it not for the rarity of such subjects in the early 1590s when it was produced, Riza's drawing could be taken as a thoroughly Persian work with no European prototype. Moreover, if we admit its reliance on the Italian print, we must equally accept that European pictures were available in Iran somewhat earlier than has previously been thought.[3]

From historical accounts it is known that Portuguese priests had supplied the Mughal emperor Akbar with illustrated Bibles by the third quarter of the sixteenth century. But what of prints acquired through trade? Proof of the late sixteenth century presence of European prints in Iran comes indirectly from an Arctic island called Nova Zembla (Novaya Zemlya). Here in 1596 a Dutch vessel trying to reach China via the Northern Passage ran aground. Although the captain and crew escaped, they were compelled to leave their ship and its cargo. In 1871 the ship and its frozen contents were discovered, and by 1872 a publication of the finds indicated that a

large number of prints were on board. Having been frozen and defrosted repeatedly, the prints had congealed into lumps which were separated and conserved only in the 1970s by the conservation staff of the Rijksmuseum in Amsterdam, which now owns the collection. Although the final publication of the six hundred or so prints has not yet appeared, they have been identified as works of the 1580s by artists of the Haarlem school of Hendrik Goltzius as well as some by Phillip Galle, Jacob II De Gheyn, and others. Subjects range from biblical and classical themes to landscapes, costume and emblematic prints. A peculiarity of this group is the absence of portraits, but they certainly figured in some shipments as written accounts attest.[4]

The Nova Zembla finds demonstrate that European prints were being sent to the East as merchandise, not only as tools of evangelism, before 1600. Although few of those who travelled on such ships wrote accounts of their journeys, further research may uncover more information about the volume of trade in pictures. Also, while we cannot be certain that the prints sent to Iran were the same as those that went to India or China, at least one European work, an engraving from a French series depicting the five senses, has appeared

in both a Persian and an Indian context (7).

The long career of Riza, which ended only with his death in 1635, saw not only the introduction of European art in Iran but also the arrival in Iran of many Europeans themselves. Works of Riza from the 1630s and of his followers from the 1640s (6) include portraits of Europeans whose names, unfortunately, are unknown to us. Given that Mu'in Musavvir or a follower portrayed the aged Riza at work on a portrait of a man in European dress, Riza must have been known as a painter of Europeans, perhaps the first Persian to do so.[5] Riza himself did not choose to adopt the style of European painting, only its trappings. He remained true to his own treatment of space, definition of form, and palette, perhaps considering the European treatment of these aspects to be as alien as the Europeans themselves.

In the hands of Riza's followers, trends he had begun were adopted and expanded. Some scenes, such as a man pulling a donkey's tail to keep him from drinking (8) are, like Riza's nudes, so unusual that one might suspect a

foreign prototype. Yet, it may be too far-fetched to see a model for the Persian drawing in the composition of an English satirical print (9). At most the Persian artist would have been inspired by the idea, but he may just as easily have seen someone struggling with his donkey and decided to record it. We really have no way of knowing which is the case.

Much of the European influence suggested in Riza's œuvre became more obvious in the work of Muhammad 'Ali, Muhammad Qasim, Muhammad Yusuf, Afzal al-Husaini and even Mu'in Musavvir, all of whom were active in the 1640s and 50s. In *Prince in the countryside* (2) attributed to Muhammad Qasim, the subject and composition adhere to traditional Persian models often found as one half of double-page frontispieces of manuscripts. Yet the painterly treatment of the sky, while introduced earlier in the work of Mu'in Musavvir, may ultimately derive from European painting. Likewise the stippled ground, so characteristic of Muhammad Qasim's work, appears much earlier in Mughal painting and may indicate influence from India, not Europe.

Whereas the artists who followed Riza continued to treat space in a conventional Safavid manner with few attempts at one-point perspective, they were more open to using shading, especially on the faces of figures, in an attempt to show modelling. Unfortunately, as in the drawing of *An inebriated youth* of ca. 1650 (11), the use of heavy shading on drawings tended to cancel out the calligraphic spontaneity of earlier Persian drawings. Thus, except for that of Mu'in Musavvir, the draughtsmanship of these artists often appears stiff and lifeless.

8. *Man pulling the tail of an ass (detail), Isfahan, ca. 1600. Ink on paper, 9.8 x 8.1cm (4" x 3¹/₂"). British Museum, London, inv.no. 1920 9-17 0279 (1).*

6. *Opposite above: Page in European dress, Isfahan, ca. 1660. Ink, gouache and gold on paper, 16.8 x 8.6cm (6¹/₂" x 3¹/₂"). British Museum, London, inv.no. 1948 10-9 062.*

7. *Opposite below: The sense of smell (detail), F. Mazot, Paris, mid 17th century, doublure of an album, Lucknow, ca. 1780. Lacquer over engraving, 43 x 28cm (17" x 11"). British Museum, London,*

9. *"All do ride the Asse...", English satirical print, ca. 1600-1610. Engraving, 25.4 x 42.5cm (10" x 17"). British Museum, London, inv.no. 1855 1-14 189.*

10. *Lady with dog, signed "work of the humble Mir Afzal Tuni" (Afzal al-Husaini), Isfahan, ca. 1640. Gouache, ink and gold on paper, 11.7 x 16cm (4¹/₂" x 6¹/₂"). British Museum, London, inv.no. 1930 4-12 02.*

11. *An inebriated youth, Isfahan, ca. 1650. Ink and gold on paper, 12 x 8.5cm (5" x 3"). British Museum, London, inv.no. 1920 9-17 0271 (4).*

Because Persian artists did not see shading as a product of the effects of light, but as a tool for defining form, their attempts at modelling were only partially successful. The drinker's chin appears quite prominent as a result of shading but his eyes are ringed and masklike.

One of Riza's most gifted followers, Afzal al-Husaini, was inspired by one aspect of his master's Europeanising tendency we have already touched on – what Richard Ettinghausen referred to as the "pin-up boys",[6] though in this case a pin-up girl (10). Here one finds a dog drinking wine or maybe water in company with a Persian woman who has fetchingly exposed her midriff to the viewer. The subject of this amusing composition harks back to Riza's late portrait of a European in which a dog drinks wine from a bowl held by the sitter while the pose recalls that of Riza's *Sleeping woman* (4). Although the increase in paintings of nudes or mildly erotic subjects has been attributed to the loose morals and general prosperity of the reigns of Shah Safi and Shah 'Abbas II, such scenes would not have gained currency with the leading artists of the day had they not been familiar with European prints of similar subjects. Furthermore, in the case of Afzal al-Husaini the examples set by Riza would have paved the way for combining the exotic, in the form of a "European pose" and Chinese-style blue and white porcelain, with the erotic.

The painting of a *Mother and child* (13) bears a false signature of Riza and a dedication to Manuchihr, the Superintendent of Roads. The subject could derive from a Venus and Eros composition, somewhat sanitised by clothing the child in a dress. Although sixteenth century manuscript illustrations contain vignettes of mothers and children, the subject was not excerpted and treated on its own until the seventeenth century. Even then the subject was rare. Also, the mother is too scantily dressed to be considered a portrait figure, as respectable Persian women were depicted fully clothed.

The pictures discussed so far demonstrate various strains of European influence. In addition to direct borrowings from European prints, Persian artists adapted European subject matter to their own style. They also portrayed Europeans themselves and by the 1640s were experimenting with European-style shading. But what evidence is there for European art being present in Isfahan in the seventeenth century? First, Jean-Baptiste Tavernier, who made six trips to Iran from the 1630s to 1670, told of bringing an artist along with him on his second trip, about 1640. This man "had in his chest several engraved cuts,

part landskips, part figures, together with the pictures of certain courtesans drawn to the waist."[7] Such prints would have exposed Iranian artists or their patrons to three genres of European pictorial arts: landscapes, portraiture and possibly nudes, all or any of which could have depicted mythological or religious subjects. Additionally, European artists themselves accompanied travellers to the East and in some cases settled in Isfahan. The most intriguing of these is mentioned by Thomas Herbert, who accompanied the British Ambassador, Sir Dodmore Cotton, to Iran in 1626. According to Herbert, the artist, "John, a Dutchman (who had long served the king [i.e. Shah 'Abbas]) celebrated his skill here to the admiration of the Persians and his own advantage."[8] This artist had painted narrative scenes in Shah 'Abbas' palace at Ashraf on the Caspian. Also, Herbert asserted that John the Dutchman schemed with an enemy of the deceased Robert Sherley to ruin his widow, so we must suppose that he was no saint.

As for paintings in the European style but not necessarily by European artists, Adam Olearius described one of the royal audience halls in Isfahan which he visited in 1637 as follows: "The Hall itself had on the upper part of it, towards the roof, several portraitures of women, clothed in several modes, all done after some European copies...".[9] How European these paintings really looked may be indicated by paintings that remain in the Chihil Sutun, a palace built in 1647 in Isfahan by Shah 'Abbas II. The wall paintings of feasts and battles in the European style in this palace have been shown quite convincingly to be contemporary with the years immediately following the completion of the building.[10] In addition to the large Europeanising scenes, the palace contains traditional Persian garden scenes and pictures of figures in European dress standing in European-style settings.

As one might expect, the churches of New Julfa, the Armenian quarter of Isfahan in which all foreigners resided, contain paintings by Europeans as well as Armenians or Persians working in both the European and Persian styles. The paintings in All Saviours Church were based on the illustrations of the first Armenian Bible, printed in 1666, and are considered the work of one of the Italian or Flemish artists living in Isfahan. Local Armenian or Persian artists produced other paintings in the church. One might argue that the relationship between European and Persian art would necessarily be closer in the Armenian, Christian setting of New Julfa than in the Safavid court itself. However, by the second half of the seventeenth century several court artists, including Shafi' 'Abbasi, Riza's son, Muhammad Zaman, and 'Ali Quli Jabbadar, were working consistently in a European mode or under European influence.

An album of 55 flower drawings in the British Museum contains three signed works by Shafi' 'Abbasi and several others that are attributable to him. Not only are the drawings interesting in their own right as examples of Shafi' 'Abbasi's work but also their placement in an album of works with strong ties to European art is noteworthy. Two drawings of flowers signed by Shafi' 'Abbasi and dated 1640 and 1644 are not obviously based on European prototypes. Yet the third signed and dated drawing, from the first day of Ramazan 1081AH (1671AD), presents a stiffer, more complex composition (1). Unlike the earlier flowers which grew from clumps of foliage, these are arranged in a pitcher, described as European by Basil Gray who published the album in 1959. The pitcher resembles a sixteenth century South Netherlandish tankard, a type of vessel also depicted in European prints. The use of a grey wash and cross-hatching inside the rim in the drawing, and striations near the handle to produce shading, strongly suggest that it derives from a European prototype, more probably a picture than an actual object. Rather than copying directly from a foreign model, Shafi' 'Abbasi may simply have borrowed the idea and adapted it to his own style. Such internalising and transforming of the foreign example represents the most creative and felicitous use of imported ideas.

The pricking along the outlines of the flowers and pitcher indicate that this drawing was used as a pounce to transfer the image to another surface. The album includes many other pounced drawings, a fact which led Basil Gray to conclude that the drawings were designs for textiles.[11] Thanks to the original encouragement of Shah 'Abbas I, the textile business was thriving in seventeenth century Iran. Along with textiles produced for the domestic market and raw unwoven silk sold abroad, the East India Company actually set up its own factories in Iran for textiles made to the English taste. It would not necessarily be far-fetched to imagine an artist such as Shafi' 'Abbasi supplying designs to the English factories based on European prints, or perhaps adapting designs from the English for Persian textile weavers. Three textiles signed *Shafi'* are extant (**12**), proving the close connection of his drawings to textiles.

To emphasise the reliance of the artists in this album on European models, one need only

12. Silk and metallic thread velvet panel signed Shafi', Kashan or Isfahan, ca. 1640. 198 x 58cm (6'6" x 1'11"). Courtesy Sotheby's New York.

13. Mother and child, falsely attributed to Riza, Isfahan, ca. 1640. Gouache and gold on paper, 17 x 9cm (7" x 3¹/₂"). British Museum, London, inv.no. 1922 7-11 01.

look at folio 55r (**14**), copied directly from the *Therd Booke of Flowers, Fruits, Beastes, Birds, and Flies*, illustrated by John Dunstall and published in London in 1661 (**15**). As Basil Gray suggested, such a book would have provided patterns for textiles destined for the English market. European herbals such as the well known *Hortus Floridus* of Crispin de Passe (**17**) may also have inspired the artist of a group of drawings of tulips in the British Museum album (**16**).

Unfortunately, not all encounters of Persian artists with European works of art resulted in such attractive paintings or drawings. One of the Safavid artists most thoroughly influenced by European painting was Muhammad Zaman. Although he was once thought to have travelled to Rome and studied Italian painting, scholars have now decided that he must have studied with European artists in Iran.[12] Eleanor Sims has further suggested that he spent some time in Kashmir where he would have encountered European painting through the intermediary of Mughal painting.[13] Of course, he also could have seen Mughal paintings in Isfahan. Certainly his heavy-lidded, tubular-armed figures could reflect the influence of Mughal styles from the third quarter of the seventeenth century. Active from about 1650 until the early eighteenth century, Muhammad Zaman incorporated European techniques in his work more completely than his predecessors. Not only did he employ chiaroscuro and a kind of rudimentary one-point perspective, but he equally adopted the landscape techniques of Netherlandish painting. In at least two cases, the 1539-43 *Khamseh* of Nizami made for Shah

14. *Flowering branch (detail), Isfahan, ca. 1665. Ink on paper, 13.8 x 8cm (5¹/₂" x 3"). British Museum, London, inv.no. 1988 4-23 056, f.55r.*

15. *Birds and flowering branch (detail) from the Therd Booke of Flowers..., London 1661. 16.2 x 27.5cm (6¹/₂" x 11"). British Library, London, inv.no. 432.k.1.*

Tahmasp (**18**), and the late sixteenth century *Shahnameh* begun for Shah 'Abbas I, in the Chester Beatty Library, Dublin, Muhammad Zaman completed unfinished miniatures or added new ones. In these paintings the contrast is marked between his figures and those in the earlier, classical Safavid style. The sixteenth century angels look only toward the Prophet, their eyes, noses, and mouths rendered with the most delicate of brushstrokes. Muhammad Zaman's angels, on the contrary, have fleshy mouths and large eyes. In one case the angel gazes directly at the viewer. The idealised, otherworldly quality of the early angels has been transformed, as if Muhammad Zaman's angels were simply human beings with wings.

In addition to manuscript illustrations Muhammad Zaman also painted flowers, notably a single iris in the collection of the Brooklyn Museum, portraits of courtiers, and paintings based on European religious prints. In some but not all of his works he favoured a stippling technique, perhaps in emulation of the mid seventeenth century artists, Muhammad Qasim and Muhammad 'Ali. In an equestrian portrait ascribed to Muhammad Zaman (**19**) but possibly by one of his contemporaries, the stippling is evident really only in the grass. Far more than in his manuscript illustrations we can see how he combined Persian with European and even Indian techniques. The shading and delicate colouring of the faces lend them a verisimilitude that is absent from traditional Persian portraiture. Yet the men's torsos and the horse could not appear more flat. The treatment of textiles ranges from decorative, in the case of the sumptuous gold dress and turban of the prince, to modelled, in the case of the *saqi*'s blue trousers, in which the ridges of folds are accentuated by highlights. The Indian figure at the right wears a transparent robe over his orange dress and purple and white striped pajama pants, rendered here as they would be in a Mughal

painting. In fact, given the three artistic styles here and the possible identification of the *saqi* from his hat as European, perhaps the painting was not only a portrait but also an artistic conceit, showing off the painter's ability to work in the three dominant styles of late seventeenth century Iran.

So far the ways in which European art influenced Persian artists in the seventeenth century have been discussed. Most of these artists worked for Persian patrons. But what of the Isfahan artists who produced paintings for the Europeans in Isfahan? For this type of work we must turn to a second album in the British Museum, acquired by the museum's founder, Sir Hans Sloane, from the library of Engelbert Kaempfer.

Born in Westphalia, Germany, in 1651, Engelbert Kaempfer studied medicine and ultimately joined the Swedish embassy to Persia, setting off in March 1683. Having travelled through Russia across the Caspian to Shamakha and Baku, Kaempfer arrived in Isfahan in early 1684. Over most of the next two years he busied himself learning as much as possible about the natural history of Iran as well as the history and customs of its people. Rather than return to Sweden, he decided to join the Dutch East India Company as its physician so that he could travel further east to Japan. In late 1685 he left Isfahan for Bandar Abbas (Gumroon) on the Persian Gulf. Having contracted fever in Gumroon, Kaempfer was forced to retire to the mountains to recover, and he did not finally leave Iran until June 1688.

The pictorial aspect of Kaempfer's sojourn in Iran is slightly odd. In addition to the album, the British Museum owns five popular paintings collected by Kaempfer in Iran (20). They are painted in thin pigments on flimsy paper in a most slapdash fashion. Each one is inscribed with a three-digit number, perhaps indicating that they were part of a series of Iranian *types locales* such as dancers, hunters, courtesans and tribal people. Although the more recent museum records suggest that these were acquired in the Isfahan bazaar, they could just as plausibly have been bought at the beginning of Kaempfer's trip at Shamakha or Baku or at the end at Gumroon. Their main interest lies in the fact that Kaempfer bought them in the first place and that this type of work was being done at the same time as Muhammad Zaman's explorations of European and Mughal painting. They demonstrate the range of quality in the pictorial arts in the 1680s and presumably what was available on the open market as opposed to the more rarified artists' ateliers of the capital city.

Far more intriguing are the paintings and drawings contained in Kaempfer's album. Bound in horizontal format with glossy, watermarked paper, the album must have travelled from Europe with Kaempfer. The first illustrated pages in the album contain an ink drawing of Yezdikhast, a town on the road from Isfahan to Shiraz, two drawings of an unnamed ruined hilltop village and a column of horns in Isfahan. Presumably Kaempfer started sketching in the album while he was living in Isfahan in 1684-85, though the album includes a drawing of the fort at Hormuz. Following Kaempfer's own sketches comes a group of 18 painted pages of Persian types, plus Layla and Majnun, with Persian inscriptions and Dutch explanations or transliterations.

The Kaempfer album raises the question of whether by the 1680s Persian artists working in the European style constituted a special group. Like Shafi' 'Abbasi in his 1671 drawing of the flowers in the tankard (1), the artist of Layla and Majnun (21) used grey washes to

16. *Tulip and bee, Isfahan, ca. 1670, ink on paper, 19.3 x 12.4cm (8" x 5"). British Museum, London, inv.no. 1988 4-23 056, f.20r.*

17. *Tulip (detail), from Hortus Floridus Book 1, Crispin de Passe, Arnheim 1614. 16.6 x 24cm (6¹/₂" x 9¹/₂"). British Library, London, inv.no. 453.a.10.*

19. *Prince on horseback with a courtier and servants, attributed to Muhammad Zaman, Isfahan, ca. 1670-80. Gouache and gold on paper, 20.6 x 14.3cm (8" x 5¹/₂"). British Museum, London, inv.no. 1948 12-11 019.*

indicate shading. In some areas the drapery is modelled and shows a reliance on Western examples, whereas in other passages the drapery appears oddly bunched but flat. The pose and face of Majnun, with his balding head and five o'clock shadow and his modestly draped loins hardly follow the traditional compositions from Safavid illustrated *Khamsehs* of Nizami. Instead the composition seems to rely on a European *Lamentation* such as that by the Dutch artist Jacob Matham (**22**). Nonetheless, the page is inscribed in Persian and depicts a scene from Persian literature, demonstrating the enduring ability of Persian artists to employ European means to Persian ends.

All but one of the sixteen remaining pages in this group contain pictures of two people, sometimes in related professions and sometimes not. Thus, we have the palace usher and the royal bodyguard or the musketeer and the king's bodyguard. A few pages later the mullah sits with the bazaar harlot and later still the Zoroastrian woman stands beside the Turkish woman. As records of the style of dress worn by different types of people, these paintings are extremely informative, but as works of art they leave plenty to be desired. The Europeans for whom they were made got exactly what they wanted, namely a pictorial record of the type of people they had seen, not major works of art. Later pages consist of pairs of animals – goats, ibexes, antelopes, and a rhinoceros whose resemblance to the real thing is tenuous.

The key to this album is contained in the inscriptions on two paintings, one of which states that "on the 10th of Dhu'l Hijja 1096AH (8 November 1685) this portrait of the famous Arab beauty Sakineh, the daughter of Husain and granddaughter of 'Ali, was completed by Jani farangi saz son of Ustadh Bahram farangi saz at Isfahan" (**23**). The key words here are "farangi saz", meaning loosely "painter in the European style". Stylistically, the painting is consistent with the others in the album, although the landscape in the background relies more closely than most of the other pictures on a European model. What is curious about the works in the album is that they are true hybrids, neither European nor fully Persian.

Although there is no documentary information about this Jani, his father Bahram may be the same as Bahram-e Sofrekesh, who signed a painting of *Two lovers*, dated 1640.[14] As Abolala Soudavar has pointed out, the one other work by this artist depicts an Indian woman holding a flat-bottomed ewer. The woman in this picture is also Indian and the bizarre relation of moth to flowers and people recalls the spatial illogic of Deccani painting. Nonetheless, the openly erotic theme and use of heavy shading on the faces may be linked to European influence and may have earned the artist the sobriquet "farangi saz".

In the hands of a somewhat more skilled artist, working nearly forty years later, the synthesis of European and Persian modes has progressed (**24**). This painting depicts the last Safavid Shah, Sultan Husayn, distributing Nauruz, or New Year's, gifts in 1720, two years before his death. The work of Muhammad 'Ali, son of Muhammad Zaman, the group portrait reveals the extent to which European artistic ideas had been adopted at the highest levels of patronage. Now the artist employs shading extensively on faces, drapery, and

18. *Opposite: Mi'raj, from the Khamseh of Nizami, original by Sultan Muhammad, 946-50AH (1539-43AD,) additions by Muhammad Zaman, 1086AH (1675AD), at Ashraf, Mazandaran. 28.7 x 18.6cm (11" x 7¹/₂"). British Library, London, inv.no. Or.2265, f. 195r.*

20. *Dancing girl, Isfahan or provincial centre, 1684-85. Gouache on paper, 22.7 x 12.6cm (9" x 5"), acquired in Iran by Engelbert Kaempfer. British Museum, London, inv.no. 1928 3-23 01.*

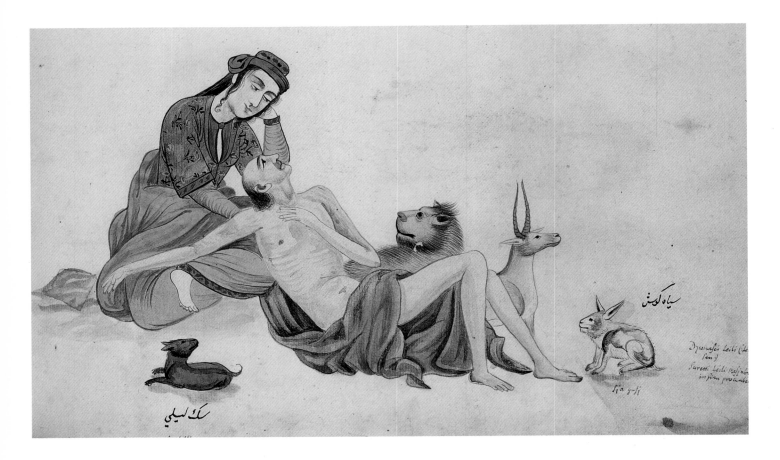

21. *Layla and Majnun,
attributed to Jani farangi saz,
from the 'Kaempfer album',
Isfahan, 1684-85. Gouache on
European paper, 20.9 x 29.2cm
(8" x 12"). British Museum,
London, inv.no. 1974 6-17 01 (7).*

22. *Lamentation, Jacob
Matham, Venice, dated 1607.
Engraving, 16.4 x 21.3cm (6¹/₂" x
9¹/₂"), Rijksmuseum, Amsterdam,
inv.no. RP-P.OB-27.012.*

even on the floor, although it still has no relation to a source of light. In fact, light seems to come from various directions, illuminating everyone's face or head except that of the Shah. Thanks to the use of shading, three-dimensional forms are convincingly substantial. Even though the figures do not focus sharply on the activity at hand, they are each differentiated from one another by means of pose and varying facial features, and are not completely idealised. With the exception of the Shah's beautiful gold cloak with its fur collar, the palette is subdued, almost muddy due to the shading. The artist still has not mastered European perspective, but he has used the figures in the foreground as a *repoussoir* to draw our eyes into the picture and toward the Shah.

Although Muhammad 'Ali has studiously applied some of the techniques of European painting to his work, it nonetheless would never be confused for a European painting. Since he was clearly a capable artist, he must have consciously chosen to follow only

certain tenets of post-Renaissance European painting. He must have been willing to sacrifice the brilliant palette and emphasis on line that characterise so much of earlier Persian painting. Yet the Europeans' burning desire for verisimilitude seems never to have gripped Persian artists, or at least not in the same way. Even at their most European, Persian artists seemed more concerned with presenting things as they should be, not as they ruthlessly are. Thus, in Muhammad 'Ali's painting the physical attributes of the figures may be portrayed faithfully, but their interrelationships have as much to do with their placement in relation to one another as with their poses. Possibly the meaning of their gestures will be revealed from textual descriptions, but it is just as likely that the full interpersonal richness of this scene can only be interpreted from the painting, which is both utterly traditional in its composition and experimental in its technique.

In reviewing Safavid painting from 1580-1720, one can conclude that European art influenced Persian painting in myriad ways. Artists such as Riza gained inspiration from European prototypes, amusement from European sitters, and perhaps a new palette from European oil painting. Nonetheless, his style and his aesthetic remained his own, as if the theoretical grounding of European painting were unknown to him. In the hands of his followers shading and risqué subject matter became increasingly prevalent. By the 1670s it appears that such artists as Shafi' 'Abbasi were working for European patrons, at least indirectly. Muhammad Zaman was producing European-style paintings for Shah Süleyman, while European artists living at Isfahan were painting in Persian palaces and Armenian churches and some Persian artists became specialists in European-style painting. As fashionable and fascinating as European painting must have seemed to seventeenth century Persian painters, they were not inclined to discard their own artistic heritage.

At the risk of generalising grossly, one might propose that underlying the greatest Persian paintings from the late fourteenth century onward is a sense of rhythm and a balance between mass and sinuous line that is peculiarly Persian. Adherence to the narrative, technical perfection, lyricism and an avoidance of ugliness play an important role in Persian painting. Confronted with European art – a different set of stories, a far broader approach to brushwork, the open expression of a range of emotions, not to mention different techniques – it is no wonder that Persian artists and their patrons were selective. Tastes simply could not change so fundamentally overnight. While, from the sixteenth century, European painting had an undeniable effect on Persian art, even at its most European, Persian painting still remained identifiably Persian. Until the nineteenth century Persian taste never wholly embraced European art; rather Persian artists and their patrons appropriated only those aspects of European art that would allow them to maintain their own system of aesthetics.

Notes see Appendix

23. Famous Sakineh, signed by Jani farangi saz, son of Bahram farangi saz, from the 'Kaempfer album', Isfahan, 1684-85. Gouache on European paper, 21.2 x 29.7cm (8½" x 12"). British Museum, London, inv.no. 1974 6-17 01 (37).

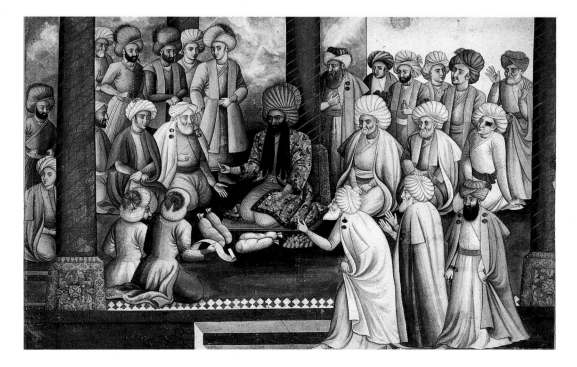

24. The distribution of New Year gifts by Shah Sultan Husayn, signed by Muhammad 'Ali, son of Muhammad Zaman, Isfahan, dated 1721. Gouache on paper, 33.1 x 24.5cm (13" x 10"). British Museum, London, inv.no. 1920 9-17 0299.

5

THE CHISELLED SURFACE

Chinese Lacquer and Islamic Design

YOLANDE CROWE

From the mid thirteenth to the early sixteenth century, and especially during the Mongol supremacy in Central Asia, representations of Chinese artefacts can be noticed in Islamic works of art. The deep-carved technique of Chinese lacquer inspired imitations in several different media, including leather, wood and stone. Many of these used the familiar repertoire of Chinese designs such as the dragon and the phoenix, expressed in a style that progressively distanced itself from the Far Eastern prototypes.

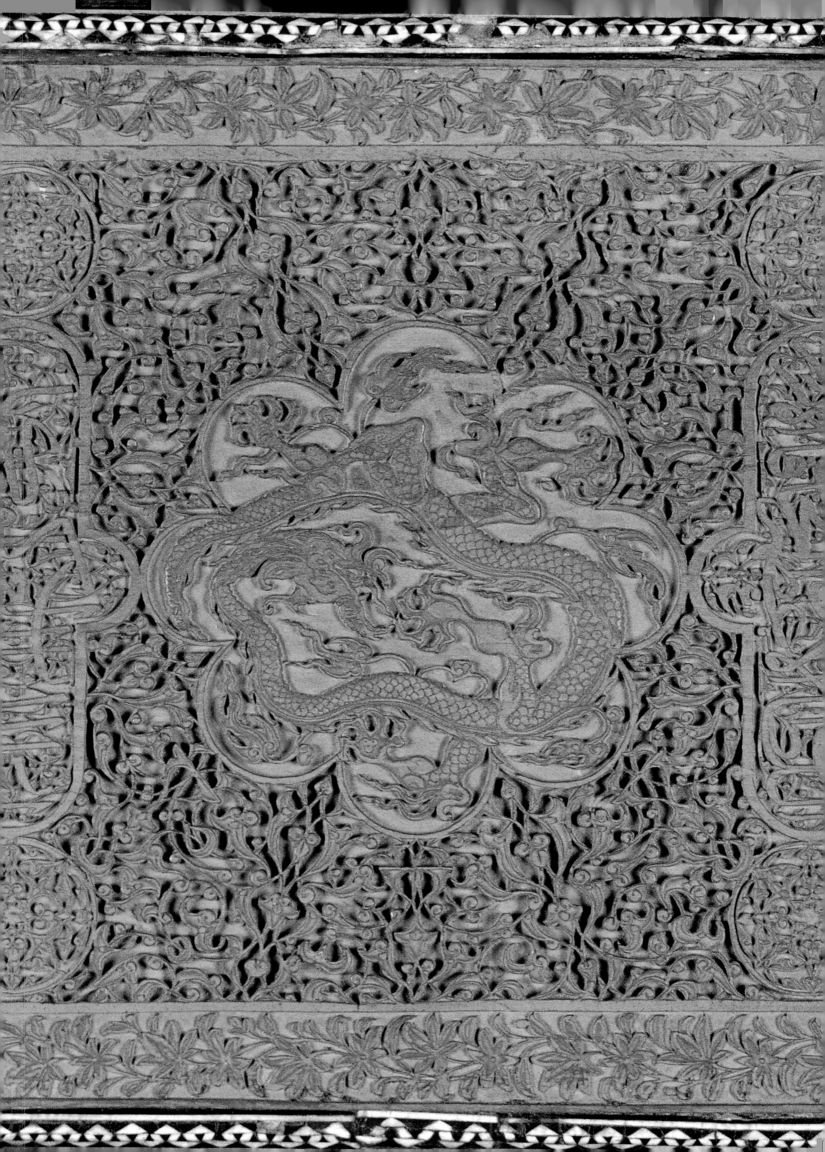

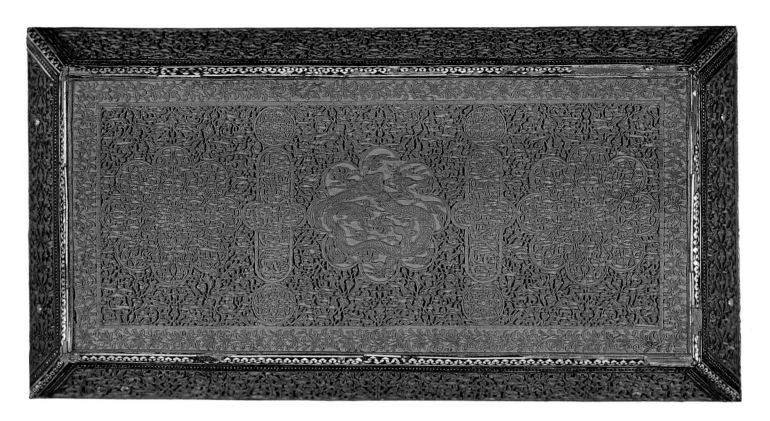

According to ancient Chinese texts, lacquerwork, a technique involving the use of sap derived from the lacquer tree, first appeared in China during the rule of the legendary Emperor Shun at the end of the third millennium BC. Recent archaeological work in the provinces of Hebe and Honan has brought to light fragments of lacquer from Shang dynasty tombs (1300-1028BC), and the Mawangdui tomb in Changsha has yielded important lacquer finds datable to the middle of the second century BC. A graceful free-hand painting enhances the lacquered surfaces of burial chests, boxes, dishes, bowls and cups.[1] Under the Han dynasty (206BC-220AD), increasing demand for such objects was met by numerous imperial and private workshops. New decorative techniques were introduced early in the Tang dynasty (618-906AD): mirrors and boxes were inlaid with metal foil, and rough carving through several layers of colour made its first appearance in the lacquer covering leather plaques of armour. Aurel Stein recovered such finds in 1906 at Miran, a fortress in Inner Asia once under Tibetan occupation in the late Tang period.[2]

Neither climatic nor local conditions in western Asia lent themselves to the cultivation and exploitation of the lacquer tree. Only through export did lacquered luxury wares reach westwards beyond the deserts and steppes of Central Asia. The road to the west was opened in 138BC by the imperial mission of Zhang Qian, sent by the Emperor Wudi to seek allies against the Huns. Their quest was also for strong horses, the 'celestial horses', desperately needed by the Chinese cavalry to fight back the endless incursions of the Barbarians.

Thereafter many more imperial missions, embassies and conquering armies found their way as far west as present day Tashkent in Uzbekistan, thus creating a permanent trade route, the so-called Silk Road, along which a multiplicity of goods and various religions moved both ways.

Among the few early remnants of Chinese lacquer to survive outside the Chinese empire are those found in Begram, north of Kabul in Afghanistan, excavated in the 1930s.[3] The lacquer itself, the most durable form of vegetal sap, has survived since the first century AD on its delicate wooden support, thanks to the constant humidity and temperature of the ground. Few, if any, fragments have come to light

in western Asia as the dry climate is damaging to lacquer, causing it to crack. From the beginning of Islam (622AD), Muslim merchants dominated trade between eastern and western Asia, and it is quite possible that Chinese Tang lacquer as well as textiles and early porcelain made their way into the lands of Islam at this early stage. But whereas the story of Chinese silk and porcelain, and their gradual penetration into western Asia and Europe, are part of history, discovering the history of Chinese lacquer is more difficult; early western Asian imitations can only hint at long vanished originals, and of these early imitations only fragments remain.[4]

The pre-World War II excavations at Nishapur in Iran yielded two pieces of lacquer, one a fragment of a red wooden box with a decor of circular repeats and punched circles, not unlike the Tang armour fragments of Aurel Stein, the second a bone figurine 5cm high, painted red. A third fragment, the remains of a round box 6cm wide by 6cm high, was found twenty years ago in the caravanserai of Robat-i Sharaf on the Meshed-Sarakhs road, also in Khorasan. Two red bands enclose the main part of the body which is coloured black with incised figures, perhaps representing the signs of the zodiac, in green, yellow and red. These remains would date from before the fall of Baghdad to the Mongols in 1258. They shed light on attempts by Muslim craftsmen to imitate the red or black of Chinese lacquer, though in the decoration emphasis is placed on the incised *sgraffito* outline.

Two further boxes have been attributed to the Mamluk period; one was excavated on the Red Sea at Quseir el-Qadim, the other was auctioned at Christie's in 1995.[5] Their shape is not Chinese, neither is the type of incised geometric decor, yet the dominant red colour recalls Far Eastern lacquer, where the sap is coloured with cinnabar. In Islamic lands the technique of producing lacquer is certainly not the same. Whereas the Chinese sap can be used as a varnish directly from the tree, the varnish used in western Asia is extracted from a

5. *Garden scene (detail), from the Kalila wa Dimna, Herat 833/1429. Topkapı Saray Library, Istanbul, inv.no. R.1022 f2a.*

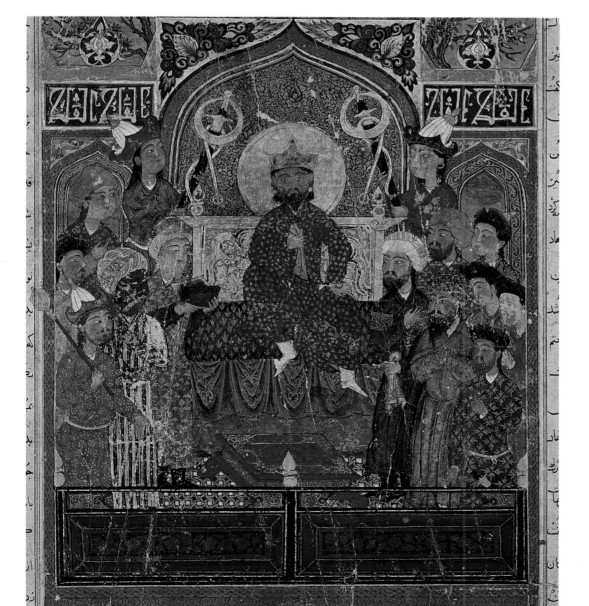

6. *Alexander enthroned, from the Shahnama of Firdausi (formerly Demotte Collection), Iran, ca.1335. 29 x 20cm (11" x 8"). Musée du Louvre, Paris, inv.no. AO 7096.*

7. *Detail of a marble stairway, The Forbidden City, Beijng.*

resin and must be dissolved in a solvent. In a western Asian context lacquer also means the product of the *lac* insect, which is resin with the added red dye of the female's eggs. The end product is *shellac* which dissolves in alcohol and produces a varnish. R.M. Riefstahl has commented that "The Near Eastern (and Indian) lacquer techniques might as well be called varnishing".[6]

In a different historical context and in different media, more recent memories of Chinese lacquer may be traced in the fourteenth and fifteenth centuries, a period when most of northern Asia had come under the sway of the steppe people, the Mongols and their successors the Timurids, the descendants of Timur (Tamerlane). The best witness for such a statement is a finely carved sandalwood box now in the Topkapı Saray Museum in Istanbul (**2, 3, 4**). The calligraphy in Arabic script gives the name and titles of its owner: Ulugh Beg, grandson of the great Timur, whose rule extended into western Asia from 1360 to 1405. Parts of Central Asia were under the control of Ulugh Beg from 1420 until he was assassinated in Samarkand by order of his brother in 1447.

Other hints at the existence of Chinese lacquers in these western lands come from various Persian miniature paintings starting with pages from the so-called Demotte *Shahnama* painted in the first half of the fourteenth century. About ten of the Mongol court scenes in this version of Firdausi's epic include tables or footstools some of which could be lacquered. Three miniatures stand out in particular. The first illustrates the choosing of a Chinese princess;[7] the second, Alexander enthroned (**6**);[8] and the third, Zal the nobleman approaching the king.[9] In fifteenth century miniatures some tables are enhanced with gold; they look unmistakably Chinese (**5**), as do the blue and white porcelain vases decorating some of them.

It so happened that Ulugh Beg was sent on an embassy by his father Shah Rukh to the court of the Ming Emperor Yongle (1403-1424). The whole mission to China was recorded by Ghiyathuddin Naqqash who describes their arrival in Beijing on 14 December, 1420. The inauguration of Yongle's new capital was to take place on 28 January, 1421. One can but marvel at the timing of the Timurid embassy, although the recorder makes no mention of such an important event. Beijing, according to the Persian text, was "of an inordinate magnitude made all of stone".[10] Even today the visitor inside the walls of the Forbidden City is struck by the huge scale of the palace and the lavish use of marble. Confronted with such a vast programme of architecture and craftsmanship, Ghiyathuddin failed to notice that the buildings were made of wood apart from their foundations, and that deeply carved marble lavishly enhances railings, flights of steps and the inclines of the emperor's paths (**7**).

It is easy to imagine the gigantic efforts of creativity and the enormous amount of skill and labour which went into the conception and building of the new capital. Together with the development of the capital and palace, new life was injected into all applied arts. This included much produced elsewhere such as silk fabrics and embroideries, jade carvings, porcelain, furniture, and last but not least lacquerwork (**8**). Already during the Yuan dynasty (1271-1368), a new approach to the treatment of lacquered surfaces was being

*12. Glazed tilework in the
spandrel of the portal of the
Buyan Quli Khan Mausoleum,
Bukhara, ca.1360.*

developed, without painting or metal foil inlays. Incised work, initiated on Tang leather armour, was carried deeper by Yuan craftsmen, through the many levels of lacquer now applied generally to a wooden base. By the early part of the fifteenth century the technique had developed to the point that up to a hundred layers of lacquer were meticulously prepared for the carver, whose main tool was the chisel or knife.[11]

The technical control and visual approach of the Yuan and early Ming lacquer carver differs both from that of the earlier painted lacquered surfaces and from the later decor inlaid with mother-of-pearl. This greater depth in the carving could be compared in geological terms with the erosion of deep sunken canyons into the even surface of a plateau. The design is what remains of the plateau after the deep erosion by the chisel. It is this special effect which seems to have attracted the Muslim craftsman as he contemplated the fragile red lacquered objects from China which had reached him through his rich sponsors. He started to carve into surfaces to new depths although it could not be through layers of lacquer; more permanent media such as stone, wood, terracotta or the leather of book bindings were at hand. In all cases he used a technique known as *haft qalam*, which at first sight would translate as *seven pens*. However another possible translation for *qalam* is *chisel*, which would fit exactly the description of the exceptionally deep carving. A number of photographic examples of this technique from the catalogue *Timur and the Princely Vision*[12] provided the stimulus to study the connections between certain types of Chinese lacquer and their Muslim counterparts.

*13. The mausoleum of the
Shirvan Shahs, Baku, showing
stone-carving in the portal,
839AH (1435AD).*

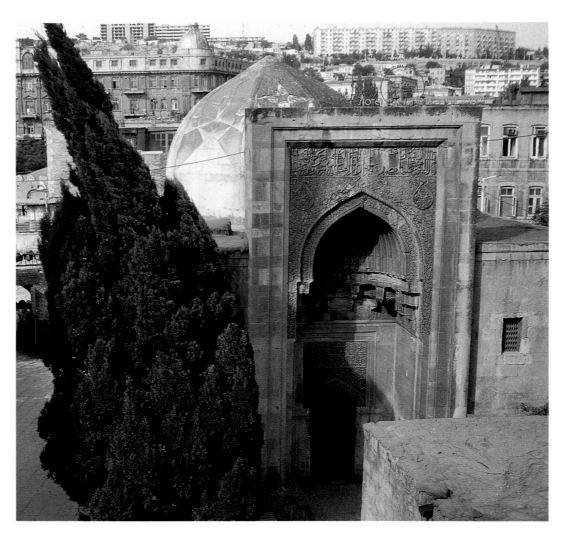

Although popular under the Yuan dynasty, *guri* patterns of spirals and scrollwork seem to have made little impression on the Muslim designer. He remained attracted to the deeply carved dragons and phoenixes, and also to Chinese flowers, the lotus, the hibiscus, the peony and the chrysanthemum, which filled the circular surfaces of boxes (**9**) and small dishes. On the whole the bold design is dense with little breathing space. The top of the Victoria & Albert Museum Chinese table, of the period of the emperor Xuande (1426-1435), is filled with a cartouche containing a dragon and a phoenix on a bed of blossoms (**8**), the spandrels vibrate with phoenixes in flight alternating with elongated dragons against a dense ground of flowers. Again there is little empty background. Even denser carving is reproduced on the Ulugh Beg box. Its eight-lobed central cartouche contains only one dragon (**2**). It is poised at the centre of the cover with at either side a calligraphic cartouche encompassed by two circles, and an eight-lobed rosette at both ends. Only the central dragon stands out on a plain ground; the design of the lid and sides consists of close patterning which forms a compromise between the flowing design of Chinese origin and rigorous Muslim geometry. The combination of the two styles sometimes creates a confusing design.

Could it be that drawings of Chinese patterns preserved in the Topkapı Museum library and other collections (**10**) were copies of carved decoration on round lacquered boxes and square trays as well as textiles? No doubt Chinese lacquered work was at hand, but its fragility could have led the Muslim workshop designers to keep a record of their favourite designs. It might also explain the circular drawings on album leaves, which would correspond to the pattern on the lid of a Chinese box. Such a practice could be expected to result in the Muslim carver producing work close in both pattern and feeling to a Chinese composition, as is best exemplified in the Ulugh Beg box in the Topkapı Museum.

Echoes of Chinese stools or tables can be seen in certain miniatures as Jessica Rawson has shown.[13] Such tables were not part of the usual paraphernalia of a Muslim household. They were an exotic addition to a luxurious decor, similar to the blue and white porcelains. The tables soon disappeared from the miniatures but the porcelains survived, not only in later miniatures but also in the imperial collections of the Ottoman sultans and the Persian shrine of the Safavid dynasty (1501-1732) in Ardabil.

For climatic reasons Chinese lacquered tables and stools could not themselves survive further west in a Muslim context. Echoes nevertheless remain in vernacular furniture such as a wooden Qur'an stand with its decoration in *haft qalam* technique. Usually such stands are made of two pieces of wood hinged together in the middle to allow them to stand open to receive the Book. A section of a stand dated 761AH (1349AD) from the Metropolitan Museum of Art (**11**) could represent one of the earliest examples of the new type of deep carving. The variable depth of the chiselling has created several levels which outline the controlled Islamic decoration enclosed in the central niche shape. On the other hand, the contrasting borders and spandrels seem free to breathe with the swaying of flowery branches of lotus with some dianthus close to Chinese lacquer and embroidery. Such a blend of two traditions seldom fits so closely together.

In Bukhara at about the same time, the façade of the undated tomb of Buyan Quli Khan, a local Mongol puppet ruler, was decorated with deeply carved glazed panels. Although the style still follows the classical scrolling of Muslim design, the depth of the carving is unmistakably close to the *haft qalam* fashion. In the spandrel of the entrance portal, the use of contrasting dark and light turquoise glaze reinforces the feeling of separate layers (**12**). Between 1371 and 1383 Turkan Aqa, Timur's elder sister, built a gem-like tomb for her daughter Shad-i Mulk Aqa in the Shah-i Zinda in Samarkand. The same ceramic technique was applied to panels on the inside of the entrance to the tomb: fashionable Chinese lotuses, rigorously displayed within the frame of a prayer niche, spring forward with blue touches added to the earlier turquoise colour scheme (**1**).

Up to the time of Ulugh Beg's embassy to

14. Wooden door, Iran or Central Asia, mid 15th century. 2.05 x 0.76m (6'9" x 2'6"). Metropolitan Museum of Art, New York, Rogers Fund 1923, inv.no. 23.67.7.

15. Stone cenotaph (top detail) Gazurgah, near Herat, second half 15th century.

China, the decoration in *haft qalam* remains close to the Muslim arabesque patterns and the flowery motifs inspired by Song and Yuan textiles as well as the newly developed blue and white porcelain designs. The fresh outpouring of artistic inspiration[14] generated at the time of the foundation of Beijing appears to have provoked a burst of creativity in design which was bound to reach out beyond the frontiers of China. By the second quarter of the fifteenth century the renewed flowering of the arts under the Timurids was visibly absorbing once more a set of exotic patterns from the east. The resulting style is sometimes referred to as International Timurid since it was picked up by most Muslim courts and their craftsmen in several media, as in a splendid undated wooden door (**14**) in the collections of the Metropolitan Museum of Art. The central panel is emphasised in *haft qalam* carving with a geometric composition of stylised Chinese flowers and leaves; the Far Eastern lotus and dianthus have now shed their exoticism and enough of the ground is visible to provide space in the decoration. Some of this effect is retained in the stone buildings of the Shirvan Shahs in Baku, where *haft qalam* technique can be seen on the spandrels of the portal to the mausoleum of 839AH (1435AD) (**13**). Here the balance is well kept between the vernacular calligraphy and the Chinese-inspired lotus blossom. Stems and flowers spread gracefully through the restricted space.

A remarkable series of cenotaphs carved in *haft qalam* bears witness to the skill of the Muslim stone carver in Central Asia. Some of the best examples of the second half of the

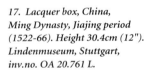

16. *Ottoman leather binding, Turkey, 887AH (1483AD). Türk ve Islam Museum, Istanbul, inv.no. 1905.*

17. *Lacquer box, China, Ming Dynasty, Jiajing period (1522-66). Height 30.4cm (12"). Lindenmuseum, Stuttgart, inv.no. OA 20.761 L.*

fifteenth century are preserved at Gazurgah near Herat (**15**) in the shrine of Sufi Ansari, an eleventh century mystic. The design is well controlled, defining areas to be enclosed in a geometric outline; the framing borders seem to flow despite the disciplined pattern of leaves or blossoms. Other examples from further east have found their way to the United States[15] and to the Victoria & Albert Museum.[16] The latter example is said to have come from near Bukhara and was registered in 1901. The date of 942AH (1535AD) indicates the survival of the *haft qalam* style well into the sixteenth century with the controlled patterning on the top part enclosing leaves and tendrils, whereas on the sides the light picks up the dense swinging movement of the blossoms and leaves. That the effect of deep carving was still fashionable in the mid sixteenth century is apparent in the field of bookbinding. Up to the mid 1470s a variety of tools were used to cut out levels of decoration. Thereafter the newly discovered technique of pressure-moulding provided greater depth without the intricacies of tooling. It gave a sculptural effect to the whole composition on the outer covers, the doublures and the flaps. The colour was of course a matter of choice for the binder. In the mid sixteenth century binding of a copy of the *Mantiq al-Tayr* of Farid al-Din al-Attar (**16**), the exterior is of black leather, which does not lend itself to a clear reading of the cloud and spiral scrolls; by contrast the doublures are of a fawn colour, rendering more visible the split palmettes and lotus scrolls.

The arrival in Central Asia of Yuan and early Ming lacquers provoked in its early days a desire to chisel in depth; a local style of deep carving, regardless of its origins, was thus adapted to a number of materials during a period of almost three hundred years. Depending on the medium, some expressions endured longer than others. In glazed ceramics, the use of deep patterning did not last into the fifteenth century. Already in Samarkand, its presence was restricted to particular areas of buildings, and vied with underglazed painted tiles. Wood on the other hand responded well to chiselling; besides the Quran stand, many monumental doors resisted the passage of time, though only one object, the Ulugh Beg casket, reached the twentieth century. As to stone witnesses to *haft qalam*, they have survived in numbers, whether on buildings or as single sculpted cenotaphs.

Even in a world beyond Central Asia, the Indian subcontinent, it is possible to find examples of the *haft qalam* technique. At a glance one would expect the great Mughal constructions of the sixteenth century to lend themselves to this type of decoration. And yet the carving usually retains its traditional three-dimensional character. Only in one particular area of the short-lived capital city of Fatehpur Sikri, built in red sandstone by the Emperor Akbar (1542-1605), does one see the *haft qalam* carving applied specifically to the sides of pilasters and panels in the single room of the Anup Talao (the peerless pool) pavilion, completed by 1575. It is revealing that in attempting to define the style of the carving, one earlier commentator has equated it to that done by Kashmiri wood carvers; another has suggested the presence of Chinese artisans. The carved sandstone on one side of a pilaster recalls the flat surface dug into by the chisel (**19**). A lotus scroll under the eaves comes very close to the feeling of early Ming lacquer (**18**), which by the sixteenth century concentrated more on composite scenes set in a garden or the countryside. Of the eight panels inside the room itself, two of them pick up the theme of trees in a more or less stylised manner with twisted trunks (**20**), and, in one instance, Chinese clouds.

By 1585 Akbar had moved the court to Lahore. Thereafter the deep carving of stone ornament disappeared to give way to low relief, remarkable in its own right but with a totally different feeling for density and space. In a similar manner, in China the deep carved style of early Ming lacquer had been replaced by mother-of-pearl designs inlaid into the black lacquer thus creating a flat surface, a genre soon imitated in Gujarat for export to Europe.

Notes see Appendix

18. Lotus carving (detail), Anup Talao pavilion, Fatehpur Sikri, 1575.

19. Pilaster (detail), Anup Talao pavilion, Fatehpur Sikri, 1575.

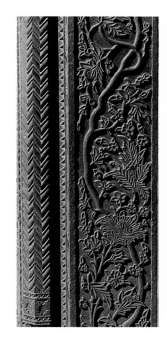

20. Panel 2, Anup Talao pavilion, Fatehpur Sikri, 1575.

6

CHINA FOR EUROPE

Export Porcelain of the Qing Dynasty

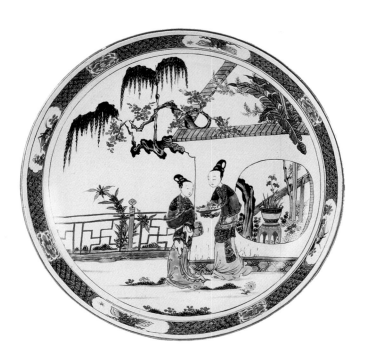

COLIN D. SHEAF

European maritime trade with China introduced many 'exotic' elements into Western society during the seventeenth and eighteenth centuries. None became cheaper or more influential than Chinese export porcelain. Arriving initially in small quantities on Portuguese and Spanish merchantmen, the trade was revolutionised and hugely extended by Dutch and British traders. Millions of pieces of imported Chinese porcelain, associated with new Western standards of polite behaviour, transformed the way in which hospitable Europeans entertained their guests during the 'Age of Elegance'.

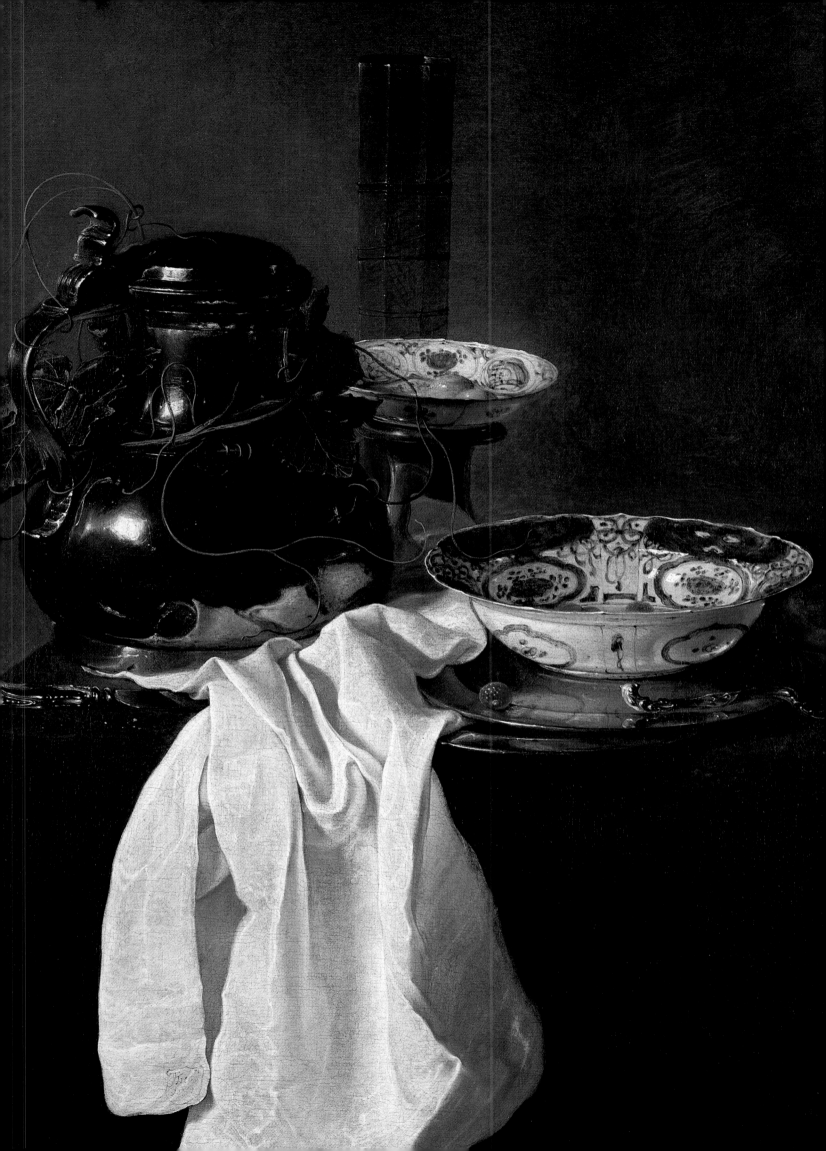

1. Title page: Famille verte dish, ca. 1700. Diameter 34cm (13"). Courtesy Christie's London .

2. Facing title page: Still life with a pewter flagon and two Ming bowls, Jan Jansz Treck, 1649. Oil on canvas, 76.5 x 63.8cm (2'6" x 2'1"). The National Gallery, London, inv.no. NG4562.

N o Chinese craft product caused such sustained interest in Europe, and proved such a long-running commercial proposition for its shippers, as export-quality mass-produced porcelain. During four centuries of European trade with Asia, porcelain primarily from Jiangxi province, but on occasion also from Fujian and Zhejiang, fulfilled three important functions. It filled up cargo holds with a commodity largely unaffected by damp and sea water. It bolstered, in a regular but unspectacular way, the profits from the homeward leg of voyages to Asia. And it played an often underrated role in Western Europe, as polite society developed new standards of civilised social behaviour to which the use of porcelain greatly contributed.

Unexceptional in technical quality by Chinese standards, frequently mere canvases onto which repetitive designs from late Ming and Qing Dynasty printed book illustrations could be wearisomely copied, catering for foreign markets which were neither understood nor respected: how did such commonplace, technically second-rate porcelains come to feature so prominently in the smart salons and candle-lit dining rooms of Europe?

There were two principal reasons. The first was economic, an effect of the victory of the Qing (Manchu) invaders over the native Chinese Han Imperial Court. The kilns were rebuilt, and by 1680 the structure was in place for a resumption of western trade. It would take a generation, however, for export-quality porcelain production to resume in substantial quantities, especially as the Dutch had established a regular parallel porcelain trade with Japan through residential Dutch trading factories at Fort Zeelandia in Taiwan, and Batavia in Java. The second reason was social, relating to the way in which post-medieval fashionable Europe evolved new forms of entertaining and social behaviour, under the influence of the French court of Louis XIV.

The economic reason was an effect principally of new patterns of maritime trade around the entrepots of Southeast Asia. The Dutch were the first to develop a regular import trade to Java, and subsequently to Europe, in low-quality export porcelains, especially blue and white from Jingdezhen, and the coarse enamelled wares from Swatow. The porcelains were unspectacular in Asia, adequate for markets in the Indonesian archipelago and the Philippines, which had absorbed junk-loads of undistinguished blue and white since the fourteenth century. A very small quantity had reached Europe during the sixteenth century, either as diplomatic gifts or as trade curios exciting enough to justify being mounted in gold or silver and stored reverently in a princely treasury: but maritime trade with Europe was an effective monopoly of Spain and Portugal, and porcelain never featured as a possible bulk cargo before the last years of the sixteenth century.

The Dutch changed this perception. In 1602 and 1604, two Spanish galleons had been captured and their ceramic cargoes sold at auction in Europe. The international excitement

3. Famille verte tureen, ca. 1730. Width 31cm (12"). Courtesy Christie's London .

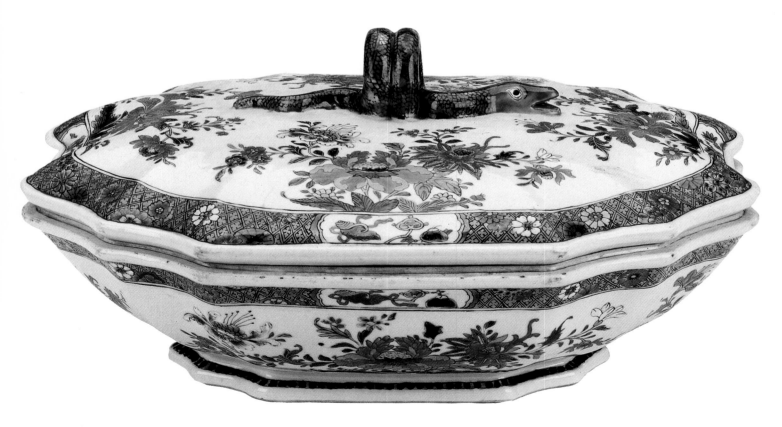

these auctions of Chinese porcelain caused was not to be equalled until the Nanking Cargo auction in Amsterdam 380 years later. This was an important sign of the way in which Dutch Asian traders had broken the monopoly of 'Catholic' trade with Asia. Importing porcelain in bulk to the embryonic Netherlands was a by-product of the much more lucrative trade in valuable commodities into which, for the first time, a European Protestant country could enter by virtue of its newly acquired maritime strength. English merchants followed quickly under a Royal monopolist charter, sensing that an overwhelming superiority had been eclipsed. Both countries had established mutually distrustful trading posts on Java by 1610; relationships veered between shared hostility to the Catholic nation traders, and mutual antagonism as competition for access to the lucrative spice markets of Southeast Asia led to each establishing other fortified entrepots around the region.

The growing porcelain trade was a small by-product of these economic and political shifts, a microcosm in Asia of European rivalries, played out in malarial, humid and isolated trading posts as remote as Benkulu and as politically unstable as Fort Zeelandia. Porcelain became more accessible in the West. For the first time, it appeared consistently in the ultimate seventeenth century Dutch testament to conspicuous consumption, still life paintings. Artists such as Kalf, Heda and Claesz frequently included a Chinese porcelain dish or bowl laden with glossy fruits, as part of the setpiece of expensive glass and gold or silver vessels which attested the success of the rich burgher who had commissioned the painting (2). Pictures such as this reveal that imported Chinese blue and white porcelain was highly esteemed but nevertheless available in seventeenth century Holland. Like gold, silver, elaborate glass and exotic fruit, it attested a sober but financially successful lifestyle, ostentatious in an understated manner appropriate for a respectable Protestant burgher.

Almost invariably the porcelain depicted in such still life paintings was blue and white, the first time that Chinese export was used as a decorative adjunct. Readily accessible, utilitarian, but with a particular cachet, it was infinitely superior in its technological quality to any ceramic available in Europe, where low-fired earthenware such as Delftware dominated the market until hard-paste porcelain finally became available at Meissen in 1708. It would be another eighty years before such true porcelain was mass produced in Europe, and in the meantime the exotic imported porcelain from the fabled lands of Cathay was highly sought after, especially in a period when Western embassies and travel writers were beginning to publish first-hand reports of the region.

As enamelled wares became fashionable, compositions including elegant ladies within pavilion landscapes and gardens enclosed by fretwork balustrades became common on export porcelain (1). Owing something to late Ming printed book illustrations, these designs were appreciated for their quaint and exotic quality. In early English inventories

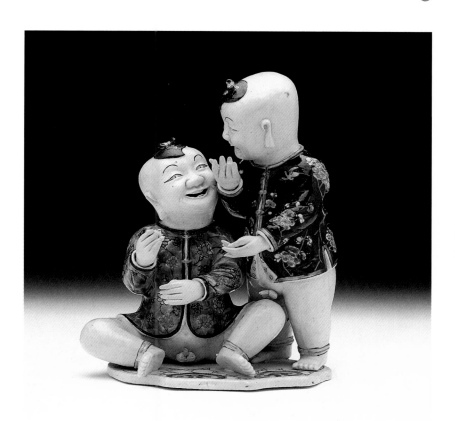

4. *Famille noire group of 'laughing twins', ca. 1700. Height 22cm (9"). Courtesy Christie's London.*

5. *A pair of famille verte figures of Westerners, late 17th century. Height of man 24cm (9½"). Courtesy Christie's London.*

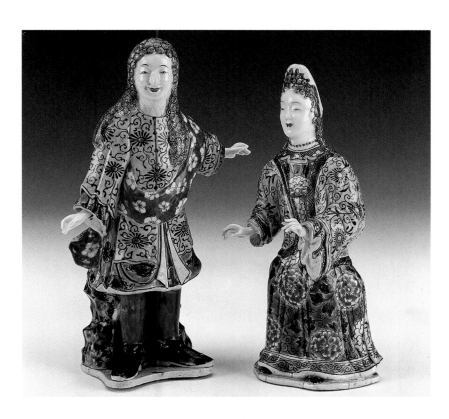

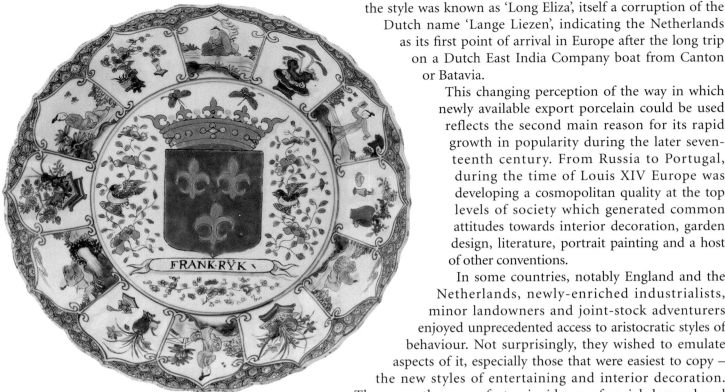

6. *Famille verte armorial dish, early 18th century. Diameter 31cm (12¹/₂"). Courtesy Christie's London.*

7. *A rose-verte armorial plate, ca. 1730. Diameter 23cm (9"). Courtesy Christie's London.*

the style was known as 'Long Eliza', itself a corruption of the Dutch name 'Lange Liezen', indicating the Netherlands as its first point of arrival in Europe after the long trip on a Dutch East India Company boat from Canton or Batavia.

This changing perception of the way in which newly available export porcelain could be used reflects the second main reason for its rapid growth in popularity during the later seventeenth century. From Russia to Portugal, during the time of Louis XIV Europe was developing a cosmopolitan quality at the top levels of society which generated common attitudes towards interior decoration, garden design, literature, portrait painting and a host of other conventions.

In some countries, notably England and the Netherlands, newly-enriched industrialists, minor landowners and joint-stock adventurers enjoyed unprecedented access to aristocratic styles of behaviour. Not surprisingly, they wished to emulate aspects of it, especially those that were easiest to copy – the new styles of entertaining and interior decoration. There was thus a perfect coincidence of social demand and commodity supply. The latter initially generated the former; and as the codes of court society permeated down through middle-class buyers, so demand increased the supply as the East India Companies of Western Europe tailored their imports to prevailing local taste. The importers came to commission specific styles of ceramic decoration, and shapes which had no place in traditional Chinese porcelain production. Figure models became adapted from Asian-subject prototypes into specifically Western models. During the late seventeenth century, enamellers at the Jingdezhen kilns expanded the repertoire of over-glaze colours by combining established translucent enamels, and adding an opacifier to them. A pair of 'laughing twins' (**4**), the *Hehe Erxian* of Daoist folklore, displays one such combination of established colours, creating a rich glossy black palette by careful painting of a thin matt black enamel ground, and overlaying it with translucent glossy green. Although rare in Europe, a figural group of this kind would have found a ready market, sometimes being mounted in ormolu for even greater opulence.

Unlike the preceding figural group, whose subject is firmly within the tradition of Chinese folklore, a pair of Westerners (**5**) owes nothing to a Chinese original subject. It is suggested that these figures may be based on French fashion plates of circa 1700, possibly engravings by Bonnart of members of the royal family. The male figure is often, if contentiously, identified as Louis XIV, while the female could be one of several court aristocrats including Mme de Maintenon, Mme de Montespan and Mme de Mainfloron. If these were made specifically for the French market, they represent very early examples of such export porcelain.

It is this development which makes most interesting a whole class of Chinese porcelains imported from the late seventeenth century; exotic wares, which nevertheless remained sound commercial propositions until Western ceramic technology caught up in the 1780s, and a sober neo-classical taste in Europe supplanted the enthusiasm for bright, colourful pots which had been a major feature of the period 1700-1780.

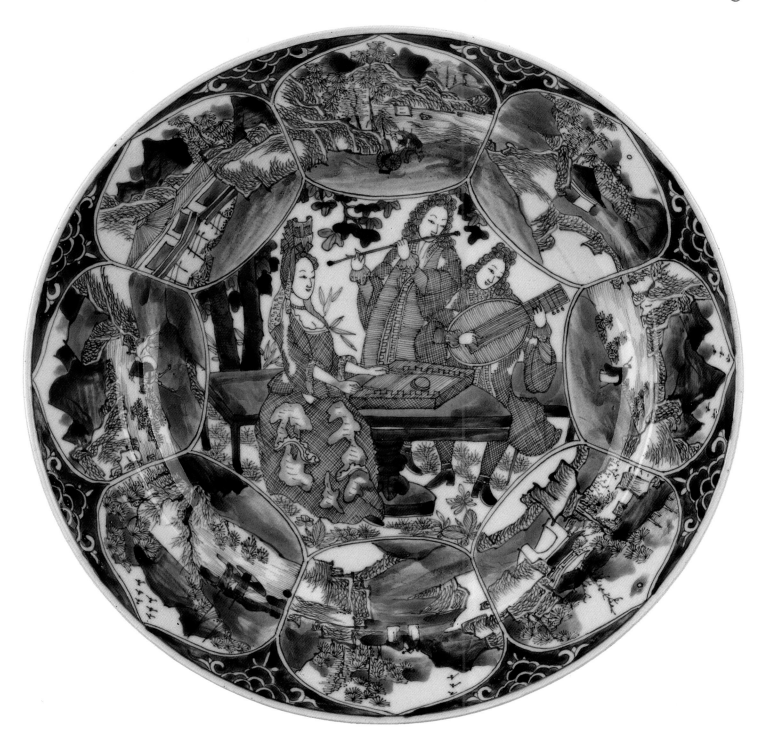

8. Blue and white dish, early 18th century. Diameter 30cm (12"). Courtesy Christie's London.

Two features most clearly distinguish the best export porcelain for the Western market from contemporaneous Jingdezhen ceramics manufactured for the domestic one. Firstly, there is a group of wares, primarily shaped vessels rather than flatwares, which specifically reproduce in Chinese porcelain shapes familiar to Europeans in Western glass, precious metals, brass and even porcelain. One of the most striking, the dinner-table tureen, is obviously based on the Western vessel made in gold or silver as an essential part of rich table services, following the remodelling and elaboration of canons of court etiquette and social behaviour under Louis XIV a generation earlier. The appearance of this shape in porcelain seems to occur in about 1730, although more common forms are made in blue and white until the nineteenth century. The *famille verte* tureen illustrated (3), may be the earliest closely datable rectangular tureen made in China for Europe. Its exact counterpart exists in Rouen in northern France, where it was presented to the Governor of Normandy in 1728. Made of faience, the Rouen vessel was probably the prototype for the design.

Secondly, by virtue of regarding the porcelain as a white canvas on which to paint a picture, Western buyers during the eighteenth century developed an increasingly straightforward system of commissioning Chinese ceramics to be painted with a specific coat-of-arms, or a copy of a European print. These designs were primarily executed on

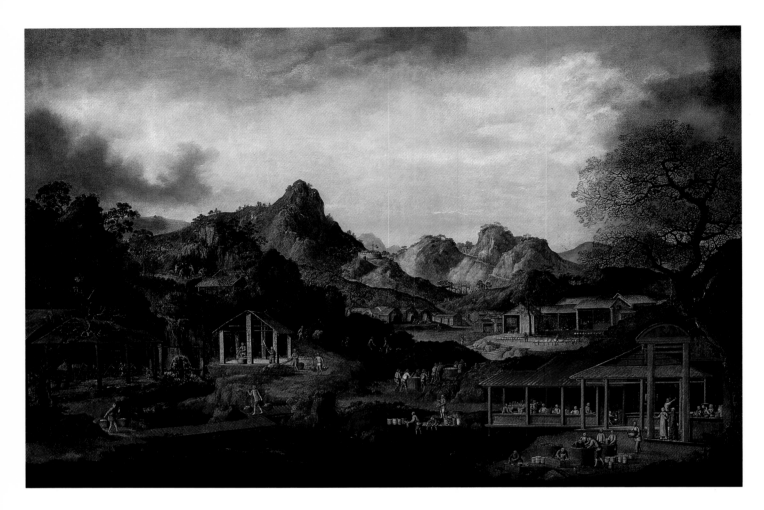

9. The manufacture and decoration of porcelain, Chinese School, ca. 1800. Oil on canvas, 130 x 190cm (4'3" x 5'3"). Courtesy Christie's London.

10. A pair of ormolu-mounted famille rose pheasants, 18th century. Height 70.5cm (28"). Courtesy Christie's London.

11. Blue and white 'Bacchus' dish, early 18th century. Diameter 37.5cm (15"). Courtesy Christie's London.

flatwares for dinner and tea or coffee services. A large blue and white dish (8) provides a most interesting example of Kangxi period porcelain (1662-1722), painted quite specifically after a European print. It closely reproduces 'The Music Lesson' by the Parisian Robert Bonnart, after a print produced by his brother Nicholas Bonnart entitled *Symphonie du tympanum, du luth et de la flûte d'Allemagne*.

There are two kinds of armorial wares: corporate and personal. Among the earliest enamelled export wares with Western coats of arms are a range of *famille verte* fluted dishes, variously painted with the arms of European countries, and of provinces in the Netherlands. Judging by the spelling in the illustrated example (6), they were probably commissioned by Dutch merchants using Dutch prints of the arms; their ultimate market in Europe is unclear, and they were presumably private trade porcelain rather than Company cargo. As these armorial wares become more popular, they were commissioned by organisations as diverse as Livery companies, political pressure groups and country inns.

For most collectors, family armorial wares are more readily obtainable. The arms in the example shown (7) are those of the Scottish family Graham of Duntroon, whose principal claim to fame was that of taking a significant role in both Scottish nationalist Jacobite uprisings, in 1715 and 1745. The estate at Duntroon was sold to Alexander Graham in 1735, and later settled on his brother David, for whom this service was probably made. Much of the interest in collecting these personal wares is in providing a tangible link to forgotten episodes and family histories. It is interesting that as late as 1743 services were still being commissioned without shaped vessels, such as tureens, which soon became essential elements of armorial services.

These two categories, Western shapes and Western patterns, comprise special commission wares, which interestingly reveal the cross-cultural fertilisation of technique and material. However personal these commissions were, it continued to be significant that this Chinese export was, from about 1680-1770, the cheapest porcelain available in substantial quantities. This was especially true for export blue and white ware, which had no Western competition, until the innovation of transfer-printing patterns into a ceramic surface enabled European potters to create the production-line organisation in factories which had long given Jingdezhen its commercial success, as rare Western paintings fancifully depict. One spectacular example of China Trade painting (9) uses the Western technique of

painting in oil on canvas to depict a largely imaginary explanation of the various stages of potting, firing and decorating porcelain in Jingdezhen. This Arcadian countryside complex of rustic buildings bore absolutely no resemblance to the cramped, dusty industrial landscape of Jingdezhen, which, as we know from Jesuit reports, were packed with brick-built furnace kilns burning day and night. Still, pictures such as this gave Westerners at least an inkling of the origins of their salon and dining room accessories.

The colour palettes used on export porcelain are no different from those used on domestic market wares. Underglaze-blue decoration remained the staple of the industry, having one great advantage in that it only required a single kiln-firing to complete the product. When labour was cheap and materials the principal cost, wood for kiln firing became increasingly expensive, since it had to be gathered from further and further afield in Jiangxi province. Hence blue-decorated wares remain by far the most common in the West, or indeed in the East, representing probably nine-tenths of extant Kangxi period export porcelain (1662-1722), and at least two-thirds of the bulk of most shipping cargoes until the later eighteenth century, as Dutch and English East India Company cargo manifests reveal.

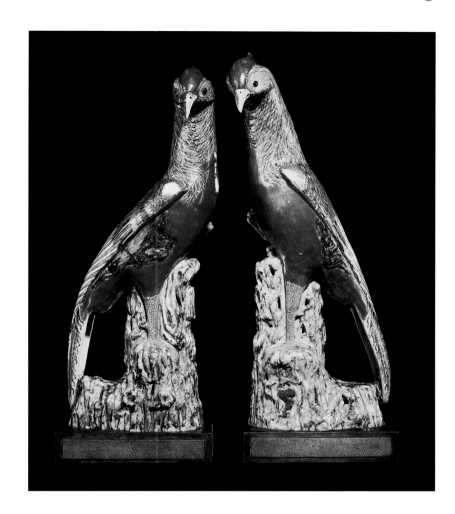

Most of this, in the form of dining-table ware, was in sizes and forms that changed little over a century, the main exceptions being vessels copying silver shapes, which slowly and imprecisely followed evolving Western forms. Flatware shapes however remained fairly constant: it is one of the great mysteries of Chinese export porcelain how, and why, the standard size of a circular dinner plate was established, and for a century remained with a wide flat border and measuring nine inches in diameter.

While established flatware shapes did not change, new shapes entered the repertoire as specific copies of Western forms. Although export wares normally reproduce European metal forms, it is possible that others, such as the example illustrated here, used a Dutch Delft pottery plate as inspiration (11). The 'gadrooned' spiral border on this plate is often found on metalwork, but the central design with a young vine-wreathed Bacchus standing on a tiled floor strongly suggests Dutch interiors commonly found in pottery designs; the 'blue dash' border over the gadrooning also recalls Delftware. The amusing central pattern owes nothing to a Chinese source, although the wide, leafy flower-scroll meander is a well-established way for Chinese potters to fill an inconvenient empty border. A formal dinner came to involve more elaborate serving vessels as etiquette for the courses became established, and many quintessentially non-Chinese shapes, such as cylindrical beer mugs, oval fish dishes with pierced strainers, square salad bowls and covered custard cups, made their appearance in dinner-services.

A massive water-fountain for the dining-room provides a rare example of private trade cargo whose commissioning

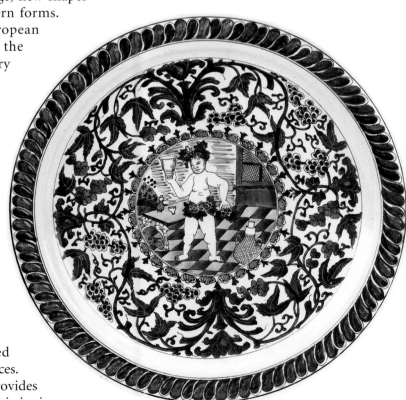

can be clearly traced **(13)**. The Dutch draughtsman Cornelis Pronk was retained by the Dutch East India Company for four years (1734-38) to produce designs in Western taste that could be copied onto Chinese porcelain. Although his original watercolour drawing for this 'hand-washing' pattern does not survive, there is strong evidence that this was one of his most successful designs, consistent with others for which his drawings are extant. Cisterns such as this would have been used for water, or possibly wine, and are very occasionally found still associated with the large oval basins which originally accompanied them, painted with elements from the same designs. There is no precedent in Chinese domestic ceramics for such a vessel.

The blue and white wares were all self-evidently potted and finished in Jingdezhen, since provincial blue and white production such as that of Fujian was of consistently poorer quality. It is logical therefore that all the blue and white wares which copy Western prints were also produced there. This is significant, because some scholars believe that many of the export wares painted in over-glaze enamels were in fact decorated in Canton, where the Western merchants rented their annual warehouses as bases for each season's trading with the Chinese. The theory is that undecorated white pieces, or ones perhaps with minimal blue and white standard border decoration, would be enamelled and fired with Western designs, especially coats of arms, more conveniently and quickly at Canton, rather than having to collect the Jingdezhen product a year later. The theory is sensible, but at the moment not proven. Anyhow, there is little doubt that all the underglaze-blue decoration which copied Western prints was completed in China's porcelain city. The only possible competitor, the coastal kilns of Fujian Province, lacking technical skills, had normally to

12. A pair of famille rose vases and covers , ca. 1770. Height 69cm (27½"). Courtesy Christie's London.

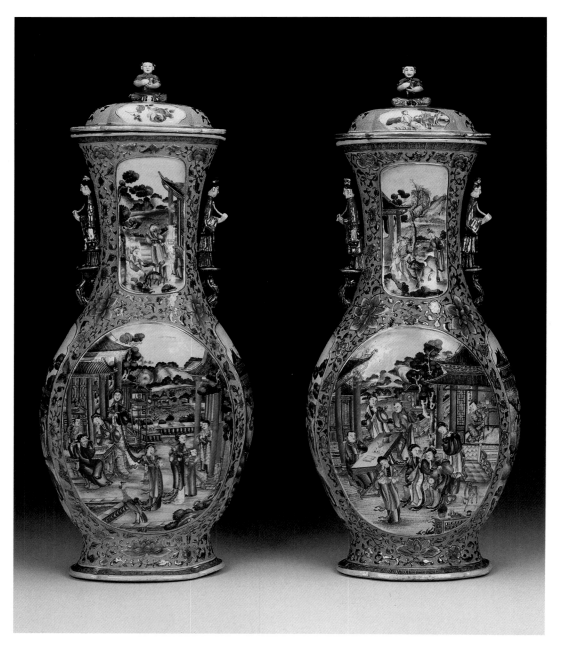

rely on applying a very obviously thick glaze over a distinctive violet-blue cobalt, and the vessels themselves were muddier and different in character from the crisply-potted thinly-glazed, carefully painted Jingdezhen export blue and white wares.

The principal over-glaze enamel palettes found on Qing Dynasty export porcelain are *famille verte* and *famille rose*. The first, continuing a basically late Ming dynasty combination of translucent green, yellow, aubergine and blue, and opaque iron-red enamels, lasted from ca. 1650-1720, when it rapidly disappeared, the primarily green tones eclipsed by a new colour. This was the result of technological innovation at the enamelling kilns in Limoges, France, where a generation earlier colourists had developed a rich pink enamel derived from colloidal gold. Introduced to the Chinese via the medium of Jesuit priests attached to the Imperial Court, who were always hungry for Western innovation to bolster their shaky position at court, this new pinkish-red enamel revolutionised the traditional palettes at Jingdezhen. A further innovation made it even more flexible and effective. By adding an opacifier, for the first time delicate and controlled gradations of the now opaque enamel tones could be achieved when painting on porcelain; the superb Imperial *famille rose* wares of the Yongzheng period (1723-35) were the principal beneficiaries, but even export decoration became richer and the colour combinations more versatile.

A pair of *famille rose* birds, made purely for a foreign market (**10**), is a remarkable example of the eighteenth century pleasure in associating spectacular Chinese export porcelain figure models with Western ormolu mounts. The birds are superbly matched in colour, always an important consideration for collectors today, and are clearly intended to be a mirror-image pair, since the heads are turned in opposite directions. This would be less of a priority with Chinese potters making figure models for the domestic market. Ever since the Tang period, when funerary horses invariably look to the left, the normal tradition is that heads look forward, and therefore the concept of a matched pair with heads deliberately inclined to face each other does not occur. The only exception to this is when heads are made separately and applied, as in the case of blanc-de-chine, but there is no evidence that the angle of the head in these cases is more than a random choice.

Manufactured some thirty years later, the elaborate painted figural decoration and cluttered border surrounds on a pair of large vases (**12**) foretell the decline of export designs, and their evolution into the over-crowded 'Canton *famille rose*' patterns of nineteenth century export wares. Such later *famille rose* production influenced a number of new English porcelain factories, particularly at Newhall, and spawned a crop of Staffordshire transfer-printed imitations. The figural handles and finials were a new development in export ware, and were never found on domestic-taste wares of any quality during the eighteenth century; it is possible that they were in fact inspired by European hard-paste factories, which produced far more porcelain sculptures for all purposes than did the Chinese.

Novel in palette but familiar to Westerners in subject matter and form, setting new standards of elegance but relatively cheap, a sign of social prestige and a vehicle for a more elegant life-style for many non-aristocrats, Chinese export porcelain had much to commend itself in the seventeenth and eighteenth centuries, and the pleasure it afforded then still strikes a chord today with collectors in Europe and the Americas. It was only rarely outstanding, unusual or glamorous; but it had a very marked effect on society during one of the most fascinating periods in the development of post-Renaissance European interior decoration.

13. Imari Pronk 'hand washing' water-fountain, ca. 1737. Height 73cm (29"). Courtesy Christie's London.

7

THE PROGRESS OF RAMA

The *Ramayana* in Khmer bas-reliefs of the Angkor period

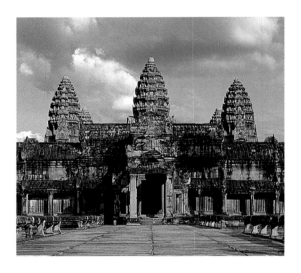

THIERRY ZÉPHIR

In India and throughout the Indianised world, literature has always been one of the chief sources of inspiration for artists. Both religious texts and heroic epics were traditionally recited, but at the same time they provided inspiration for miniatures, mural paintings, and narrative bas-reliefs such· as those developed by Khmer artists of the Angkor period, from the early tenth century. The *Ramayana* is one of the most influential of the early epics and was regularly evoked on Khmer temples, culminating in the superb bas-reliefs of Angkor Wat.

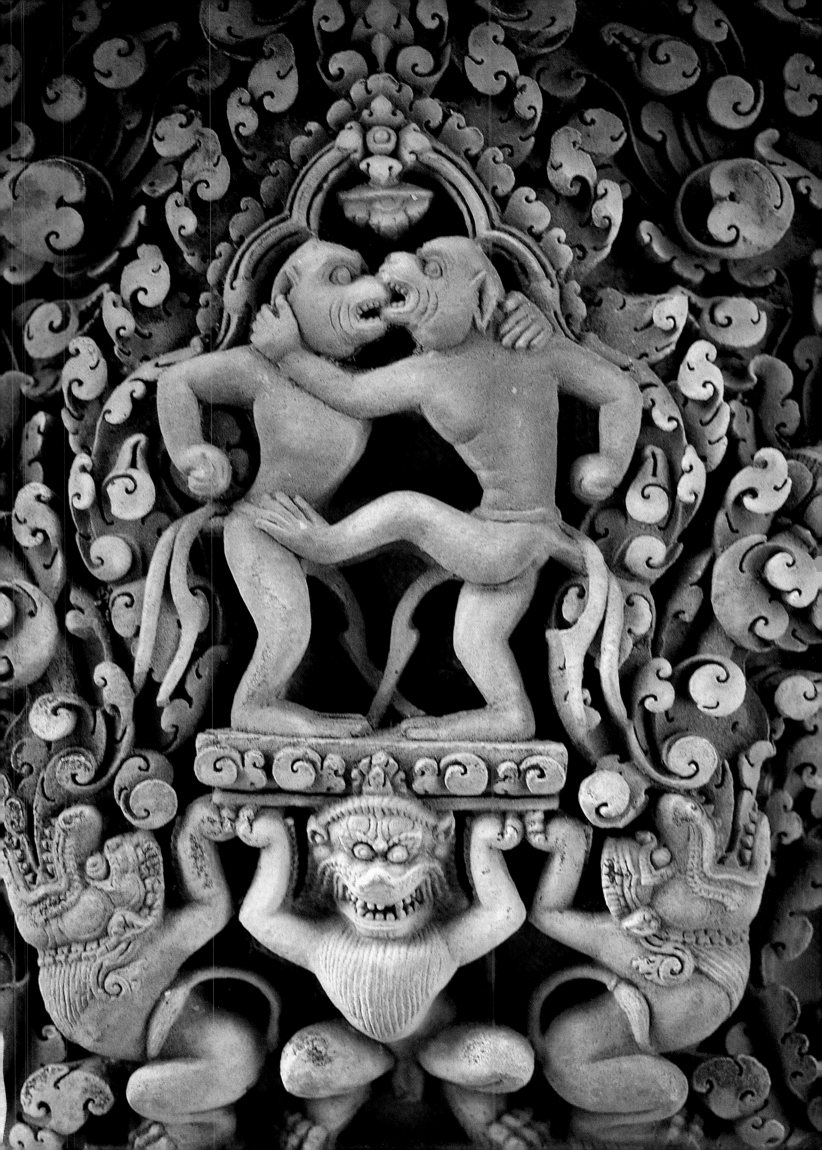

1. Title page: General view of Angkor Wat from the west, first half 12th century.

2. Previous page: Sugriva's battle with Valin (detail), Banteay Srei, central sanctuary, northern lintel, 967-968AD.

The influence of Indian art and literature first began to be felt beyond her own borders during the first centuries of the Christian era, thanks in large part to the forging of intensive trading links between India and Southeast Asia. Among the earliest evidence of this are inscriptions[1] and a series of remarkable Buddha images, reflecting Indian and Sri Lankan stylistic traditions,[2] which mark the routes of the trader-navigators. One of the ways in which aesthetic ideas were disseminated was by contact with the votive statuettes carried by many of the travellers, no doubt as much to ward off danger as to ensure the continuity of their personal devotions. The cultural elite of the southern seas and coastal strips of Southeast Asia were captivated by the rich new culture. Percipient rulers may well have sensed its potential, furthering their power, prestige and desire for political hegemony, for it was not long before the Indian concept of the *cakravartin* – the monarch of the wheel, the universal sovereign according to the dharma – was assimilated and adapted to their own needs by the monarchs of the Javanese and Khmer kingdoms.

Between the ninth and thirteenth centuries, the Khmer empire became one of the most powerful and centralised states in Southeast Asia, as well as one of the most brilliant. In its heyday it covered an area reaching from central Thailand in the west to central and south Vietnam in the east. It emerged following prolonged struggles between various smaller kingdoms of which we still know very little. The most important of these, known to the Chinese as Funan, occupied a substantial area in the south of historical Cambodia.[3] At the end of the sixth century AD Funan was absorbed by Zhenla, a powerful kingdom further to the north,[4] and it is by this name that the Chinese referred to the Khmer empire until the thirteenth century. These little-known kingdoms contained the seed of much that was to constitute the originality, the power and also the greatness of the Khmer empire at its height during the Angkor period, so-called after the town to the north of present day Siem Reap in northern Cambodia.

The first kings of the Khmer developed a strategic soil irrigation system[5] which resulted

3. Rama's struggle against Marica, Baphuon, gopura (entrance gateway) II west, eastern face, third quarter 11th century.

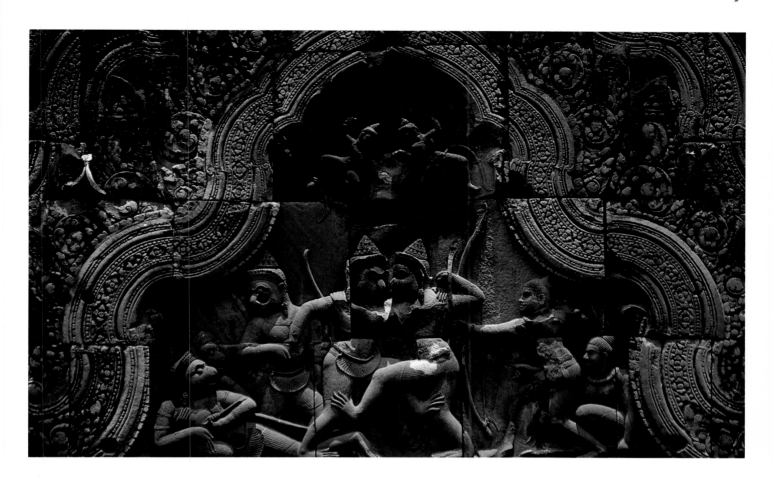

4. *Sugriva's engagement with Valin and death of Valin, Banteay Srei, gopura II west, eastern pediment, 967-68AD.*

in improved soil cultivation capable of sustaining a large population. These technologies for collecting, storing and distributing water made possible the development and evolution of the Angkor region. The power of the Khmer empire was thus founded to a large extent on their engineering skills, culminating at the end of the ninth century in the creation of the hydraulic city of Angkor, which would be the capital of the empire until the beginning of the fifteenth century.

As the great Indian religions of Hinduism and Buddhism became established in Khmer culture, they brought with them a considerable body of philosophical, poetic and epic literature, as well as the language which would long remain their vehicle, namely Sanskrit. Right from the start, the two epic poems, the *Mahabharata* [6] and the *Ramayana,* occupied a position of fundamental importance within this literature. That they were known at an early date is evidenced by several inscriptions, one of which tells us that the *Mahabharata,* the *Ramayana* and the *Harivamsha*[7] were all recited from the seventh century onwards.[8] As a whole, the Indian texts which reached Southeast Asia constituted what the great epigraphist George Coédès called the 'stock-in-trade' of the image-carvers.[9] However much the stories were adapted or even reshaped according to local traditions and practical considerations, they were never actually abandoned. Even today in a fundamentally different religious context, the story of Prince Rama and his wife Sita enjoys enormous popularity throughout most of the countries of Southeast Asia.

Traditionally, the writing of the *Ramayana* – the 'progress of Rama' – is attributed to a single author, the sage Valmiki, who came from a low caste and was said to have ended his life as an ascetic. He remained motionless for a thousand years, so that an ant-hill or *valmika* formed around him while he was lost in meditation. The work consists of some 24,000 verses *(shloka),* divided up into seven books *(kanda),* themselves further divided into 645 songs *(sarga).* Known in several versions in India itself, and in even more variants in Southeast Asia, the *Ramayana* was originally transmitted orally before being written down, in the opinion of most modern linguists and exegetes, at some point between the second centuries BC and AD.

The epic narrates the story of Rama, an *avatar* (incarnation) of the Hindu god Vishnu, who is both a solar hero, marked out to reign gloriously for ever, and a human prince. Upright and righteous, he is respectful of ancestral traditions and the moral code, but his destiny leads him through cruel torment and suffering until he finally comes to transcend his human condition. On reaching adulthood, Rama, prince of Ayodhya and a superb

archer, wins the hand of the princess Sita. His happiness is short-lived however, for he is unjustly banished from the kingdom for fourteen years as a result of a court intrigue. Accompanied by Sita and his favourite brother Laksmana, he lives as a hermit in the forest and gives proof of his superiority in victorious struggles with the demon race of the Raksasas, ruled by Ravana. Taking revenge, the latter abducts Sita and imprisons her on the island of Lanka, where he attempts in vain to seduce her. Rama makes common cause with the monkey Sugriva, ruler of Kishkindha, helping him to dispose of Valin, a rival for his throne. In a final great battle, fought between Rama and the monkeys, led by Sugriva, on the one hand, and Ravana and the Raksasas on the other, Sita is liberated. Rama finally returns home with Sita and is crowned king.

Khmer epigraphy is extremely rich and, following a tradition widely attested in India, inscriptions often draw on passages of the epics in order to praise the qualities of sovereigns, comparing their deeds with those of the heroes or gods. No comparison is too explicit, no deed too lofty to use in extolling the virtues of the powerful Khmer monarchs. The stele of Pre Rup provides an example of this convention. Written in praise of King Rajendravarman (944-967AD), it offers a comparison drawn from the third book of the *Ramayana*. In

5. Eastern view of the temple of Banteay Srei, 967-968AD. The pediment over the entrance gateway depicts Shiva dancing.

George Coédès' translation, the stanza runs: "At the sound of the first syllable of his name, the enemy king, despite his valour, was seized by a fear aroused by no other (syllable), just like that felt by Marica (on hearing the first syllable of the name) of Rama".[10] This is an unequivocal allusion to the demon Marica's death at the hands of Rama, aimed at establishing a parallel between the mythical hero and the historic king.

It would seem that episodic relief sculpture did not develop in Cambodia until the third quarter of the tenth century, with Banteay Srei, a temple built in 967-968. Previously, Khmer art seems to have limited itself to the evocation of a few great myths,[11] or the representation of specific deities.[12] Such scenes are known mainly from lintels, since pediments predating Banteay Srei have only survived in a seriously damaged and almost illegible state. The continuous frieze composition occupying the long supporting wall of the fifth step of the pyramid of Bakong (881) is an exception in this respect, but it is in such a state of dilapidation that it is impossible to determine the subject originally represented.

Banteay Srei was a private Shaivite temple, built some twelve miles from Angkor by Yajnavaraha, a Brahmin of royal descent (5). The buildings of Banteay Srei, mainly of

6. Attempted abduction of Sita by the demon Viradha, Banteay Srei, central sanctuary, west lintel, 967-68AD.

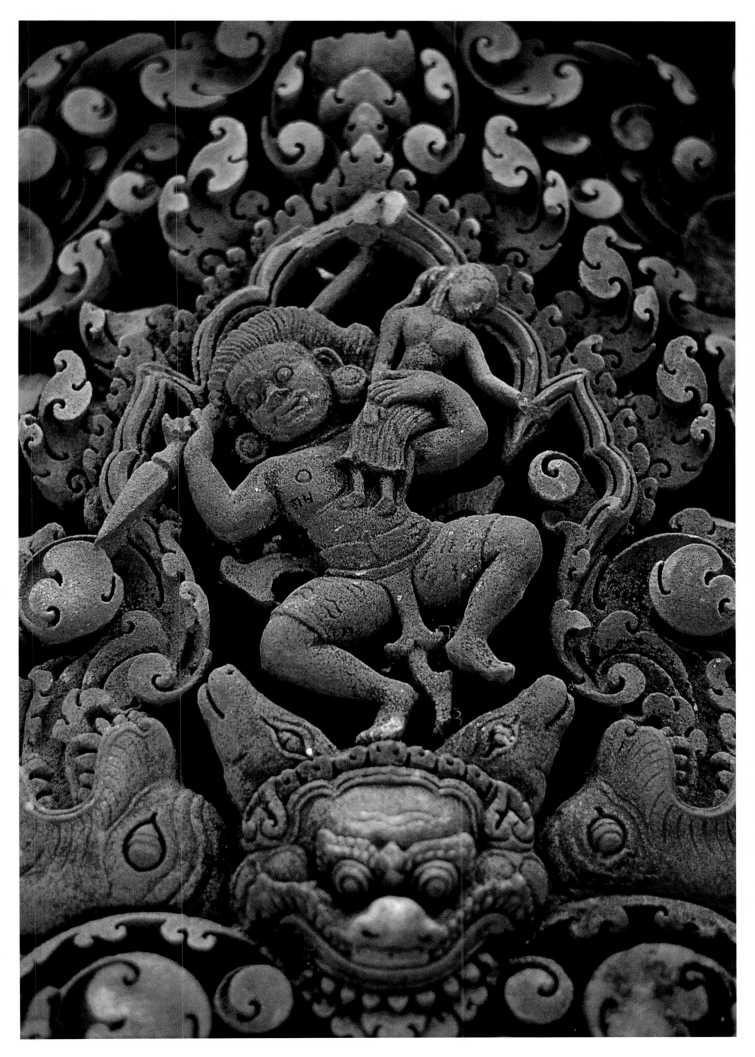

7. Awakening of the demon Kumbhakarna, summoned by Ravana to fight in the battle of Lanka, Baphuon, gopura I west, eastern face, third quarter 11th century.

8. Sugriva's battle with Valin and death of Valin, Angkor Wat, southwest corner pavilion, first half 12th century.

sandstone, are adorned with a profusion of elaborate ornament and relief figure sculpture. Both lintels and pediments have compositions taken from various episodes from the *Mahabharata* and *Ramayana*. One such example is to be found on the eastern pediment of the *gopura* (entrance gateway) II west. Here, the fight between the rival rulers of the monkey realm Sugriva and Valin, and the ensuing death of the latter (**4**), have been grouped together into a single panel. The bas-relief has been clearly structured, allowing for space around the figures to enhance the readability of the scene. The story unfolds from the right to the left, with the combat forming the central axis. To the right, Rama shoots the arrow which will kill Valin, while Laksmana crouches behind him, pointing to the central scene. To the left, Valin lies in the arms of his wife Tara, with Sugriva looking on, his position and attitude leading the spectator's eye towards the final scene. In India, the custom of depicting several episodes of a story within a single area is as old as the art of the bas-relief itself. It came into its own from the second century AD in the various scenes decorating the *vedika* (balustrade) of the Buddhist stupa. The same phenomenon is found in Cambodia from these earliest remaining narrative bas-reliefs onwards.

At the other end of the spectrum of styles found at Banteay Srei is the lintel over the fake western door of the central sanctuary, carved with the abduction of Sita by the demon Viradha (**6**). Here, on a background of rich foliage, the two principal actors appear as if embedded in a setting of worked gold. A similar style is found in the lintel over the fake northern door of the central sanctuary, which depicts a simplified version of the combat of Sugriva and Valin (**2**). The two opponents appear on a pedestal supported by three fearsome lions. The image of the fighting monkeys is set in a lobed and petalled arch. To the right of this central group, Rama is just visible among the branches of abundant foliage that make up the essential part of the lintel's sculptural decoration. The simplification of the composition is accompanied by a more sober representation of the characters, who are unadorned. By comparing two representations of the same scene, found in the same monument and dating from the same period, two contemporaneous but diametrically opposed currents in the Khmer narrative bas-reliefs become apparent. On the pediment, we find a complete and detailed description of the episode, while the lintel merely alludes to it by evoking the

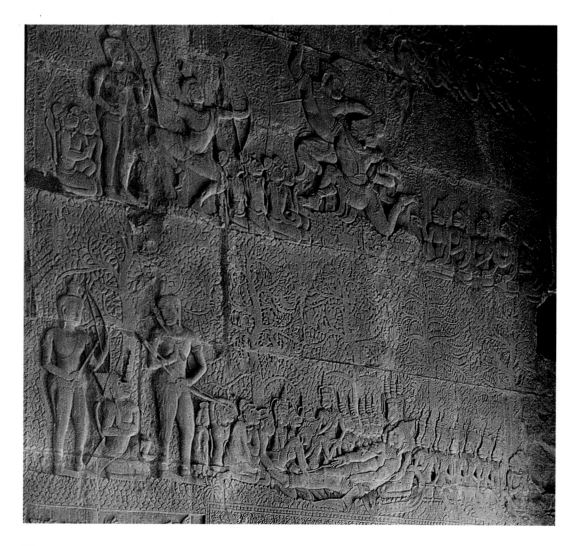

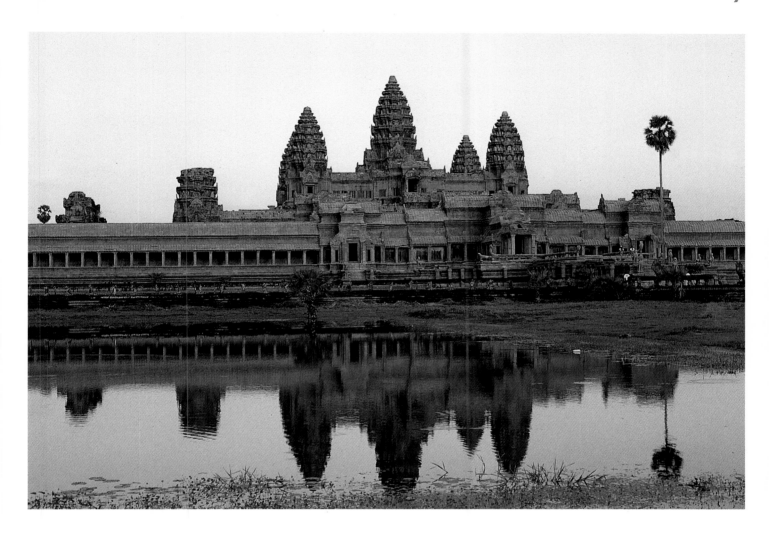

central scene. The decorative vocabulary differs radically, depending on the size and shape of the architectural element which is to hold the sculpture. However, in both examples, the composition concentrates on the essential characters, skilfully summarising the most typical elements in the scene. This is a characteristic feature of the art of the Angkor bas-reliefs, where the principles of composition tend largely towards the spirit of synthesis.

9. General view of Angkor Wat from the northwest.

Thus, beginning with Banteay Srei, narrative becomes an important feature in Khmer architectural decoration, found not only on pediments and lintels, but also on half-pediments, the bases of pillars, and on inner and outer walls. The wide variety of placement for this decoration was to become a striking feature of the style of Angkor Wat, at the very moment when the narrative art of the bas-relief reached its highest expression.

The Baphuon, a temple built as a stepped pyramid at Angkor during the rule of Udayadityavarman II (1050-1066), is remarkable for its innovative compositional style. Here the artist devised a system of sculptural decoration in small quadrangular panels and superimposed registers (**3, 7**) on the exterior walls of building. This decorative system is found, for example, on the *gopura* of the second gallery enclosure on the third storey of the pyramid. The same compositional device was used to decorate the walls of the anteroom to the shrine of the Prasat Khna Sen Kev, a temple some eighty kilometres northeast of Angkor. This system, which was subsequently abandoned, would have allowed the sculptors to give their works more descriptive continuity. By covering the outer walls with bas-reliefs, the sculptor could make use of larger surfaces, free of the space constraints imposed by the limited area of the lintel or the triangular fronton with its multilobed outline.

In spite of the increased use of architectural surfaces for narrative bas-reliefs, the epics were never represented in continuous scenes in Khmer art as they were elsewhere in Southeast Asia, in Javanese art in particular.[13] We do not know the reasons, if any, which led the sculptors to proceed in a manner which one might almost describe as haphazard, repeating scenes or omitting important episodes when seemingly rendering a more or less continuous account of one of the great epics. A partial answer might be that it may have seemed more important to stress the symbolic aspect and implications of a single episode, rather than to give a necessarily imperfect and incomplete reproduction, in stone, of the whole.

With the emergence of the style of Angkor Wat, the art of the bas-relief reached new

10. *The gallery of bas-reliefs, Angkor Wat, first half 12th century.*

heights. Built by Suryavarman II in the early twelfth century, Angkor Wat is the crowning achievement of Khmer architecture, the culmination of all the features of earlier styles **(11)**. The temple is dedicated to Vishnu and is accordingly oriented toward the west.[14] As in the preceding monuments, the epic narrative represented in the bas-reliefs remains fragmentary and incoherent; pediments and lintels, many of which have been totally eroded over time, are decorated with a variety of episodes in no apparent order. In the styles of Banteay Srei and Baphuon, the sculptors focused on the principal characters, while maintaining the readability of the scene. At Angkor Wat, on the other hand, the artists took pleasure in dense, crowded compositions, sacrificing clarity to overall effect. Organised in furious melées or neatly disposed in superimposed registers, numerous secondary characters now appear, making the immediate identification and comprehension of the scenes increasingly difficult.

An exception are the striking bas-reliefs found in the interior of the southwest and northwest corner pavilions of the third gallery enclosure. Epic scenes are set into an elaborate landscape or architecture, which forms a dramatic backdrop to the action. The status of the principal characters is symbolically conveyed by their heroic dimensions. Finally, the ambitious size of these panels gives the epic scale of the texts sufficient space to unfold. Aesthetically, they are executed with a care and delicacy reminiscent of carving,

11. *Sugriva's struggle against Valin and death of Valin, Angkor Wat, central sanctuary tower, northern porch, eastern half pediment, first half 12th century.*

rather than of the chiselled bas-relief usually worked in a coarser manner. One such composition is the scene of struggle between Sugriva and Valin portrayed in the southwest corner pavilion (8). Rama, in a less than chivalrous fashion, unleashes his fatal arrow into Valin's back, followed by the death of the great monkey surrounded by his tearful wives. The scene is treated with a subtlety and finesse never seen before in Khmer art. While the principal of grouping together successive scenes in one single panel is upheld, the way of expressing the scene has changed radically. Here, in the twelfth century, the virtuosity of the sculptors reaches its fullest maturity.

In the famous gallery of bas-reliefs (10) the sheer extent of the surfaces made it possible to represent events in a way that mirrored the epic text, as not only dense and complex, but continuous and narrative in the strict sense. The reliefs occupy a length of almost fifty metres and a height of about two metres. The battles of the Kurukshetra and of Lanka – the set pieces of the *Mahabharata* and the *Ramayana* respectively – are reproduced with numerous details and a vigour previously unknown in Khmer art (12). At first sight the scenes seem confused and repetitive.[15] But on closer inspection it is possible to make out a large number of complementary and interrelated compositional units, giving coherence to these epic combats by unifying the detail and the whole. Most of the units are composed along diagonal lines, guiding the eye from the lower to the upper part of each panel,

12. The battle of Lanka, Ravana on his chariot, Angkor Wat, gallery of bas-reliefs, western face, north wing, first half 12th century.

leading the visitor from one scene to the next along the gallery. This is an exceptional example not only in Khmer art, but also in the ancient arts of the Indianised world as a whole. It is perhaps this aspect which marks the bas-reliefs of Angkor Wat out as a major creative achievement.

Thus in its subject-matter, if not in its forms, Khmer art was deeply indebted to India, the true foster-mother of Southeast Asia. Yet from its very origins, in all probability, Khmer artists were able to transcend this original influence and allow their own originality to achieve dazzling expression. This is particularly evident in the narrative bas-reliefs of Angkor, where the sculptors of ancient Cambodia created a powerful and revitalised vision of the intellectual and spiritual world with which they had been presented, while remaining essentially faithful to its spirit.
Notes see Appendix

8

RITUAL &
SPLENDOUR

The Gold of Indonesia

KALPANA KARTIK

Animistic beliefs inherent in many of the traditional cultures of Indonesia, influenced by successive waves of Hinduism, Buddhism and Islam, have for centuries given rise to remarkable works of art. Among the finest artistic achievements of the Indonesian island cultures are the works of art produced in gold, which have played a central role in social and religious ritual from at least the eighth century AD to the present day.

1. *Title page: Necklace with fruit motifs, Wonoboyo, Central Java, 9/10th century. Length of beads: 2.5-5.5cm (1-2"). National Museum, Jakarta.*

2. *Previous page: Stone relief from the 9th century Hindu temple of Prambanan, Central Java.*

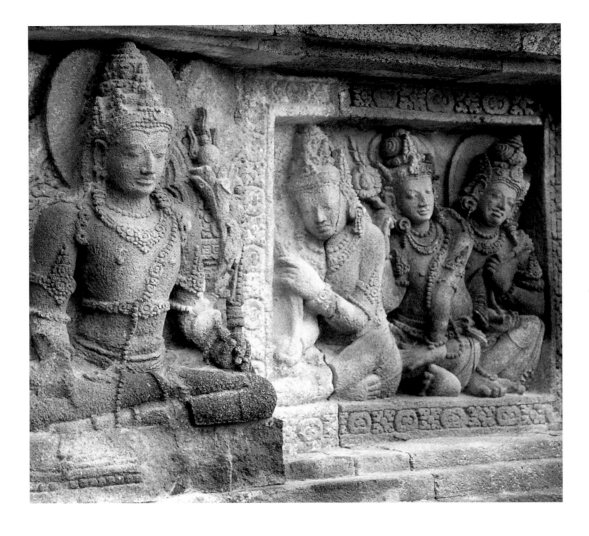

3. *Stone relief from the temple of Prambanan, Central Java.*

4. *Lid of a bowl, Wonoboyo, Central Java, 9/10th century. National Museum, Jakarta.*

Throughout the recorded history of the Indonesian Archipelago, gold has played a crucial role in the religious and economic life of the community at all levels of society. It was used in temple offerings, marriage alliances and funerary rites, and as a form of valuable gift exchange between kings and their subjects.

The artistic production of gold in Indonesia is of two main types: the classical styles of the Hindu-Buddhist period, produced from the seventh to the fifteenth century, and the tribal style, which arose in the nineteenth century or earlier. The latter is mostly found in the islands lying at the outer border of the archipelago and is characterised by a blend of indigenous art forms with foreign elements.

The earliest reference to the existence of gold in these islands is to be found in an Indian literary source, the *Ramayana*, and in the *Geography* of Ptolemy, the Greek mathematician and geographer's most famous work and a standard text until the sixteenth century. In the latter, written in the middle of the second century AD, Ptolemy mentions the existence of *Iabadiou*, also known to the ancients as *Suvarnadwipa* or *Yavadwipa*, the fabulous gold-producing islands in the Malay Archipelago.

Lured by the promise of wealth, many Indian and Chinese merchants began to roam the South China Seas in search of the islands of gold, thronging the ports of Sumatra, Java and Borneo. As early as the third century AD, these traders began to settle in coastal areas, bringing with them new religious beliefs. Hinduism and Buddhism were introduced to the area at this time, and remained powerful until the advent of Islam in the fifteenth century.

The earliest Hindu kingdom in Java was Tarumanagara, whose founding king, Purnawarman, ruled in west Java in the fifth century, according to a stone inscription in the South Indian Pallava script and discovered in Citarum River near Bogor, West Java. Today, very few traces of this early Hindu kingdom remain, and our knowledge is mainly based on reports from Chinese travellers who visited the island in the fifth century. One of the most famous descriptions comes from the Chinese pilgrim Fa-Hsien, who wrote that many Brahmins lived on the island.

In the eighth century power shifted to Central Java with the emergence of

the Hindu kingdom of Mataram, founded by King Sanjaya. Hinduism was by then dominant throughout the island and magnificent sanctuaries had been built, many of which exist to this day. One of the oldest sites, on the Dieng Plateau in Central Java, has several small Hindu shrines dating back to the eighth century or even earlier. Other Hindu temples of the eighth and ninth centuries are scattered throughout Central Java, and the crowning achievement of this golden period is the great temple of Prambanan.

At the same time as the Hindus ruled Central Java, the Shailendras, who were Buddhists, emerged as a power in the north of the island. Thought to have come from the agricultural lowlands of the Javan interior, the Shailendras extended their power to the northwestern coasts, from where their emissaries both raided and traded with the Malay Peninsula and Indochina. Mahayana Buddhism was first introduced during this period, resulting in a major cultural renaissance on the island. Hindu rule nevertheless became increasingly dominant, and in the mid ninth century Balaputra, last prince of the Shailendra dynasty, left Java for Sumatra, where he ruled as king of Srivijaya.

From the seventh to the thirteenth centuries, Srivijaya was a powerful maritime kingdom whose eponymous capital, as we know from contemporary accounts, was home to many Buddhist monks. It exercised control over international trade routes, opening its ports to ships from all over the Archipelago, the Persian Gulf, China and India, and maintaining diplomatic relations with the Indian kings of the Pala dynasty in Bengal, and the Chola dynasty of South India.

EARLY EVIDENCE OF GOLD
The earliest known inscriptions mentioning the use of gold were discovered in the region of Kutei on the island of Kalimantan (Borneo). The oldest Hindu kingdom in Indonesia, it was ruled by Mulawarman, a native convert. Evidence of his rule comes from seven inscribed sacrificial stone slabs (*yupa*) found in Kutei. Written in the fifth century South Indian Pallava script, the inscriptions describe a religious event in which gold formed part of the offerings given to the high priests. A number of Javanese-inspired gold artefacts have been discovered at excavation sites such as Jaong and Limbang, indicating that production of gold in Kalimantan was of a significant quantity.

Inscriptions dating from the seventh century relate to the ritual function of gold in ancient Java. On important occasions it was given away as *anugraha* (gifts): reference is made to gold in the form of coins, figurines, rings and ornaments which were given to high officials, ministers and those who performed ceremonies. Other inscriptions state that a large quantity of gold coins were minted on the island.

5. Handle of a water dipper, Wonoboyo , Central Java, 9/10th century. 15.8cm (6"). National Museum, Jakarta.

6. The Ramayana bowl, Wonoboyo, Central Java, 9/10th century. Height 9.3cm (4"). National Museum, Jakarta.

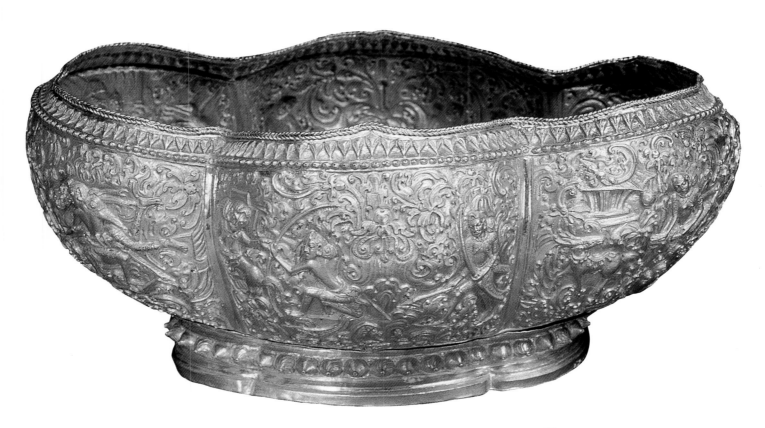

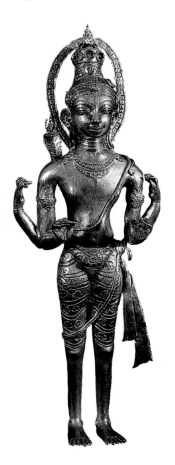

7. *Four-armed Shiva, Gemuruh,*
Central Java, 9th century.
Height 20.5cm (8").
National Museum, Jakarta.

8. *Ritual bowl in the form of*
a palm leaf, Wonoboyo,
9/10th century, Central Java.
Height 6.6 cm (2½").
National Museum, Jakarta.

Temple reliefs, such as the well-preserved stone sculptures in the temples of Prambanan in Central Java, give a clear indication of the ways in which gold was worn as body ornament, and have provided valuable evidence for the reconstruction of jewellery which has been found in a fragmented state. And in keeping with southeast Asian artistic tradition, statues of divine kings and deities show their subjects richly adorned with gold jewellery such as necklaces, chains, pectorals and armlets **(2, 3, 7, 12)**.

CLASSICAL JAVANESE GOLD

The period of joint Hindu-Buddhist rule in Java between the eighth and tenth centuries proved to be exceptionally rich in terms of artistic, cultural and literary achievement. It was at this time that gold-working attained its zenith. Little is known of the dynastic chronology of the island's rulers during this period, beyond an early eighth century inscription, discovered near Borobudur, referring to Mataram, the first Hindu kingdom in Central Java. The emergence of the Buddhist Shailendra dynasty at the end of the eighth century is amply attested however by the numerous temples they erected. The following two hundred years saw the active construction of both Buddhist and Hindu temples, during the apparently peaceful rule of the Hindu princes of the Sanjaya dynasty.

During the tenth century for reasons that today remain uncertain (natural catastrophe, invasion from Srivijaya, economic interests), the centre of power moved to East Java. Here, a new line of kings founded the great empires of Singasari and Majapahit. With the shift of dynastic power to the east, artists developed a new iconographic style, moving away from the older tradition of Central Java which had largely been inspired by Indian prototypes.

Gold objects have been unearthed in Java since the nineteenth century. One of the greatest treasures found since Indonesian independence in 1945 was excavated as recently as 1990 in the village of Wonoboyo, not far from the temple of Prambanan, in Central Java. A bronze pot and three Tang period Chinese ceramic jars were discovered to contain more than six thousand gold and silver objects. The hoard, consisting of magnificent gold jewellery, ceremonial objects and gold and silver coins, may have belonged to the father of King Sindok, the last ruler of the Kingdom of Mataram at the beginning of the tenth century – inscriptions on cups found among the treasure tell us that the owner renounced his kingship to dedicate himself to the life of a hermit. Now in the National Museum of Jakarta, the treasure of Wonoboyo bears witness to the extraordinary technical skill and creativity of ninth and tenth century classical Javanese goldsmiths, who demonstrate complete mastery of a range of techniques such as repoussé, soldering, chiselling, and joining separate elements by rivetting and polishing.

The ritual objects in the Wonoboyo hoard give some indication of the splendour of religious ceremonial during this period, when high officials and nobles appeared in the temple richly adorned with gold ornaments, and priests officiated using objects made of gold. Inscriptions in Nagari script on gold ritual bowls, such as 'Saragi Dyah Bunda' and

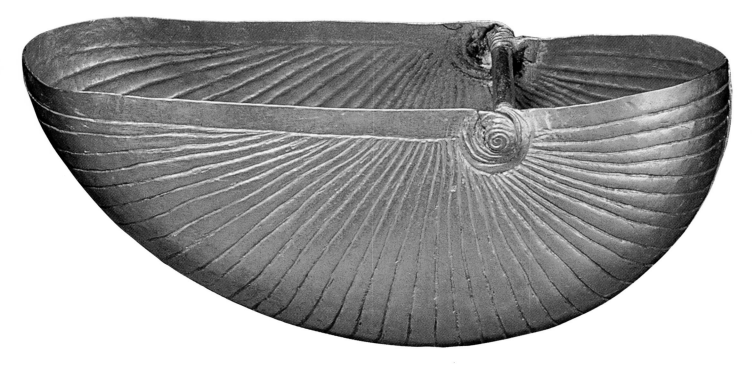

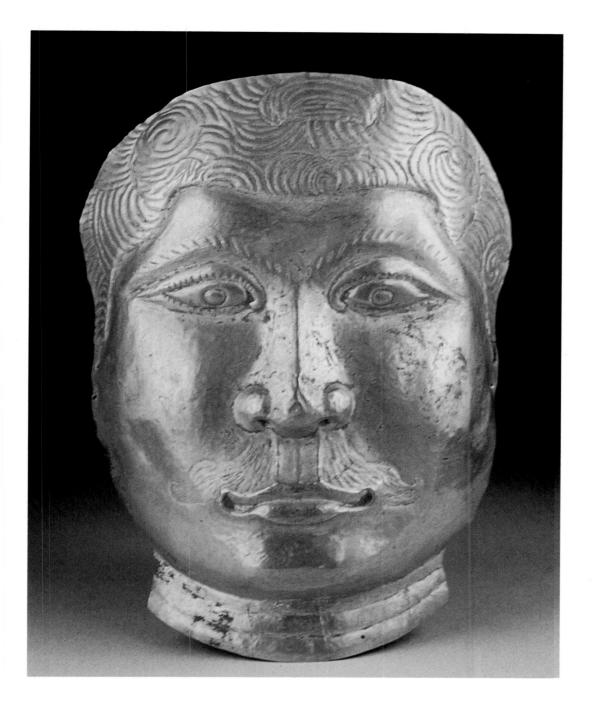

10. *Earrings with flame border motifs, Wonoboyo, Central Java, 9/10th century. National Museum, Jakarta.*

9. *Mask, Yogyakarta, Central Java, 8th-9th century. Height 15cm (6"). Sono Budoyo Museum, Yogyakarta.*

11. *Gold foil lotus petals, Diro Sleman, Yogyakarta, Central Java, 9th century. Depth 21cm (8"). National Museum, Jakarta.*

'Sri Pi', attest to the royal or noble lineage of those who commissioned them. Some of the bowls depict themes inspired from Indian lore as well as traditional Javanese motifs, while many of the ceremonial utensils carry rich floral and ornamental decoration.

The *Ramayana* bowl (**6**), depicting the Exile of Rama and the Abduction of Sita, is one of the masterpieces of Wonoboyo art. Beautifully executed in hammered and repoussé techniques, the rounded flower-shaped bowl is decorated with four picture panels, each containing two scenes taken from the Indian epic poem the *Ramayana*. Triangular petals *(tumpal)* decorate the upper border of the vessel. Bowls of a similar elongated quadrilobe form are frequently found in Chinese ceramics of the Tang period; the shape is based on the flower of the *haitang,* a tree indigenous to northern China. However, while influenced by Chinese prototypes, Javanese gold-smiths used a decorative vocabulary based entirely on Indonesian taste. The base, with a still visible layer of clay, was made separately and is embellished with a row of protruding flower bulbs. Its shape, if not its decoration, is once again reminiscent of Tang ceramics. Both the bowl and the base were rivetted together with short metal pins.

Themes from the world of nature were frequently used. A water dipper in the

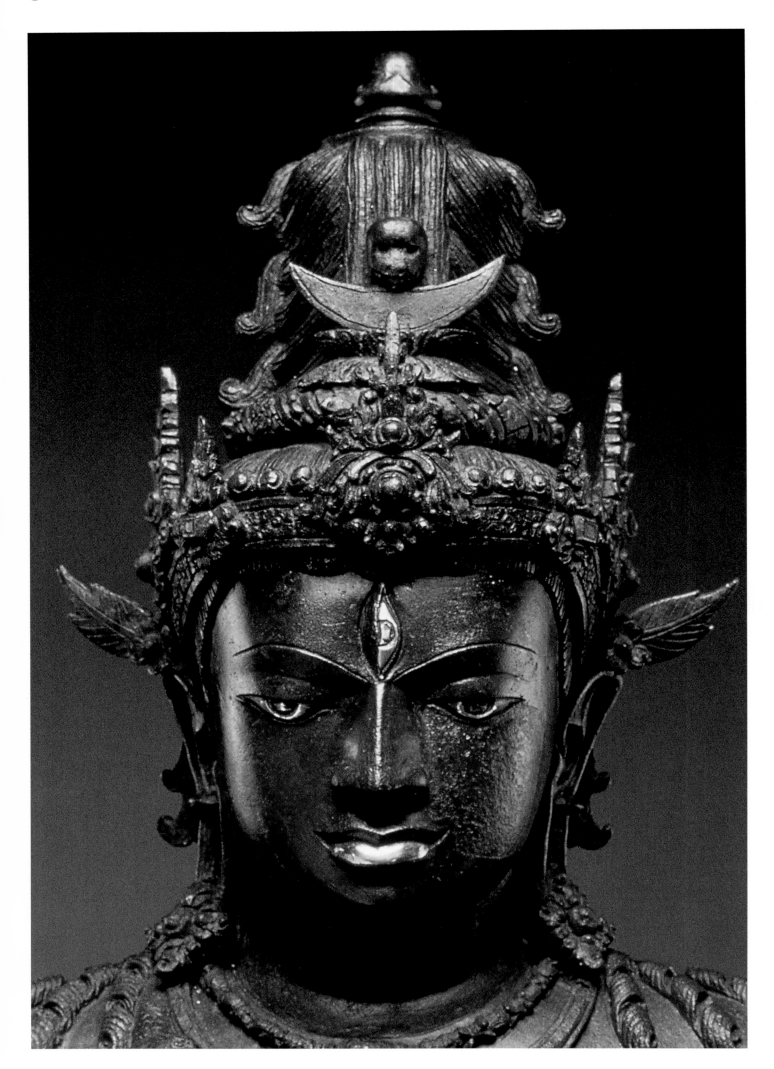

form of a palm leaf, the only one of its kind known **(8)**, reveals the unlimited creativity of the Javanese goldsmiths, as does the bowl cover decorated with a spiral and lotus motif, surmounted by a crystal jewel **(4)**. Arabesques, stylised floral and dense ornamental designs of the kind often seen on ninth century temple reliefs are also much used in the classical gold tradition, as on a carved water dipper handle in the Wonoboyo treasure **(5)**.

Elegantly designed jewellery made up an important part of the treasure. Necklaces were made in various forms, using floral, fruit and animal motifs. The *keben*, a local Javanese fruit believed to bring luck to the wearer, was the inspiration for a necklace embellished with flower designs, each made separately and attached by a wire **(1)**. The conch *(sankha)*, a symbol of fertility and an attribute of Vishnu, is highly appreciated by the Javanese for its elegance of form, and occurs frequently in the iconography. A necklace – also unique – composed of 38 shell-shaped gold pieces **(14)** was made with the lost-wax technique: remnants of clay from the first moulding are still visible within each shell. Several stages were needed to produce an object such as this. The artist would first shape the desired form on wax-covered clay. Onto this another layer of clay would be applied, leaving a small hole through which the gold could then be poured. The final stages of the process demanded great delicacy and precision, especially where the pieces had to be soldered to cylindrical forms, which in their turn were joined together by a fine wire.

Certain types of gold rings and earrings have been found not only in Wonoboyo but in sites across Central and East Java. Elegant floral shapes, for instance, characterise classical pieces from the ninth century, often ornamented with stylised carved motifs such as the *lidah api* (flame border), a Shaivite symbol of power **(10)**.

Gold sculptures representing Hindu or Buddhist deities were used during religious

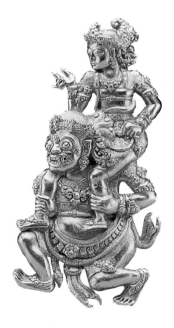

13. Plaque with Prince Sutasoma on the back of the demon Kalmasada, East Java, 14th century. Height 6cm (2¹/₂"). The University of Amsterdam.

14. Necklace with shell motifs, Wonoboyo, Central Java, 9/10th century. Length of shells 3.5-5cm (1¹/₂-2"). National Museum, Jakarta.

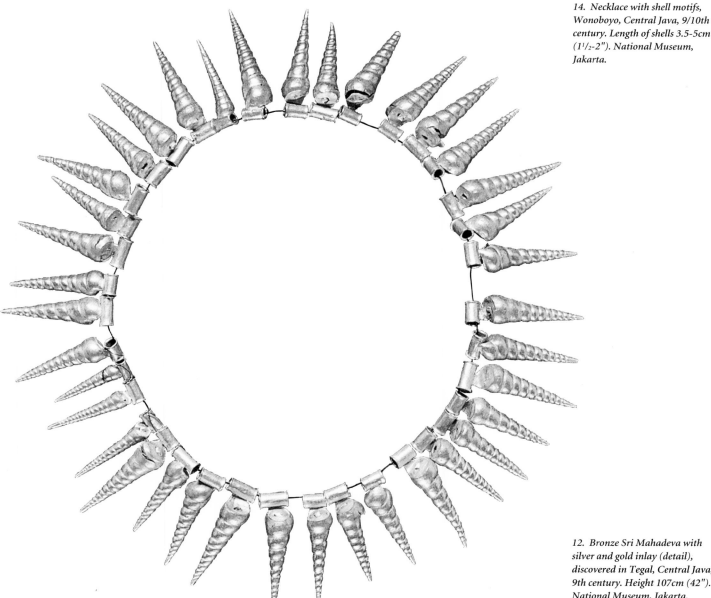

12. Bronze Sri Mahadeva with silver and gold inlay (detail), discovered in Tegal, Central Java, 9th century. Height 107cm (42"). National Museum, Jakarta.

ceremonies. Nine such statues from the village of Gemuruh, situated not far from the Dieng Plateau, were discovered in 1903. The find consists of eighth and ninth century Hindu deities, five of them freestanding and four in the form of repoussé gold plates. One of the freestanding figures is a four-armed Shiva, richly clad in a fine transparent cloth. He wears the *jatamukuta* crown of matted hair set with stones, and his head is surrounded by a halo (7).

The presentation of offerings of gold was a way of venerating the deities. Several gold plates in the shape of animals, symbols of divinities and lotus petals were discovered in a sacrificial well in the Lara Jonggrang, the main Shiva temple of Prambanan. Lotus petals, cut from gold foil, were among the sacred items used during religious ceremonies, serving as bowl covers, or hung as ornaments (11). Similar flowers made from silver foil have been discovered in China and date back to the Tang period.

In Java, as on the other islands, gold was also linked to funerary practices. In this context it could be used either in the form of a complete mask, or formed into thin gold plates, cut in the shape of mouth, nose or eyes. Incised masks were used to cover the faces of dead nobles and members of the royal family. Several examples of these sculpted masks have been unearthed on the island, including an eighth century gold mask which was discovered in an earthenware jar in a rice-field near the village of Nayan, between the Central Javanese cities of Yogyakarta and Solo (9).

THE EAST JAVANESE STYLE

The downfall of the Central Javanese empires was followed in the tenth century by the rise of the East Javanese kingdoms. Under the influence of social change and the shifting of royal power, late classical iconography in East Java began to move away from the flamboyant decorative style characteristic of the art of Prambanan, developing a more realistic style of representation which introduced purely Javanese themes and motifs. Profile figures with facial characteristics resembling the famous *wayang* (shadow puppet) forms began to appear on temple reliefs.

One of the masterpieces of the art of fourteenth century Majapahit, the last of the Hindu empires on Java, is a small gold plaque (13). It illustrates an episode from the Indian tale of Prince Sutasoma, in which he is carried off on the back of the demon king, Kalmasada. The prince is shown wearing elaborate jewellery as a sign of his royal status, and a characteristic headdress of a type still used in the popular *wayang* plays.

15. Dagger (golok), Gorontalo, Sulawesi, 19th century. The upper part shows a stylised dragon. Length 46cm (18"). National Museum, Jakarta.

16. Chastity plaque, Madiun, Central Java, 14th century. Height 10cm (4"). National Museum, Jakarta.

Gold ornamental chastity plaques were used in East Java. Of triangular shape, the plaques are decorated with stories, such as that of Sri Tanjung – a popular Javanese folk myth (16). This tale, frequently depicted on temple reliefs, tells how the heroine Sri Tanjung, accused of infidelity, was killed by her husband Sudapaksa and transported to the afterworld on the back of a mythical fish-elephant. She was refused entry since her time had not yet come, and returned to the mortal world.

The reigns of King Kertanegara and King Hayam Wuruk, in the thirteenth and fourteenth centuries, marked the golden age of the kingdom of Majapahit in East Java. At this time the kingdom comprised nearly all of Sumatra, the eastern islands, Kalimantan (Borneo) and the Malay Peninsula. The fourteenth century royal chronicles, the *Negarakertagama*, vividly describe the splendour of the walled city of Majapahit, commenting on manners and customs, including court entertainments, music and dance. Gold was present in abundance at court performances, both in the elaborate headdresses worn by the royal dancers (12, 17), and in the form of finely carved ceremonial objects such as a repoussé vessel decorated with fine regular lines evoking the coarse exterior of a cone (18). It is topped with four long slender leaves, fashioned from thin gold foil.

The period of greatest artistic achievement in sculpture and architecture in Java came to an end with the decline of Hinduism and Buddhism. On the island of Bali, however, Hinduism remained strong, and until the nineteenth century the courts continued to produce splendid gold objects for use in royal ceremonies. The Balinese had long been influenced by the artistic traditions of Java, and were excellent goldsmiths. One of the objects that developed a characteristic Balinese style at the court of Klungkung was the water pot *(kendi)*, commonly used throughout Indonesia.

At a number of other Indonesian royal courts gold was used to decorate weapons. The blending of the classical idiom with local styles characteristic of each area gave birth to elegant forms such as those seen in a dagger *(golok)* from the island of Sulawesi (15).

19. Man's bracelet, Batak style, North Sumatra. Gold and gilded silver, width 17cm (7"). Barbier-Müller Museum, Geneva, inv.no. 3150-2.

TRIBAL GOLD

It was not until the beginning of the twentieth century that connoisseurs began to be aware of artefacts from islands other than Java and Bali. Nineteenth century travellers and missionaries chronicled their visits and brought back ethnographic objects, amongst which were splendid gold jewellery and ornaments. By the late nineteenth century, foreign elements were impinging on ancient ways of life. The islanders began to embrace Christianity and Islam, leaving behind their ancestral beliefs and finally ceasing to make gold objects for their ritual ceremonies.

According to tradition, gold artefacts were regarded as sacred heirlooms or *pusaka*, the embodiment of spiritual power and symbols of royal status. Only nobles, royal families and those who had achieved high social rank by accomplishing rituals and deeds strictly in conformity with *adat* (ancestral law) were allowed to wear gold. During ceremonies – marriage, birth, great feasts, even funerals – nobles would appear in their gold finery, each object and motif appropriate to the occasion. Gold ornaments have been found amongst the Batak tribes in the highlands of Sumatra, on the island of Nias in West Sumatra, Celebes, Tanimbar in the South Molluccas and the Lesser Sunda islands of Timor, Sumba and Flores.

The beauty of tribal gold, in contrast to that of the Javanese classical style, lies in the originality of the forms that characterise each island, in which indigenous tradition is blended with outside influences. These included the Megalithic traditions of the peoples of continental Asia, a source for both geometric forms and anthropomorphic figures, some of which are still being used in weavings and tombstone carvings to this day. The Dong Song, a civilisation that flourished at the end of the Bronze Age in Annam (Vietnam), also played a major role in forming Indonesian traditional arts. Their characteristic spiral motifs are amongst the most common design elements to be found throughout these outer islands. A man's ceremonial bracelet (**19**) shows the use of double spirals in the work of the goldsmiths of Batak Karo from Sumatra.

20. Laso so Hagu, wood carving representing the royal ornaments, on the wall of the chief's house, Baw Mataluo, South Nias.

PRESTIGE AND POWER

Regarded as belonging to the realm of the gods, gold is associated with a complex mythological symbolism in nearly all the beliefs of traditional Indonesian societies. On Nias Island it plays a crucial role in both the social and ritual life of the community. In the homes of the nobility, wooden panels carved with representations of jewelled gold ornaments indicate the occupants' royal connections. One example represents a diadem (**20**). The central stylised form with hooks, its ends terminating in a spiral floral design, is known as the *saita*, and probably represents a type of ship that is commonly found in the Eastern part of the archipelago. The upper half of the *saita* is topped by stylised fern leaves and the royal comb, itself in the form of a miniature *saita*. A gold necklace and earrings decorate the lower part. Royal carvings such as these are an exact replica of the ritual headdresses and ornaments that were worn by noblemen and women of ancient Nias.

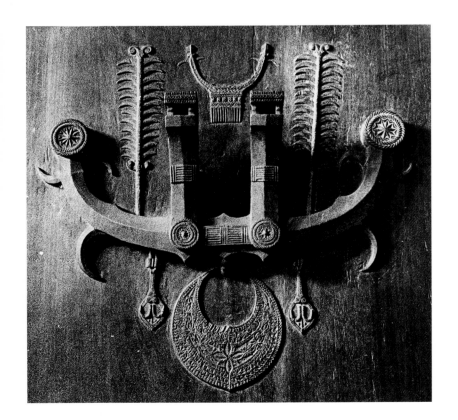

Acquiring higher social status and establishing power within the community has long represented the ultimate goal of every man in Nias. One means of ascending the social hierarchy used to be through great ritual feasts, or *owasa*, for which large quantities of gold ornaments were commissioned by nobles.

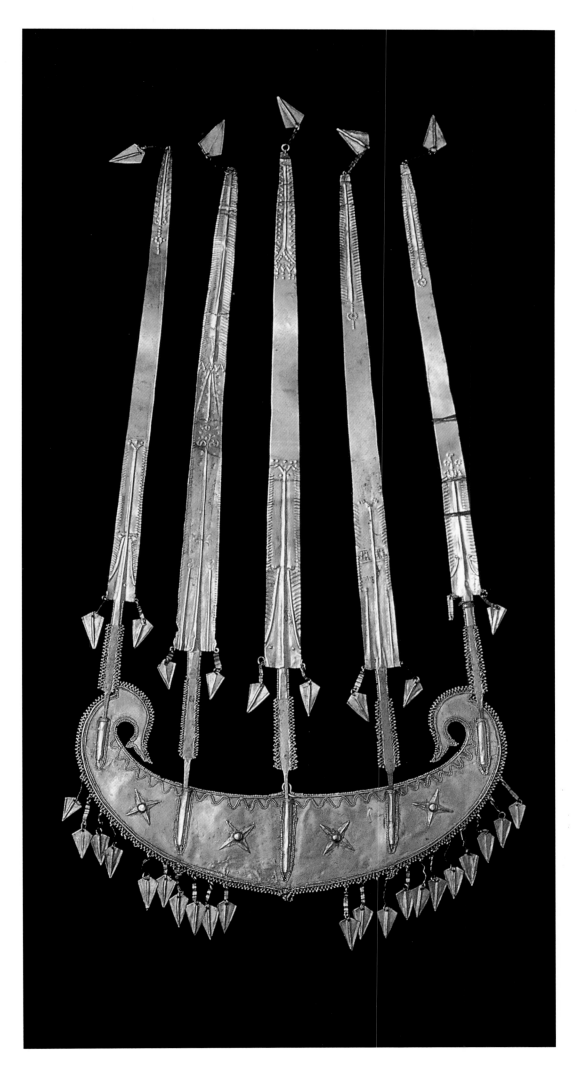

22. A woman from South Nias wearing the double spiral earrings and the golden crown, 1938. Musée de l'Homme, Paris.

21. Frontal crown from the village of Nage, Central Flores. Height 47cm (18"). Barbier-Müller Museum, Geneva, inv.no. 3525-5.

23. Mamuli earring, West Sumba. Height 5cm (2"). Barbier-Müller Museum, Geneva, inv.no. 3660-8.

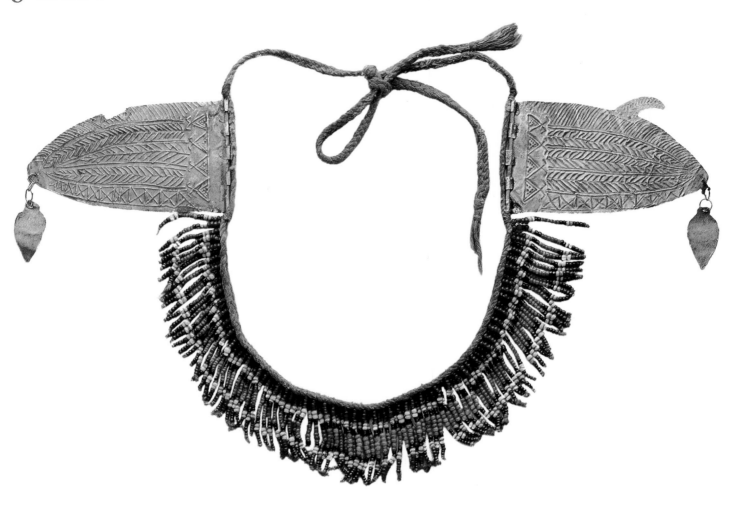

24. *Facial ornament, Sumba. Gold and beads, length 12.5cm (5"). Barbier-Müller Museum, Geneva, inv.no. 3680.*

25. *Pectoral (marangga), West Sumba. Width 30cm (12"). Barbier-Müller Museum, Geneva, inv.no. 3676.*

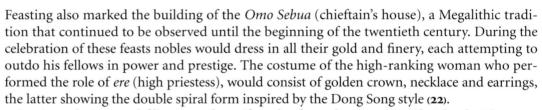

Feasting also marked the building of the *Omo Sebua* (chieftain's house), a Megalithic tradition that continued to be observed until the beginning of the twentieth century. During the celebration of these feasts nobles would dress in all their gold and finery, each attempting to outdo his fellows in power and prestige. The costume of the high-ranking woman who performed the role of *ere* (high priestess), would consist of golden crown, necklace and earrings, the latter showing the double spiral form inspired by the Dong Song style (22).

Intricate designs and filigree work typify styles from the Lesser Sunda Islands. The ceremonial crescent-shaped forehead ornament with long curving spikes (21) is characteristic of Flores and may be related in design to an earlier form of feather headdress. Traditionally both men and women wear head ornaments of this type. Another motif found in the eastern archipelago is the omega, representing the female genitalia. Regarded as a symbol of fertility it is worn by women in the form of earrings: additional figurative ornament appearing below the stylised omega usually indicates royal provenance (28). On the island of Sumba, particularly in the western part where ancestral tradition, known as *marapu*, has been most strictly observed, earrings of this design were used during ritual festivities.

Marapu is a word of Sumbanese origin, literally meaning 'ancestors'. In its wider sense it stands for the whole of the ancestral religion, whose practices centred on spirit worship. To the Sumbanese, ancestral spirits are present everywhere, in each village, forest, mountain, lake, sea, tree and even gold artefact. Along with other gold objects, the four-sided, diamond-shaped earrings, known as *mamuli*, were considered to be sacred *marapu* treasure. They were kept secret and hidden for generations, only to be displayed during specific rituals such as those enacted by priests, which were believed to

endow magical powers. *Mamuli* could be embellished with filigree work and dense double spiral decoration, but other earrings copied the simplicity of the older classical Javanese style **(23)**. Carvings on Megalithic stone slabs in Sumba frequently depict sacred *marapu* objects such as pectorals in the form of two joined triangles **(25)**, as well as *mamuli* and the crescent-shaped head ornament. *Mamuli*-motifs also appeared on other jewellery, such as the gold plaques of a chin ornament **(24)**.

Money has never been used as a bridal gift in Sumba, where according to ancestral tradition, bridal alliance gifts performed an essentially ritual role in the religious ceremony of handing the bride over to her husband and his family. Various combinations of gold chains and *mamuli* were paid by the family of the bridegroom to his future wife at different stages of contracting a marriage, commencing with the girl's birth. These were counterbalanced by gifts such as woven textiles and porcelain given by the bride's family to the husband.

Gold ornaments such as heavy gold chains **(27)** acted as royal badges of office for East Sumbanese aristocrats. The example shown here ends in stylised *naga* (snake-dragon) motifs, out of whose mouths spill three chains with disks attached. These and other gold objects were buried with the dead, following a period of months or even years during which the the corpse was kept in the house according to prescribed rituals. On the day of the burial, which would have been carefully prepared by the family, the body was wrapped in several magnificently woven ikat textiles and buried together with gold treasures.

Ancestral practices such as those described here continued to be observed until around the middle of the twentieth century. However, with increasing modernisation, old traditions are now rapidly fading away. Events such as the travelling exhibition *Power and Gold*, recently mounted by the Barbier-Müller Museum, Geneva, help to create an awareness of the beauty of Indonesian tribal gold. But further research must be encouraged if this ancient art form is not to be lost to the memory of a past era.

26. A woman wearing mamuli-style earrings during the Pasola festivity in West Sumba.

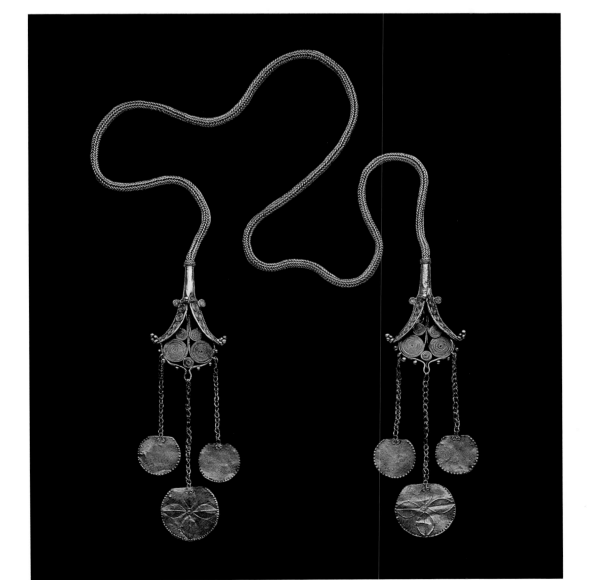

*27. Long chain (kanatar), East Sumba. Length 148cm (58").
Barbier-Müller Museum, Geneva, inv.no. 3672.*

*28. A mamuli earring decorated with warriors, East Sumba. Height 12.7cm (5").
Barbier-Müller Museum, Geneva, inv.no. 3660-12.*

9

A FEARFUL SYMMETRY

The Mughal Red-Ground 'Grotesque' Carpets

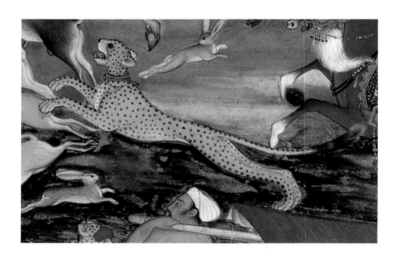

STEVEN J. COHEN

Almost everyone has been intrigued, at one time or another, by thwarted attempts to solve a great mystery. For those involved in the study of classical Indian carpets, the art historical identification of a small number of knotted-pile carpet fragments – whose design is best described as a symmetrical arrangement of 'grotesque' beasts and monster masks upon a rich red ground – has proved to be one of the most perplexing of conundrums.

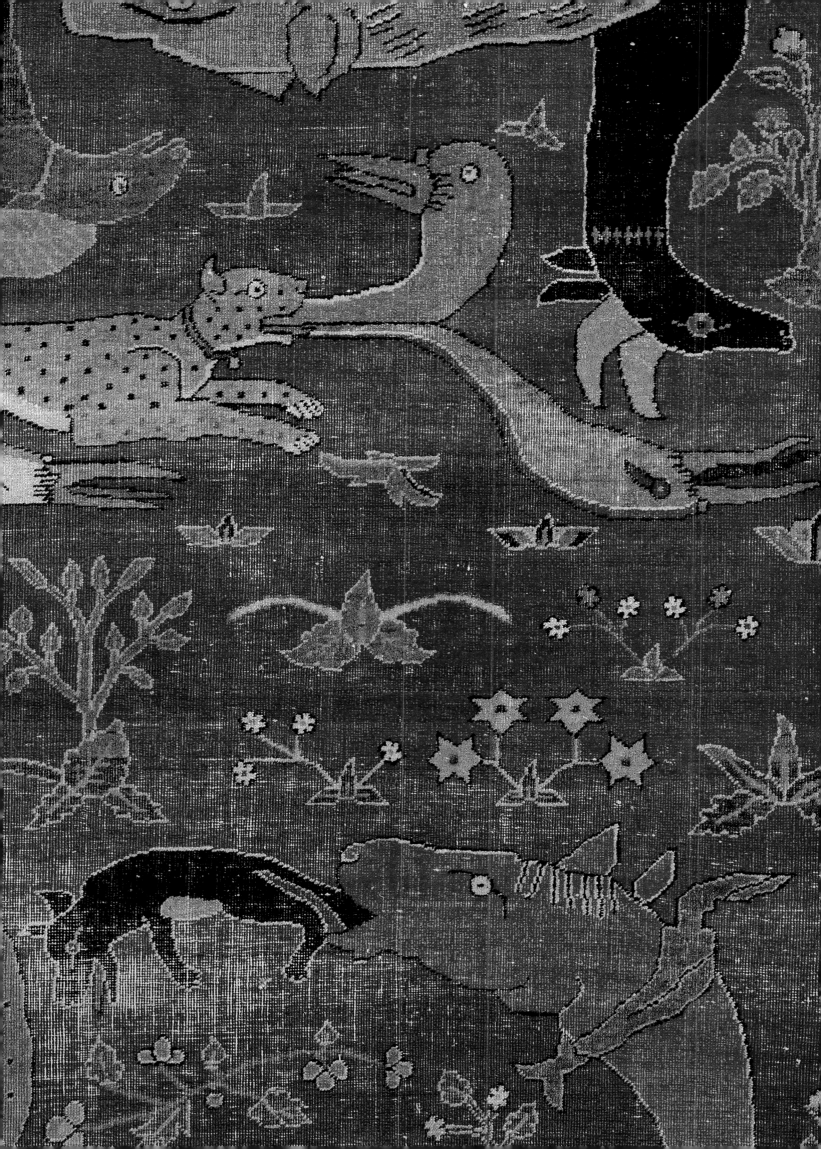

1. *Title page: A leaping cheetah, detail of a painting from the Akbarnama (see 15).*

2. *Previous page: A leaping cheetah, detail from a red-ground grotesque carpet fragment (see H).*

3. *Blue-ground carpet fragment (one of four), India (?), first half 17th century (?). Fine pashmina wool pile on a silk foundation, 104 x 83.5cm (3'5" x 2'9"). Ex-Beshiktash Collection, Musée des Arts décoratifs, Paris, inv.no. 5212.*
Note: All carpet captions cite warp dimension first.

Though hardly typical in design of carpets woven on the Indian subcontinent during the past four hundred years, the red-ground 'grotesque' fragments, ironically, are among those which the public most readily accepts as 'classical' Indian carpet production. This is only to be expected, as members of this group have been illustrated in that context more often, over a longer period of time, and by more authors, than any other type of Indian carpet. However, after almost ninety years of published speculation, the world's most esteemed carpet authorities still seem unable to reach a consensus regarding such fundamental issues as the full design of the carpets, their age, specific provenance, and even the minimum number of carpets required to account for all the currently known fragments.

Under such circumstances, it might appear arrogant to state that the purpose of this article is to attempt to end that speculation by: i) charting the date of the discovery of each fragment and summarising the shifting views concerning its provenance; ii) placing the draughtsmanship and weaving within a narrower cultural context; iii) reconstructing the full pattern repeat; and iv) briefly exploring the broader relationship between the basic design and the parallel international evolution of 'grotesque' art. Admittedly, greater scholars and art historians have failed to solve all these mysteries, but their lack of success was primarily due to the inaccessibility of sufficient data. Today, with excellent colour photographs, exact measurements, and detailed structural analyses of over fifteen fragments, enough information is available to answer most, if not all, these perplexing questions.

The first few attempts to discover the provenance of the carpets failed for quite obvious reasons. The use of comparative structural analysis was still in its infancy and was, therefore, never applied. More to the point, the images woven on the first two published fragments were so incomplete that it would have been impossible for anyone to visualise the full design solely on the basis of that information. Even had such a reconstruction been possible, the particular artistic style is so unusual and specific to such a narrowly confined time and place that no one but an expert in late sixteenth century Indian art could have been able to identify correctly the artistic genre to which the fragments belonged. Finally, and perhaps most pertinently, there has always been a great difficulty in isolating the individual elements from the basic design, and that basic design from that of the archetypal classical carpet which served as its ultimate model.

Given that these obstacles would have been encountered by whoever first attempted to discover the provenance of the carpets, the situation was made far worse by what actually did occur in 1907, when Gaston Migeon published the first two medium-sized fragments in his *Manuel d'Art musulman* (A, B). At that time both belonged to M. Jeuniette of Paris. Migeon, a curator of medieval and renaissance art at the Louvre, was a competent scholar who eventually rose to an eminent position there. But in 1907 he was inexperienced as a carpet historian, and his speculation regarding the origins of the fragments, by introducing irrelevant information which obscured their true identity, had a disastrous effect on most subsequent discussions of the group.

The fact that Migeon concluded that the fragments had been designed by Armenians and woven by Greeks somewhere in Asia Minor during the fifteenth century was silly, but unimportant. This view, probably inspired by a late night reading of Marco Polo's colourful 'autobiography', is so absurd that it was never seriously accepted by competent scholars. However, frustrated by his inability to relate the red-ground fragments directly to any other carpets, or even to begin to discern their basic underlying design, Migeon was forced to direct all his attention to what he, a European medievalist, found most familiar: their grotesque aspects.

By 'grotesque' we most often mean extravagant, fantastic or whimsically designed orna-

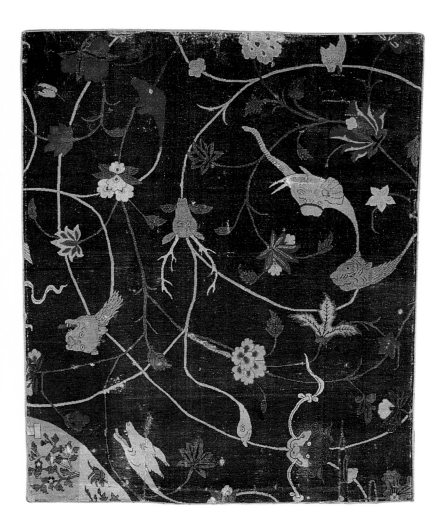

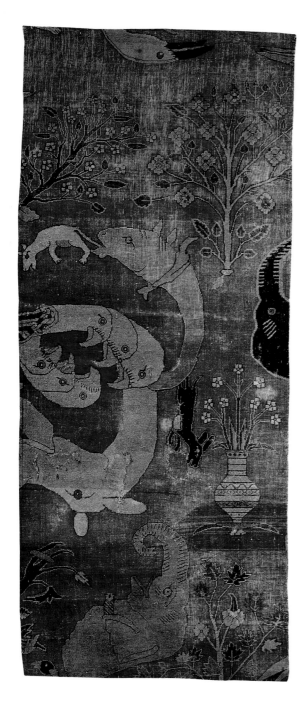
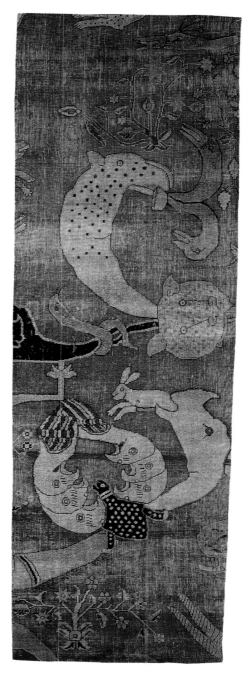

4. *Structural detail of a red-ground grotesque carpet fragment (I) showing highly depressed alternate cotton warps.*

A. *Red-ground grotesque carpet fragment, India, late 16th or early 17th century. Wool pile on a cotton foundation, 150 x 59.6cm (4'11" x 1'11½"). Ex-Jeuniette Collection, Musée du Louvre, Paris, inv.no. 7225[a].*

B. *Red-ground grotesque carpet fragment, India, late 16th or early 17th century. Wool pile on a cotton foundation, 150 x 49.6cm (4'11" x 1'7½"). Ex-Jeuniette Collection, Musée du Louvre, Paris, inv.no. 7225[b].*

mentation consisting of unnatural figures of humans, plants and animals. Such ornamentation is obviously present in the representation of almost every beast and monster on the red-ground carpet fragments. But just as a subject can be artistically treated in various ways, so there are many different recognised forms and styles of grotesque art. Failing to acknowledge such distinctions, Migeon erroneously decided that the two red-ground carpet fragments were the same 'type' as four crudely joined blue-ground fragments in the Musée des Arts décoratifs (MAD), Paris (3). To translate and paraphrase him: "I consider, for my part, as archaic, a type of woollen carpet of which I know only two fragmented specimens in the Jeuniette Collection and in the Musée des Arts décoratifs. The design is composed of large, sinuous vines *[grands rinceaux très flexibles]*, terminating in the heads of lions or imaginary animals...".[1]

To anyone familiar with the two red-ground Jeuniette/Louvre fragments and the four blue-ground ex-Beshiktash fragments in the MAD, this attempt to establish a connection can hardly be comprehended. When judged by the standard criteria of structure, material, colour, quality, handle, age or basic design, these 'types' are as unrelated as different carpets could be.

Though admirable for robust draughtsmanship and deeply saturated colouring, the red-ground fragments cannot be considered 'fine' in terms of material or construction. Their highly depressed (average 65°-70°) alternate warps (4) are sturdy, multi-stranded, off-white to ivory cotton (z7s). Their wefts (3 shoots of 3z with some 2z and 4z) vary in colour from off-white to beige unbleached cotton (6a, b), while their woollen pile (mostly z2s, some z3s) in up to four-

teen colours (dominated by a clear insect-derived red) is asymmetrically knotted, open to the left, achieving a respectable density of 2,754-4,550 knots/dm² (178-294/in²).

In contrast to the unremarkable quality of the red-ground fragments, the foundations of the blue-ground group are silk – alternating bands of z2s multi-coloured warps (pale green, yellow and white), with bright scarlet wefts – and their pile is extremely fine wool, knotted approximately twice as densely as the red-ground examples (7).

To advocate any significant connection between these groups is analogous to comparing ants to elephants – while it is undeniable that both are animals, their differences far outweigh their similarities. If compared in terms of their basic designs, once again it is obvious that the red- and blue-ground fragments have almost nothing in common. At the level of individual elements, the discrete animal heads present in both groups are unarguably illustrated in an unnatural, grotesque style. But the specific grotesque elements found on the two carpet types differ, having evolved separately as divergent branches of the common body of grotesque art; and in addition these minor decorative effects are irrelevant since further analysis shows that they have little to do with the basic designs of the two types of carpet.

The essence of the field design of the blue-ground fragments is a perfectly balanced interlinked double series of delicate spiralling vines. Tendrils branching from green stems terminate in leaves, buds, blossoms and palmettes, while shoots emerging from pale golden stems end in the heads of animals. The animal heads have no more independent or symbolic significance than the floral terminals. Variations of both devices are found on other contemporaneous carpets, textiles, metalwork, ivory, glass, tiles and illuminated manuscripts.[2] The two types of terminals could have been interchanged, or even eliminated, without altering the basic design of the blue-ground carpet, its stem systems.

The only way to understand fully the more complicated basic design of the red-ground fragments is to shift one's attention from the individual components and to consider how these twenty-four animals, two varieties of monster masks, as well as assorted plants, flowers and vases, are related to one another. When enough fragments are available for study, it is possible to see that within certain groups of activity, every animal, monster mask or animal head is shown biting another creature, or gripped in the jaws of a beast, or as the base from which such groupings emerge. This is an aesthetic development fundamentally different from disembodied heads emerging from graceful spiralling scrolls. As for the floral elements and vases, most are unconnected to these dynamic creatures and are used to fill gaps in the design.

During the sixteenth and seventeenth centuries decorative arrangements of this sort were extremely popular, particularly in Europe, and may be considered one of the most common types of 'grotesque' manipulation. However, since all the animals depicted on the red-ground fragments are native to India and, more crucially, since every detail is drawn in an artistic style known from hundreds of Indian miniature paintings which may be confidently dated from about 1580 to 1610, it is most probable that the carpet was also designed in India during that period.

If this assumption is correct and we are discussing an Indian carpet woven in the late sixteenth or very early seventeenth century, why have no other carpets been discovered which share these curious design features?[3] In order to answer this question, one must investigate the design a little further. If, beginning with any fragment displaying half of a monster mask,

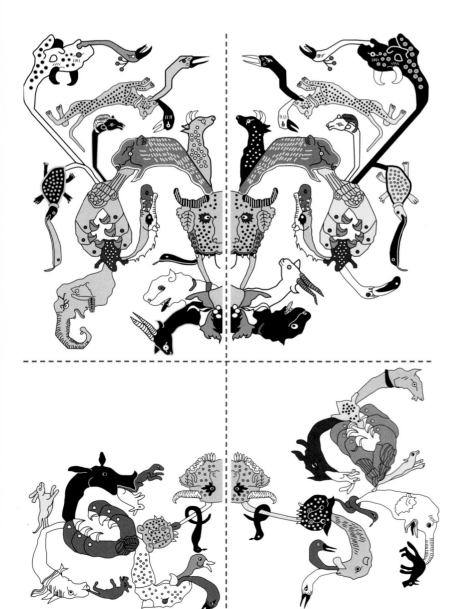

5. The four rectangular grids or pattern units which form all the field designs of the red-ground grotesque carpets.

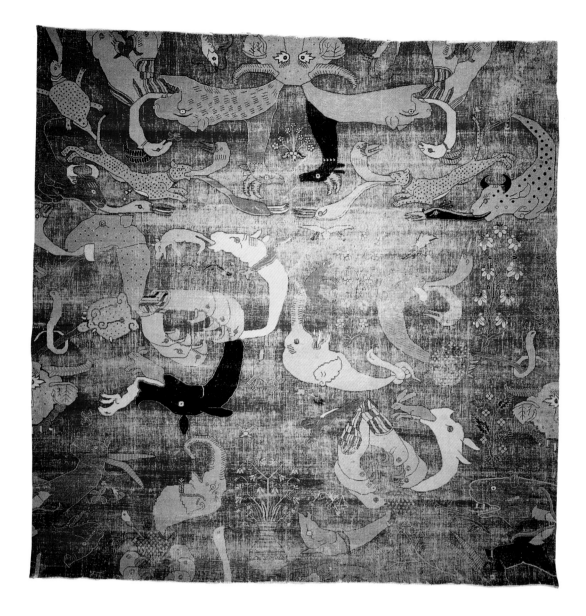

6a, b. Details from front and back of a red-ground grotesque carpet fragment (C) showing off-white cotton wefts.

C. Red-ground grotesque carpet fragment, India, late 16th or early 17th century. Wool pile on a cotton foundation, 193 x 179.2cm (6'4" x 5'10¹/₂"). Ex-Roden Collection, ex-Homberg Collection, Detroit Institute of Arts, inv.no. 31.64.

one traces all the beasts which are directly connected to that mask, every individual part of the design (except the floral elements) can be contained within one of four separate rectangular grids (5). One next perceives that the basic design of the red-ground grotesque carpets is neither random nor perhaps so mysterious, but consists of a stiff, repetitive manipulation of these four grids (pattern units) in an extended alternating point repeat, just as they would appear if their warps had been entered into four pattern harnesses on a drawloom, rather than being independently knotted on a simple carpet loom.[4]

Although this is enough information to reconstruct the original field design of a red-ground grotesque carpet and, in addition, allows one to account for the missing areas which once surrounded the presently known fragments, it does little to explain the design's curious genesis. However, if this basic design is abstracted even further, one recognises that the monster masks, either full or half, occupy the same relative positions (arranged horizontally along five equally spaced vertical columns and staggered horizontally in a drop repeat) as the full and half palmettes known from classical sixteenth or seventeenth century 'Herat', 'Isfahan' or 'in-and-out-palmette' style carpets (8). The 'clusters' of animals surrounding each monster mask/palmette also occupy the same relative positions as the associated smaller rosettes, buds, blossoms and lanceolate leaves which conventionally surround the full and half palmettes of those same carpets. It seems evident, therefore, that the model for the red-ground grotesque carpets was the ubiquitous contemporaneous 'in-and-out-palmette' carpet type (9), and that each monster or 'cluster' of grotesque beasts was an intentional substitution for more conventional floral elements.

The next part of the story begins in 1908 when the Swedish art dealer F.R. Martin, author of the monumental *A History of Oriental Carpets before 1800*, published a third red-ground carpet fragment from the Roden Collection in Frankfurt (C) and insisted that all three fragments had been woven in the Persian province of Kirman during the fifteenth century.

7. Detail of the foundation of a blue-ground grotesque carpet fragment (Museum of Fine Art, Boston, inv.no. T.05.58).

He also mentioned that they had been purchased "some years ago in Paris".[5]

Martin was a keen observer and could easily have dismissed Migeon's ramblings with his own analysis of the Roden fragment. Instead, he became the first of many to entangle himself in the snare laid by Migeon, and ended up contradicting himself in an attempt to argue both for and against design similarities between the red- and blue-ground carpets. Recognising that the necks of many of the beasts found on both groups were unnaturally distorted, one of the most common grotesque conceits, Martin felt that there were nevertheless important differences between their basic designs. In his opinion, the drawing of the red-ground group differed fundamentally because the creatures were "far more crude and quite detached, preceding neither from a tree nor a spiral",[6] which was central to the design of the blue-ground fragments.

Such a clear statement should have been enough to sever Migeon's spurious connection between the two, but then, ignoring his own observation, Martin went on to compare the

8. Section of the basic design of a red-ground grotesque carpet, with palmettes from a conventional Indian or Persian 'in-and-out palmette' design carpet inserted in place of the monster and lion masks.

decoration of the Jeuniette and Roden red-ground fragments with a bookbinding, a pottery vessel and, most regrettably, with an Ilkhanid "manuscript dated 1388 with a miniature representing the tree 'Vahvah', the leaves of which are formed of heads of women and animals".[7] However, all three of Martin's examples had designs based on trees or spirals, elements also used to decorate the blue-ground fragments, but which he had just explained could have nothing to do with the basic design of the red-ground group.

Now the situation was hopelessly muddled. Migeon had introduced the unrelated blue-ground fragments to the discussion of the red-ground group and then Martin further confused the issue by linking them all, however nebulously or unintentionally, to illustrations of the famous talking tree (variously Vahvah, Vak-Vak, Vaq-Vaq, Wak-Wak etc.), which, in the Iranian national epic, Firdausi's *Shahnama*, prophesied the death of Alexander the Great (10).[8] As a result of the efforts of generations of poets, bards and historians, the *Shahnama* – with its legend of Alexander/Iskandar/Sikander – became familiar to both the literate and non-literate people of Asia, from Anatolia to the borders of China (11). Such widespread dissemination ensured that any artist intending to produce an immediately recognisable illustration of the story's principle dramatic episodes would have to adhere closely to the poet's description of events.[9]

The tree of the *Shahnama* is tall with boughs, branches and a double trunk. It differs from a normal tree in only two respects: the surface of the surrounding earth (or possibly the tree's trunk) is covered by animal skins, and somehow its leaves are meant to 'speak'.[10] For almost a millennium this description has guided artists in their attempts to illustrate the fabulous tree, though many have found this concept difficult to depict. The problem has usually been resolved by substituting small human and/or animal heads for 'speaking' leaves which then appear at the end of thin curving branches, to emphasise metaphorically the tree's vocal ability. This was an obvious artistic solution; related decorative motifs based on grotesque scrolls had enjoyed great popularity in Europe and western Asia long before the first surviving illustrations of the talking tree were drawn in Iran. The artists responsible for those illustrations merely adopted a pre-existing device for this specific purpose. Latter-day art historians have therefore been unjustified in assuming that every previous and subsequent appearance of a grotesque scroll must somehow be associated with the talking tree.

Even a superficial familiarity with any of these conventional illustrations should convince most observers that the decoration of Martin's bookbinding and his pottery vessel do not derive

from illustrations of the talking tree but are simply common grotesque ornaments. And as for the red-ground carpet fragments, since Martin had already proved that their decoration proceeded "...neither from a tree nor a spiral..." and as they contain none of the arboreal features conventionally associated with illustrations of the talking tree, it is equally clear that the red-ground grotesque fragments have nothing to do with that story. In Martin's defence, one should emphasise that he never actually wrote that the designs of any of the carpet fragments were illustrations of that mythical tree. But since it was obliquely implied, many authors have chosen to interpret all grotesque carpet designs in that way and even today both groups are still erroneously referred to as 'Vak-Vak' carpets.

Two years after Martin's first intervention, the Jeuniette/Louvre fragments were displayed alongside the larger Roden piece at the 1910 Munich Exhibition of Islamic art. When published, the measurements of the entries were accidentally reversed and the wefts were mistakenly identified as consisting of both cotton and wool (perhaps this misconception is why Martin had originally thought they were from Kirman). Of greater importance is the fact that the 1912 catalogue entry, written by Martin and the great German art historian Friedrich Sarre, attributes all three fragments to seventeenth century India, a view still most often accepted as correct.[11]

In 1913, a minor exhibition of textiles travelled from France to the City Art Museum of St Louis. A catalogue was issued and years later it was reported that a red-ground grotesque carpet fragment had been shown at this otherwise unremarkable event.[12] This assertion has been difficult to confirm because the original catalogue is rare, the fragment was not illustrated, and the name of the exhibitor and the correct catalogue numbers were confused. Rather than no.91, "Fragment of a Flemish tapestry", shown by Kouchakji Frères, it seems that the red-ground fragment was shown by Bacri of Paris as no.93, "Fragment of Persian rug, XVI century, design of Chimera, very rare specimen... 30 x 21 in" (K).[13]

Another exhibition catalogue, this time from the Cleveland Museum of Art and dated 1919, records a fifth fragment, then owned by the legendary Armenian dealer, Dikran Kelekian of Constantinople, Paris and New York. The description: "Fragment of animal rug, South Persia, 1450-1500" is unilluminating, but the unusual dimensions (given as 2'9" x 10'1") accompanying the illustration leave no one in doubt as to its identity or present location (E).[14]

Where had Kelekian's large fragment come from? By 1919 at least five central field fragments of the red-ground grotesque carpets had been exhibited, all of which could be traced to Parisian dealers. It now seems fairly obvious that someone in Paris was cutting up a pair of very large, distressed red-ground grotesque carpets and intentionally destroying their borders. The grotesque field designs were so unusual that unscrupulous or unsuspecting dealers were tempted to attribute their fragments to the fifteenth century with some hope of success. But if those borders had been clearly typical of other late sixteenth and early seventeenth century Indian or Persian carpets and had remained attached to the fragments, such early

9. Conventional red-ground 'in-and-out palmette' design carpet, Isfahan, Persia, early 17th century. Wool pile on a cotton foundation, 415 x 217cm (13'7" x 7'1½"). Courtesy Davide Halevim, Milan.

attributions would have been impossible to sustain and the commercial value of the fragments would have dropped.

In 1922, the publication of *L'Orient Musulman* afforded Migeon a chance to correct his original attribution of fifteenth century Asia Minor. By then the Jeuniette fragments had been acquired by the Louvre, and he now described them as seventeenth century Indo-Persian (whatever that might mean).[15] However, he was stubborn, and even as late as 1927, when he finally agreed that the fragments were seventeenth century Indian, he refused to admit that there were differences between the basic designs of the red-ground and blue-ground fragments.[16]

The astute Viennese carpet dealer Julius Orendi had undoubtedly been aware of the earlier sale of the Roden fragment to the collector Octave Homberg before publishing it in 1930 as an "Indo-Persian carpet of 1650".[17] In June 1931 it was sold again, in Paris, to the Detroit Institute of Art.[18] Only four months later a major article was published on the subject by the Turkish Islamicist Mehmet Aga-Oglu. At the time this was the most carefully considered evaluation of the red-ground grotesque fragments to have been formulated.

Aga-Oglu believed that Detroit's fragment (C) dated from the end of the sixteenth century and represented an early synthesis of Persian carpet weaving traditions with indigenous, non-Islamic art. He wrote of the "loose relation" of the beasts, "connected only in that they are devouring each other", or by forming "remarkably decorative groups". In addition to their mirror-image groupings, they probably also formed a "round medallion in the center of the carpet".[19] He dismissed the blue-ground grotesque fragments in Paris as unconnected, while the concept behind the red-ground group was seen as "...the representation of magic animals of different kinds, whose bodies are made up of innumerable men and animals, and, particularly, of parts of the bodies of animals".[20] He then listed miniature paintings which also made use of that device.

Aga-Oglu had been able to examine and evaluate a wider body of material than any of his predecessors because his colleague at the Museum of Fine Art, Boston, Ananda Coomaraswamy, had drawn his attention to another very large fragment which had been lying in storage since being given to the museum by Denman W. Ross in 1904 (D).

Another small red-ground fragment appeared in a 1935 exhibition at the Hermitage Museum in St Petersburg (F). Following this it seems to have disappeared, and its location subsequently remained uncertain for decades.[21]

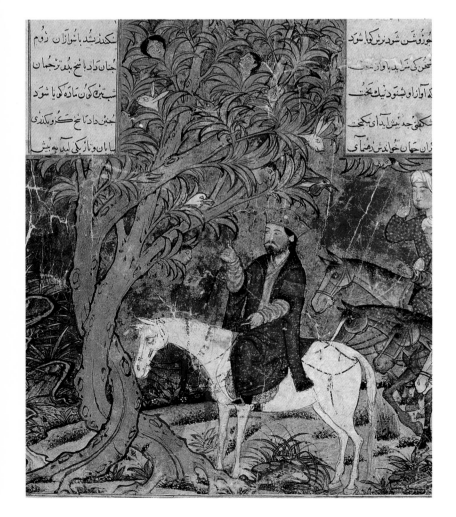

10. Alexander and the Talking Tree, painting from the Demotte Shahnama, Iran, ca. 1360. Freer Gallery, Washington DC, inv.no. 35.23.

The history of the largest of the fragments (G) is still confusing because it acquired many different names from its various owners in a very short period of time. Kurt Erdmann first published an illustration of it in 'Rezension', his 1941 review of Arthur Upham Pope's 'The Art of Carpet Making'.[22] Pope had included blue-ground grotesque fragments in his selection of Persian carpets, but Erdmann rejected that conclusion because he believed that the blue-ground fragments were too similar to firmly attributed Indian carpets. Erdmann's first cited example of a definite Indian carpet was a red-ground grotesque fragment once owned by Weininger of Berlin. Although incomplete and somewhat out of date by 1941, his list of other fragments, including Detroit, Jeuniette, Boston, Kouchakji Frères and Kelekian, superseded Aga-Oglu's.

The 1958 English edition of Wilhelm von Bode and Ernst Kühnel's *Antique Rugs from the Near East* (translated and expanded by Charles Grant Ellis) attempted a comprehensive evaluation of the red-ground grotesque fragments as a group, but the results were uneven and their list, citing the Louvre, The Textile Museum, Washington DC, Detroit, St Louis and private collections, already required updating. According to Kühnel, the carpets (probably two in number) were woven in circa 1500 and their

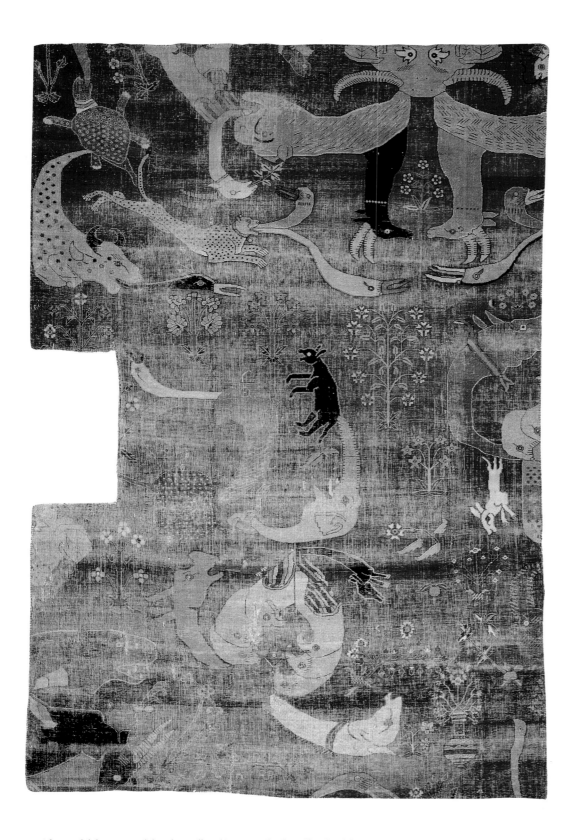

11. *Alexander and the Talking Tree, painting from the Miftah al-Fuzala by Muhammad Shadiyabadi, Mandu, India, ca. 1490-1500. British Library, London, inv.no. OR 3299, f.293a.*

D. *Red-ground grotesque carpet fragment, India, late 16th or early 17th century. Wool pile on a cotton foundation, 190.5 x 127.7cm (6'3" x 4'2"). Museum of Fine Arts, Boston, Denman W. Ross Gift, inv.no. 04.1697.*

motifs could be traced back to "Indian symbolism". The blue-ground fragments represented a later revival of the same theme.[23]

Though most of this was not original thought, the information regarding the two Washington fragments was new. George Hewitt Myers had acquired the ninth example (J) from de Hauke in 1950 and the tenth (I) from Kelekian's estate in 1952. Bode and Kühnel illustrated Erdmann's 'Weininger' fragment, but only stated that it was formerly owned by Loewenfeld of Paris.[24] But by 1958 the Weininger/Loewenfeld fragment (G) had been in another collection for 24 years and had even been exhibited by William Burrell in Glasgow in 1949 and 1951. To compound the confusion, when Erdmann released *Der orientalische Knüpfteppich* in 1955, he wrote that the Weininger/Loewenfeld fragment was in Detroit![25]

In 1959, with his publication in *Indologen-Tagung* of 'Der Indische Knüpfteppich', Erdmann intended to identify further the characteristics of Indian carpets. Essentially, however, the article was only a refinement of his 1941 'Rezension'. Briefly, he argued that the term

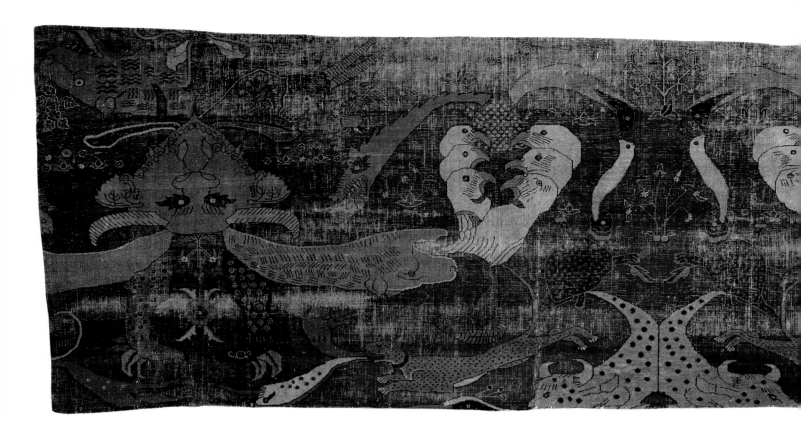

'Indo-Persian' was obsolete and imprecise. Carpets were either Persian or Indian but could not be both. The fragments which had all apparently appeared on the Paris art market in about 1900 were undoubtedly Indian, although the date of 1500 and the question of whether they were fragments of one or more carpets was still undecided. He argued that grotesque animal figures of this type were not found on early Persian carpets (he could also have added that most of them do not appear on any other classical Indian carpets), but that they did have parallels as elements of 'animal magic' in Indian miniatures. He found that the plants and blossoms were freely distributed around the carpet and were of only secondary importance to the design. The distinctive way in which animal heads appeared on the red-ground fragments, particularly pairs of heads which face each other, could be taken to indicate an Indian provenance.[26]

Britain's pre-eminent carpet scholar, Dr May Beattie, entered the red-ground grotesque carpet debate in 1961, when she published an article on the carpet collection of Sir William Burrell.[27] The Weininger/Loewenfeld fragment (G) had been in the Burrell Collection since it was sold by Weininger at Christie's in London in 1934.[28] Beattie agreed that the fragment was "...probably the oldest and certainly one of the best known [Indian] pieces..."[29] and then in her list of other red-ground fragments she revealed that yet another was in the David Collection, Copenhagen (H), bringing the number of known fragments to eleven. An examination of Mr David's correspondence revealed that it had been purchased in 1956 from the Paris Fine Art dealer, Joseph Soustiel.[30]

No new fragments came to light during the following decade, but the location of two previously known examples was reconfirmed. In 1965 Joseph McMullan published a red-ground fragment in his own collection (K).[31] It had not been illustrated before, but if one compares its recorded dimensions (30¹/₄" x 21⁵/₈") to Bacri's 1913 St Louis example (30" x 21") they correspond too closely to be merely coincidental. Erdmann's missing Kouchakji/Bacri fragment was probably McMullan's, now in the Metropolitan Museum of Art, New York. That same year, 1965, the elusive example last seen in the Hermitage exhibition of 1935 was illustrated in the Indian art journal, *Marg*, and its presence in St Petersburg was re-established (F).[32]

In 1970 the English edition of Erdmann's *Seven Hundred Years of Oriental Carpets* appeared, based on his collected *Heimtex* articles from the 1950s.[33] Whether or not one agrees with all his judgements, the book remains the starting point for those who wish to pursue the subject seriously. The now obligatory listing of fragments had expanded to include the Louvre, Boston, Washington, Detroit, Glasgow, Copenhagen, St Louis, St Petersburg and the Palace of the Legion of Honour, San Francisco.[34]

Erdmann's announcement of three examples in San Francisco returned the Cleveland/Kelekian specimen (E) to the list of accessible fragments and also added two new members to

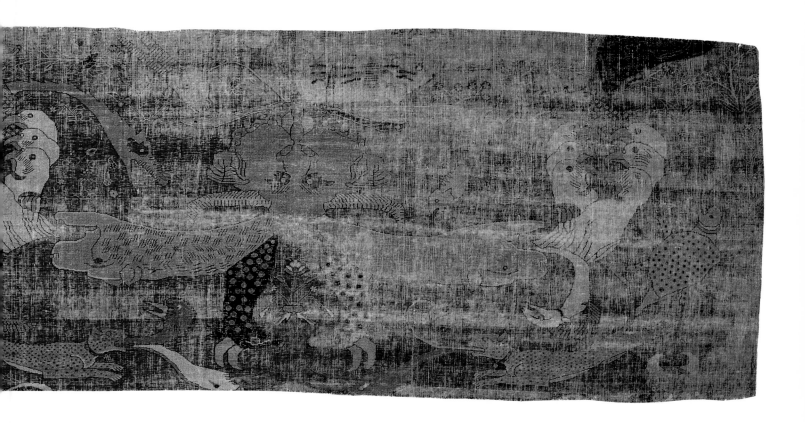

the group (L, M). Museum records indicate that all three were among the many art objects bequeathed to the city of San Francisco by a wealthy local collector, Arthur Sacks, who was living in Paris at the time of his donations.[35] How long all three fragments had been in his possession and whether any or all had been purchased from Kelekian has not been established. However, this is a distinct possibility, in which case Kelekian may well have been the dealer responsible for mutilating the original carpets and slowly releasing fragments over the years as their commercial value increased.

Later that same year a selection of acquisitions by the David Collection was published, which included an illustration of the small fragment first mentioned by Beattie in 1961 (H). In a provocative essay by André Leth, it was suggested that the textile was a product of the end of the sixteenth century and that its very early Indian theme could ultimately be traced back to Central Asian artistic conventions.[36]

Little more about the group appeared in print until 1976, when Stuart Cary Welch illustrated one of the Textile Museum's two fragments (J). This was extremely important because it was the first time since Migeon's 1907 *Manuel* that an article on the fragments had been written by someone other than a carpet 'expert'. As a Harvard lecturer and discriminating collector of Indian and Islamic art, Welch was able to contribute fresh opinions from a different perspective. When viewing the creatures on the red-ground fragments he recognised stylistic features which prompted him to write that "its dynamic rhythms and animal force match the other arts associated with Fatehpur-Sikri, one of the cities where, according to the *Akbarnama*, Akbar 'caused carpets to be made of wonderful varieties and charming textures.'"[37] This association between the carpet and the other arts of Akbar's court suggested a specific date for the weaving of the carpet: the "third quarter of the sixteenth century."[38]

Murray L. Eiland Jr. was another welcome contributor to the debate. Welch had provided insight into specific areas of Indian art, Eiland concentrated upon structural features which had previously been neglected. He was the first since Sarre to publish relatively complete structural analyses of the fragments. This approach immediately drew attention to the presence of the group's z7s cotton warps. Since multiple stranded cotton warps (z6-12s) are a common feature of late eighteenth and nineteenth century Indian carpets, Eiland proposed a late, possibly eighteenth century date for the whole group.[39] After this bold observation, it was disappointing to find repeated the old assertion that both the red-ground and blue-ground fragments depict heads "connected by scrolling vine work" (scrolling vine work does not appear on any red-ground grotesque fragment) and a statement that "both carpets are depictions of the talking tree, or 'vak-vak', which Alexander the Great is alleged to have encountered".[40]

During the 1980s, the greatest stimulus to the debate was the decision by London's Victoria &

F. Red-ground grotesque carpet fragment, India, late 16th or early 17th century. Wool pile on a cotton foundation, 97 x 67.5cm (3'2" x 2'2¹/₂"). Ex-Stieglitz School of Design, Hermitage Museum, St Petersburg, inv.no. YT 1017.

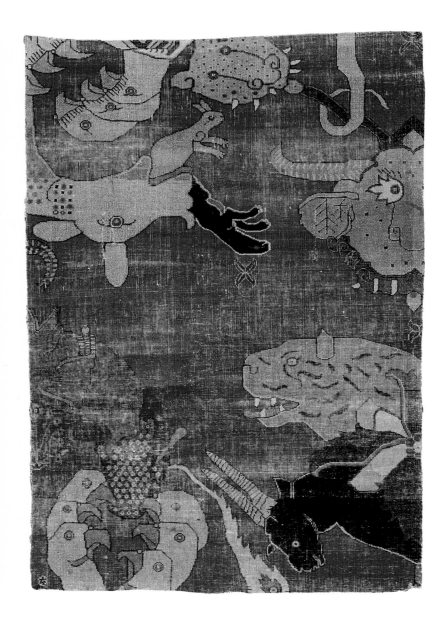

Albert Museum to sponsor a Festival of India in 1982. It proved to be so popular that many other public institutions in Europe and North America staged their own exhibitions of Indian art, and Indian carpets received much deserved attention from a new generation of scholars. Rosemary Crill, writing in the V&A's exhibition catalogue, dated the red-ground fragments to the late sixteenth/early seventeenth century on the basis of the plants' and animals' very distinctive style. She dismissed the idea that the design was derived from a depiction of the "waqwaq" tree, relating it instead to the mythical composite animals popularly portrayed in manuscript paintings beginning in the seventeenth century.[41]

Daniel Walker's article on 'Classical Indian Rugs' appeared later that same year in *Hali*. Walker proposed a 'Lahore group' of Indian carpets with shared colouring and designs which could be roughly dated to the middle of the seventeenth century, as its parameters were determined by the Girdlers Carpet (circa 1631-33) and some of the Jaipur Palace pieces which are labelled circa 1650 or later. According to Walker, the red-ground grotesque fragments are members of this Lahore group.[42] Walker published an illustration of a privately owned fragment which had been loaned to Harvard University's Fogg Art Museum in Cambridge, Massachusetts (N). Not altogether surprisingly, that fragment too had been purchased in Paris – at auction in 1965.[43]

In that same issue of *Hali*, Hanna Erdmann reviewed most of what was known about the blue-ground fragments. She listed their locations at that time and discussed their structural characteristics, but her most valuable contribution was a clear, accurate and historically supported argument opposing the belief that the design of the blue-ground fragments was in any way inspired by the story of Alexander the Great and the mythical talking tree.[44]

By the end of 1982 all but two of the currently known fragments had been identified. However, new articles continued to provide curious supplementary details about the subject. Rosemary Scott's 1983 description of the Burrell fragment (G) included the information that it was "formerly in the Imperial collection in Vienna".[45] This had been copied from the London auction catalogue, but seems improbable as Friedrich Sarre, who with F.R. Martin had described the Roden and Jeuniette fragments in the 1912 Berlin catalogue, was familiar with the Habsburg holdings and would certainly have mentioned the presence of such an unusual carpet fragment in *Altorientalische Teppiche*, published in 1926 and 1928 with Hermann Trenkwald.

12. Schematic reconstruction of a pair of red-ground grotesque carpets, showing the most abbreviated format able to encompass all the currently known fragments in their correct orientations. Approximate dimensions of the field of each carpet: 9.6 x 3.8m (28'9" x 10'1").

The 1985 Indian exhibition at the Metropolitan Museum of Art, which brought the Cleveland/Kelekian/Sacks/De Young fragment to New York (E), encouraged Welch to expand the thesis he had proposed earlier. He still firmly attributed the carpet to the Akbari period and specifically to the years 1585-1590. He rejected Walker's attribution of mid seventeenth century Lahore because the red-ground fragments were less stiff in their design and were less well constructed than those later carpets, implying "...the technical flaws of a new workshop".[46]

In 1986 the fragment in St Petersburg was illustrated in colour for the first time, and in the caption written by Shkoda it was stated that this piece had been acquired from the Stieglitz School of Art and Design in 1925.[47] It is not known whether it too had originally been purchased from a Parisian dealer (F).

The most recent relatively large fragment to appear on the art market was sold at Christie's, London in 1994 (O), but it seems rather unlikely that it will be the last.[48] In addition to the

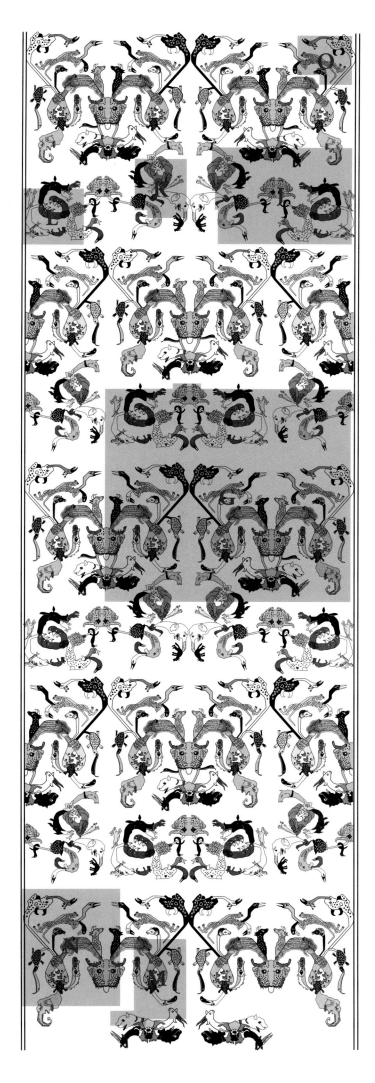

fifteen large fragments already mentioned, a small patch with the maximum dimensions of 113 x 102mm was removed by Nobuko Kajitani, Senior Conservator of Textiles at The Metropolitan Museum of Art, New York, from an unrelated Turkish carpet formerly in the James F. Ballard Collection.[49] She immediately recognised that it was structurally and stylistically consistent with the Metropolitan's other red-ground fragment and it has been separately stored as a study piece. A similar situation arose at the Burrell Collection when their extremely worn, patched and over-darned fragment was last conserved. A number of small fragments (51 x 22mm; 20 x 12mm, etc.) which had been glued to the back of the carpet to cover holes were removed. They remain with the conservators. It is therefore probably most accurate to state that by the end of 1995, fifteen large field fragments, as well as an indeterminate number of smaller fragments of red-ground grotesque carpets, have been identified and documented.

My own interest in the group began in the late 1970s while working on a doctoral thesis on pre-Mughal Indian floor coverings. If any knotted-pile Indian carpets from that early period had managed to survive, the current literature implied that the red-ground grotesque fragments were the most likely candidates. By 1987 I had become curious enough to analyse the structure of all the examples except those in the David Collection and the Hermitage. Fortunately, Robert Pinner and Elena Tsareva provided me with detailed structural information on the Hermitage/Stieglitz fragment and the David Collection's conservator Anne-Marie Keblow answered my questions about the other.

After a certain amount of pleading, the art department at *Hali* produced large black and white prints of each fragment to exactly the same scale, which I then photocopied on sheets of transparent acetate. That way I had one set of prints plus a second set on transparent

13. *Painting from the Babur-nama, India, ca. 1590, showing an Indian rhinoceros. British Museum, London, inv.no. OR 3714, f. 379b. Note that the drawing of the rhinoceros' head is precisely echoed in several of the red-ground grotesque carpet fragments (see top left corner of G).*

film which could be reversed to act as a third mirror-image set of each fragment. By first abstracting individual details, and later groups of figures, from each fragment, and slightly changing their scale on a photocopier when necessary, I was able to begin re-creating the original carpet design by first drawing all the missing, contiguous parts. This can now be done more easily using computer graphics (**12**), but at that time my efforts were restricted to what I could achieve with transparent film, pens and a photocopier.

For example, if the figure on a fragment was incomplete, with only part of a cheetah's hind legs and tail intact, it was relatively easy to add the animal's front legs and head, correctly positioned, and even to add the two bird's heads emerging from the cheetah's mouth, because those additional elements were always present on every other fragment which displayed cheetahs. Not all of the reconstructions were that easy. If a fragment ended with only a few parrot heads, more could be added and correctly positioned, but then there were four different combinations (the fourth a mirror-image of the third) of various beasts which might have been connected to those six joined parrot heads. It was only after carefully examining every animal and monster mask which was attached or nearby that it became possible to add the missing parts. In some cases there was not enough evidence to be entirely certain, but most fragmentary figures could be reconstructed and even expanded a little.

An important, but often neglected, part of structural analysis includes determining the top and bottom of each knotted-pile carpet fragment by noting the direction in which the pile has been beaten while on the loom. With

that in mind, it is easy to arrange all the fragments according to their original orientation. And once all the contiguous and directly connected figures had been added, it was then possible to place individual fragments next to one another, correctly oriented, and to begin building larger blocks of design. In the end I was able to insert most of the fragments then known into three very large joined units.

At first, determining the width of the carpet's full field seemed impossible because the groups of joined beasts and monster masks could, logically, have continued their sequential repetition indefinitely. But fortunately, the largest fragment (G) still retained a tiny portion of one vertical outer guard stripe. By analysing the design break at that point, as well as reconstructing the missing portion of the longest narrow fragment (L), I felt certain that four pattern units per loom width was the most likely arrangement.

Another theoretically difficult question that was more easily answered once all of the fragments were correctly oriented and roughly positioned according to the perceived design, was whether they had been generated by more than one carpet. If a single carpet contained a symmetrical arrangement, four pattern units wide, which included all of the presently known fragments correctly aligned according to their orientation, the carpet would have been extraordinarily long – almost 21 metres. It is much more likely that a contemporaneous pair of carpets, woven

G. Red-ground grotesque carpet fragment, India, late 16th or early 17th century. Wool pile on a cotton foundation, 270 x 267.5cm (8'10" x 8'9"). Ex-Weininger, ex-Loewenfeld, Christie's, London (13 December 1934, lot 286), Burrell Collection, Glasgow, inv.no. 1934/9/1.

14. Soundbox of harp inlaid with figure of hero clasping a human-headed bull in each arm (detail), Ur, first half 3rd millennium BC. University Museum, Philadelphia, inv.no. CBS-17694.

15. Painting from the Akbarnama (detail), India, ca. 1590. Victoria & Albert Museum, London, inv.no. IS2-1896, f.27.

H. Red-ground grotesque carpet fragment, India, late 16th or early 17th century. Wool pile on a cotton foundation, 78.5 x 67.5cm (2'7" x 2'2½"). Ex-Soustiel, Paris, David Collection, Copenhagen, inv.no. Text.32.

from the same design but with their orientations reversed, was the source of all of the red-ground grotesque fragments (**12**).

These were the general conclusions I had reached by 1990, when I presented a paper on the subject at the Sixth International Conference on Oriental Carpets in San Francisco. By that time, I must confess, the subject of grotesque art had begun to interest me more than the actual red-ground grotesque carpet fragments, and after the conference I began to work on other projects. It was only after reading Dr Franz Sindermann's excellent paper on the design of the carpets that I decided to return briefly to the subject in order to discuss more fully the relationship between the general evolution of grotesque art and the design of what I believe to have been a unique pair of early Mughal carpets.[50]

As was emphasised earlier, there are many different styles of grotesque art, and the appearance and evolution of each type was not restricted to Indian art, but was a much more widely distributed international phenomenon. Because these distinctions are easily recognisable, no justification exists for assuming a relationship between different artefacts when their only similarity is a reliance upon grotesque artistic conventions which are demonstrably different. An obvious example is the distinction discussed above between the red- and blue-ground grotesque carpets.

Though the complete history of grotesque art has yet to be written, enough is currently known about the invention, development and transmission of its different forms to allow us to outline some of their more distinctive characteristics. In respect of the red-ground carpet fragments, however, the discovery of their most immediate stylistic origins has limited value, because the majority of those artefacts which most closely resemble the red-ground fragments are too far removed from them in time or by distance to have been able to exert any direct influence. Early prototypes are available and I have spent several years investigating their appearance and evolution in the early art of Europe and Asia, but continuous transmission of this art – from antiquity to the seventeenth century – is impossible to prove. Nevertheless, such sources must be briefly considered, if only to eliminate them from further consideration.

In addition to the Indian subcontinent, the other centres which may have been the earliest sources of the carpet design are those cultural complexes closest to India: Mesopotamia and Iran to the west, Central Asia to the north, and China to the east. Europe, though more physically distant, exerted a profound influence on Indian art during the Mughal period and must also be considered an important potential source of inspiration.

Artefacts which strongly rely upon grotesque conventions are known even from the very beginnings of Indian civilisation in circa 2300-1700BC. They are present among the objects excavated at the subcontinent's first large urban centres of Mohenjodaro and Harappa in the Indus Valley. Small seals and carvings discovered at those and culturally related sites are sometimes embellished with composite, hybrid creatures: a beast with three heads – bison, unicorn and ibex – joined to one body; a pair of lion heads joined to a single trunk; six horned beasts with one common body; five animals joined together at their heads or bottoms and so on.[51]

That the style of these seals as well as their still indecipherable script derives from Mesopotamian prototypes should not be unexpected, as the peoples of the Indus Valley and Baluchistan maintained trading links with those much further to the west. The Near Eastern connection also explains the imagery of a standing man grasping a lion with each outstretched arm (**14**) and perhaps even the presence of a horned, cross-legged man surrounded by many animals.[52] This seal, though less obvious than some examples, has been interpreted as a local version of the Mesopotamian

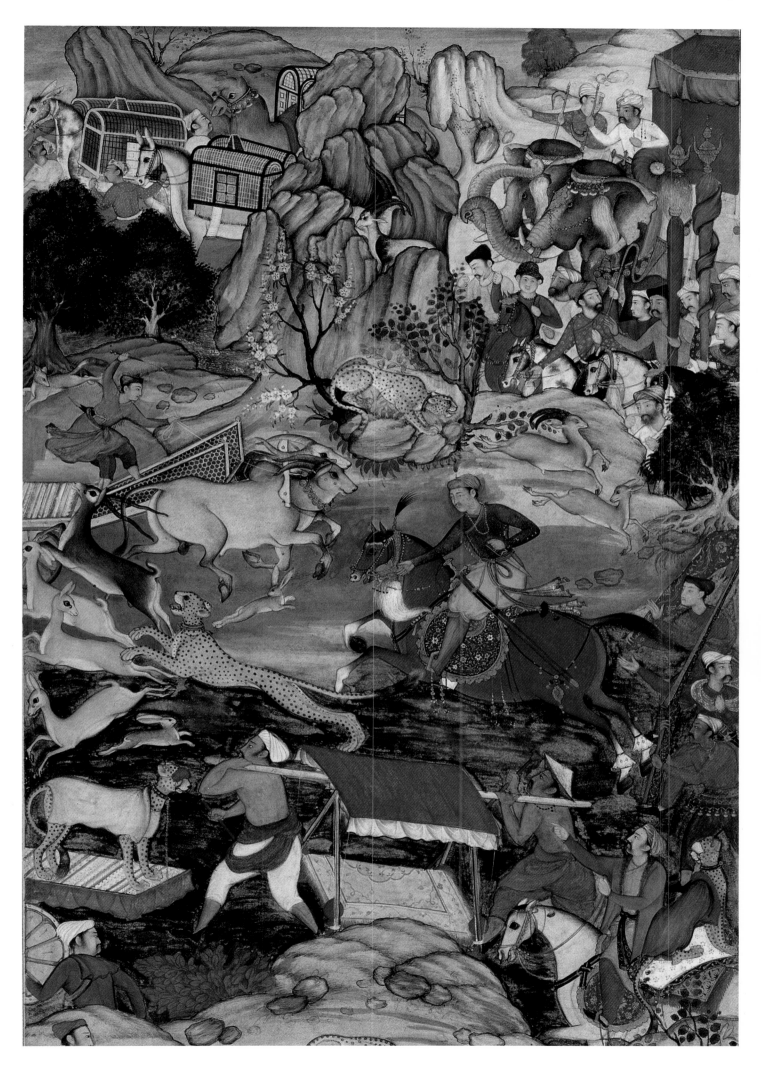

I. *Red-ground grotesque carpet fragment, India, late 16th or early 17th century. Wool pile on a cotton foundation, 30.5 x 37.8cm (1'0" x 1'3"). Ex-Kelekian, Paris, Textile Museum, Washington DC, inv.no. R.63.00.20B*

16. *Painting from the Hamza-nama (detail), India, ca. 1562-77 or 1556-70. Custodia Collection, Paris, inv.no. 1974 T.1.*

'beast master' but others see it as a predecessor of the later Hindu god, Shiva, in his form of Pasupati, 'Lord of Beasts'.

The Indus Valley civilisation collapsed shortly before (or possibly as the result of) the incursion of the first Indo-European speaking tribes into northwestern India in about 1500BC, but grotesque inventions remained an active element of Indian art throughout its long history. Who could imagine such art, whether Buddhist, Hindu or Jain, without its most famous grotesque convention, the endowment of additional limbs or heads to indicate the representation of divine beings?

Though independently developing its own artistic traditions, India was never culturally isolated from the rest of the world. Foreign trade in cotton textiles, dyes, foodstuffs and precious stones as well as trans-shipment of imported commodities such as silk, were extremely important commercial activities from a very early period. The fact that her northwestern borders were continually invaded, occupied and ruled by successive waves of Achaemenids, Seleucids, Parthians, Scythians (Shakas), Kushans, Sasanians, Huns (Ephthalites), Arabs, Mongols and Turks from around the sixth century BC until 1526AD, when the Mughals arrived, also ensured that her artists were periodically exposed to new ideas.

As a result of those contacts, Indian craftsmen produced works of art displaying many of the same grotesque conventions one associates with the art of Mesopotamia, Iran, China and even Europe. Obviously different styles and techniques predominated in different areas of the subcontinent at different times, but most of the typical grotesque applications known from the rest of Asia and the east Mediterranean world were at least experimented with, however briefly, at one time or another. This was especially true from the late Mauryan through the Kushan and early Gupta periods (circa first century BC – fifth century AD), when Graeco-Roman influence in Asia was at its height.

If one wished to search carefully for the most typical applications of grotesque art on the Indian subcontinent, from the arrival of the first Indo-Europeans up to the beginning of the seventeenth century, it would be possible to chronicle most of the invasions of foreign peoples and the types of art which they introduced or sponsored, while at the same time describing the evolution and/or abandonment of each earlier artistic style and regional variation. But such a vast accumulation of documentation would not establish the Indian provenance of the red-ground grotesque carpets any more effectively than a focused survey of the specific design elements present on the carpets, grotesque or not, and a determination of whether or not each was characteristic of Indian art at the end of the sixteenth century.

We have already stated that the red-ground grotesque carpets seem to be unique. Nothing exactly like them is known from India, nor are there exact parallels extant from other parts of the world. Why, therefore, do we feel so strongly that they are of Indian origin and why, specifically, must they date from the late sixteenth or very early seventeenth century?

The explanation is complicated, but in the simplest terms: i) from a strictly physical point of view, the structure of the carpets, the materials used, and the range of colours, are all characteristic of other Indian carpets, but are not typical of non-Indian carpet producing areas; ii) the illustrated animals are native to India and even the mythical beasts are types familiar to most Indians; iii) all the individual animals (with the possible exception of what may only be an unconventional illustration of a dead lioness), the monster masks, the plants, and even the decorative vases, are quite familiar,

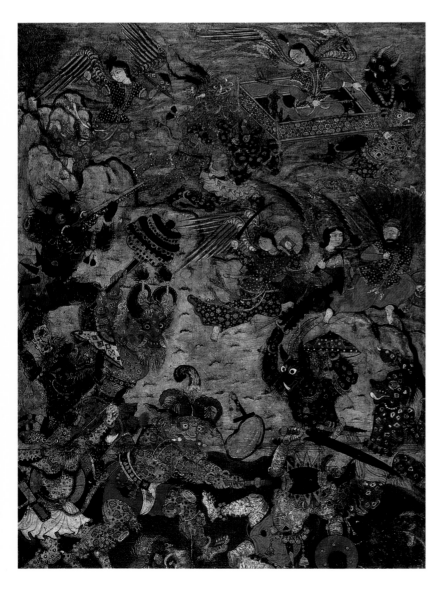

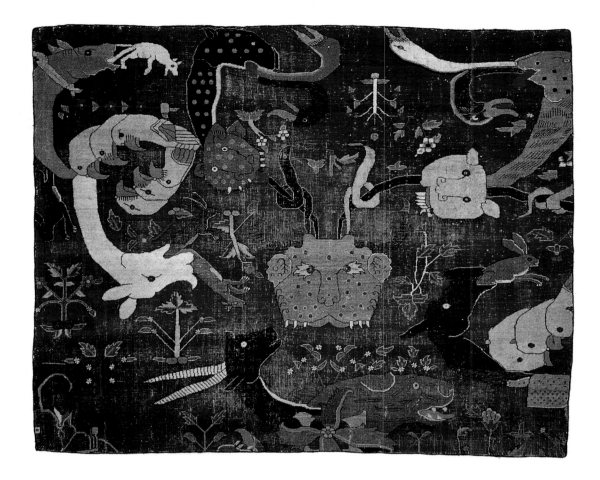

J. Red-ground grotesque carpet fragment, India, late 16th or early 17th century. Wool pile on a cotton foundation, 106 x 129.2cm (3'6" x 4'3"). Ex-de Hauke, Textile Museum, Washington DC, inv.no. R.63.00.20A.

portrayed in exactly the same style as their counterparts in miniature paintings of (and only of) that specific historical period.

In the 1560s and 1570s, in illuminated manuscripts such as the *Tutinama*, as well as in individual miniature paintings, representations of animals had not yet developed the semi-naturalistic style seen on the red-ground grotesque carpets.[53] Though attractive, these earlier beasts are still fairly unsophisticated late Sultanate/early Mughal types, with much more rounded, less well-defined bodies.

Great strides in animal representation were achieved by the artists working on the thousand *Hamzanama* folios from about 1556-1570 (conventionally dated to 1562-1577) as well as the *Anwari-i-Suhayli* of 1570. But it was not until the 1580s that the finest artists working for the Mughal emperor Akbar were able to draw the same animals in exactly the same style as on the red-ground carpets. Their achievement was not perfected until the 1590s, with the completion of royal manuscripts such as the *Baburnama* **(13)**, the *Akbarnama* **(15)** and others.

The earlier style of animal representation had become too polished and had begun to lose some of its naive vigour by the 1620s, a process that continued throughout the seventeenth century.[54] Even more crucially, the primitive style of plant drawings seen on the red-ground grotesque carpets reflects no interest in botanical accuracy. This is typical of most plant representations found on Indian Islamic paintings of the late Sultanate and Akbar periods.[55]

During the 1620s, however, under the personal direction of Akbar's son and successor, Jahangir, plant and floral representations by Mughal court artists underwent a dramatic change. By copying printed European Herbals and other imported works of art, Indian artists were exposed to European mannerist conventions. When this knowledge was combined with a close study of living specimens, a new style of floral art was invented. If the red-ground carpets were designed by a court artist much later than the 1620s, the design should probably reflect the new plant style. Admittedly this argument carries less force than the discussion of the style of animal representations, as we also know of later Indian carpets such as the Girdlers (circa 1631-33) and the Fremlin (circa 1640) which are without mannerist-influenced plants. But they were only average quality products of commercial workshops in Lahore, not probable royal commissions, and with the exception of the clumsy insertion of European coats-of-arms and associated figures, their designs were simply a reworking of standard late Akbar period in-and-out palmette carpet designs.[56]

A more important reason to reject a post 1620 date for the red-ground grotesque carpets is the personal taste of Jahangir and the growing sophistication of his court artists. When Akbar

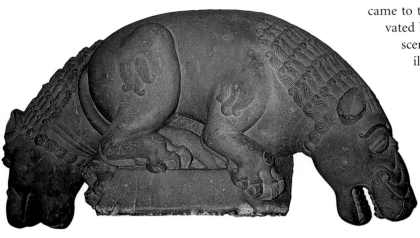

17. Lion capital, Gwalior, India, 7th century AD. National Museum, Delhi, inv.no. 51.95.

K. Red-ground grotesque carpet fragment, India, late 16th or early 17th century. Wool pile on a cotton foundation, 78.3 x 55cm (2'7" x 1'9¹/₂). Ex-Bacri, Paris, McMullan Collection, Metropolitan Museum of Art, New York, inv.no. 1971.263.3.

19. Winged half-figure on the Dhamekh stupa, Sarnath, India, 5th century AD.

18. Winged half-figure, Ephesus, Turkey, 4th century AD.

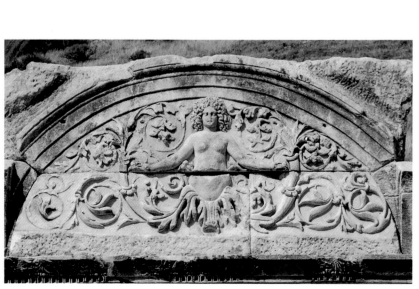

came to the throne of Delhi as a boy of thirteen he was captivated by tales of mythological heroes and demons, hunting scenes and battles. These remained favourite topics for illustration by the artists of his court. The appearance of so many prominently displayed monster masks would have been quite out of place on a Mughal carpet of the 1620s, but it perfectly reflects the spirit of the *Hamzanama* half a century earlier, since the monsters are exactly the same type (**16**). And the wide variety of spirited animals is entirely compatible with the illustrations from the *Akbarnama* (**15**) a few decades later (circa 1590).

Thus the carpets' combination of plant and animal styles as well as their subject matter were really only popular in India from the middle of the Akbari period to the beginning of Jahangir's reign, from around the 1580s to the first decade of the seventeenth century. Of course, popular court fashions in every medium were frequently copied and perpetuated in provincial centres long after they had been abandoned by the top artists working for the emperor, his family, or powerful nobles in the capital. But it is most unlikely that such provincial works (if the red-ground grotesque carpets really were provincial) would have been popular for more than a decade or two after Akbar's death.

There remains another factor to be considered before accepting this chronologically neat explanation of the carpets' most probable dates. Their most exceptional design feature, the many varieties of grotesque zoomorphic junctions, was not common in Indian art before this time. One junction requires creatures to emerge from the mouths of others, while a second type of grotesque union only occurs where the unnaturally extended neck of one beast joins the neck of another, or more dramatically, at a point where the necks of beasts dwindle from their natural sizes to become thin, attenuated stems attaching themselves to the body parts of other creatures. Some of these forms have been traditionally associated with Indian architectural decoration, but others do not regularly appear until the late sixteenth century. It is necessary to search for examples of all of the carpets' various zoomorphic junctions in other types of Indian art in order to understand more clearly their combined presence in the carpet design.

In any general survey of grotesque manifestations in Indian art one would probably begin with the most obvious examples – gods, goddesses, demons and sacred vehicles with multiple limbs, heads and various other body parts: the Vedic god Brahma, most often portrayed with four arms and four heads; Ravana, the eight-headed, multiple-armed demon king of Lanka; and the god Indra's mount, the four-tusked elephant Airavata.[57]

Then there are "the animals born of fancy... Ihamrga" or the "grotesque *(vikata)*" composite, hybrid creatures, whose illustrations begin with ordinary humans or animals but to which the attributes of other creatures are added or substituted.[58] Garuda, the vehicle *(vahana)* of the god Vishnu, is always shown as half bird and half man. The god Ganesh always has the head of an elephant grafted to the top of his chubby human body. Then there are the countless minor composite creatures such as the *makara*, whose form changed over the millennia but which was originally based on the Gangetic crocodile, with additional parts taken from fish, elephants, boars and others; the *sarabha*, an eight-footed demon, part-bird, part-lion; and the *vyala*, basically a fantastic leonine creature which assumes "several shapes taking its parts from animals like the boar, horse, deer, parrot, elephant, tiger, vulture, dog, wolf, ibex, rhinoceros, man and so forth".[59]

Other grotesque forms related to types known from Mesopotamia and Europe are the Graeco-Roman inspired winged half-figures from Mathura (circa 100AD) whose upper torsos rise from an acanthus calyx and may even have pairs of dragons attached to their shoulders (**23**).[60] Graeco-Roman examples from circa fourth century Ephesus in Ionian Turkey (**18**), or from the circa fifth century Buddhist Dhamekh stupa at Sarnath (**19**), though obviously influenced by

local traditions, show a remarkable resemblance to one another. Then there are other grotesque types such as the five deer bodies joining one head from a circa fifth century pilaster capital at Cave 1 at Ajanta; the famous seventh century capital from Gwalior (17) with the front torsos of two lions joined back to back, and so on.

One could continue this list of Indian grotesque inventions indefinitely, but these and the vast majority of all other Indian grotesque compositions have one thing in common. When an unnatural number of limbs or heads or other body parts are joined to a basic figure, they almost always achieve their conjunctions where they would most logically be expected to do so. Additional heads are joined at the neck, arms and wings attach to the shoulders, and tails – even if these are from another genus – are always attached below the base of the creature's spine. But except for the two spotted bull torsos which share part of a common body, the six parrot heads sharing one body, and the extended necks of some creatures which merge together, most of the other zoomorphic junctions illustrated on the red-ground grotesque carpets are not of this common variety. For their origins, one must explore yet another strain of the Indian artistic heritage.

The types of grotesque zoomorphic junctions and even the basic compositional relationships typical of the red-ground carpets first began their evolution in India from around the second century BC, and continued until at least the second century AD. Their philosophical justification had been conceived even earlier by Buddhist and

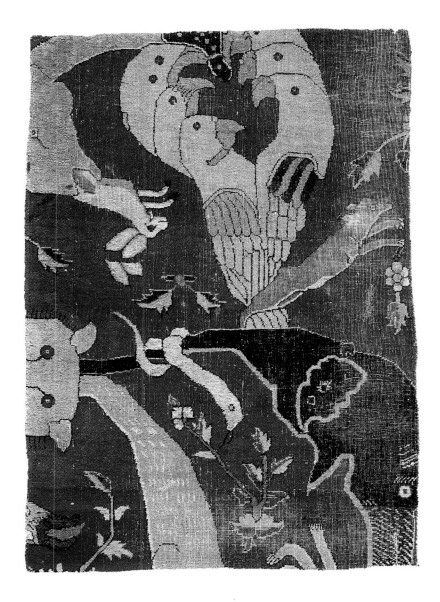

Hindu thinkers.[61] The low relief stone carvings at early Buddhist sites such as Sanchi, Bharhut, Udayagiri and Amaravati prominently display thick meandering stems, most often emerging at one end of a structural member (usually a vertical upright or horizontal lintel) from the mouths of water symbols. Those symbols can take the form of a water pot, a *makara*, an elephant, a tortoise, a goose or any creature primarily associated with water; or they could issue from the arm of a tree spirit (*yaksha* or *yakshi*); or any fat, round pot-like shape such as the stomach or mouth of a dwarf (*gana*). The thick stem usually re-enters the mouth or body of a matching being at the opposite end of the column or lintel. Fruits, flowers, animals or people frequently burst from the sides of those meandering vines. Even without prior knowledge of the supporting texts, it is obvious that these carvings were intended to represent the essential flow of sap or juice (*rasa*), and were visual expressions of the vital forces of generation and fecundity. Though artistically related to contemporary Graeco-Roman inhabited scrolls, the early Buddhist compositions were uniquely Indian in spirit and execution.[62]

With the passage of time the *makara* – the elephant-snouted crocodilian which traditionally served as the vehicle of Varuna, the Vedic god of the waters – became the predominant symbol to be placed at the ends of those scrolling stem systems. When, later, they were used to enhance temple arches (21) or to act as frames surrounding or placed behind Buddhist, Hindu and Jain images (20), their continuous meanders were

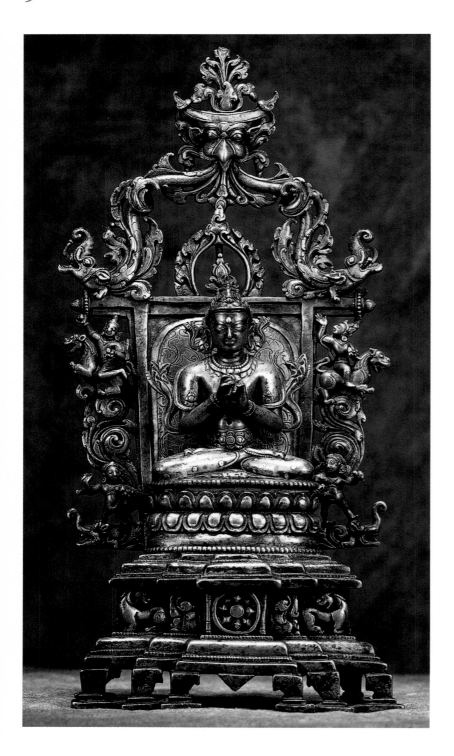

20. Seated Lokeshvara, bronze, northeast India, Sena dynasty, late 12th century. Courtesy John Eskenazi, London.

often interrupted in the centre of the upright or at the apex of the arch by yet another important grotesque invention, the *kirtimukha* or 'face of glory' (22). Whether, as Coomaraswamy believed, the *kirtimukha* originally consisted of two confronting *makaras* which gradually lost their lower torsos and merged into a single vertically symmetric face like the Chinese *t'ao-t'ieh* and the Urartian mask, or whether it simply began as a stylised lion head which absorbed grotesque accretions, the *kirtimukha* had already appeared in Buddhist art on the crown of a *naga* king at Amaravati by the second century AD. As early as the fourth century AD Hindus considered it to be a fierce demon associated with the worship of Shiva: according to that apocryphal tradition, a *kirtimukha* should always be placed over the entrance to Shaivite shrines and on the back of Shaivite images to protect them from evil.[63]

In Central India during the Gupta period (circa fourth to fifth centuries AD) the basic form of the classic *makara-torana* arch was developed. Buddhists, Hindus and Jains all considered it be a decorative device appropriate for use on religious buildings and images, and in that way the composition quickly entered the popular culture of medieval India. Eventually, the *makara-torana* arch lost its exclusively religious connotations, and purely decorative arrangements based on different linear connections between *makaras* and *kirtimukhas* spread throughout the Indian subcontinent (23). From India they travelled as far as the Buddhist and Hindu communities of Central Asia, China and Southeast Asia, where they were used to decorate everything from temple and domestic entrances, to textiles, statues, vessel handles, weapons, jewellery and so on.

These compositions are still widely used and though each individual component can become stylised, all *makara-toranas* retain basic elements. In the middle there is a central figure or monster mask (usually a *kirtimukha* though a *garuda* is preferred in Nepal, and Ganesh appears frequently). If the composition is arched, the mask or central figure is placed at the apex. A pair of *makaras* (or snakes) is positioned on either side of and below the central mask, and there will be some continuous connection (whether actual or implied) between the central mask and the side figures, ideally achieved by stems, strings of pearls or volutes of foliage which emerge from their mouths or tails. Water pots, though not absolutely necessary (the *makara* is, itself, a water symbol) are often found somewhere in the arrangement.[64] Thus the original symbolism of the primal flow of liquid from one creature or vessel to another is perpetuated.

The symbolism associated with images of the combined *makara* and *kirtimukha* were so well understood by Indian artists that even when illustrated outside the context of a traditional *makara-torana* arch, they could not conceive of displaying either of those figures without something grasped in their mouths. In Caves 6 and 8 at Ellora (circa fifth century) and Cave 16 at Ajanta (circa seventh century), the backs or sides of the thrones in which the Buddha images sit are ornamented with purely decorative *makara* heads. And yet from each *makara*'s mouth thin spiralling stems are emitted which are transformed into the heads of weird birds.

With the obvious exception of hunting scenes (which are not really Indian in origin), violent images where one animal tears into another with its teeth are uncommon in non-Muslim

Indian art. But when one does encounter examples of Indian beasts grasping other creatures in their jaws or with garlands, strings of pearls, stems or foliage in their mouths, there are almost always *kirtimukha*s or *makara*s involved. It seems that the original symbolism and imagery of the *makara-torana* arch exerted a tenacious grip upon the minds of Indian artists of all periods.

To return to the design of the red-ground grotesque carpets, although there do not seem to be any conventional *makara-torana* arches present, we have noted that most of the carpets' zoomorphic junctions take place where one creature emerges from the mouth of another. We have also seen that in Indian art this is an artistic convention most often associated with *makara-torana*s or with individual *makara*s or *kirti-mukha*s. Could a variation of that traditional Indian architectural arrangement be intentionally hidden in the design of the carpets, and if so, why would that have been done?

The designer of the red-ground grotesque carpets, whether Hindu or Muslim, either had to be an elite artist familiar with Mughal court painting conventions of the 1580s or 1590s, or

L. Red-ground grotesque carpet fragment, India, late 16th or early 17th century. Wool pile on a cotton foundation, 67.3 x 67cm (2'2¹/₂" x 2'2¹/₂"). Fine Arts Museums of San Francisco, inv.no. Sachs 1952.33.

someone with access to such an artist's work, in order to have so faithfully reproduced the great variety of semi-naturalistic animals present on the carpets in that distinctive style. Artists privileged enough to be given access to manuscripts such as the *Akbarnama* would also have been familiar with the Persian-inspired Mughal monsters *(djinns)*. With their massive, heavily bearded, gap-toothed heads, curved horns, and distinctive leaf-shaped eyes and ears, they were the most typical style of monster to be found on pages of the great *Hamzanama* and all subsequent illustrated manuscripts of Akbar's long reign.

The carpet designer has cleverly used two sizes of these Mughal monster masks to replace the traditional Hindu *kirtimukha*. Two larger masks are placed in a single horizontal row, and each has a pair of long-necked tiger[65] heads curving down from either side of the top of the monster's head, in direct imitation of the curve of stems which in more conventional compositions would normally flow, below, from a *kirtimukha*'s mouth.[66] From those tigers' open jaws, an implied arch descends through six joined parrot heads, then on through a tortoise's body, finally entering the tail of the creature one would most expect to find at the end of a *makara-torana* arch, a *makara,* which is either swallowing or disgorging the head of a fish or snake. Surely the fact that this composition begins with a monster mask and ends with a *makara* is no accident?

21. Makara-torana arch from a temple interior at Badoli, Rajasthan, India, Pratihara dynasty, 10th century.

A second arrangement appears on alternate horizontal rows and is based on smaller monster masks. One full *kirtimukha* substitute lies in the centre of the carpet and two half masks are positioned along its outer perimeters on either side. Rising this time from the top of the smaller monster's head are pairs of thin stems (exactly the same sort that emerge from the central palmettes of conventional 'in-and-out-palmette' design carpets). On either side, following the most direct ogival path downward, one first encounters a leopard mask, then the six-headed parrot, and finally a rhinoceros beside a small mammal, possibly a weasel, with a rabbit in its mouth. In another variation of animals springing from the smaller monster mask, the implied curve travels from the leopard's head through a snake, then to an elephant's neck, the hind legs of a small rodent, the

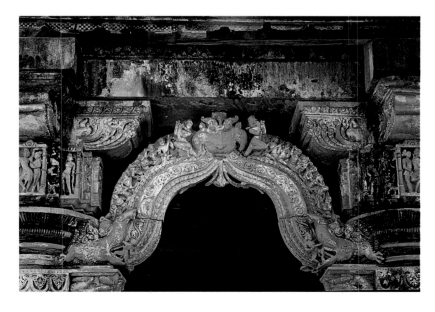

six-headed parrot, a tortoise and finally ends at a goat's head. In either series, if one draws a line from any of the monster masks down through the most direct arched path, one ends up with horizontal rows of arcading, the same effect one would produce drawing a line through a row of *makara-torana* arches.

Other animals (a *nilgai* or 'blue bull', the common wild antelope; a cheetah with both a duck and a crane in its mouth; another tortoise with a snake; a bull with a peacock, and an elephant in the second variation) are also attached to the first complex group of beasts springing in unusual clusters from the head of the large monster mask. Similarly, other clusters of animals have attached themselves to the principal arch sprouting from the smaller monster mask. The presence of these additional beasts is superfluous to the design of either type of *makara-torana* arch, but if our assumption is correct, the artist was again humorously parodying a feature of standard Mughal carpets.

First, he substituted fashionable Mughal equivalents (animals and monster masks) for the traditional components of an Indian arch. Then, using more Mughal animal elements grouped together in clusters, he replaced the various parts of a conventional Mughal in-and-out palmette carpet. The idea of owning a unique pair of carpets whose true design would not immediately be understood by the uninitiated would have appealed enormously to a patron such as Akbar. They would also have made appropriate gifts to one of his favoured courtiers or to a powerful noble who happened to share Akbar's idiosyncratic view of the world. Carpets whose patterns held a secret known only to the select: a design hidden within another, itself a substitute for something as common as an ordinary floral carpet, is the sort of pseudo-mystical puzzle which one might expect to have been produced during Akbar's reign.

If one believes his biographer, the Emperor personally encouraged his artists and craftsmen to experiment with new art forms and, when possible, to combine traditional Hindu and Islamic art to create objects superior to either prototype. His orders to translate Sanskrit literary classics into Persian and then to illustrate them as if they had been Persian or Arabic works is one example of that desire to select the best elements from both cultures.[67] The building of his new capital at Fatehpur-Sikri using classical Hindu, Jain and Islamic architectural features together is another. His failed attempt to create a syncretic religion with himself as head is a third. And the design of the red-ground grotesque carpets, though insignificant in comparison to those other ambitions, was probably yet another example of his wish to combine the various cultural traditions of India within single works of art.

Akbar's descendants would probably not have understood the carpet designer's wit. Even if they had, these relatively coarse carpets were not the sort of projects with which they would have concerned themselves. Akbar's son and grandson were much more interested in prestigious art which impressed the viewer and supported an imperial image of the dynasty. Both Jahangir and Shah Jahan considered themselves connoisseurs of exquisitely fine works of art; jewels, paintings and marble-clad buildings were their preferred subjects, and when they commissioned carpets, they were more likely to be knotted with the finest wool from the underbelly of Kashmir goats, on a foundation of brilliantly dyed striped silk. Those small treasures were the most tightly knotted classical carpets ever woven and their aesthetic qualities are unrelated to the concepts that motivated the design of the red-ground grotesque carpets.

Even if one accepts that the designer

22. Kirtimukha from a temple column re-used at the Quwwat al-Islam Mosque, Delhi, India, pre-1197.

23. Two makaras and a kirtimukha on a column from Cave 23 at Ajanta, India, late 5th century AD.

24. Merman, Mathura, India, ca. 100AD. After A. Coomaraswamy, Yaksas, Delhi 1980, pt.II, pl.41, no.2.

25. Stair-riser, Vijayanagara kingdom, the Deccan, south-central India, 13th-14th century. Victoria & Albert Museum, London, inv.no. IS122-1984.

M. *Red-ground grotesque carpet
fragment, India, late 16th or
early 17th century. Wool pile
on a cotton foundation, 66.3 x
67.5cm (2'2¹/₄" x 2'2¹/₂"). Fine
Arts Museums of San Francisco,
inv.no. Sachs 1952.34.*

of the red-ground carpets was strongly influenced by a familiarity with the artistic conventions
of the traditional Hindu *makara-torana* as well as a practical knowledge of the designing of
Indian floral carpets and drawloom textiles, important questions regarding the inspiration of
additional details remain unanswered. Normally, a *torana* (gateway) is decorated by positioning
makaras at the base or top of each post, or at the ends of the crosspiece, or sometimes in all of
these positions. A *kirtimukha* or a pair of addorsed *kirtimukha*s is usually found in the centre of
the crosspiece. All the *makara*s and *kirtimukha*s are normally joined by some continuous system
of stems or other linking devices emerging from the mouths and/or tails of each element. In the
most elaborate examples, the crosspiece may be filled by a linked series of *kirtimukha*s, but
there are no earlier Indian examples of a continuous series of linked animals encumbered by
the superfluous clusters of additional beasts which are such an important feature of the red-
ground carpet design. The purpose of these clusters is clear; they represent the minor buds,
blossoms, rosettes and lanceolate leaves traditionally found on standard Mughal floral carpets.
But grouping animals together in this fashion has almost no precedent in earlier Indian art, so
where did it originate?

Before the proposed date of the red-ground carpets, the late sixteenth or very early seven-
teenth century, the only Indian artefacts which even begin to approximate this artistic concept
are much simpler compositions – a few composite sculptures, Jain miniature paintings, and
architectural stair-risers from the Hindu kingdom of Vijayanagara in the Deccan (**25**).[68] Dated
to the thirteenth or fourteenth centuries, these are stone sculptures of huge *makara*-like
winged creatures devouring the smaller lion-headed winged dragons or snakes with which they
are intertwined. The bodies of the beasts have been so distorted and compressed that when
combined, their outline approximates the shape of a conventional stair-riser. But this is a rare
example of a grotesque convention which was almost unknown in India before the late six-
teenth century and is not likely to have influenced the design of the red-ground carpets.

Suddenly, with almost no known precedents, one finds an artist working in the imperial
workshop *(karkhana)* at Fatehpur-Sikri producing an illustration from the *Razmnama* (circa
1582-86), Badauni's Persian translation of the Hindu epic, the *Mahabharata*. This painting (**26**)
contains two trees which typify the hitherto rare grotesque convention just described. In out-

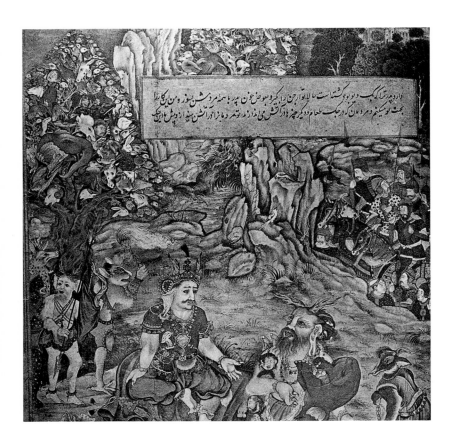

line, they seem to be ordinary trees, but unnaturally compressed among their branches are dozens of human and animal heads replacing the leaves. Considering all the confusion created by earlier discussions of the blue-ground grotesque carpets, it is ironic that the artist of this *Mahabharata/Razmnama* painting was also attempting to illustrate a talking tree, but not the well-known tree of the *Sikandernama* legend. His trees came from a story added quite late to the original *Mahabharata*, which must have been inspired by the famous tale of Alexander's quest.[69]

Any Mughal court artist would have been familiar with the standard depictions of Alexander's tree from copies of the *Shahnama* in the royal library. But rather than simply suspending a 'talking' head or two from stems or branches as was done in another painting from that same *Razmnama*, this artist achieved his goal in a less conventional manner.[70] This is not the only painting to rely upon that visual technique. In another folio from the same work, one finds a depiction of *yupas*, sacrificial stakes, where birds and beasts have been bound, prior to the commencement of an important ritual.

26. Painting from the Razmnama (detail), Fatehpur-Sikri, ca. 1582-86. Private collection of the Maharaja of Jaipur. After T. Hendley, Memorials of the Jeypore Exhibition 1883, London 1883-85, vol.IV, pl.XCVII.

Though entirely logical in this instance, the illustration of these animals has also been treated in the same 'compressed' fashion. The results are crude, as if the artist had not yet fully understood or mastered a new concept. How and when did this style of 'compressed' art enter Mughal India?

Before answering that question, one must add that the paintings in the *Razmnama* were probably not isolated examples of this artistic convention in India. They are merely among the first securely dated artefacts known to employ it. In addition to those paintings and the clusters of animals knotted on the red-ground carpets, one finds that since around 1585-1600, hundreds or even thousands of other examples based on this grotesque concept have been produced in India, and indeed continue to be produced today. Most fall into two categories: drawings and paintings of individual composite animals, and carved ivory powder primers.

27. Cotton chintz with composite figures (detail), India, 17th century. Musée de l'Impression sur Etoffes, Mulhouse, inv.no. 986.50.

The 'composite' drawings and paintings are rarely fully integrated landscapes or genre scenes but are most often isolated compositions intended to amuse or solicit admiration by their ingenuity. The basic outlines of familiar animals – most commonly horses, camels and elephants – are packed with the bodies of many animals, humans or demons compressed and distorted until every space within the outline has been occupied (**28**). Often the animals are shown biting each other or emerging from the mouths of their neighbours, exactly like some elements on the red-ground carpets. Drawings and paintings of this type were extremely popular with artists working in many different schools of Indian art, and composite drawings of this nature remain popular today (**27**).[71]

Like the composite drawings, the compositional aspects of the ivory powder primers also seem to have little or no direct relationship to earlier Indian artistic traditions. Most belong to the period from around 1600 through the eighteenth century, and all have a similar rounded outline, thick in the middle with two tapering ends, one usually thinner than the other (**29**). These were described by W. Born in 1942 as "fish shaped", though this may not at first seem obvious. However, when compared

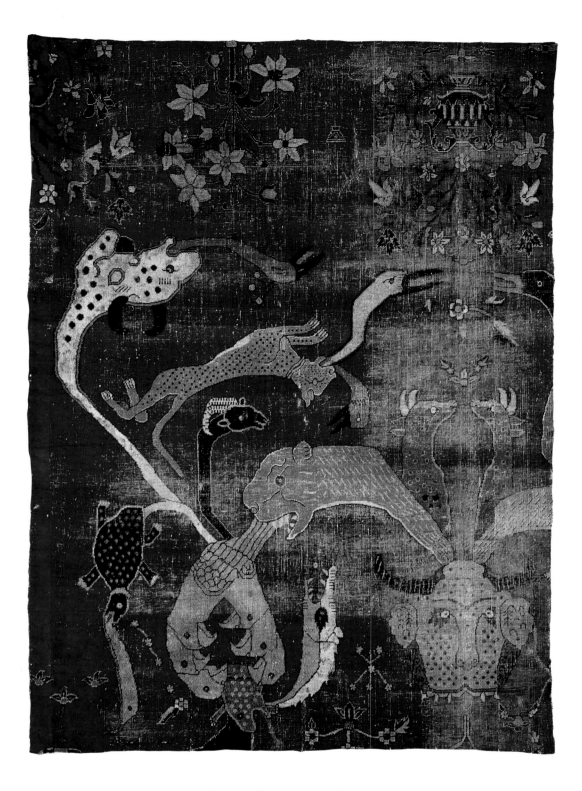

28. *Composite painting of elephant and rider, the Deccan, India, ca. 1580-1600. Victoria & Albert Museum, London, inv.no. IS224-1960.*

N. *Red-ground grotesque carpet fragment, India, late 16th or early 17th century. Wool pile on a cotton foundation, 142 x 101cm (4'8" x 3'4"). Ex-Adda sale, Paris (3 December 1969, lot 1019), private collection USA, Harvard University Art Museums, Cambridge, Massachusetts, loan inv.no. 358.1983.*

to a third century BC stone *makara* in the Museum of Fine Arts, Boston, the ivory carver's intention becomes clearer.[72] Within the piscine outline, the curved surfaces of these primers are most often divided into three general zones, a geometric pattern or hunting scene may occupy the centre, while more closely packed configurations of animal combats or dense chains of fantastic animals emerging from each other's open jaws fill both ends. In the most skilfully composed examples, those ends are carved in the round and terminate as full animal heads gripped in the jaws of the preceding beast.

The relationship of the composite drawings, carved powder primers, talking trees and sacrificial posts from the *Razmnama* to the clustered details of the red-ground grotesque carpets is clear. All rely on a specific grotesque convention which does not seem to have been popular on the Indian subcontinent prior to the middle of the 1580s. Brilliantly executed compositions reliant upon the same style of 'compacted' art had been known in China as early as the late Shang period of the thirteenth to eleventh centuries BC,[73] and in Mongolia and Siberia as well as China during the Warring States period of the fifth to third centuries BC.[74] Compacted grotesques were a feature of Scythian art, and one of the finest examples, a plaque (30) of the late sixth century BC, reflecting every nuance of that convention, was found

as far west as Vettersfelde in eastern Germany. But these examples are far too removed in time to have served as the inspiration for the Mughal revival of that style of art in the late sixteenth century AD. Speculation regarding Central Asia as the direct source must also be dismissed. By the late sixteenth century much of Central Asia had come under the political and cultural influence of the great empires surrounding its borders, following earlier domination by the Mongols in the thirteenth century and the Timurids (to a lesser extent) in the fourteenth century. Safavid Iran, Mughal India, Ming China as well as the nascent Russian Empire were now increasingly important influences on Central Asian art of the late sixteenth century. Whether Turkmen, Uzbek, Mongol, Tibetan, Kirghiz, Kazakh or Buryat, Central Asian artefacts could no longer be considered examples of 'animal style' art.

Art dominated by depictions of dynamic biting beasts had long moved westwards, out of Central Asia, along with the Scythians, Cimmerians, Sarmatians and other mounted nomads, first to influence the art of the Celts during the La Tène period (circa fifth century BC to early first century AD) and, much later, during the fourth through the sixth centuries AD, the art of Europe during the migration period of the Huns, Goths, Vandals and other 'barbarian' tribes.

European printed pattern books for use by architects, artists, sculptors, jewellers and other craftsmen (as well as actual artefacts dependent on those designs) are the most probable sources of the late sixteenth century Mughal artistic convention which grotesquely compressed and distorted images of people and animals into outlines unrelated to their natural shape.

The revival of that art in post-classical Europe may be observed as early as the eighth and ninth centuries in illuminated manuscripts from Ireland, Northumbria and northern France. The initial letters of Gospels and Psalters incorporating drawings of tiny fish and dolphins were earlier introduced into Irish art through the copying of Coptic manuscripts. Once these traditions assimilated the Germanic convention of biting animals bound by interlaced ribbons, all the decorative elements required to create the charming inhabited initials from Corbie and Chelles were available to the artist.[75]

From the tenth up to and including the thirteenth century, Anglo-Saxon and then Romanesque artists added classical acanthus leaves, lion masks and human figures to their inhabited letters, compressing and distorting ever more figures within the confining outlines of each frame until they began even more closely to resemble the grotesque compositions which appeared in sixteenth century Mughal India.[76] But as yet there was no means of regularly transmitting this style from northern Europe directly to India.

In sculpture, similar compressed designs are found on the sides of carved ivory boxes,[77] and on a larger scale in York (the Scandinavian capital in northern England) on a carved beast column in the tenth century York Minster, which is entirely covered by a densely packed arrangement of writhing, biting "Jellinge-style beasts caught up in an interlace of pigtails, tails and ribbons".[78] Those columns foreshadowed the Romanesque tombstone (circa 1140) from St Peter's Church, Northampton,[79] the fantastic beasts compressed into carved capitals and tympanums so typical

29. Ivory powder primer, Mughal India, early 17th century. Victoria & Albert Museum, London, inv.no. 597-1923.

31. Jahangir Preferring a Sufi Shaikh to Kings (detail), painting by Bichitr, Mughal India, ca. 1615-18. Freer Gallery, Washington DC, inv.no. 45.15a.

30. Late Scythian gold repoussé plaque, found at Vettersfeld, Germany, late 6th century BC. Staatliche Museen zu Berlin, inv.no. F17114C.

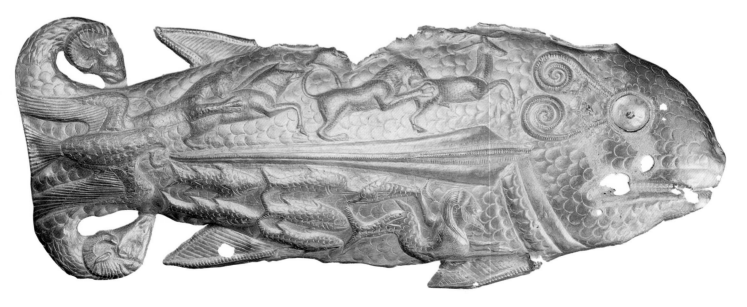

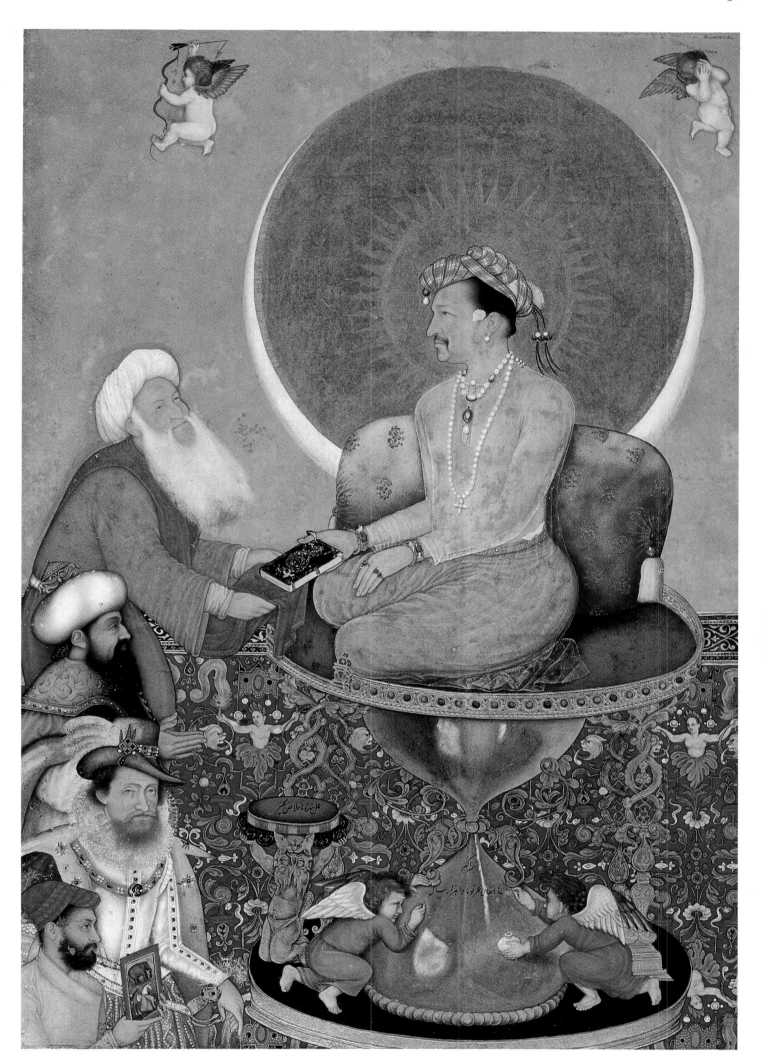

of Romanesque art,[80] as well as the well known beast column from the doorpost *(trumeau)* of the Abbey Church at Souillac in southern France, which also dates from the second quarter of the twelfth century. This astonishing sculpture parallels the spirit of the later Indian powder primers with their composition of biting, contorted human and animal figures, all forced into the shape of a structural column.[81] But we are still too far removed in time for those European masterpieces to have been directly able to influence later Indian works of art.

Following the discovery in 1488 of the ruins of the Emperor Nero's 'Golden House' in Rome, Renaissance artists became fascinated with the designs and patterns of the ancient classical world. At first they merely copied the conventional scrolls, hybrid beasts and ornamentation at one time so popular throughout the Mediterranean in the early centuries AD, but once they had mastered those classical compositions, artists such as Raphael began to modify what had come to light in the abandoned grottoes. Inhabited letters, beast columns and all the other varieties of grotesque art then current in Europe were combined with older classical forms to become a vital strand of sixteenth and seventeenth century European art. It was this European tradition which began to inspire Indian artists by the late sixteenth century.

French engravers such as Jacques Androuet du Cerceau (1515-1584) published sets of grotesque prints **(33)** in 1550, 1562 and 1566, inspired by the work of earlier Italian artists such as Veneziano, Rosex da Modena and Vico.[82] Hugues Sambin (1520-1601), another influential French architect and engraver, produced pattern books filled with grotesque inventions. His composite architectural orders are decorated with exactly the type of grotesque conventions we are seeking, though his animals and people are of types more familiar to Europeans. Masses of people, animals and mythological beings are unnaturally arranged so that they completely fill the outlines of conventional architectural structures.[83] Jan Vredeman de Vries (1525-1604) was another influential designer whose books contained "the essence of the Netherlands Grotesque style".[84]

These Renaissance designers, as well as others not yet identified, probably wrote the books or engraved the prints which found their way to India by the 1580s and inspired the artists of the *Razmnama* and the designer of the red-ground grotesque carpets.[85] Or, if these particular Indian artists did not personally have access to those specific prints, they must have studied the work of a European craftsman, most probably a jeweller or ivory carver, who was demonstrating his skill in India. Without such intervention it would not have been possible for this particular grotesque convention to have reached India so soon after its invention, yet we have proof that this was a style known in India and practised in miniature painting, ivory carving and carpet design by the beginning of the seventeenth century.

We know that both Akbar and his son Jahangir so greatly admired European works of art that their governors and military officers received orders to send foreign merchants directly to the capital as soon as their ships reached an Indian port, so that the court would have first refusal of all their goods. Their agents were periodically dispatched to the Portuguese stronghold of Goa to acquire 'rarities' and on several occasions during both reigns, the Jesuits were invited to send missions from Goa to the Mughal court, bringing with them their holy books and paintings. In this way Akbar was presented with seven volumes of the richly engraved Antwerp Polyglot Bible in 1580.[86] Both emperors' love of European paintings was so intense that, when unable to acquire them from the European owners, they immediately ordered their artists to make copies.[87]

As yet there is no direct evidence that printed pattern books of grotesque designs reached India by the late sixteenth century. However, the presence in India of objects such as the Canning Jewel,[88] a late sixteenth century Flemish or Italian masterpiece of gold, baroque pearls, diamonds and rubies, with Indian additions, or the Mughal artist Bichitr's later allegorical painting of Jahangir (circa 1615-18) proves that the Mughals had acquired examples of European grotesque art, or the pattern books containing that art, or artists capable of faithfully working in that style. The former features a male grotesque emerging from a vegetal scroll, while the latter **(31)** depicts the Emperor enthroned above a floor covering which is an extremely accurate copy of a Renaissance tapestry, embroidery or

O. *Red-ground grotesque carpet fragment, India, late 16th or early 17th century. Wool pile on a cotton foundation, 39.9 x 67.5cm (1'3½" x 2'2½"). Ex-Christie's, London (18 October 1994, lot 569), private collection, France (?).*

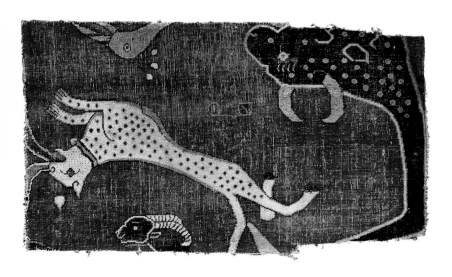

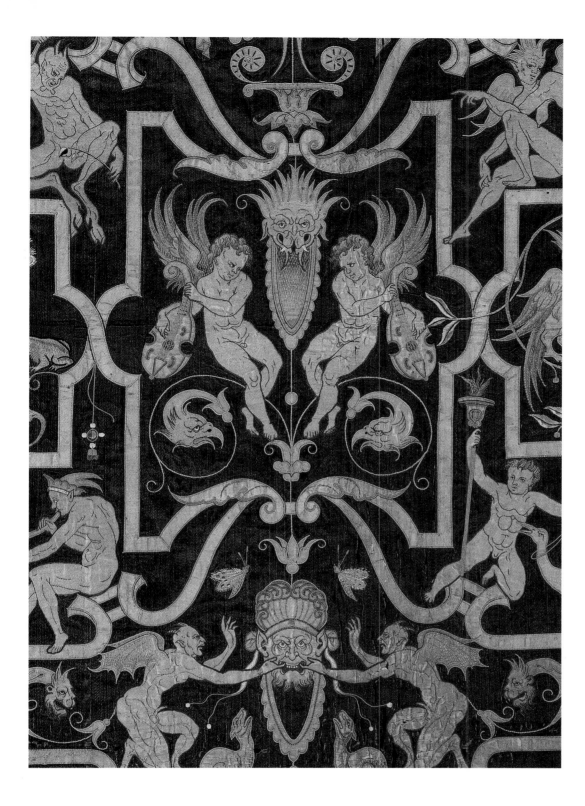

33. Grotesque architectural decoration by Androuet du Cerceau (ca. 1515-84), Liber de picture genre de quod Grottesche vocant Itali, 1550. After facsimile reprint, 1880, National Art Library, London, no.52/B/105.

32. Satin appliqué bed head (detail), France, ca. 1550-60. Victoria & Albert Museum, London, inv.no. T.344-1980.

appliqué (**32**), complete with mannerist strapwork, grotesque half-figures rising from acanthus bracts, grotesque lion heads terminating in spiral scrolls and so on.

Robert Skelton has conclusively shown that imported European Herbals of the early seventeenth century were among the principal components in the genesis of the semi-naturalistic Mughal plant style so closely associated with Mughal art from the late 1620s onward.[89] But our historical records of earlier contacts between Europeans and Mughal artists are far from complete. We know the names of ambassadors, Jesuit missionaries, captains of European ships and East India Company officials (British as well as Dutch), but those of ordinary private adventurers and their activities on the subcontinent remain more of a mystery. The presence of an additional European artistic convention in India by the 1580s, the unnatural compression of figures into an unrelated outline, suggests that the transmission of Renaissance art occurred even earlier than previously suspected. How and when that transfer of information first began remains unclear, but the use of that European grotesque convention in the hands of a skilled Indian artist resulted in an unexpected design element appearing on a unique pair of red-ground carpets.

Notes & technical tables see Appendix

10

MEIBUTSU-GIRE

Textiles in the Japanese Tea Ceremony

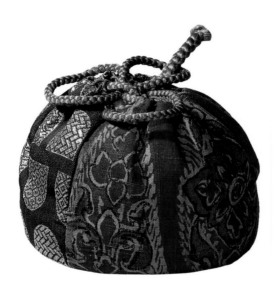

SUSAN-MARIE BEST

One of the most characteristic forms of Japanese cultural expression, the Tea Ceremony is admired for the austere beauty and contemplative harmony of tea-room and tea utensils. This article traces the less well known history of textiles imported to Japan during the fourteenth to eighteenth centuries and used to protect, handle and display the most precious ceramic tea-bowls and caddies.

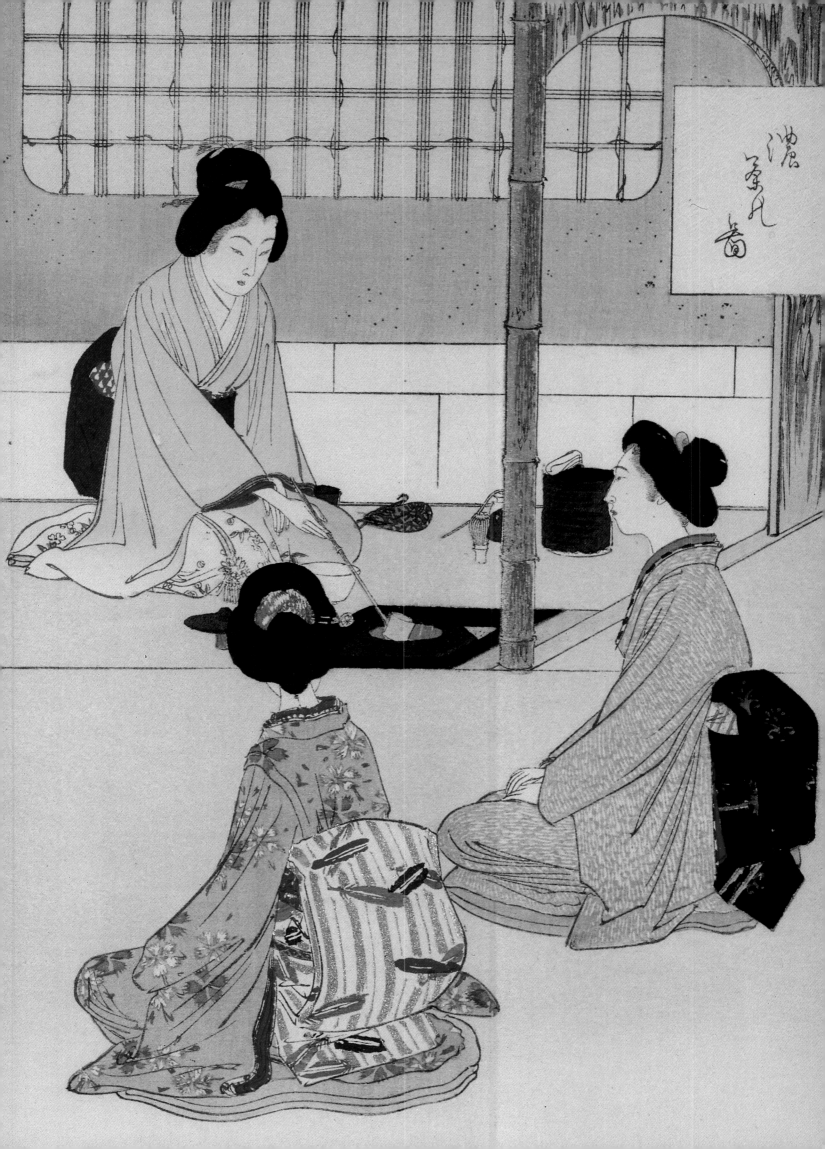

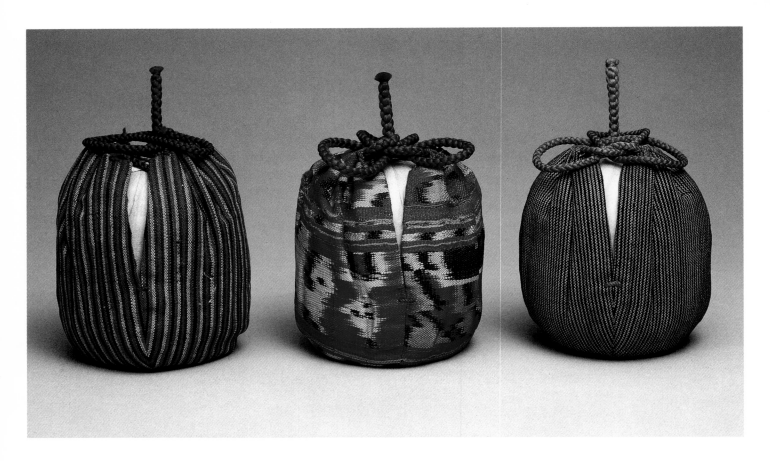

3. Three shifuku for the 'Rikyū Shiribukura' tea-caddy: striped kantō; 'Taishi Kantō'; 'Rikyū Kantō'. Height 7cm (2¹/₂"). Eisei-Bunko Museum, Tokyo.

1. Title page: Shifuku, Indian chintz and Japanese indigo gold-stamped inkin, Edo period (1600-1868). Schmidt Collection.

2. Previous page: Tea Ceremony (detail), woodblock print by Mizuno Toshikata (1866-1908). The hostess ladles hot water into a white tea-bowl. She has a red napkin tucked into her waist sash and a blue shifuku is placed at her left side. 23.5 x 33.5cm (9" x 13"). Victoria & Albert Museum, London, inv.no. E3131-1905.

The Japanese word *Chanoyu* (Tea Ceremony), literally 'hot water for tea', is a simple term that belies a complex orchestration of aesthetic sensibilities and ritualised procedures. Each tea gathering is a unique occasion, when the host and guest/s meet to drink a specially prepared tea, to contemplate their surroundings – the gardens they will have walked through to reach the tea-room or tea-house – and to appreciate the carefully chosen utensils selected to contain, prepare and drink the tea. Among these utensils crafted from clay, porcelain, lacquer, bamboo, wood, metal and fabric, ceramics such as the hand-built, expressively textured Raku tea-bowls enjoy the highest profile, while up to now the textiles have escaped the limelight that accrues from the interest of scholars and collectors.

Textiles play their part in the Tea Ceremony in a number of ways: as mountings for the hanging scrolls of calligraphy or paintings used in the tea-room, as napkins,[1] and as bags used to store, protect and display the utensils. This article will focus on the textiles used for bags, or *shifuku,* and for napkins, many of which originated from outside Japan, and therefore tell not only the story of the Tea Ceremony but also illuminate the socio-political influences on trade, patronage and connoisseurship. Disappointingly, if not surprisingly, London's major museum collections of Japanese tea utensils do not contain significant numbers of textiles. Even Japanese museums do not always pay them due attention, leaving them to textile historians, who in turn ignore the contents of these collections. A fortuitous introduction to the owners of a private collection of ceramic tea-caddies, many with their accompanying *shifuku*, and a visit to the resident Tea Master at the London Urasenke Foundation for Chanoyu, provided me with the starting point for this article.

With the spread of Zen Buddhism in thirteenth century Japan came a vogue for tea gatherings as a venue for displaying Chinese art treasures – paintings, calligraphy, bronzes, ceramics. By the mid fifteenth century rivalry among collecting aristocrats and warlords was such that they commissioned expert connoisseurs to advise them on the acquisition and display of their collections, including valuable Chinese tea utensils. The appreciation of tea as an art brought the rise of the specialist Tea Master and the formation of Tea Ceremony styles in architecture, gardens, utensils and practice.[2] Murata Shukō (1423-1502), Tea Master to the Shogun Ashikaga Yoshimasa, created a new form of Tea Ceremony, designing a small specially built tea-room to evoke the frugality and tranquillity of an idealised rustic retreat from the pressures of the material world, wracked at the time by civil wars.[3] Shukō called this new style 'poverty tea', drawing upon ancient Japanese aesthetic concepts and the Shinto approach to the natural world, and infusing them with contemporary Zen Buddhism,

in a rejection of previous ostentatious trends.[4] Instead of a gallery of artworks, Shukō hung a single scroll of Zen calligraphy in the tea-room alcove. Saying "The moon is not pleasing unless partly obscured by a cloud", he harmonised the contrasting beauty of antique Chinese and contemporary Japanese utensils by likening their opposing aesthetic qualities to the irregular beauty of nature. The moon and clouds seem also an appropriate analogy for the relationship between the tea-caddy and its tailor-made *shifuku*.

The aesthetic of 'poverty tea' reached its full realisation under Japan's most influential and controversial Tea Master, Sen Rikyū (1521-1591), who codified the Tea Ceremony into a style known as *wabi* (literally 'simplicity', 'quietude' or 'absence of ornament'). He cited a poem by Fujiwara no Ietaka to illustrate the ideal of *wabi* as a sense of unexpected modest beauty:

> *To those who wait*
> *only for flowers,*
> *show them a spring*
> *of grass amid the snow*
> *in a mountain village.*[5]

Rikyū designed a tea-room of only 'two mats', just a few square feet, and within this stage-like setting the tea utensils assumed a monumental character. The only 'furnishings' were the tea-room alcove and the hearth for the tea-kettle. In the fifteenth and sixteenth century Japanese potters were not as skilled as Chinese craftsmen, whose technical brilliance was exemplified in the highly finished antique Jian and Jizhou ware tea-bowls. Rikyū, however, championed the use of Japanese-style tea utensils, preferring the contemporary haphazardly ash-glazed and incised surfaces of local kiln wares, and patronising the Raku ware potter Sasaki Chōjirō (1516-1592). In the same spirit he favoured subdued cottons over gold brocades for *shifuku*.

All tea utensils may be wrapped in textiles. Unwrapping successive layers to reveal the precious object, beginning with the outer storage box, is part of Tea Ceremony ritual. The main objects which interact with the *shifuku* are the tea-bowls and tea-caddies – the latter of ceramic or lacquer depending on whether thick or thin tea is being served.[6] The utensils are handled using a special napkin, thought to have been devised by Rikyū's wife, which when not in use is worn tucked into the kimono sash (**2**).

Of textiles, the most appreciated for *shifuku* were those woven in the tenth to thirteenth centuries and imported to Japan from the fourteenth to eighteenth centuries. These are

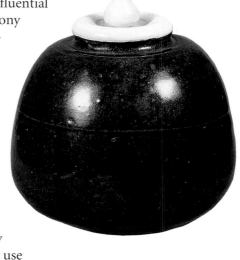

4. Tea-caddy, 'Rikyū Shiribukura', Southern Song/Yuan dynasty, 13th-14th century. Eisei-Bunko Museum, Tokyo.

5. Shifuku, 'Enshū Donsu' silk and striped kantō with a purple drawstring cord; wooden storage box, identifying the tea-bowl as the work of Kenzan (1663-1743); tea-bowl, inscribed with a poem and plum blossom. Schmidt Collection.

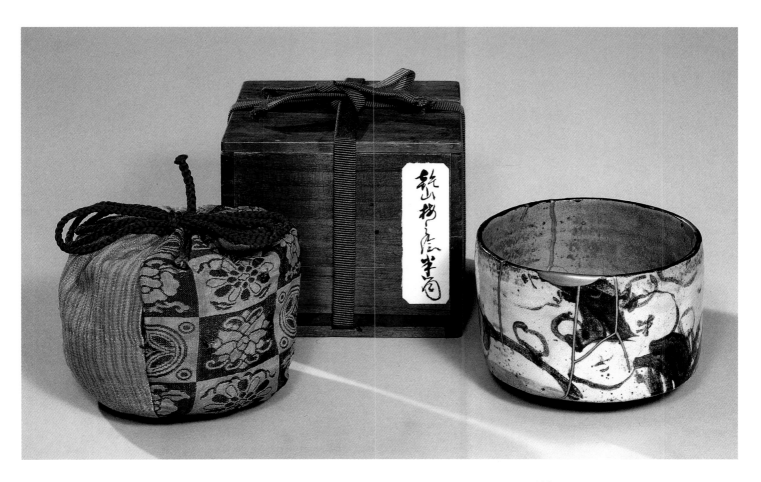

6. *Shifuku, 'Mochizuki Kantō';*
(detail), named after the Tea
Master Mochizuki Sochiku
(d.1749), Persia or India,
probably 17th century.
Tokyo National Museum.

traditionally classified by their period of import.[7] Trade with Yuan (1279-1368) and Ming dynasty (1368-1644) China brought gold brocades, silver brocades and satin damasks to Japan.[8] European traders bound for the Spice Islands introduced exotic European fabrics such as wool and velvet, stimulating the vogue for European artefacts, fads and fashions. Trade along the Coromandel Coast of India introduced textile designs of Mughal dynasty origin (1526-1857), striped, checked or thread resist dyed cottons and chintz – hand-drawn or printed calico and cotton.[9] Warp and/or weft ikat, later called *kasuri* when woven in Japan, was made into large *shifuku* for the outer wooden canisters for storing the tea-caddy; multi-coloured brocades[10] were made into small napkins. These fabrics first came into use as *kesa* (priests robes), Shogunal clothing, costumes for the Nō and Kyōgen theatre and as mounts for paintings. The diminutive size of the prized Chinese tea-bowls and caddies (the latter generally no larger than 9cm/4in. high) enabled Tea Masters to tailor left-over precious scraps into protective bags, giving rise to the naming of certain patterns after individual Tea Masters.

The tradition of naming Tea Ceremony utensils arose from the Chinese custom of giving names to objects of outstanding beauty or interest. A *meibutsu-gire*, literally 'named textile',

7. *Shifuku, 'Suminokura*
Kinran', gold brocade fragment
with Chinese animal repeat
design. The rabbit is often paired
with rushes, pounding rice cakes,
leaping waves, or the moon.
Tokyo National Museum.

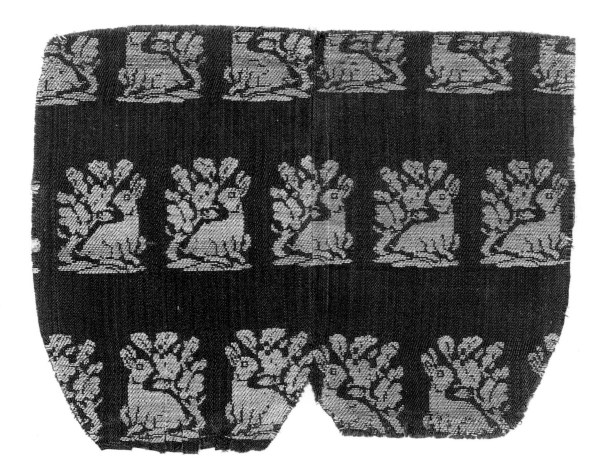

8. *Maple Viewing, six-fold screen*
(detail), Kanō School, Muromachi
period (1392-1513). Colours on
paper, 1.49 x 3.64m (4'11" x
11'11"). This scene of an outdoor
tea gathering at Takao shows
fashionable Korean celadon tea-
bowls in use. Korean potters were
brought to Japan in the 16th
century following Hideyoshi's
military campaigns. Tokyo
National Museum.

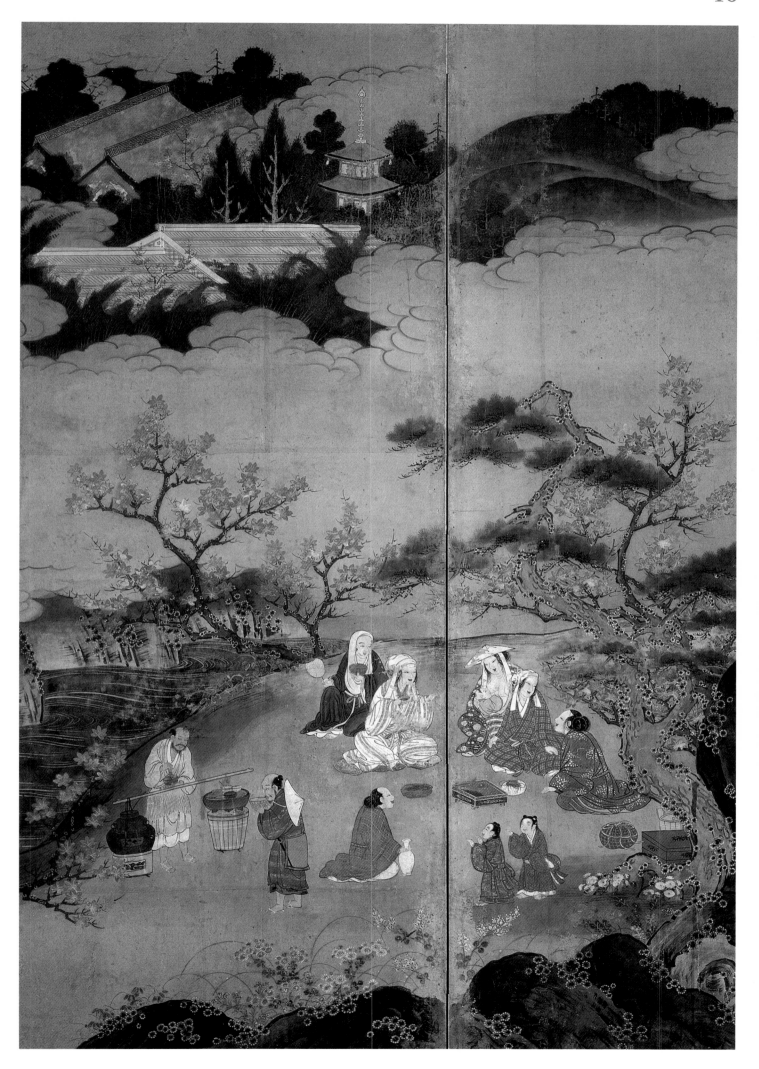

9. Shifuku fragment (detail), 'Daitō Kinran' metal thread brocade with cloud motif, China, Yuan dynasty (1279-1368). Tokyo National Museum.

enjoyed substantially greater prestige and its value was enhanced.[11] The name could derive from a variety of things: the pattern, the owner – from Shogun to distinguished courtesan – place of keeping, the trader who first imported the type of textile, the weaver, or the name already given to the tea-caddy. Thus each association and change of hands added another layer of interest. It is not generally possible, however, to establish a precise date for pieces from the fourteenth to the eighteenth century.

Tea utensils favoured or named after Rikyū are numerous. The career of one group of objects bearing his name, the 'Rikyū Shiribukura' – a Chinese tea-caddy – and three associated *shifuku* (3, 4), is well documented in Tea Ceremony records. One of these records concerns the Grand Kitano Tea Gathering hosted by ruling warlord Hideyoshi in 1587 (**11**),[12] an occasion that brought together the three current styles of tea.[13] A more intimate tea gathering using the 'Rikyū Shiribukura' caddy was held in the early dawn after the year's first snowfall with three distinguished guests – Daitōkuji Abbot Kokei Sochin, the nobleman Hosokawa Yusai, and the author of the *Nanpōroku*,[14] Nampō Sokei. One of the three *shifuku* accompanying this caddy is called 'Rikyū Kantō' (**3**). It has a minute indigo and cream striped 'plover-lattice' pattern, evoking the small birds that swoop in flocks around the seashore.

10. Shifuku, satin damask of 'Daikokuya Donsu' type, Japan, Edo period (1600-1868). Schmidt Collection.

In works on Tea Ceremony connoisseurship in which named pieces were catalogued, the first mention of a *shifuku* appeared in 1478, while the first description of fabrics can be found in records of tea gatherings written in the Tenmon era (1532-53). During the Edo period (1600-1868) the Tea Ceremony became less of a spiritual ideal for the elite and more a hobby practised by the nouveau riche in which, responding to trends in the wider arts, the decorative aspect of *shifuku* became dominant.

Under the guidance of the influential Tea Master Kobori Enshū (1579-1644), the *shifuku* became as prized as the tea-caddies they held. The first book with a section devoted to textiles appeared in about 1655, and by 1694 the term *meibutsu-gire* had become an established classification, indicative of aesthetic and monetary appreciation for the textiles.[15]

Many extant named fabrics are partly threadbare, with an antique patina created by age and long service. This desolate beauty is respectfully referred to as *sabi*. Mindful of the inevitable wear and tear on textiles, woodblock illustrated books and textile swatch books were compiled during the Edo period to record designs and fashions in taste. The earliest of these, the *Kire Tekagami* (Mirror of Fabrics) is thought to have been compiled by Enshū, and the swatch book itself was stored in an outer bag

made from a fabric named as 'Enshū Donsu'. *Donsu*[16] (shining satin) was introduced from China in the Tensho period (1573-1592) and is a yarn-dyed satin weave in which different warp and weft colours are used to create the pattern. An example of 'Enshū Donsu' can be seen in a composite *shifuku* in the Schmidt Collection (5).

The striped fabric seen in this *shifuku* is a *kantō*, a term used for fabrics imported into Japan from Canton by Dutch and Portuguese traders. Many *kantō* fabrics have patterns of stripes, including those with bands containing floral motifs, and checked and warp ikat weaves from China, Persia, India and Southeast Asia. Some *kantō* fabrics made in Bengal and Madras appear to be cut from bolts of cloth intended for clothing such as *dhoti* (6).

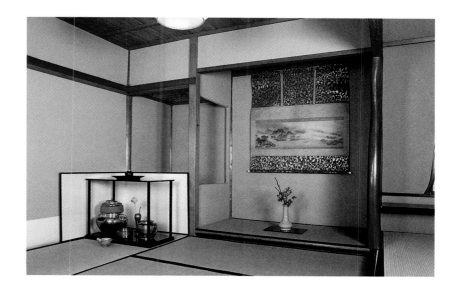

11. *Installation with some of the tea utensils used at the Grand Kitano Tea Gathering. Nezu Institute of Fine Arts, Tokyo.*

The excellent quality of the Indian fabrics, their 'exotic' designs and simplicity of manufacture appealed to the early Tea Masters, and they became some of the first named fabrics, although they were later surpassed numerically by satin weaves and gold brocades.

Named fabrics are also grouped according to their designs. Many gold and multicoloured brocades and satin weaves have Chinese patterns[17] consisting of compound repeating motifs showing a bird, animal or flower set against a geometrically stylised natural motif (7). This type of pattern appears to be influenced by Persian motifs, which have been admired in Japan since the mid eighth century and can be seen in many early objects in the Shōsōin Repository at Nara. Also commonly found on named fabrics are scrolling arabesque patterns, and motifs such as stylised clouds, waves, flowing water, and animals with auspicious or magical connotations such as the phoenix, crane, dragon, *kirin* (griffin) and rabbit.

The Chinese 'Various Treasures' pattern is combined with a floral arabesque on a *shifuku*

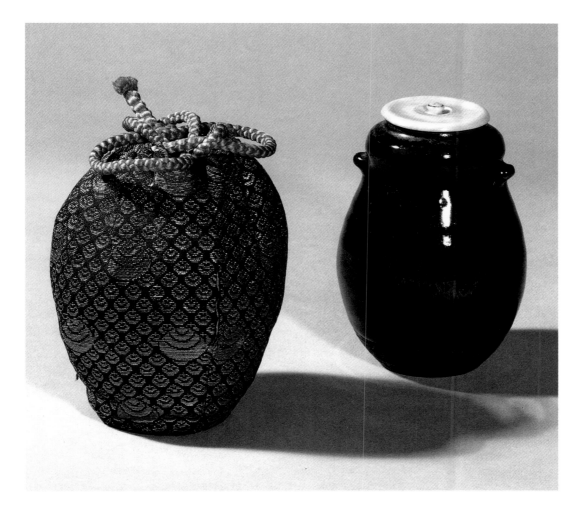

12. *Shifuku, purple and gold brocade with design of Buddhist flaming pearl, Japan, Edo period (1600-1868); tea-caddy, Takatori ware, Edo period. Schmidt Collection.*

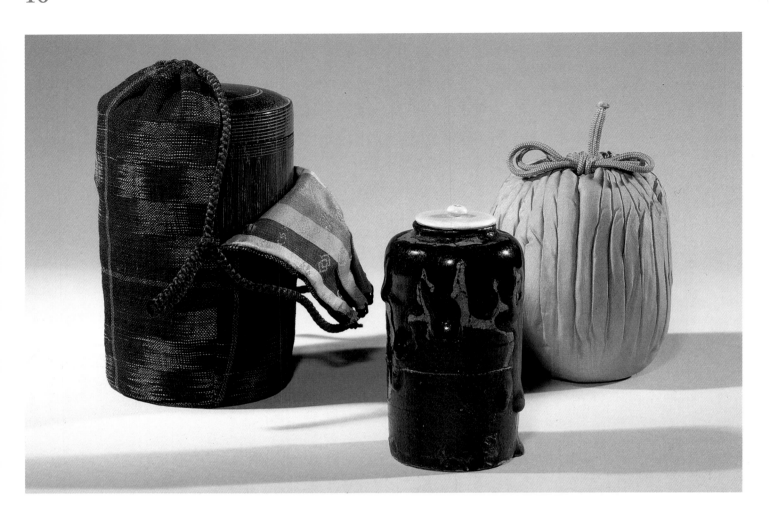

in the Schmidt Collection (**10**). This composite pattern is called 'Daikokuya Donsu', an allusion to the hammer of the god Daikoku (an element in the 'Various Treasures') which releases the flaming pearl of Buddhism. Floral arabesque designs changed over time, with fantastic Indian flowers and lotus appearing when Buddhism was first introduced into Japan in the sixth century, giving way later to gentian and plum blossoms, chrysanthemums, cherry blossoms, and paulownia, while the peony arabesque, dating from the Yuan and Ming dynasties, remained constantly popular.

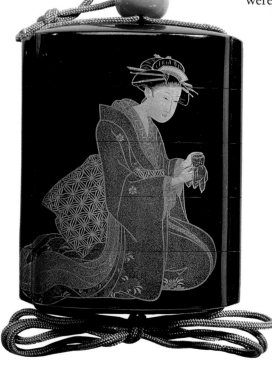

Like the subtle lustre of damasks such as the 'Daikokuya Donsu', the metallic sheen of gold and silver brocade[18] was appreciated in the shadows of the tea-room. Both fabrics were imported from the late sixteenth century through China, but the gold brocading technique was introduced from west India and Persia, and generally features a twill weave ground with the weft pattern woven in thread-like strips of gold or silver paper. A *shifuku* of luxurious purple brocade has a densely repeating gold pattern of the flaming Buddhist pearl (**12**). A similar style, the 'Daitō Kinran' (**9**), is named after the Daitōkuji Zen temple in Kyoto, where the early Tea Masters became lay priests in their study of tea.[19] The gold and orange textile was taken from a Yuan dynasty *kesa* worn by the first abbot of Daitōkuji, who was known as Daitō Kokushi (1282-1337). Derived from the form of a balsam pear, favoured fruit of the Tang Chinese princesses, the cloud motif is redolent with spiritual associations and is commonly found on early priests' robes.

Although chintz had been known in Japan since the late fourteenth century, it only became popular in tea textiles after about 1800. One fifteenth century 'famous fabric' is named after the safflower red predominant in Indian chintz. Persian, Chinese, Siamese and Javanese chintzes differ in the technique of printing the pattern onto calico or cotton cloth, using hand drawing, copperplate or woodblock printing with wax resist methods of separating colours (batik). A *shifuku* from the Schmidt Collection (**1**) has a characteristically red and blue floral patterned Indian chintz combined with an indigo fabric with a stamped gold-leaf design of shields. Heavier fabrics such as *kasuri* were used for larger bags (**13**).

Figured velvets were also used (**15**): velvet was known as *birodo* – a corruption of the Portuguese word *veludo*. In this *shifuku* the lattice of yellow, green, red and vertical white and silver threads on an ivory ground is reminiscent of the seventeenth to eighteenth century *jardinière* velvets made in Genoa.

One of the many procedures in the Tea Ceremony involves the display of distinguished tea utensils – named pieces in particular if one has them. The tea-caddy is shown with its *shifuku*, the drawstrings neatly tied into a decorative knot indicative of whether the caddy contains tea, and placed on a small napkin as chosen by the host. When the caddy is ready to be used it is precisely removed from the *shifuku*, wiped in an act of purification with the host's napkin and placed without its bag on a small napkin. Tea is prepared and drunk and then the guests inspect the tea-caddy and *shifuku* as they wish, always using their own napkins to handle them. Today the Tea Master's napkin is made of plainweave silk, which after weaving may be dyed either purple for a man or red for a woman.[20]

Infused with religious and political significance, the choice of true purple and scarlet may reflect the role of the napkin as a functional representation of the Zen ideals that underlie the Tea Ceremony. The symbolism of the napkin is best explained by Tea Master Soshitsu XV, direct descendant of Rikyū, "When the *fukusa* [napkin] is not being worn it is in a state of *mu* or 'nothingness'; when folded in half and tucked in one's belt, the outer side corresponds with heaven, and the side hidden at the back with the earth – in other words one carries heaven and earth with one. This is a manifestation of yin and yang. By folding the *fukusa* into fourths, it comes to represent The Four Heavenly Kings and the four directions – north, south, east and west. One purifies objects with the feeling that one is conducting a ritual purification of the four directions. When the *fukusa* is folded into eighths, one enters the realm of the Buddha's enlightenment".[21] Thus metaphysical and aesthetic considerations combine to create the overall harmony of the Tea Ceremony, which from its earliest evolution relies on the very juxtaposition of form, media and function within which the colours, patterns and texture of fabrics play a subtle but integral role. *Bibliography and notes see Appendix*

13. *From left: Shifuku, kasuri fabric with silk lining; tea-caddy Shidoro ware, Japan, Edo period (1600-1868); bunched silk shifuku. Schmidt Collection.*

14. *Inrō by Kanshōsai Toyō, with a fashionably dressed girl at a Tea Ceremony, holding a tea-caddy with her napkin, Japan, 19th century. 7.6cm (3"). Courtesy Sotheby's, London.*

15. *An Iga ware tea-caddy, Japan, Edo period (1600-1868), with its two wooden storage boxes and two shifuku: 18th century European brocade (left), and 18th century European velvet (right). Schmidt Collection.*

11

THE EMPEROR'S TREASURE HOUSE

Seventh and Eighth Century Textiles in the Shōsōin

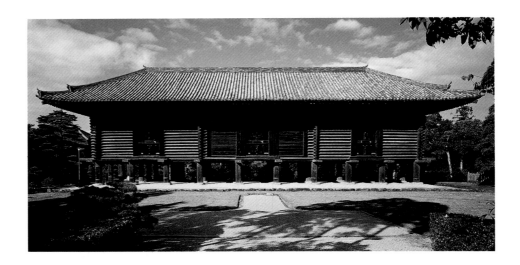

ALAN KENNEDY

The Shōsōin in the historic Japanese city of Nara houses the world's greatest repository of seventh and eighth century textiles. Included in this rich assortment of cloth are a number of large-scale pieces that were once used as interior furnishings. These floor coverings, folding screens and table cloths tell us something about how certain kinds of fabric were used in Asian interiors of that time. They exemplify techniques and designs that were transmitted eastwards along the Silk Road, as well as those that originated in Japan itself.

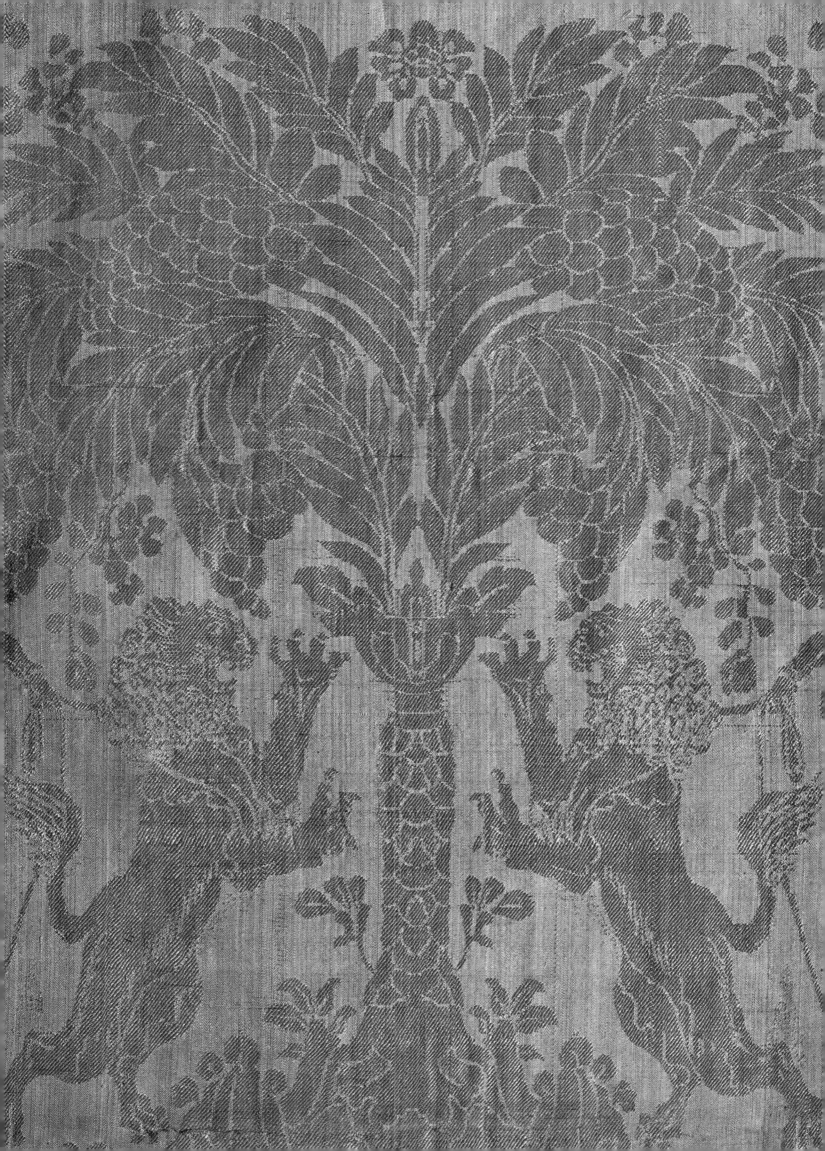

The Shōsōin in Nara is a twelve and a half centuries-old time capsule of Asian life. In terms of both quantity and quality, the collection is astonishing. Of the textiles alone, there are over 180,000 examples, with still more pieces remaining to be counted and catalogued. Extensive inventory records and inscriptions provide valuable information on the dating and usage of many of the textiles, as well as on textile and design terminology of the time.

In 745AD construction was started on one of the most ambitious building projects ever attempted in Japan. The then Emperor Shōmu wished to commemorate both the material and the spiritual progress made in Japan since the introduction of Buddhism in 552AD. Japan, previously a backwater outpost of Asia, lacking even a written language, had made enormous strides in the subsequent two centuries, in part as a result of the civilising influence of Asia's most widespread religion. The nation was mobilised in order to provide the materials and manpower needed to build a giant bronze Buddhist statue *(daibutsu)* and a multi-edifice temple complex in Nara, the then capital. The temple complex has always been known as Tōdaiji (The Great Eastern Temple), a name signifying its importance in Japan, as well as Japan's importance at the easternmost limits of the Buddhist world. The Daibutsu was completed in 752, in time to commemorate the two hundredth year of Buddhism in Japan, and religious officials from as far away as India attended the dedication ceremony.[1]

3. Kasen, detail of 4.

Shōsō was a generic term for the storehouses then in use throughout Japan, mainly for rice, the food staple of Japan. The Shōsōin in the Tōdaiji complex was instead used to house the personal possessions of Emperor Shōmu, who died in 756. Still standing today, although no longer used as a repository, the Shōsōin is of log cabin construction under a tile roof, has about three hundred square metres of floor space, and an overall height of 14 metres (1). Shōsōin textiles today still carry associations with the North, Middle or South Sections of the storehouse. This provides useful information in terms of dating and provenance of individual pieces, as do inscriptions actually written on some of the textiles. The first holdings in the Shōsōin were the approximately 650 objects selected and donated by the dowager empress from the belongings of the deceased Emperor Shōmu. These items were recorded in an inventory that exists to this day. During the following two years, further donations were made by the dowager empress, and were also noted in extant inventories. These earliest donations remained under the control of the imperial family and were kept in the so-called North Section of the Shōsōin. In spite of imperial supervision, within the next century certain objects were 'borrowed' and never returned, or replacements were given for things that were taken. For these reasons, objects associated with the North Section do not necessarily match the original inventories.

In the middle of the tenth century, many objects from a damaged storehouse from another site within the Tōdaiji complex were transferred to the South Section of the Shōsōin building. These items primarily consist of Buddhist ritual objects, textiles included, and are thought to have originally been associated with Emperor Shōmu and with the 752 ceremony consecrating the Daibutsu. This group remained under the temple's control, but its inventory records were somehow lost. Objects from the South Section occasionally found their way to the imperially-controlled North Section, and by the twelfth century the most important treasures belonging to the Tōdaiji came under imperial control and were then moved to the Middle Section of the Shōsōin. Many of the objects that have been in

the Middle and the South Sections bear inscriptions that include dates and information relating to their use. These include costumes, banners, presentation cloths, and other objects that were used in ceremonies between the years 753 and 768. Another large group of objects associated with these sections consists of various tools and garments belonging to the artisans and scribes who were employed in the construction of the Tōdaiji and in the transcription of religious texts.

With the Meiji period (1868-1912) and the beginning of Japan's modern era, changes came about in the composition of the Shōsōin's textile holdings. In the 1870s the Tōdaiji lost all jurisdiction over the Shōsōin as the result of imperial policy aimed at weakening the authority of religious institutions. The Imperial Household Agency and several government ministries became the overseers of the collection. In 1876 it was decided that a large number of objects from the Hōryuji on the outskirts of Nara, Japan's oldest important Buddhist temple complex, founded in the seventh century, should be donated to the Imperial Household in exchange for funds to repair the temple's buildings. The transfer of the Hōryuji items, which included several thousand textiles, was not completed until 1882, when they finally arrived at the Tokyo Imperial Museum. In the intervening six years the objects, while in transit, had been stored in the Shōsōin, and some remained behind at the storehouse. Textiles that entered the Shōsōin as the result of this transfer presumably predate the textiles that have been kept there since the storehouse was built in the mid eighth century. Many textiles remain at the Hōryuji, and they are considered to be as early as the temple's beginnings in the seventh century.

Another development during the modern era affected the textile holdings of the Shōsōin and resulted in the dispersal of some pieces. After the passage of more than a thousand years, many of the textiles in the ancient storehouse had deteriorated and were reduced to fragments, some as small as three centimetres (a fact that helps to account for the extraordinary number of textiles in the storehouse). Some were completely lost: turned to dust inside their storage chests. In 1876 the Imperial Household decided that the three imperial museums could be given examples of Shōsōin textiles of which many fragments existed. Textile firms, schools, small museums and private collectors in Japan also came to possess textile fragments, some pasted into albums. Yamanaka and Co., an international antiques firm based in Japan, was even able to acquire textile fragments for resale. Some fragments eventually found their way into museum collections in the United States as a result of the Imperial Household's decision to deaccession.

The modernisation of Japan also resulted in a more 'Western' approach towards its cultural heritage. The Shōsōin artefacts had for centuries been seen exclusively as precious relics associated with the early period of Buddhism in Japan and with a deified emperor. Now the foreign disciplines of museology and art history started to play a role in the treatment of these objects. In 1883 an invitation-only

4. *Kasen (felt carpet), Central Asia or territory to the north of China, mid 8th century. 2.76 x 1.39m (9'1" x 4'7"). North Section, Shōsōin, Nara, Japan.*

exhibition of Shōsōin treasures was held, probably coinciding with the annual airing of the collection.[2] The first exhibition became a yearly event, although only two or three days in duration, and with strictly limited access. The first public display of some of the Shōsōin textiles took place in 1925 at the Nara Imperial Museum. A study of the textiles was begun in 1908, and is still ongoing. By 1932 some 66,812 pieces had been catalogued. The first publications that included numerous photographs of Shōsōin textiles appeared in 1908.

The next important period of increased accessibility to the Shōsōin textiles came with the defeat of Japan in World War II and its new Constitution in 1946. The imperial collections were nationalised, although the Imperial Household Agency remains the administrator of the Shōsōin collection. Extensive conservation of the textiles was undertaken, continuing earlier efforts that were carried out using traditional Japanese methods. Fragments and complete pieces have been glued, using rice paste, onto large folding screens and hanging scrolls, and into albums, as had been done as early as the seventeenth century. The nume-

5. Kasen (felt carpet), Central Asia or territories to the north of China, mid 8th century. 2.43 x 1.21m (8'0" x 4'0"). North Section, Shōsōin, Nara, Japan.

rous textiles mounted in this manner during the post war period became too cumbersome and bulky to remain in the Shōsōin proper. Instead, a provisional warehouse was used, which by 1959 contained some seventy thousand textile fragments and complete pieces in their mounted format. In 1960 the temporary warehouse was dismantled, and a climate-controlled concrete building was erected. The entire Shōsōin collection is now stored in this and another similar building, while the original wooden structure is now empty and protected as a national historic landmark. When speaking of "textiles in the Shōsōin", it should therefore be remembered that this is just a figure of speech.

Since 1946 there has been an annual two-week autumn exhibition at the Nara National Museum of selected Shōsōin objects. Apart from this, the objects are only rarely lent for exhibition elsewhere in Japan, and are never shown outside Japan. A small format catalogue of the yearly exhibition is published and some textiles are always included. Catalogues are sold to the many thousands of visitors to the exhibition, but are not otherwise readily available. There are surprisingly few other publications relating to Shōsōin textiles, especially considering the age, scope and importance of this collection. Even since the modernisation of Japan, access to the textiles and other Shōsōin holdings has remained under the strict control of the Imperial Household Agency. Curators at the Office of the Shōsōin conduct research and publish their findings on the collection. Their recent publication, *The Treasures of the Shōsōin: Furniture and Interior Furnishings*, has served as the primary source for this article. Apart from research carried out by the Shōsōin Office, much of the work that has been done on the textiles has been by various staff members of Japanese museums that are fortunate enough to possess Shōsōin fragments.

Among the most striking and enigmatic of the textiles in the Shōsōin collections are the large-scale patterned felts called *kasen* in Japanese (**3, 4, 5, 6**). Of the two Japanese

characters that make up this word, the first means 'flower', the second designates woollen textiles. Since all the *kasen* in the Shōsōin have at least some floral motifs in their patterns, the word is accurately descriptive. There are altogether 31 large, rectangular-shaped *kasen* in the Shōsōin with average measurements of about 2.4 by 1.3 metres. In addition there are three smaller, rectangular felts, five square *kasen* and two fragmentary pieces, as well as fourteen unpatterned, monochromatic felt carpets.

Kasen are mentioned in one of the inventories listing objects donated by the dowager empress during the two years following the emperor's death in 756. Sixty examples are listed, including their measurements, but none of the listed sizes correspond with measurements of any of the extant *kasen*. In a document dated 759, those in the inventory are noted as having been released on loan, however there is no record of their return to the Shōsōin or of their eventual whereabouts. The present *kasen* have been stored in the North Section of the Shōsōin, where most of the dowager empress' gifts have remained since the mid-eighth century. Because some of the *kasen* bear a seal on their reverse side stamped with the characters for 'Tōdaiji', it can be assumed that the temple provided the replacements for the missing *kasen* borrowed in 759.

Based on their large sizes, the *kasen* were undoubtedly made as floor or dais coverings. Most of the extant examples are quite similar in size and shape, and some have designs that are virtually identical, meaning that at least some of the carpets were probably used in pairs. Their individual design motifs and patterns were popular across Central and East Asia during the eighth century. The predominant motif is the flower, shown either head on or in profile, sometimes with leaves and stems. Infrequently seen are: a standing male figure – the illustrated example (6) may represent a polo player – mountains (5), clouds and birds. The patterns most frequently feature a central, large roundel, two smaller symmetrically placed roundels, or straight or diagonal rows of repeated motifs. Individual motifs are oriented so as to be seen in an upright position when viewed from either end or from all four sides or corners of each carpet. Their borders are simple; usually a narrow stripe, a series of dots, or an undulating line of half rosettes.

Kasen were made by the age-old method of manipulating loose, wet wool fibres, which is considered to be one of the most primitive means of textile production. First, the fibres, probably sheep's wool, were felted together to make a simple white carpet. Then dyed wool fibres were placed on the white foundation and secured by further felting in order to produce the desired pattern. Very complex patterns with intricate details, as seen in (3, 4) and (5), would have required frequent and minute juxtapositioning of many different coloured fibres. How these precise arrangements of multi-coloured yarns remained in place during the heavy manipulation necessitated by the felting process remains unclear.

It is not easy to determine where these carpets were made. No other complete or fragmentary carpets of this type or period are known outside of the Shōsōin collection. The few felt fragments recovered from Asian archaeological sites dated to the eighth century or thereabouts do not relate to the *kasen* in Japan. Substantial felt carpets found in sites located in Mongolia and Siberia, which date to the first century AD and earlier, are unrelated both in technique and design. Contemporary descriptions in literature or depictions in paintings have also failed to pinpoint the origin of the *kasen*. Japan is an unlikely source, since it has never had a long documented tradition of sheepherding or the production of woollen textiles. However, records which date to the eighth and the tenth centuries mention woollen goods and *kasen* being sent as tribute from the provinces to the

6. Kasen (felt carpet, detail), Central Asia or territories to the north of China, mid 8th century. 2.37 x 1.24m (7'9" x 4'2"). North Section, Shōsōin, Nara, Japan.

capital, and such items could have been imported from the Asian mainland.

China also lacks a long history of woollen textile production. For the Chinese, silk has always been the textile fibre of preference. Several of the many different peoples on China's borders are more likely candidates as producers of these or of related felts, but concrete evidence is so far lacking. Depictions of what are thought to be felt carpets appear in manuscripts, paintings and murals of Central Asian origin. They are attributed to the Uighur people, and dated to the eighth and ninth centuries. Although these depictions are contemporary in date with the *kasen*, they show designs that are more abstract and curvilinear than those of the Shōsōin felts. The Uighur felts are closer in design to ancient felt carpets found in Mongolian and Siberian sites, and to the relatively modern felts of the Kirghiz, Mongols and Kazakhs. Both the ancient and modern felts are typically patterned by means of appliqué and embroidery. These felt-making traditions are therefore unrelated in design or technique to the *kasen* in Japan.

One possible clue to the origin of the *kasen* can be found in labels attached to one of the fragmentary pieces and to one of the unpatterned felts. Notations on the labels are thought to refer to the Unified Silla Dynasty (668-918), then located in part of present-day Korea. Whether this was the place of manufacture for the *kasen*, or simply a transit point for them, is uncertain. One other theory proposes that painted ceilings inside caves at the Buddhist site of Bezeklik in Central Asia have a possible relationship with the patterns seen in *kasen*.[3] Perhaps further examination of current archaeological evidence from the Asian mainland and new archaeological finds will help solve the mystery of where these felt carpets have come from.

Another group of large-scale furnishing textiles from the Shōsōin were used in a vertical manner. Following the custom then current in China and Korea, interior spaces were not divided into rooms by walls or partitions. In Japan, as on the Asian mainland, folding screens and textile hangings primarily served the purpose of creating more intimate spaces within otherwise large, undivided interiors. They also enriched the visual environment of the sparsely furnished interiors of the time. The folding screen, as it existed in the eighth century, measured about one and a half metres in height, its six panels having a combined width of about three metres when fully extended. Screens of this format and size have been used continuously in Japan up to the present day. They are still made by the original method, using simple wood frames

covered with paper or fabric layers, which serve as the ultimate support for the outermost decorated surface of the screen. The panels which make up a screen are joined together by fabric or paper hinges, which run the length of each panel. Individual panels are now all that remains of what were once six-panel screens in the Shōsōin. Of the 106 screens (representing originally a total of 636 panels) listed in inventories associated with the Shōsōin, only forty intact panels remain. A number of these are decorated by means of textile techniques, rather than by painting.

In the inventory of Emperor Shōmu's effects dated 756, ten folding screens are listed as *rōkechi*, meaning their designs were rendered by means of a resist-dye method.[4] Of these ten six-panel screens (sixty panels in total) four single panels remain intact, although the dyed lengths of fabric from the original panels have been remounted onto other supporting surfaces for conservation purposes. Three other *rōkechi*-dyed lengths of fabric have been reconstructed from numerous fragments.

Two of the four extant complete lengths show identical weave irregularities and therefore seem to have been made using plainweave fabric from the same bolt of silk (**8**). In addition, a document dated 856,[5] lists a folding screen with motifs similar to those that appear on these two remaining lengths, and with the same background colour. It therefore seems likely that they once formed part of the same screen. They also share certain identical motifs, such as the various tufts of grass, indicating that the resist substance for those motifs was applied using the same stencil (or woodblock). A possible clue as to their place of manufacture can be found in the form of a small ink inscription that appears on the panel shown on the right. The simple notation, equivalent to a date of 751, is thought to be of the type originally written on bolts of cloth that were sent from the provinces to the capital as a form of tax payment. This would indicate that the plainweave silk used for the *rōkechi* textiles was woven in Japan, and, presumably, that the dyeing was done there as well. Furthermore, the date of manufacture can be placed within the period 751 to 756.

There remains the remote possibility that the plainweave silk was sent out of Japan, to China, for example, in order to be resist-dyed. There is evidence, however, that folding screens were made in Japan. In the course of conservation work on panels belonging to another screen listed in the 756 inventory, scrap papers that formed parts of the supporting layers were discovered within the panels. These proved to be documents that were written in Japan.

The unique function of these textiles can be seen in other ways. As befitted use on folding screens, their motifs are all oriented in an upright direction. The principal motifs are impressive both for their scale and overall size, and some have been enhanced by the addition of white and green pigments. The designs used are fairly exotic: the elephant (**8**), for example, is not an animal native to Japan. As in the other complete lengths, the principal animal motifs appear beneath the base of the central tree. This is an unusual juxtaposition, and is perhaps a Japanese variation of the Western Asiatic composition featuring paired animals on either side of a tree (see **12**).

If compared to other *rōkechi*-dyed textiles of the period that have been found on the Asian mainland, the textiles discussed above have no equivalents in terms of principal motifs, size and painted highlights. It may well be that this particular resist-dye technique was introduced to Japan via China, for example, or executed in Japan by Chinese dyers. Chinese tombs as early as the Han Dynasty (206BC-220AD) have

7. Kyōkechi (clamp-resist dyed) silk panel, Japan, 756 or before. 1.50 x 0.57m (4'11" x 1'11"). North Section, Shōsōin, Nara, Japan.

8. Rōkechi (resist-dyed) textile panels, Japan, ca. 751-756AD. Each 1.63 x 0.57cm (5'4" x 1'11"). North Section, Shōsōin, Nara, Japan.

yielded textiles that are considered to have been dyed using this resist method.[6]

The textile technique that was used to decorate the majority of the folding screens listed in the inventory of 756 is called *kyōkechi*. Of the 65 screens noted (390 panels in total), only a very few of the *kyōkechi*-dyed lengths survive, and an additional few are extant in fragmentary form. The resist-dye process of *kyōkechi* is best known as clamp-resist dyeing in the West. It is still not fully understood, but the basic principle involved the use of a single or a pair of boards carved with the desired pattern. The textile to be dyed was folded and sandwiched between the boards, dyes were then poured through holes on the uncarved side of a board, according to the colours desired for the various motifs within the pattern. It is not clear if just one or both of the boards were carved with the pattern. Textiles dyed using this technique usually have a polychrome pattern against a solid colour background. The *kyōkechi*-dyeing process facilitates the use of several colours, allowing for more flexibility in colouration than the *rōkechi* method. All that was required was to pour the dyes into the holes corresponding to different parts of the pattern. Even so, painted and inked details were sometimes added to *kyōkechi*-dyed textiles in the Shōsōin.

The folding screens required motifs that appeared upright. To achieve this the fabric was folded lengthwise before being inserted between the wooden boards for dyeing. The pattern thus appears in mirror-image across a vertical axis. The boards must necessarily have been fairly long since the height of a screen panel is approximately a metre and a half. At the same time, because the textiles were folded vertically the width of the boards would have been rather narrow, the equivalent of half the width of a screen panel. Unlike *rōkechi*-dyeing, where a plainweave silk was most often chosen, *kyōkechi*-dyed textiles usually have twill or gauze-weave structures. Since two layers of silk were dyed simultaneously, it was important to use a silk that was not too tightly woven.

Due to the large quantity of *kyōkechi* screens listed in the inventory of 756, it is assumed that the technique was well-known in Japan, and that the *kyōkechi*-dyed textiles in the Shōsōin were of Japanese manufacture. The technique itself may originally have been developed in China. The Chinese term for clamp-resist dyeing, *jiaxie*, is written using the same two characters that are used for the word in Japanese. Since the Japanese began to use the Chinese writing system in the sixth century, the duplication of the written word for the technique in Japanese was probably the result of the technique itself being introduced by way of China. It is probable however that *kyōkechi*-dyeing was not practised in Japan prior to the eighth century. No examples are found amongst the numerous textiles associated with the Hōryuji, which was founded in the seventh century. The earliest known textiles found in China which are thought to have been dyed using this method date to the fifth or sixth century.[7]

Several of the *kyōkechi*-dyed textiles follow the design format seen in the *rōkechi*-dyed textiles, featuring, as in (7) a large-scale animal motif well beneath the base of a single tree. However, as the result of the mirror-image effect of *kyōkechi*-dyeing, the animal motif appears twice. The colours on the left half of this example are generally less vivid than those on the right, indicating that when folded prior to being clamped between the boards, the left half of the textile must have been facing downwards, underneath the right half, thereby receiving less of the dyes that were poured through the uppermost of the two boards. Perhaps the blue of the rock formation to the tree's left was enhanced with blue paint after the dyeing was completed. The paired animals-and-tree design harks back to the Western Asiatic format, but here

9. Featherwork panels, Japan, 756 or before. Each 1.49 x 0.56m (4'11" x 1'10"), excluding the textile border. North Section, Shōsōin, Nara, Japan.

the animals are so far removed from the tree itself that they are instead flanking a flowering plant, which is outscaled by the deer. This can be considered a Japanese variation on the original design concept. Other designs among the Shōsōin clamp-resist textiles feature landscapes, which were perhaps influenced by Chinese painting.

Another decorative technique found on textiles in the Shōsōin collection involved the use of feathers. Two different sets of six screen panels feature written characters formed by feathers pasted onto paper. Both sets of panels, which are no longer joined, are from screens listed in the 756 inventory. The use of feathers to depict written characters is an effective way to imitate brushstrokes, while at the same time giving a three-dimensional aspect to the characters (9). It appears the characters were outlined in black ink before the feathers were applied. The style of the calligraphy in this example is based on the hand of Wang Xizhi, who lived in China during the Eastern Jin Dynasty (317-420). The text contains words of wisdom for rulers and heads of families. These panels, which are also thought to be Japanese-made, use feathers from birds native to Japan. Traces of featherwork are also found on another set of six painted panels that once formed a folding screen. In some of these panels the previously mentioned Japanese documents were found, further indicating a Japanese origin. Featherwork may have originally been a Chinese technique; its use never seems to have been widespread in Japan, whereas in China jewellery decorated with kingfisher feathers has been popular into the twentieth century.

At the end of the seventeenth century, and again around the middle of the nineteenth century, restoration work was carried out on these panels. At some time the fabric border surrounding the two panels illustrated here was replaced, but the textile currently in place dates to the same period as the panels themselves. It consists of a weft-patterned silk of a type and design that is fairly common among Shōsōin textiles; apparently, there was enough of this fabric for restorers in recent centuries to feel no compunction about using eighth century fabric to remount a screen panel. In this they were following a long tradition of matching the period of the work on a screen with the period of its textile border.

The pattern of the border, only partly visible, consists of roundels and intervening quatrefoil medallions. Other identical textiles, as well as those with the same structure and design but in a different colour scheme, are known in the Shōsōin collection.[8] This design

10. Asa (hemp) curtain fragment, Japan, 8th century. 0.71 x 1.21m (2'4" x 4'0"). Middle Section, Shōsōin, Nara, Japan.

was quite popular throughout Central and East Asia, and is found in different variations (4, 11 and 13) and even on a lacquer box in the Shōsōin.[9]

Another type of vertically oriented furnishing textile represented in the Shōsōin collection are curtains made of *asa*, the bast fibres know as either hemp or ramie in the West. Cloth made of *asa* was produced all over Japan since early times, and, unlike silk, did not originally come from the Asian mainland. Bolts of *asa* cloth were a common form of tax payment: a long curtain in the Shōsōin with a painted cloud motif bears a dated inscription naming the village where its *asa* cloth was sent from.[10]

Fragments of what was once a substantial curtain painted with images of animals also survive in the Shōsōin. One of the fragments (10) still has the tabs attached along the top, through which a cord was strung for suspension. Both selvedges are present on this example, which shows the rear portion of a dragon painted in colours within a black ink outline. The partial dragon and the presence of other incomplete animals on other fragments of the same curtain,[11] suggest that the original subject matter was the set of twelve animals of the Chinese zodiac.[12] It is thought that the animals were originally painted on two different curtains, with six animals per curtain. The extant fragments show that some animals face to the right and some to the left. The original curtains probably flanked a central entranceway or an altar, orienting the animals inwards towards a focal point in the interior space.

The last type of textile to be examined here is the *joku*. During the eighth century, *joku* was used as a generic term for any flat, textile-covered pad that served either as seating or bedding, or for the presentation or display of treasured objects. They were used horizont-

11. Joku (padded textile), Japan, ca.757. Damask-weave silk, 0.53 x 1.07m (9" x 3'6"). South Section, Shōsōin, Nara, Japan.

ally on floors, beds, chairs, platforms, shelves, and low tables, and even as linings inside containers. The *joku* consists of a fine textile on top, a plainer textile underneath as a lining, and a padding material in between, generally of *asa* fabric and silk wadding; most have a contrasting textile border surrounding the principal textile used on the face of the *joku*. It is probable that they were assembled in Japan, although sometimes imported textiles were used.[13] Often they were made as accessories to specific articles of furniture, usually low tables that served as stands for objects that were presented during ceremonies in temples. Such *joku* correspond in shape and dimensions to the wooden top of their accompanying stand. Many have survived in the Shōsōin, with over sixty examples preserved in the South Section alone.

One of the rarest and most exotic textiles in the Shōsōin, at least from an East Asian point of view, was used for the face of two *joku* that are similar in size and shape. The example illustrated here (**12**) and its companion piece[14] appear to be continuous lengths cut from the same bolt of damask-weave silk. The uppermost part of the palm tree in the illustrated example is found at the base of its related *joku;* in the latter, a full repeat of the same pattern unit, followed by another repeat which appears upside down, appear above the palm tree. Assuming there were at least as many pattern units woven inversely as those right side up, the original bolt of silk would have been at least three metres long. Also, the sections of fabric seen on the two *joku* do not use the entire loom width of the silk, which would appear from a study of the pattern elements to have been at least one-third wider than the fabric shown.[15] From the point of view, therefore, both of the width and the dimensions of the pattern, the use of this particular damask-weave silk for the two *joku* seems inappropriate. Nor is a one-directional pattern a practical choice for a textile that

was meant to be seen horizontally. Such a pattern would have been more appropriately displayed vertically, as on a folding screen. Based on its motifs, the textile was probably of west Asian or even Eastern Mediterranean origin. The principal elements in the pattern are quite foreign to East Asia. The realistic lions are unlike the fanciful versions of the animal that appear in Chinese and Japanese textiles (13). Neither are palm trees nor sparsely-clothed secular male figures seen in East Asian design.[16]

The silk is also quite unusual technically, differing from the textiles used on most of the *joku* in the collection. The pattern shows a twill structure, with the direction of the twill slanting from lower left to upper right. The background also has a twill structure running in the same direction as the pattern.[17] Usually, the pattern and ground have their twilling running in opposite directions, which increases visibility. A damask-weave textile with same-direction twilling in both pattern and background will produce a pattern that has diminished visibility and little contrast with its background. On this textile the pattern is made more visible by the use of differently coloured (light and dark brown) warp and weft threads. These unusual characteristics – background and pattern twilling in the same direction and warp and weft of a different colour – occur in a textile fragment found in Dunhuang in Central Asia, dated to the eighth to ninth century, with the partial image of a peacock,[18] and in a poorly preserved Shōsōin fragment.[19] But as far as the Shōsōin *joku* are concerned, these features are found only in a very small group of the textiles used, all of which were donated by the then empress in 768 and are thus slightly later in date than most Shōsōin textiles. The exotic textile seen in (12) could have served as a prototype for at least one of the *joku* in this group,[20] which features a textile that shares coloristic, technical and design features with that of (12). The textile on the *joku* from the 768 donation has a design of paired horned animals under a tree alongside a pair of phoenixes under a tree. However, while the animals-under-a-tree composition is considered to be of west Asian origin, the choice of animals is more typical of east Asia. Also, the motifs and pattern units in the 768 textile are much smaller in scale than those on the other *joku,* and consequently more suited to the dimensions of its *joku.*[21]

Another *joku* in the collection (11) uses what is thought to be a Japanese-made textile with a design that is multi-directional, and therefore more appropriate for use in a horizontal manner. Other textiles in the Shōsōin have the same lion-flower pattern, occasionally in different colour combinations. Textiles with this pattern and weave are found on many of the banners that were used for a memorial service for Emperor Shōmu in 757, which suggests that this *joku* was probably assembled around that date.[22] These motifs repeat in an overall symmetrical fashion, following the popular Central and East Asian roundel and quatrefoil medallion pattern seen either partially or complete in (4, 11, 13). Both the textiles that have been used on the face of this example are weft-patterned silks. The border fabric has a floral design alternating horizontally on a changing-colour background; the fabric is bias cut at a 45 degree angle to the warps so that the pattern appears on the diagonal. Purple braid has been applied along the inner seam. The *joku* has the standard

12. Joku (padded textile), East Mediterranean or west Asia, first half of the 8th century. Damask-weave silk, 0.99 x 0.52m (3'3" x 1'8"). South Section, Shōsōin, Nara, Japan.

interior padding of hemp cloth and silk wadding, and its reverse side is covered with the same type of Japanese plainweave silk used for many other joku linings.

The last *joku* to be examined (13) is again one of a pair and an inscription in the lining shows it to be part of the 768 donation. Its principal fabric is also a damask-weave silk, but the twilling in the pattern and the ground slant in opposite directions, as is normal in most Shōsōin damasks. Once more this textile shows the unusual characteristic of warp and weft threads in different colours, allowing the pattern to be more visible, while the overall effect is still subtle. The design of the main fabric of the *joku* is a variation of the roundel and quatrefoil medallion pattern, but in this example the central floral motif has lost its roundness and taken on angular contours. It appears that the border fabric, a damask-weave silk, is woven with the same pattern. In any case, such a textile is appropriate for a *joku* that was used for the purpose of displaying objects and for covering the tops of tables, which were sometimes brightly painted. Its light colour and subtle symmetrical pattern would help set off, but not clash with, the object being presented and the table below it.

A final word should be said about the long-standing and still unresolved question of the origin of certain Shōsōin textiles. In the course of this century, more and more Shōsōin textiles as well as other objects have been attributed to Japan, among them a large group of polychrome glazed ceramics previously thought to have been made in China. As far as the textiles are concerned, many specimens remain to be catalogued, along with a large number of manuscripts that could yield further information and lead to new attributions. Most of the problems of attribution result from the internationalism of eighth century Asia. As people travelled extensively and traded large quantities of goods along the Silk Roads, religious thought, customs, fashion and technology were also freely exchanged. Discovering the original source for a particular textile is made even more difficult by the movement of textile artisans and textile materials. Chinese and Korean weavers are known to have settled in Japan prior to the eighth century, and it is likely that they were instrumental in establishing an industry there that allowed for the production of certain textiles that could rival those made on the Asian mainland. The imperial court led the campaign to learn from and emulate skills practised on the mainland, and workshops specialising in weaving, dyeing and embroidery were established to further those aims in textile production.

In order to advance the study of the Shōsōin textiles, and to seek more answers to the many questions that they pose, there needs to be greater international awareness of this remarkable collection. At the same time, the officials who control access to the objects, and the scholars whose job it is to research the collection, should begin to facilitate the study and exchange of information on Shōsōin objects with outside researchers. One obvious and much needed collaborative project is that of establishing a systematic comparison of archaeological finds from the Asian mainland with the myriad objects preserved above ground for over twelve hundred years in the Shōsōin.

Glossary, bibliography, notes, see Appendix

13. Joku (padded textile), Japan, 768 or before. Damask-weave silk, 0.98 x 0.54m (3'3" x 2'1"). South Section, Shōsōin, Nara, Japan.

12

SILK OF THE NORTHERN SONG

Reconstructing the Evidence

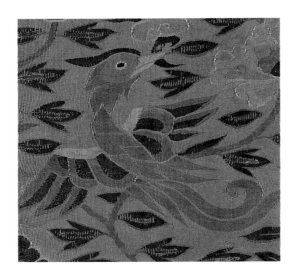

SHELAGH VAINKER

China's Northern Song dynasty (960-1126AD) is renowned for the collections of paintings and antiquities acquired and catalogued by its last ruler, the Emperor Huizong (r.1101-1125). Craftsmen of the period also produced many fine objects for use at court, of which ceramic production is probably the best known, and silk the most elusive. Pagodas and tombs have yielded some silk textiles, and by examining these in conjunction with contemporary records, it is possible to recover an impression of the importance of these largely vanished textiles within Northern Song society.

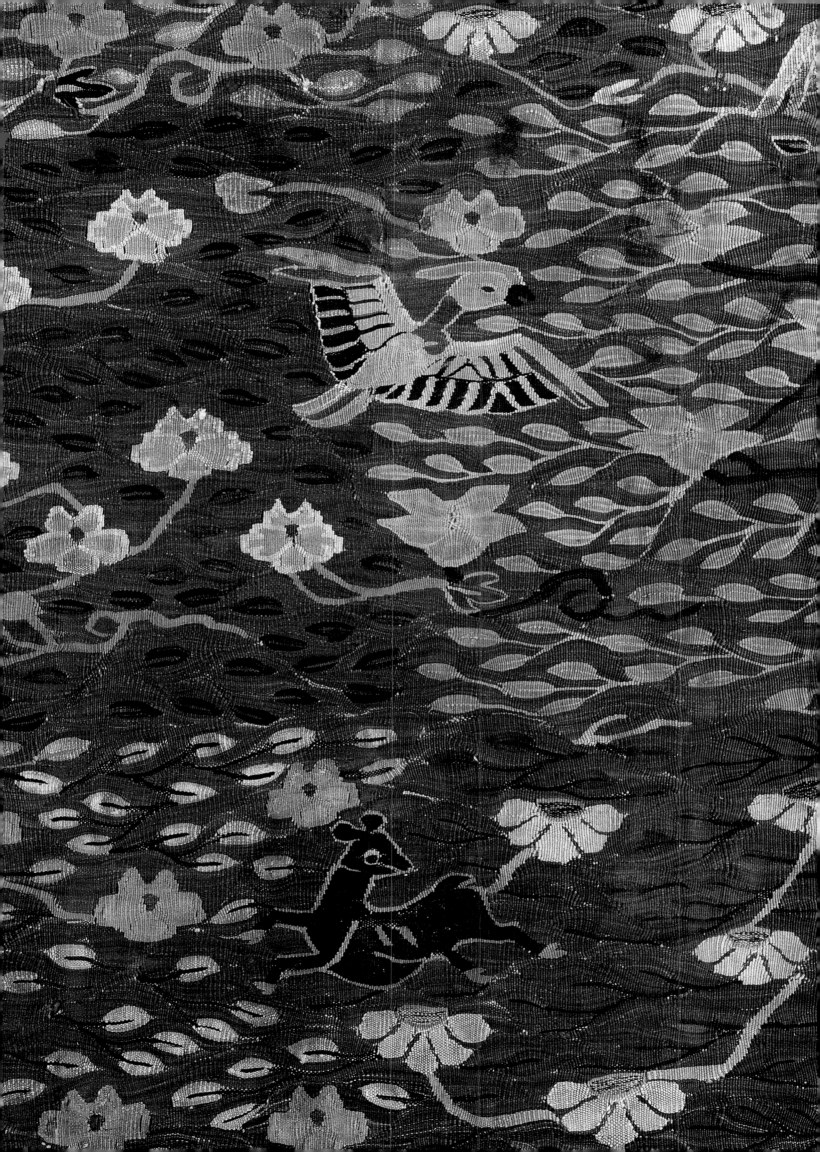

1. Title page: Detail of an 11th-12th century silk kesi scroll cover (see 19).

2. Previous page: Silk kesi panel (detail) with deer, bird in flight and flowering branches,10th-11th century. Height 53cm (21"). Musée Guimet, Paris, inv.no. MA5964.

3. Embroidered silk fragment from the border of a painting, with bird in flight, deer and peony, from Cave 17, Dunhuang, 10th century. 31 x 17.5cm (12" x 7"). British Museum, London, inv.no. 1919.1-1.052.

Silks of the Northern Song dynasty (960-1126) are scarce. Of those that survive some were preserved in pagoda deposits, some were excavated from datable tombs, and some are to be found in public and private collections throughout the world. Studying examples from tombs and pagodas in conjunction with other Northern Song objects and the numerous texts of the period relating to silk should enable us to have a better understanding of the more familiar collected pieces, while the contemporary texts and objects may help to recreate an impression of silk as it was encountered during that dynasty: its distribution, economic importance, use for religious, social and practical purposes, its ornament, and its relationship to other luxury products.

Many official and unofficial silk records of the eleventh and twelfth centuries survive. They include Qin Guan's *Can Shu* or 'Book of Sericulture' written around 1090; an account of an Imperial silkworm ritual in the *Songshi* (Song History);[1] records of regional taxes paid in silk in the 'food and goods' section of the *Songshi*;[2] references to silk in descriptive texts on more general topics, and numerous observations scattered in the jottings of such widely-quoted writers as Hong Hao, Zhuang Zhuo and Zhou Mi. All of these supplement our understanding of the silks which still exist.

Imperial involvement with the use and particularly the production of objects indicates how highly esteemed such objects were. One such instance is the Emperor Zhenzong's revival, in 998, of the Tang practice of making silk offerings in spring. In the first year of the Xuanhe period (1119), the Empress personally performed the ritual in the Yanfugong within the Imperial palace. The ceremony, described at some length in the *Songshi*,[3] was a complex one involving the Empress's progress through the capital in a sedan chair, attended by many ladies-in-waiting, before selecting the mulberry leaves for the offerings.

A twelfth century painting now in Heilongjiang Provincial Museum[4] provides further evidence of imperial involvement. It is one of a pair depicting the time-honoured subjects of ploughing and weaving, originally commissioned by the Emperor Gaozong and painted by the academician Lou Shou (1090-1162).[5] Gaozong was the first emperor of the Southern Song Dynasty (1127-1279), and it has been suggested that the scroll is a contemporary copy of the Southern Song original with possible additions by Lou Shou; the practices described in it must anyway be close, if not identical, to Northern Song methods. The scroll, a little over five metres in length, is titled *Illustrations of Sericulture* and painted in light colours on silk. It describes, in twenty-four sections, the processes of silk production current in the Jiangsu Zhejiang region, from "washing the silkworms on the appropriate day of the twelfth month" to "removing from the loom and placing in cases". Each is annotated in the hand of Gaozong's Empress Wu, it is thought, and the scroll is wrapped in a piece of Song *kesi* silk decorated with birds and beasts among flowers.

Narrative handscrolls were commissioned in quite large numbers by Gaozong, many of them to illustrate texts from the classics, often written out in his own calligraphy.[6] This interest in the classics displays a concern with antiquity and morality, and may be seen as part of the Emperor's task of bolstering the image of his own legitimacy – he had in fact seized the throne from his brother Qinzong. In this context, the Empress's silk scroll is a reminder both of the traditional overseeing of silk by the female head of the Imperial household, and of the country's economic foundations in agriculture (ploughing) and sericulture (weaving).

Official sponsorship of the silk industry is evident from the fact that, as early as 967, a *ling jin yuan* (government workshop for patterned silk fabrics) was established at Kaifeng,[7] and a century later, in 1083, a *jin yuan* (government workshop for brocades) was opened in Chengdu, Sichuan.[8] The Sichuan workshop products included designs combining squares and circles, either overlapping, as in (4), or connected by straight lines, as in the *badayun* (literally 'eight reciprocating haloes') design for which the workshops were renowned, and which also incorporated a 'single cash' motif (5) in two colours. This regionalism is reinforced by the descriptions in the *Can Shu Book of Sericulture* of silkworm breeding in Shandong in the north, as well as in the Zhejiang/Jiangsu region.[9]

One indication of the importance of silk to the Northern Song economy is the fact that it was used in a limited way as currency. During the Five Dynasties period in the first half of the tenth century, before the Song established control over the whole country, the local coinages of China became disunified. We read that "in fact the coins of Wu and Shu (Zhejiang and Sichuan) cannot circulate in each other's territories. Only silver and cloth can penetrate to a distance."[10] The use of silk as tribute in the sense that it counted as tax payment is well documented for many periods of Chinese history – indeed the 'Cloth and Silk' chapter of the food and goods section of the *Songshi*[11] is concerned largely with which

4. Drawing of a 'Crane and lantern' design polychrome silk, of the type produced in the government workshops in Chengdu, Sichuan, in the 11th century. Examples survive in Sichuan Museum, Chengdu. After Shujin shihua, Chengdu 1979, p.33.

5. Canopy tassel incorporating the 'single cash' or 'brocade ball' design, from a mural in Tomb no.1, Baisha, Henan, dated 1099. After Su Bai, Baisha Song mu, Beijing 1957, p.126, fig.30.1.

6. Embroidered gauze fragment with lotus and water-chestnut flowers (detail), Tiger Hill pagoda, Suzhou, 10th century. After Gao Hanyu, Chinese Textile Designs, Hong Kong 1986, no.250.

7. *Gauze with a scrolling floral design (detail), Northern Song (960-1127). After Gao Hanyu, Chinese Textile Designs, Hong Kong 1986, no.45.*

regions paid what proportion of tax in silk goods – but suggestions of silk functioning as currency are very much less frequent. Given the paucity of conclusive documentation, it is instructive to examine the names of the regions and the types of silk, in order to acquire some sense both of the location of principal silk-producing areas, and of their output.

The regions most frequently mentioned in the *Songshi* are Zhejiang, Jiangsu, Sichuan, Hebei, Shandong as well as Jiangxi and Shaanxi, while the cities of Chengdu and Dingzhou are also cited, the former frequently. The silk types include *jin* (brocade), gauze, *juan* (thin tough silk), silk wadding and others. The single prefecture of Yue, in the Zhejiang area, paid three hundred thousand bolts of silk annually to the government during the mid Northern Song period; in addition the government purchased a further three million bolts a year from the same region.[12] The quantities produced, then, were large, and the south-east was by no means the only silk-producing area. Silk was not only received as tax by the government, but it was also paid out by them, under the terms of an elaborate tribute system laid down in the Treaty of Shanyuan in 1004, to the Qidan Liao on the Song's northern borders and also to the Tangut Xi Xia in the west. The quantities involved eventually reached three hundred thousand bolts annually to the Liao[13] and one hundred thousand to the Xi Xia, with the balance of the sums demanded paid in silver.

Silk thus enabled the Song to stave off military incursion into their territory, yet it played a part in more harmonious exchanges too. The Koreans, who allied themselves alternately

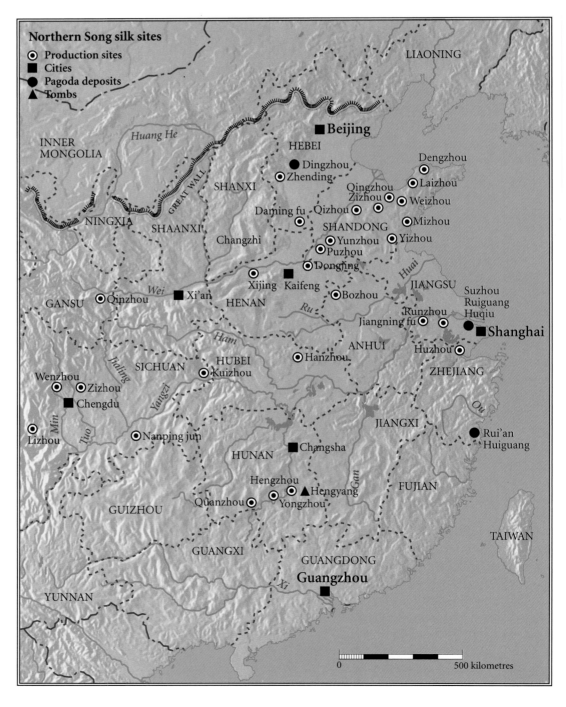

with the Song and the Liao, though principally with the latter, since they posed the greater threat, sent an embassy to Kaifeng in 1071, and in the following year the Song reciprocated with an embassy to Korea. An account of that ambassadorial retinue and the gifts they bore is preserved in the *Koryosa*,[14] the Korean official history, where we read that many types of fine silk were presented to China's eastern neighbours. They were mostly made up into items of official dress, which included gold and red gauze jackets, red embroidered jackets with gold and silver embellishment, white brocade sashes, red silk saddle blankets, and green and white silk accessories, as well as bolts of red plum blossom silk and embroidered silk gauzes.

Such records confirm that silk was important at every level of the economy, and to diplomacy, and thus to the Imperial house. An impression of the uses to which it was put may be gained from the detailed descriptions of dress – different colours, various weights and types of silks for soldiers, officials, ambassadors and so on – preserved in a number of textual sources, particularly the *Dongjingmenghua lu*, an account of the Northern Song capital compiled twenty years after its fall, by Meng Yuanlao. Examples of some of these textiles survive, while no material evidence remains of the other silk objects described in the texts such as lanterns, parasols, domestic hangings, wrapping cloths and fans. Paintings and tomb murals give some idea of dress style, but otherwise these aspects of silk use remain unillustrated in contemporary records and unrepresented in modern collections.

The pieces of Northern Song silk which have survived come principally from the three

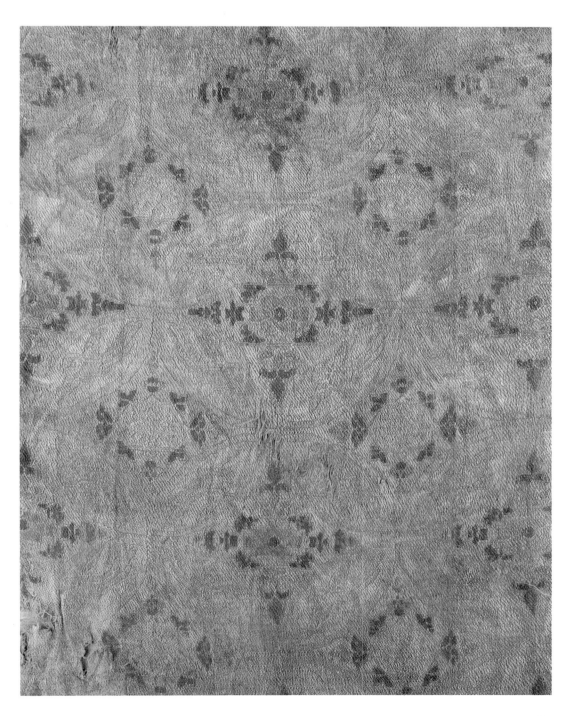

8. Detail of polychrome woven silk from a set of garments, China, 10th-11th century. Diameter of circle 10cm (4"). The design resembles Song architectural ornament, see 10. Courtesy Spink & Son, London.

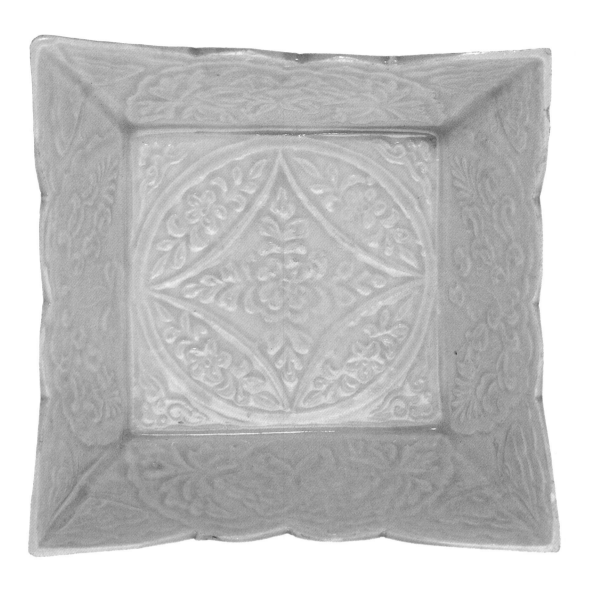

9. Square dish, northern China, Liao dynasty (907-1125), with moulded 'single cash' decoration. Each side 10.5cm (4"). Urban Council Hong Kong, Hong Kong Museum of Art, inv.no. C 88.45.

sources mentioned above: pagodas, tombs, and collections in both public and private ownership throughout the world. Some other more familiar fragments might possibly also be of Northern Song date – those collected by Sir Aurel Stein from Cave 17 at Dunhuang, and now in the collections of the British Museum and the Victoria & Albert Museum in London and the National Museum in New Delhi.

The contents of Cave 17 are dated primarily to the Tang, yet it is important to remember that the cave was not in fact sealed until some time in the early eleventh century. A painting dated 972[15] and now in the British Museum once included in its border an embroidered fragment (3).[16] It has been said that the rudimentary style of the painting reflects the isolation of Dunhuang in the tenth century, and this isolation should also prompt caution about giving the textile exactly the same date as the painting. There is no reason to believe it was not attached in 972, but since with few exceptions the Dunhuang silks are from central China, they would almost certainly have been regarded as precious enough to preserve and re-use. The fragment might thus pre-date the painting by as much as a few decades. It is embroidered in six colours onto gauze supported by dark green plain silk. The ornament lacks the density of many Northern Song floral designs, but the motifs – peony, bird in flight, deer – are all standard on, for instance, the *kesi* weaves of the period. Technically, the embroidery style may be compared to excavated fragments of known mid tenth century date from the second floor of the Yanyun Temple pagoda at Tiger Hill, Suzhou, which was built in 961 (6).[17] The long stitches forming open blooms in several colours on a gauze ground are similar to those on another Stein fragment in the British Museum, a sumptuous piece embroidered in ten colours with flowers and a deer,[18] while a plainer weft-patterned twill fragment from Tiger Hill[19] is comparable to one of the silks incorporated into the large eighth to ninth century 'patchwork' *kasaya* (monastic robe) in the British Museum.[19]

A further example of religious silk preserved outside China is the group of fragments discovered inside a wooden statue of Sakyamuni at Seiryo Temple, Kyoto, where it was deposited in 986 by the monk Chonen on his return from China.[20] It is clear that these

10. *Design for beaming, from Yingzao fashi (Construction Styles), compiled ca. 1100.*

tenth century silks preserve aspects of Tang dynasty ornament while anticipating some of the motifs and styles of Song textiles. The similarities shared by fragments from such widely distanced sites is also worth noting, and perhaps indicates that the silks discovered at Dunhuang in the far northwest came from the important Jiangsu production centre on the eastern limits of China.

A late tenth century and therefore firmly Northern Song religious context in which silks have appeared is that of the Jingzhi Temple pagoda at Dingzhou in Hebei Province, best known for the large quantities of fine Ding ware porcelain vessels preserved within stone boxes in its crypt.[22] The ceramics were wrapped in silk, but unfortunately this has not been illustrated in the site report. Another Northern Song find comes from the Huiguang pagoda at Rui'an, on the southeast coast of Zhejiang, built between 1034 and 1043, where a sutra wrapper of cinnabar-red silk decorated with gold bird roundels was discovered among the 69 objects buried in the crypt. The colours and design of this silk are matched on an inner sutra box of exquisitely fine gold-painted lacquer, and on the mounts of the sutra itself.[23] The unanimity of colour and design suggests that the objects formed a set, which itself comprised the principal contents of an important religious monument. This silk appears to be a significant element amongst objects of high quality and ceremonial status, dating towards the middle of the eleventh century. The distribution of these excavated silks with religious associations coincides with the foremost centres of silk production as noted in the written records: namely Jiangsu, Zhejiang and Hebei.

While tombs of the Northern Song period do not generally yield any textiles at all, there is one in which more than two hundred silk garments and fragments have been preserved: the tomb at Hejiazao mountain near Hengyang in Hunan Province, belonging to a man of about fifty and dated between 1086 and 1094.[24] The tomb occupant's social status is unclear:

11. *Cizhou ware jar with incised slip decoration of linked circles beneath a transparent glaze, northern China, Northern Song, early 12th century. Height 8.7cm (3"). Ashmolean Museum, Oxford, inv.no. X.1582.*

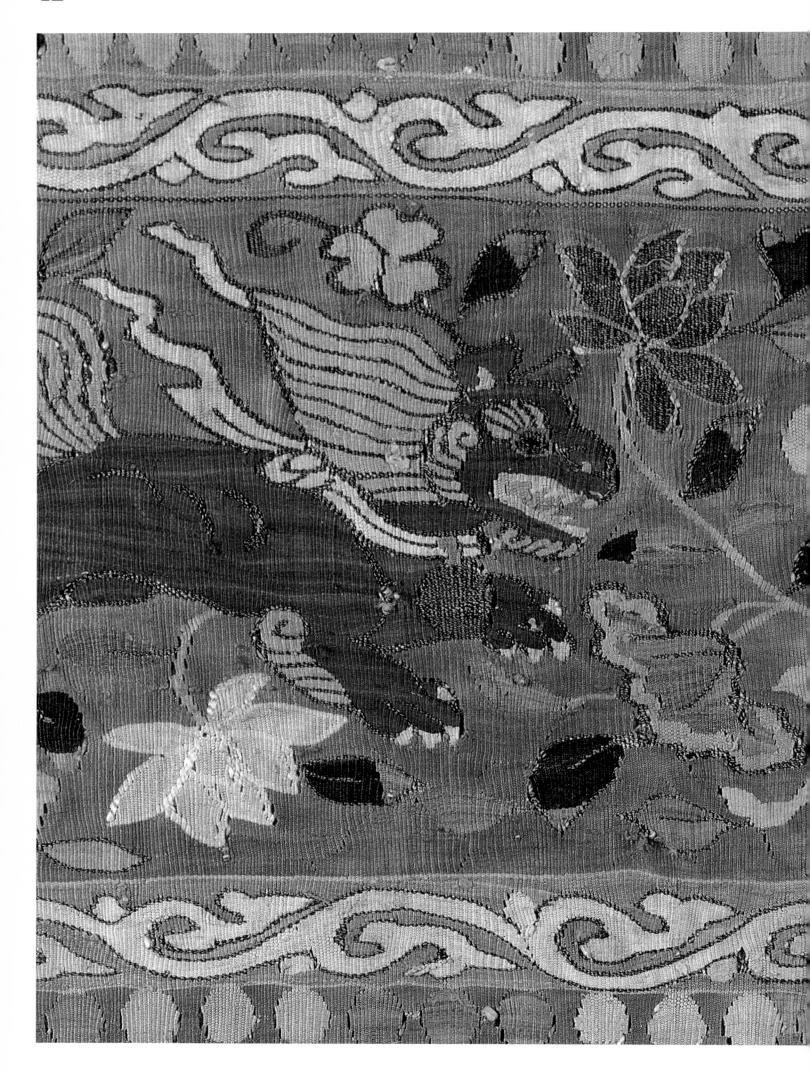

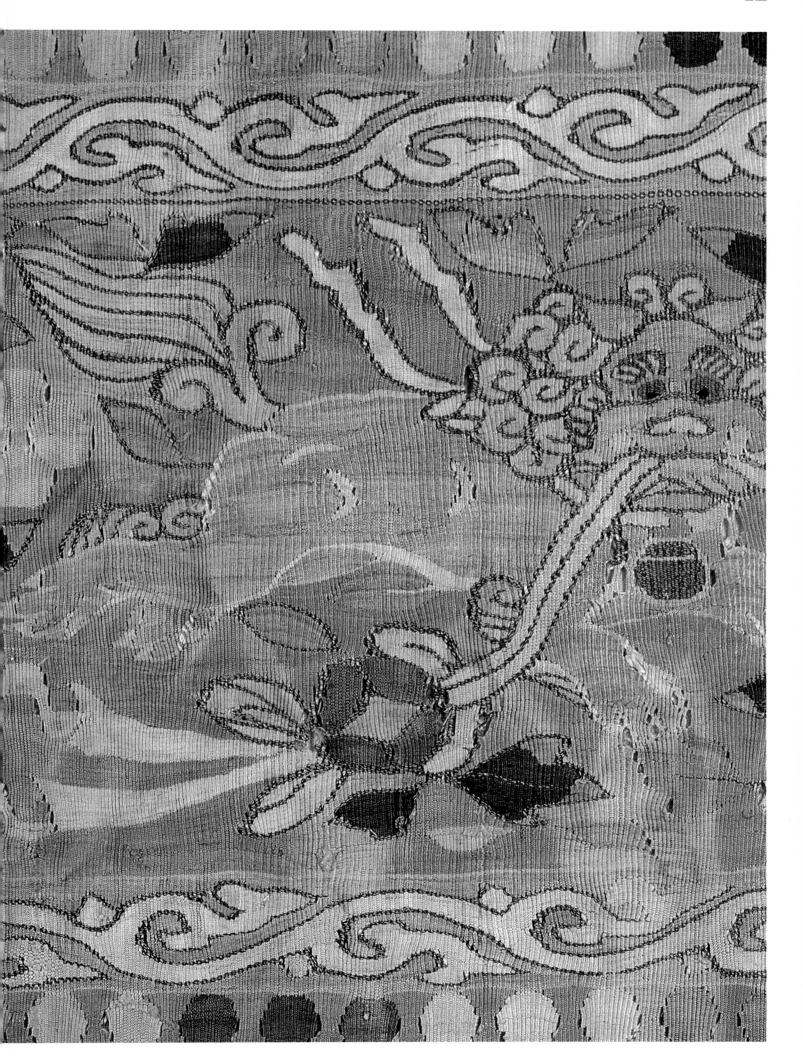

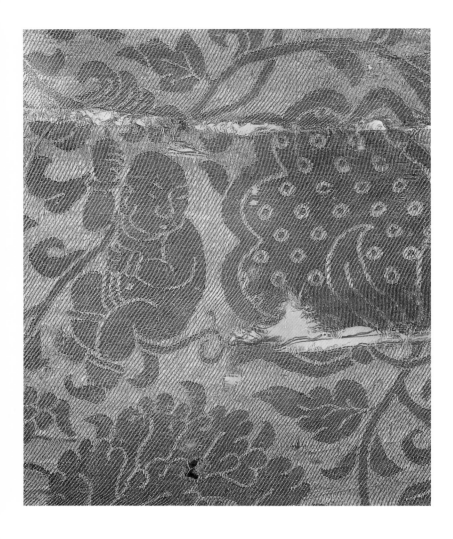

no epitaph tablet was found, and the site had been badly damaged before excavation. However, Song tombs tend to contain personal possessions rather than burial goods, and this one includes writing brushes, inkstones and a painting, from which it can be inferred that it belonged at least to an educated gentleman, if not a high-ranking official. The textile finds, numbering more than two hundred fragments (and some intact garments), are little short of spectacular and certainly the most representative surviving group of Northern Song textiles. The excavation report lists the textiles in detail. The complete garments are a silk padded gown, six silk padded short jackets, three double-sided garments, one unlined garment, five skirts, one silk wadded quilt, one gauze cap and four pairs of hemp shoes. The types of silk include *sha* (**6**) and *lúo* gauzes, plain and patterned, *ling* figured silks (**13**) and *juan* thin strong silks. Many of the patterns are geometric, some are auspicious, others are of considerable complexity and a few[25] resemble Song colour painted architectural ornament in the *Yingzao fashi* (Construction Styles) compiled by Li Jie around 1100 (**8, 10**).[26]

The textile fragment numbered 18[27] by the excavators is described as part of a lined black gauze garment with a design of 'linked cash'. The cash motif is one of the most frequently encountered designs in the Chinese ornamental repertoire, appearing on porcelains, textiles, carvings and paintings from many periods. Prior to the tenth century the motif is known on a printed silk streamer in the Shosoin[28] and on a bronze fragment from the site of a Tang palace at Linyou Xian, Shaanxi province.[29] Northern Song examples include silver pagoda[30] and sarcophagus[31] models, a bronze mirror[32] and numerous ceramics. A long-handled handwarmer made from copper coins of four different periods, lashed together with bronze wire[33] is of particular interest as it implies that the term 'cash' motif used today applies with equal correctness to the original motif, and that the auspicious connotation it has held in recent eras perhaps prevailed too in the eleventh century. Even then the design was by no means limited to textiles and metalwork, for it appears on a fairly rough Cizhou ware jar from northern China now in the Ashmolean Museum, Oxford (**11**), as well as on Cizhou wares in many other European and American collections.[34]

A single cash type motif (**5, 9**) is central to the complex design of textile no.41 from Hengyang,[35] described by the excavators as a "brown *ling* fragment with lion rolling a brocade ball amidst vines and *fu* character". The cash motif represents the brocade ball, and the *fu* character, meaning riches, denotes this as another design with auspicious intent. The 'Lion with brocade ball' motif appears almost as widely in the Northern Song period as 'interlocking cash'. It is seen on a white ware dish from the Ding kilns at Quyang, Hebei province,[36] which produced some of the finest and most prized Song ceramic wares. The lion and ball motif does not seem to feature on earlier, incised Ding wares, but is seen here moulded on to the dish. The fact that the moulding technique was introduced at the Ding kilns around the turn of the twelfth century may suggest that the design first appeared in woven silk and was only subsequently used on ceramics. The motif as seen on the Hengyang silk and the Ding dish depicts the beast coiled round the ball to form a roughly circular design; on other objects, such as a *kesi* fragment, moulded tile reliefs of Southern Song date and Cizhou painted pillows,[37] the lion is on all fours, with the brocade ball and trailing sash held in its mouth (**12**). Section six of the *Dongjingmenghua lu*[38] records that unlined upper garments of red brocade patterned with lion-playing-ball designs were worn by the Emperor's closest accompanying officials at a banquet held on the 14th day of New Year. The seniority of these officials may suggest that if status can be ascribed to designs, the

13. Fragment of ling silk, with boys amongst peonies and lotus-seedpods, from a tomb at Hengyang, Hunan Province, dated 1086-94. 43 x 46cm (17" x 18"). After Gao Hanyu, Chinese Textile Designs, Hong Kong 1986, no.43.

12. Previous pages and below: Details of a silk kesi panel with lion holding a brocade ball, 12th-13th century. Panel 55.5 x 33.5cm (10" x 13"). Courtesy Spink & Son, London.

lion-playing-ball ranked quite high. The *Dongjingmenghua lu* also records a lion festival held at two Chan Buddhist monasteries,[39] so perhaps further research into the symbolism of these creatures will eventually shed more light on the significance of the textile design, and by extension, on the occupant of the Hengyang tomb.

One of the textile fragments found at Hengyang was a gold coloured figured silk with children amongst peonies and lotus (13).[40] Once again this is an auspicious motif – children representing successive generations – and one which appears on other media of the period. Boys holding lotus flowers appear in stone reliefs and as jade carvings, as well as on Yue ware ceramics of the tenth century. Later child motifs are not associated particularly with flowers, but the 'hundred boys' are certainly a familiar theme on Ming and Qing dynasty objects. A moulded Ding porcelain bowl in the British Museum[41] has similar decoration (14), as does a northern greenware Yaozhou kiln bowl in the Ashmolean (15). The density of the decoration on these moulded ceramics has often been compared to textile ornament, and once again the Hengyang silk predates the Ding porcelain and probably the Yaozhou too, since the northern greenwares are widely thought to have derived their styles from the innovative Ding kiln centres of Hebei. These secular silks from the Hengyang burial can thus be linked through their designs to other crafts and decorative arts of the period, and

14. Ding ware porcelain bowl with moulded decoration of infants amidst melon vines and lotus flowers, Hebei Province, 12th century. Diameter 21.3cm (8¹/₂"). British Museum, London, inv.no. 1947.7-12-62.

appear to be high quality, functional items invested with hopes of good fortune.

One of the most important categories of Song silk – the *kesi* tapestry weaves – has survived in collections but not in burials, which perhaps implies an heirloom status that itself establishes it as the most highly regarded type of textile.[42] In looking at Northern Song *kesi*, we are seeking to understand the evolution that took place between the narrow bands used to embellish late Tang banner headings and sutra wrappers as known from Dunhuang,[43] and the large 'woven paintings' produced during the Southern Song period, for example those in the National Palace Museum, Taipei.[44] The body of surviving *kesi* attributed to the Northern Song fits neatly into such a stylistic evolution. It includes many pieces with rich ornament, and some quite large panels with abundant motifs (2), yet since these motifs are set in a ground of other unconnected motifs the effect is more of continuous decoration than of a carefully conceived composition (16).

In contrast to those of the silks found at Hengyang, the designs on *kesi* panels are not found widely on painted, moulded and incised ceramics, nor do they appear much in tomb murals or carving or religious paraphernalia. The birds and flowers of Northern Song tapestry weave are much more likely to be seen on gold and silver, and are most closely

15. Yaozhou ware bowl with moulded decoration of infants and flowering scroll beneath a green glaze, Shaanxi Province, 12th century. Diameter 12.2cm (5"). Ashmolean Museum, Oxford, Ingram Gift, inv.no. 1956.435.

echoed on personal ornaments fashioned in gold. For example, the object which relates most accurately to the famous bird and flower panel from Liaoning[45] is a gold perfume pouch from a husband and wife tomb at Mufushan near Nanjing.[46] It is 8.5cm (3½") high and would originally have hung from the neck on a silk cord: the phoenix flying among peonies and mallow flowers, not only parallels the decoration of the *kesi*, but the openwork technique further emphasises the similarity between the two pieces.

While ornament is generally prevalent over pictorial composition in Northern Song silk, nevertheless on some of the larger *kesi* panels, animal and plant vignettes do stand out against the leaf-dominated backgrounds. One piece[47] in particular anticipates the 'woven pictures' of the Southern Song (**19**). Many of its features occur on textiles taken as Northern Song – the border at the top, particularly the scrolling, the suggestion of a medallion edge in the top right hand corner, the children at the base. However, the central motif of a beast looking back over its shoulder up into a tree at a bird in flight is strongly reminiscent of the painting dated 1061, *Magpie and hare*, by the prominent Song academician Cui Bo.[48] In other respects, such as the more harmonious colours and the more relaxed disposition of the motifs, this panel is close to recently discovered pieces attributed to the Southern Song, and would seem to occupy, stylistically, a position midway between the densely decorated panels and the truly pictorial weaves.

Many Song *kesi* panels are thought to have been book or scroll covers. This coincides with, or springs from, Zhou Mi's twelfth century records[49] of *kesi* being used on the orders of Emperor Gaozong for the remounting and wrapping of books and scrolls in the Imperial library. There is much evidence to support this, including the wrapper on the silk processes painting mentioned above, the panel from Liaoning[50] and the purple-ground fragment now in the collections of the City Art Museum, St Louis,[51] marked with the title of a scroll by the prominent Northern Song painter Liu Cai (ca. 1080), as well as the covers illustrated in (**18**) and (**19**).

There has been much discussion of the place of manufacture of *kesi*. Zhuang Zhuo records in his *Ji lei bian* of the twelfth century that *kesi* was woven, by Uighurs, into robes which each took a year to complete.[52] The passage begins: "In Dingzhou they weave *kesi*...". In the Song Dynasty there were three places called Dingzhou: one on the Liaoning peninsula, one near present-day Wuwei in Gansu, and one at present-day Dingzhou in Hebei. Let us consider each in turn. Dingzhou in Liaoning seems a little too remote to be the likely source, though the twelfth century chronicler Hong Hao does also mention that the Liao have their own *kesi*. A few examples of this survive,[53] but it is recorded that hundreds of thousands of bolts of silk were sent annually from the Song to the Liao in the north and the Xi Xia in the west, and in both areas tomb finds show much evidence of porcelain and metalwork brought from central China.

The second Dingzhou is in Gansu in western China, which is the territory of the

16. Silk kesi fragment with metal-wrapped threads, 10th-12th century. 25 x 13cm (10" x 5"). Ashmolean Museum, Oxford, inv.no. 1995.71.

Uighurs, who have been credited with originating the technique of tapestry weaving, even before the Tang dynasty. This on its own however is insufficient reason for ascribing to them the majority of Northern Song *kesi*; the technique might easily have been introduced into China by them in the intervening centuries.[54] There were at the same period Uighurs around Beijing in Hebei (northern China), not far from the third Dingzhou, which is mentioned in the various Song sources cited above as a silk-producing area, as it had been since the Sui dynasty in the early seventh century. Hebei is also the province that produced Ding porcelain, whose designs we have seen relate closely to textiles (14). The fine quality of Southern Song *kesi* suggests that some Chinese location must have existed for its manufacture during the Northern Song period. It therefore seems very probable that Zhuang Zhuo is referring to Dingzhou in the province of Hebei as one – perhaps the premier – place among several within the Northern Song domains where *kesi* was woven.

In conclusion, it would seem that during the Northern Song dynasty silk was indeed widely distributed and of considerable economic, and therefore perhaps also political, importance. We know that it was used for religious and practical purposes and that its ornament related closely to that of other artefacts of the period. None of this is peculiar to this particular dynasty – the export, patterns and production organisation of the Zhou or the Han or the Tang are comparable. Considered alongside ceramics, lacquer and silver of the Northern Song period, however, it appears that no other material merited such close documentation or such wide comment in contemporary texts. Thus it would seem that while it has survived the least, silk was in fact the most significant of all the decorative arts of the Northern Song dynasty.

Notes see Appendix

18. Silk kesi scroll cover, formerly the wrapper for a scroll by the Northern Song painter Guo Xi, 10th-11th century. 36.3 x 31.8cm (15" x 12"). Metropolitan Museum of Art, New York, Gift of John M. Crawford Jnr, inv.no. 1983.105.

19. Silk kesi scroll cover with gold- or silver-wrapped paper, 11th-12th century. 20.3 x 34.3cm (8" x 13½"). Metropolitan Museum of Art, Dorothy Graham Bennett Fund, inv.no. 66.174b.

17. Opposite: Silk kesi panel, 11th-12th century. 59.9 x 33cm (24" x 13"). Courtesy Spink & Son, London.

13

ALL EXCELLENT QUALITIES...

Chinese Jade from the Neolithic to the Han

CAROL MICHAELSON

Throughout the history of China, jade has been highly prized, the chosen medium for many of the most important artefacts that have come down to us. Over the centuries its beauty and incorruptibility meant that it became a metaphor for moral virtue, aesthetic purity, and eternal life. And while the mysterious qualities with which jade has been imbued have changed meaning over the many millennia of its usage, to this day it continues to be especially valued and revered.

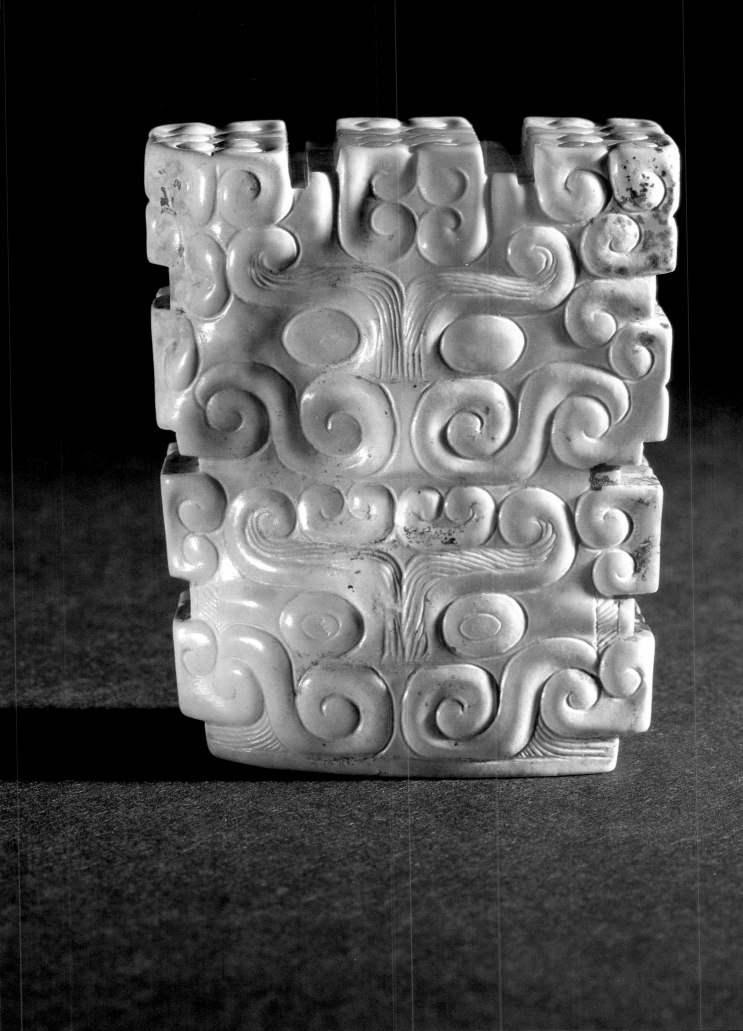

3. Pig dragon, Neolithic period, Hongshan culture, ca. 3500BC. Height 6.3cm (2½"), width 5cm (2"). Private collection.

1. Title page: Dragon pendant, Shang period, ca. 1200-1000BC. Width 3.4cm (1½"), thickness 1cm (½"). Private collection.

2. Previous page: Sword hilt, Eastern Zhou period, 6th-5th century BC. Length 4.2cm (1½"). Private collection.

In China jade has traditionally ranked in the hierarchy of valuable materials above gold, silver and the precious metals and sparkling stones so valued in the West. Its use predated that of bronze – the only material to be viewed with comparable reverence – by several thousand years. Over the approximately seven thousand years of its use, several different cultures within what we now call China have ascribed a variety of meanings and properties to jade, and associated it with a range of roles and functions, both ritual and ceremonial. The material came to be associated above all with ideas of power, whether of jade weapons, of those who wore it in the form of ornaments or pendants, or of burial jades to prevent the corruption of the body. The most significant, if not historically reliable, attempts to describe and codify the meaning and usage of jade appear in ritual texts prepared several millennia later by subsequent jade-using cultures such as the Han.

Jade (in Chinese *yü*) is in fact a generic name for two compact but quite different fine-grained but tough minerals: nephrite and jadeite. Nephrite is a silicate of calcium and magnesium of the amphibole group and was the main jade material used in ancient China. Jadeite, which was not extensively used in China until the eighteenth century AD, is a sodium aluminium silicate within the pyroxene group of minerals. The presence of compounds of iron, chromium and manganese is mainly responsible for the colour variations found in both nephrite and jadeite. Ranking high on the Mohs scale of hardness, jade cannot be carved. It must be abraded, an exceptionally long and painstaking process when, as in Neolithic

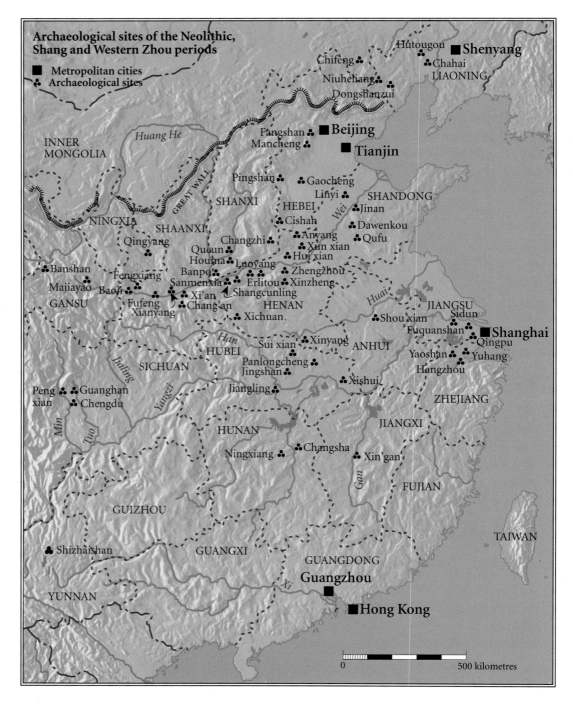

times, only the simplest tools are available.

Chinese civilisation was traditionally assu-
med to have arisen and developed in the
area of the Yellow River, but important Neo-
lithic Chinese cultures have recently been uncov-
ered in areas as far apart as northern Liaoning
and eastern Manchuria, Shandong, northern Jiangsu and Zhejiang Provinces. Such major
archaeological discoveries, made since 1975, have yielded valuable new information on
where and when jades were made and the context in which they were used and buried,
particularly within Neolithic cultures (5000-1500BC) and during the Han dynasty (206BC-
220AD). Each area and culture produced typologically different jades, with the earliest
objects so far known – ornaments, ceremonial weapons and ritual objects – produced
around 5000BC by Neolithic cultures inhabiting areas far beyond the Great Wall, known
today as Inner Mongolia and Liaoning Province. Recent work by contemporary Chinese
geologists, such as Wen Guang, has complemented these findings by determining the presence
of sources of nephrite – available in Neolithic times but since exhausted – in eastern China
during the same period.

One of the oldest pieces known, a scoop-shaped jade (4), was produced in northeast
China by the Chahai culture of Liaoning Province. Judging from its beautiful finish and

4. Scoop-shaped jade, Neolithic period, Chahai culture, ca. 4000-3500BC. Length 12.7cm (5"), width 1.8cm (³/₄"). Private collection.

5. Hoof-shaped ornament, Neolithic period, Hongshan culture, ca. 3500BC. Height 17cm (7") width 11.5cm (4¹/₂"). Private collection.

accomplished shape, this object clearly does
not represent the earliest beginnings of jade
working in China,[1] but little is known of the
society that produced it or of the develop-
mental process that preceded its making. The
first Neolithic jade-producing society of
which we do have any considerable body of
knowledge is that of the Hongshan people,
successors of the Chahai, who flourished
around 3500-3000BC. Archaeological evidence
shows a sophisticated society with cist tombs
and religious platforms built of stone.[2] They
were obviously well organised, enabling a
section of society to be set apart to work on
the production of burial jades – often the
only burial goods used by the Hongshan.
These frequently took the form of birds and
a variety of animals such as the pig dragon,
characterised by its large, bulging eyes (3),
which has been found in many tombs placed
on the chests and stomachs of the occupant.[3]
Other items comprised pieces such as a mys-
terious hoof-shaped ornament (5) which,
from its frequent placement at the head of
the tomb occupant, may possibly have been
attached to the hair at the time of burial as a
kind of headdress. But while we cannot be
certain what precise meaning this object had
for the Hongshan people, it must have been
of great significance: to hollow out a piece of
jade in this way was an extravagant gesture
given the value of the material, requiring a
substantial block of jade and the expenditure
of long and painstaking effort.

The other major jade-producing Neolithic
culture of which we have learned a good deal
from recent archaeological excavations is
that of the Liangzhu, based in what are now
Jiangsu and Zhejiang Provinces in the south-
east of China. Jade carving in the southeast
seems to have emerged first in areas around
Shanghai, amongst the Hemudu, Majiabang

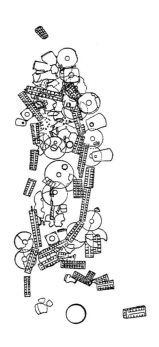

and Songze cultures, all of which slightly predated the Liangzhu. It appears that within the Liangzhu culture the importance of jade was further enhanced. Whereas in Hongshan culture graves we have found sometimes twenty jades in one tomb, in the Liangzhu burials the jades might total over three hundred if all the beads of the necklaces and pendants were counted. The Liangzhu culture is particularly known for its *bi* (discs) and *cong* (tubes), which have been found in many of the graves, though not necessarily in conjunction with each other. An archaeologist's sketch of one grave shows the *cong* clearly aligning the body, while the *bi* are placed mainly on the chest and stomach and at the foot of the skeleton (**6**). From very early times the Chinese could clearly distinguish nephrite jade from lesser and softer stones, and it has been found that the very best quality nephrite discs were placed on the stomach and chest of the tomb occupant while lesser quality jades were placed at the foot of the body, or in tombs with less prestigious occupants.

While other earlier and contemporary cultures used the *bi* disc, in varying sizes and shapes, and with differences of function, it would appear that the Liangzhu people were the first to use it in such profusion and to give it such a prominent place in the burial. One particularly beautiful example (**9**) is of a jade whose colour has altered to a creamy white and yellow on one side and on the other side has stained to a bright rust red. Both sides have very highly polished surfaces with the imperfections in the stone erased. The central

6. Plan of tomb M3 at Jiangsu Wujin Sidun showing the arrangement of axes, discs and cong along the length of the body. Neolithic period, Liangzhu culture, ca. 2500BC. After Kaogu 1984.2, pp.109-29, fig.5.

7. Cong, Neolithic period, Liangzhu culture, ca. 2500BC. Height 5cm (2"), width 8.8cm (3¹/₂"). The design, repeated in four panels, shows a simplified man's head in the upper part and a monster's face in the lower part. Private collection.

9. Opposite: Bi disc, Neolithic period, Liangzhu culture, ca. 2500BC. Diameter 18cm (7"). Private collection.

8. Man-like figure and monster on a cong from Yuhang Fanshan, Zhejiang Province.

hole has been pierced from both sides and the join is slightly uneven, a characteristic often found in Liangzhu discs.[4]

Exceptionally tall *cong*, about fifty centimetres in height, are to be found in a few museum and private collections. These tall tubes, which represent great feats of workmanship, tend to have rudimentary markings at the corners whereas the smaller, more bracelet-like *cong* often have very well delineated faces carved on them which form part of the intrigue of these pieces (**7**).[5] These mysterious faces generally comprise two elements (**8**): a human-like figure, often with what looks like a feathered headdress, surmounting and grasping a monster figure with bulging eyes, broad nose and well delineated fangs. Again we do not know what meaning this figure had for the Chinese of the time, but such jades are beautifully and skilfully made, and clearly represented a considerable investment of both time and material.

Axes were also an important feature of Liangzhu burials and many were equipped with superbly decorated fittings. No two of these fittings have been found to be identical, which might indicate that the designs in some way represented not only status but perhaps also a form of identification within the society. The decoration on the example illustrated here (**11**) is particularly finely delineated.[6]

Axes and tools were the quintessential implements of many Neolithic societies. The jade replicas of such tools gradually evolved from the rudimentary flint and stone tool shape

10. Ceremonial blade, Neolithic period, Longshan culture, ca. 2500-2000BC. Length 33cm (13"), width 8.2cm (3¼"). Private collection.

11. Ornament for the top of an axe shaft, Neolithic period, Liangzhu culture, ca. 2500BC. Height 4.8cm (2"), length 8.6cm (3½"). Private collection.

into that of the tablet or knife-like form. At first close to the original stone prototypes, the jade replicas gradually acquired a greater sophistication of form, becoming differentiated from the Stone Age tools by the addition of notches or a spreading cutting edge, and by the placing of holes which, in the original tool, would have been closely spaced together in order for the axe to be hafted to a wooden shaft. The later replicas have holes so widely spaced and blades so thin that they could never have been regarded as functional tools. These are sophisticated objects, the holes now purely decorative, remaining only as an oblique reference to their utilitarian origins. A few exceptional jades have finely incised decoration, such as (**10**) with its twisted rope patterns in incised lines and face patterns, now much eroded. Such decoration is shared by a small group of other similar blades and is dated to the Longshan Neolithic culture of about 2000BC.[7]

It is thought that some blades were used as ritual instruments or perhaps as indications of rank. Our knowledge of what these jades meant to the early Chinese peoples is derived in part from texts written during the late Zhou and in the Han dynasty (from around 475BC to 220AD),[8] when many jades were already about two thousand years old, and were probably almost as mysterious to the Chinese of that period as they are to us today. This did not deter the writers of such texts from ascribing meanings and functions, retrospectively, that accorded with the contemporary practices and thought processes of the Chinese of the Zhou and Han dynasties. In so doing they have tended to confuse our understanding of actual jade use in ancient China. The picture they present is generally oversimplified, suggesting a unitary line of development and obscuring the inevitable complexities of the actual situation. It is clear that many of the textual descriptions were based on tradition and hearsay and that the authors were not familiar with the actual jades themselves. The account given, for instance, of colour imagery and of the categorisation of jades, bears no reference to excavated pieces. Similarly, minute distinctions are made in the texts between the different types of the so-called ritual jades, while the archaeological record provides no evidence at all for making such distinctions.

In considering the jades produced by the Shang (1500-1050BC), the first archaeologically

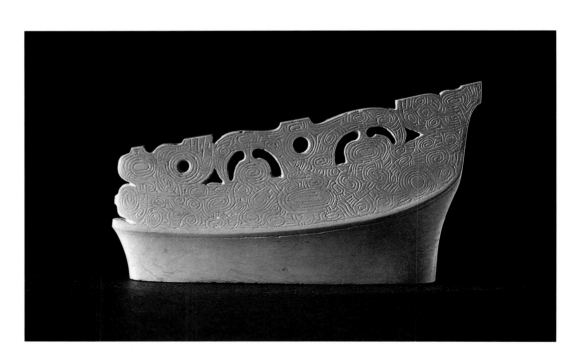

attested dynasty of Chinese history, it is interesting to compare finds from scientific excavations of many Shang tombs with jades in museums and private collections. One of the most important of the archaeological sites is the tomb of Fu Hao, a royal consort of the Shang king, Wu Ding, who died around 1200BC. Fu Hao seems to have been a redoubtable person who led armies into battle, and who apparently had unlimited access to all the luxury goods she desired. Her tomb, discovered in 1976, is up to now the only Shang period royal tomb to have been found intact, since all others have suffered some degree of looting.[9] It contained in total over seven hundred jades and 250 ritual bronzes all of which as far as we know would have been objects either associated with Fu Hao during her lifetime, or specially commissioned for her burial. The jades included Neolithic pieces, which must have been

particularly prized, and which exemplify another quintessential characteristic of jade: its durability. Fu Hao could not have known how old the Hongshan jades were but she must have recognised them as special and ancient. The tomb also contained Shang dynasty adaptations of the Hongshan pig dragon made by contemporary craftsmen (1) and many animal pendant components in a great variety of forms, including fish, birds, dragons and tigers.

Ritual jades, such as discs and sceptres, and burial jades including pendants are much referred to in the ritual texts of the Han and Eastern Zhou. Archaeological research has revealed many of these objects. The use of pendants in the Eastern Zhou period (475-221BC) can be adduced from tomb finds, though these have mostly fallen into disarray, making it difficult to be sure exactly how they were worn. One well-known attempt at reconstruction concerns pendants from the tomb of the Han King of Nan Yue, buried at what is now Canton, in 122BC.[10] This king ruled over territory which was a dependency of the Han empire and owed allegiance to it. Eleven pectoral sets were found in his tomb, including one made up of twenty pieces, composed of nine jades, one glass bead and ten gold beads. Ritual texts of this period refer to the fact that the tinkling sound of jade pendants prevented men of rank from thinking depraved thoughts, and also give descriptions of the various colours of jade pendants that could be worn by different ranks. Such texts make clear the moral symbolism associated with jade in passages such as: "A man of rank was never without this pendant, excepting for some sufficient reason; he regarded the pieces of jade as emblematic of the virtues (which he should cultivate)".[11]

Several reconstructions have been made of the pendant sets found in the King of Nan Yue's tomb, including that of the pectoral belonging to the king himself and also of those belonging to the various concubines buried with him. From these we can conjecture how such pendants were worn at least in death, while lacquered wooden models (12), perhaps give some idea of how they were worn in life. The pair of dragon pendants in (13), is similar to those found in the tomb of the King of Nan Yue.

Sword fittings, while less frequently referred to in the texts, have also been found in abundance in many graves of the period from the Eastern Zhou to the Han; clearly it was

12. Drawings of lacquer-painted figures wearing pendants from a Chu state tomb, Xinyang, Henan Province, Eastern Zhou period, 4th century BC. After Xinyang Chu mu, Beijing, Wenwu Chubanshe, 1986, fig.79:1,2.

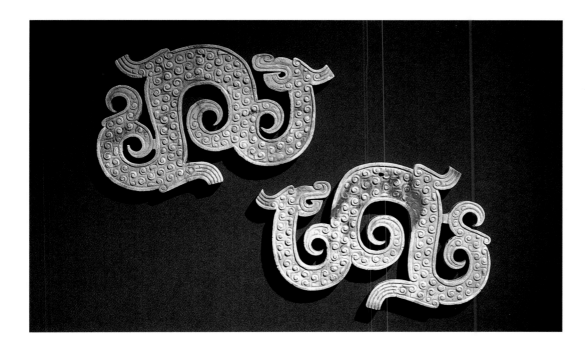

13. Pair of dragon pendants, Eastern Zhou period, 475-221BC. Height 7.6cm (3"), 7.8cm (3"), length 12.4cm (5¼"), 11.8cm (5"). Private collection.

considered important for the deceased to take plentiful supplies of such items into his afterlife. The King of Nan Yue was buried with a set of 43 spare sword fittings, placed in a lacquered box. These objects included pommels, sword slides (15), chapes and guards.

It was not until the eighth or seventh centuries BC that gold first appeared in China as a material of importance in the hierarchy of valuable items, at which time it appears to have been imported for the first time from the West. During this period, as well as valuing gold in itself, the Chinese began to adopt the forms in which it appeared, such as the many weapon fittings for swords. These fittings were replicated by the jade-carvers, as can be seen by comparing a gold dagger handle dating to the sixth to fifth century BC (18) and a sword fitting of jade which was clearly inspired by the gold decoration (2, 19).[12] Jade craftsmen

seem to have been stimulated by the intricate scroll-like decoration often found on gold – a type of design relatively easy to work on a soft metal but extremely difficult to recreate in the medium of jade.

14. Pair of eye covers: Han dynasty, 2nd-1st century BC. Length 4.2cm (1¹/₂"), width 2.1cm (³/₄"). Private collection.

We cannot know what powers were associated with jade within the cultures of Neolithic and Shang period China, but during the Eastern Zhou and Han periods it obviously came to be associated with the power to protect the body in the afterlife. By about the middle of the ninth century BC there was some feeling that jade offered a form of protection to the body after death. There began about this time a tradition of covering the facial features of the body with jade. This is clearly illustrated in an archaeological reconstruction of a facial mask from a tomb of circa 850BC from Tianma, Qucun, Shanxi Province (16). Various shaped jades began to be produced for this purpose, all with holes that enabled them be attached to some form of textile covering, which was then placed over the body in the grave.

The next stage of development was the use of large numbers of thin plaques, often deco-

15. Group of sword slides, Eastern Zhou and Han period, 3rd-1st century BC. Length of longest, 10.3cm (4"). British Museum, London, inv.nos. 1935.11-55.5; 1945.10-17.43,90; 1947.7-12.480; 1973.7-26.135.

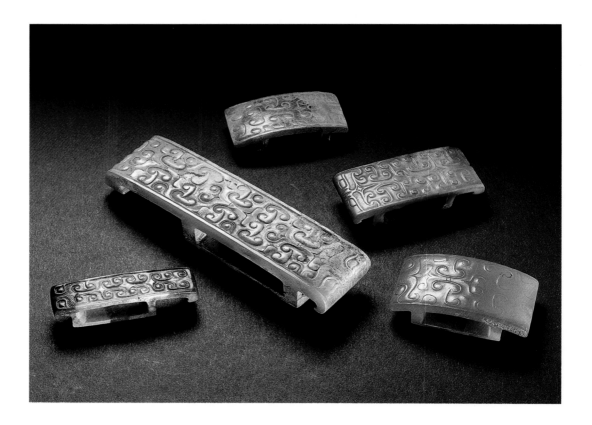

16. Sketched reconstruction of jades from Tianma Qucun, Shanxi Province, assembled to cover the face. Western Zhou period, 9th century BC. After Wenwu, 1994.8, p.68, fig.3.7.

rated, and many with holes in the corners, such as those found in the Huang tombs of the seventh century BC at Henan Guangshan Baoxiangsi.[13] The finds in the early Eastern Zhou tombs at Henan Luoyang Zhongzhoulu also include many jade coverings, but by this date there is generally less variety of shape among the plaques. The quest for the ultimate protection eventually led under the Han dynasty to the concept of a suit of jade that encased the entire body. The production of such a funerary suit was so time-consuming and so costly that it was proscribed by law during Han times. The suit of Liu Sheng, the brother of one of the Han dynasty emperors, who was buried in Mancheng, Hebei Province, in about 113BC, contained about 2,500 plaques. Each of the four corners would originally have been sewn together with gold thread, though silver and bronze thread were used for less important people.[14] It has been surmised that such a suit took about ten years or one hundred thousand hours of manual labour to make.

However, for the majority of people who simply could not afford a whole burial suit, alternative types of jades were produced to insert into the orifices of the body, a practice which was believed to prevent the corpse from decomposing. Such pieces included eye covers (14), nose and ear plugs, and cicadas, to place on the tongue (17). The cicada was

considered appropriate for such a purpose since its peculiar life cycle suggested rebirth or reincarnation. Small jades in the form of pigs were used as shroud weights or placed in the hands of the deceased.

Following the Han, jade usage continued to be highly valued in Chinese society, taking, in recent centuries, a more decorative vocabulary of forms that represents a very different aesthetic to the early ritual jades. Over the years its physical attributes of hardness and durability and its sensuous tactile quality became equated with the most desirable human characteristics, and associated, through rite and ceremonial, with earthly and spiritual powers. Writing in the fifth century BC, Confucius perhaps best sums up the deep reverence for jade that is embedded in Chinese culture:

> Anciently superior men found the likeness of all excellent qualities in jade. Soft smooth and glossy, it appeared to them like benevolence; fine, compact and strong, like intelligence; angular, but not sharp and cutting, like righteousness; hanging down as it would fall to the ground, like propriety; when struck, yielding a note, clear and prolonged, yet terminating abruptly, like music; ...esteemed by all under the sky, like the path of truth and duty.[15]

Notes see Appendix

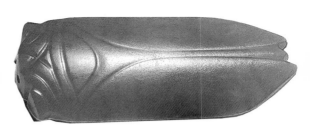

17. Cicada, Han dynasty, 206BC-220AD. Length 6.6cm (2¹/₂"), width 3.5cm (1¹/₂"). Private collection.

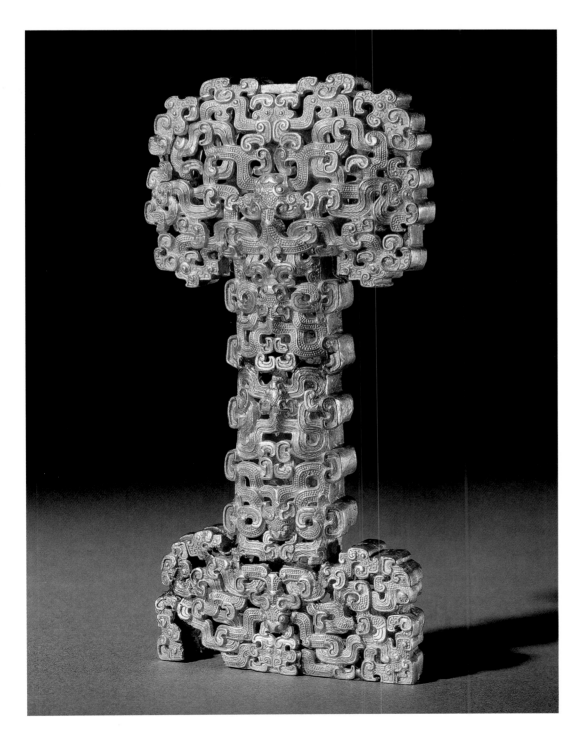

18. Openwork cast gold sword hilt, Eastern Zhou period, 6th-5th century BC. Height 9.8cm (4"). British Museum, London, inv.no. 1937.4-16.218.

19 Jade sword hilt, detail of 2.

APPENDIX
Acknowledgments, notes, bibliographies

3 THE MESSAGE OF MISFORTUNE
Pages 32-45

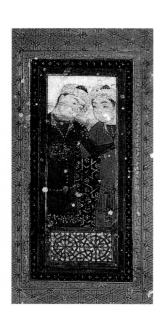

I should like to thank David Roxburgh, who took working photographs of the manuscript on my behalf.

1. For an exception, see the article on a 16th century illustrated manuscript of the Bukhara school by A.S. Melikian-Chirvani, in R. Hillenbrand (ed.), *Studies in Persian painting, Festschrift for B.W. Robinson* (in press).

2. A fair amount of what is presented here is admittedly speculative; but it should be a step in the right direction.

3. For a basic description of the manuscript, see A.J. Arberry, E. Blochet, M. Minovi, J.V.S. Wikinson and B.W. Robinson, *The Chester Beatty Library. A Catalogue of the Persian Manuscripts and Miniatures*, I, Dublin 1959, p.39.

4. Evidence suggesting that this script was developed in the 1370s was presented by Elaine Wright in a paper delivered at the symposium *The Art of the Mongols*, Edinburgh, July-August 1995. See also W.M. Thackston, *A Century of Princes. Sources on Timurid History and Art*, Cambridge, Mass. 1989, p.341.

5. See Arberry et al., op.cit., p.39. For Baisunghur's *kitabkhana*, see T.W. Lentz, *Painting at Herat under Baysunghur ibn Shahrukh*, unpublished Ph.D. dissertation, Harvard University, 1985, and T.W. Lentz and G.D. Lowry, *Timur and the Princely Vision. Persian Art and Culture in the Fifteenth Century*, Los Angeles and Washington 1989, pp.159-236, esp. 165-169. For further information on Jafar Tabrizi, see Thackston, op.cit., p.340.

6. The ex libris reads "For the treasury of the books of the eminent sultan Baisunghur Bahadur Khan, may Allah prolong his reign for ever", Arberry et al., op.cit., p.39.

7. The principal evidence for this is contained in the so-called *Arzadasht*, literally 'petition' but effectively a progress report on the activities of a royal Timurid atelier (Istanbul, Topkapi Sarayi Library, H.2153, f.98a), datable ca. 833AH/1430AD; for a translation and commentary, see Thackston, op.cit., pp.323-7. Of particular interest is the reference right at the beginning of the *Arzadasht*, and thus in the position of honour, to one Amir Khalil, who "has finished the waves in the two sea scenes of the *Gulistan* and will begin to apply colour". He was the supervisor of painting in Baisunghur's atelier, while the chronicler Daulatshah refers to him as a "second Mani" (Mani being the legendary exemplar of the arts of painting) and as one of four "craftsmen at the Shahrukhid capital who had no equal in their time in the inhabited quarter [of the world]" (Thackston, op.cit., p.323). Since the Dublin *Gulistan* has two sea scenes, and is dated within three years of the suggested date of the *Arzadasht*, this is almost certainly the manuscript in question. A few lines later there are references first to one Khwaja Ghiyath al-Din, who is not only engaged on illustrating a manuscript entitled *Rasa'il* but is also "at present... busy repairing a scene that was spoiled in the *Gulistan*" (ibid.), and then to Maulana Shihab, who "at present is busy with another scene in the repair of the *Gulistan*" (ibid., p.324). Thus there appear to have been at least three artists working on these paintings. Still further on, there is a statement that "Khwaja Ata has finished the sections of the *Gulistan*" (ibid., p.325), and since his other work is described as illumination, the likelihood is that it is his work on the illumination rather than on the

calligraphy of the *Gulistan* that is meant here. Amir Khalil was not only the chief painter but also the boon companion of Baisunghur, as is revealed by a lengthy anecdote recounted by Dust Muhammad in his preface to the Bahram Mirza album (Istanbul, Topkapi Sarayi Library, H.2154; tr. Thackston, op.cit., p.346). For further discussion of Amir Khalil, see B.W. Robinson, *Fifteenth-Century Persian Painting. Problems and Issues*, New York and London 1991, p.7-8 and id., 'Prince Baysunghur and the Fables of Bidpai', *Oriental Art* XVI, 1970, esp. pp.150-154.

8. Compare Thackston, op.cit., p.342, for a discussion of Sultan 'Ali, a calligrapher whose working life – as documented from signatures – appears to have lasted 69 years.

9. It is strange that such a long passage – more than a third of the entire text – should have remained unil-lustrated. When coupled with the evidence of the *Arzadasht* that work on the manuscript continued after the date of its colophon, this fact might suggest that the volume was never finished. The reference in the *Arzadasht* to damage sustained by one of the paintings might have something to do with the book's apparently unfinished state.

10. V.R. Prentice, *The Illustration of Sa'di's Poetry in Fifteenth-Century Herat*, unpublished Ph.D. dissertation, Harvard University, 1977, 1. I am most grateful to Dr Prentice for generously lending me her own personal copy of her dissertation and allowing me to make a copy of it. Sa'di lived from ca.1213-1292 (see Prentice, op.cit., p.2, for the range of dates which have been suggested, which extend from 1184 to 1219), and the *Gulistan* had been recognised as a classic for well over a century by the time that Baisunghur ordered his copy. The Dublin *Gulistan* is preceded by a copy with Shiraz-style illumination in the India Office Library dated 819AH/1416AD (B.W. Robinson, *A Descriptive Catalogue of the Persian Paintings in the Bodleian Library*, Oxford 1958, p.16).

11. The self-conscious and self-referential nature of court painting at this time is perhaps best revealed by the custom of including free copies of earlier masterpieces in each new cycle. See A. Adamova, 'Repetition of compositions in manuscripts: the Khamsa of Nizami in Leningrad', in *Timurid Art and Culture. Iran and Central Asia in the Fifteenth Century*, L. Golombek and M. Subtelny (eds.), Leiden, New York and Cologne 1992, pp.67-75; Lentz and Lowry, op.cit., pp.376-379, and N.M. Titley, 'Persian miniature painting: the repetition of compositions in the fifteenth century', in *Akten des VII. Internationalen Kongresses für Iranische Kunst und Archäologie*, W. Kleiss (ed.), Berlin 1979, pp.471-91.

12. The seascape was a theme which had quite recently attracted the interest of progressive painters, perhaps because it fitted the new fashion for juxtapositions of colour. Examples include the Gulbenkian *Anthology* of 1410 in Lisbon, LA. 161 (B. Gray, *Persian Painting*, Geneva 1961, p.76), the *Anthology* of 1410-11 in the British Library, Add.27261 (Titley, op.cit., fig.16) and the *Khamsa* of Nizami in St Petersburg, dated 1431, VP-1000 (ibid., fig.17).

13. This device, which is employed three times in the Dublin *Gulistan*, takes up a theme which was first exploited by the painter of 'Humay before Humayun's castle' in the *Kulliyat* of Khwaju Kirmani

in the British Library, Add.18113, dated 1396, and was thereafter appropriated by one fashionable painter after another (for typical examples, see Lentz and Lowry, op.cit., p.376).

14. See respectively Lentz and Lowry, op.cit., p.130 and N. Atasoy, 'Four Istanbul Albums and some Fragments from Fourteenth-Century Shah-Namehs', *Ars Orientalis* VIII, 1970, fig.25; ibid., fig.21 and B. Gray, *The Shahnameh of Ferdowsi. The Baysonghori Manuscript. An Album of Miniatures and Illuminations,* Teheran 1971, pl.XVIII; and I. Stchoukine, *Les peintures des manuscrits de la "Khamsah" de Nizami au Topkapi Sarayi Müzesi d'Istanbul,* Paris 1977, pl.IIa. Images of Bahram Gur in pavilions of various hues are another possible source, Lentz and Lowry, op.cit., p.377.

15. For a list of manuscripts attributed or dedicated to Baisunghur, see Thackston, op.cit., pp.325-326.

16. His *Shahnama* of 833AH/1430AD in Teheran (Gulistan Museum, 4752) is the classic case. See Lentz, *Painting at Herat*, pp.100-109 and 385-387.

17. It is no accident that this period represents the high-water mark of Timurid Qur'ans. For a brief overview, see D. James, *After Timur. Qur'ans of the 15th and 16th centuries. The Nasser D. Khalili Collection of Islamic Art*, General Editor J. Raby, vol.III, London and Oxford 1992, pp.14-45, Lentz and Lowry, op.cit., pp.72-79 and M. Lings, *The Quranic Art of Calligraphy and Illumination*, London 1976, pp.171-187.

18. Moreover, the manuscript explores roles for illumination which are not encountered in Timurid Qur'ans. Indeed, the illumination deserves a study to itself. The experimental nature of the Baisunghuri atelier is revealed by the *Chahar Maqala* and by the illustrations to the *Kalila wa Dimna* (notes 67-68).

19. E.g. Lentz and Lowry, op.cit., p.121; for cognate experiments, see ibid., pp.128-129, 190, 202, 204-205, 270.

20. In this respect, the manuscript is strangely prophetic of the *muraqqa'* which was to be so distinctive a feature of 16th-17th taste, and in which new relationships between text, calligraphic panels, illumination and illustration were constantly being explored. See the study of this form by A. Adamova in *Parthian and Sasanian Themes in Iranian Art*, V. Curtis, R. Hillenbrand and J.M. Rogers (eds.), in press.

21. For a brief conspectus of the literary nature of the *Gulistan*, see A. Schimmel, 'The Genius of Shiraz: Sa'di and Hafez', in *Persian Literature*, E. Yarshater (ed.), Albany 1988, pp.216-217. See also the discussion of overlap at the end of the present article.

22. It is especially ingenious in ringing the changes from one folio to the next in the page layout. Thus the degree of indentation employed for quotations is in a state of constant flux, with the announcement that a new tale is coming *(hikayat)* being located at the left edge of the margin, perfectly centred or inclining to the fore-edge.

23. Another area of ambiguity is what the weather or season is, though sometimes, when this is a crucial factor, it is made clear – for example, the distressed poet and Sa'di encountering the maiden.

24. As in much Muzaffarid painting: e.g. B. Gray (ed.), *The Arts of the Book in Central Asia*, Paris and London 1979, pls.72-73 and XXXIV.

25. A textbook case is the battle scene from the copy of Nizami's *Khamsa* made for Shah Tahmasp and dated 1539-43 (Gray, 1961, p.134).

26. Sa'di himself refers to his reason for writing the *Gulistan* as follows: "Every moment a breath is expiring of my life; when I curiously inspect it, I find that only a little is left. O man! fifty years of thy life are gone..." (J. Ross, *Sadi: Gulistan or Flower-garden*, London, n.d., p.67).

27. E.g. M.S. Ipsiroğlu, *Saray-Alben. Diez'sche Klebebände aus den Berliner Sammlungen*, Wiesbaden 1964, pl.XIV or R. Ettinghausen, *Persian Miniatures in the Bernard Berenson Collection*, Milan 1961, pl.VI. It could also be a free adaptation of a royal 'picnic' of the kind which was popular at this time for frontispieces (e.g. that for Baisunghur's *Kalila wa Dimna* of 833AH/1429AD in the Topkapı Sarayı Museum, Istanbul, R.1022: see Lentz and Lowry, op.cit., pp.110-111).

28. E.g. Gray, 1979, pl.XXXIV. For a close contemporary parallel, from the *Chahar Maqala* of 835AH/1431AD made for Baisunghur (Istanbul, Türk ve Islam Eserleri Muzesi, no.1954, f.22a) see ibid., pl.L.

29. See Ross, op.cit., p.70.

30. Ibid., p.71.

31. Cf. Prentice, op.cit., p.38. It was not rare for the frontispiece to be sited a folio or two after the beginning of the book (e.g. the double frontispiece of the *Rasa'il Ikhwan al-Safa* in the Library of the Süleymaniye Mosque, Istanbul, Esad Efendi 3638, which occupies ff.3b and 4a: R. Ettinghausen, *Arab Painting*, Geneva 1962, pp.98-99).

32. E.R. Hoffman, 'The Author Portrait in Thirteenth-Century Arabic Manuscripts: A New Islamic Context for a Late-Antique Tradition', *Muqarnas* X, 1993, pp.6-20.

33. The *Anthology* of Sultan Iskandar in the British Library (Add.27261), dated 813-4/1410-11, is an apt illustration of experiments with complex antiphonal colour rhythms.

34. A. Serajuddin, *Architectural representations in Persian Miniature Painting during the Timurid and Safavid Periods*, unpublished Ph.D. thesis, University of London, 1968, p.80. The "turquoise-blue palace" is the sky.

35. Ross, op.cit., pp.78, 113 and 166.

36. Ibid., p.93. The text on the page with the painting ends with the dervish pleading with the monarch: "O thou who in good fortune hast not thy equal in the world, I admit that thou hast no cause of care for thyself, but hast thou none for us?" It is only on the next page that we learn that "the king was pleased with this speech".

37. Ibid., pp.123-124. The dénouement is chilling. Acting on the advice of his vizier, who points out that "now the orange is soiled by having fallen in the mire, how can it again grace the hand of a king?" the monarch presents him with the negro, to whom in turn he gives the damsel, "for it is meet that a dog should eat the leavings of a dog".

38. One can only admire the way the painter has invested a stereotypical composition with such dramatic intensity.

39. Ross, op.cit., p.222. The analysis which follows has already been published in substantially the same form: R. Hillenbrand, 'The Uses of Space in Timurid Painting', in Golombek and Subtelny, op.cit., p.95. Cf. Prentice, op.cit., pp.34-38 for an eloquent assessment of this image.

40. It is worth noting that this reversal goes against the grain of the text itself.

41. Ross, op.cit., pp.186-198, especially pp.191-193.

42. The sky, being potentially limitless, emphasises his plight, while his white drawers make him appear still more vulnerable.

43. The gestures of the figures facing the youth follow a hierarchy whereby the first gesticulates more energetically than the second, who in turn is more active than the third. See also Hillenbrand, 'Uses of Space', pp.92-95, and D'zul Haimi bin Muhammad Zain, *Formal Values in Timurid Miniature Painting*, Kuala Lumpur 1989, p.76.

44. As in the wrestling match, the man drowning, the distressed poet (whose dress employs the traditional iconography used for slaves and prisoners) and the dervish. Cf. the scene of the royal lover in Baisunghur's *Anthology* of 830AH/1427AD in I Tatti, Florence, f.44a (Ettinghausen, *Persian Miniatures*, pl.III).

45. As in the encounter between Sa'di and the maiden. Cf. the scene of Farhad brought before Shirin in the

PICTURE CREDITS

MONUMENTS OF THE DECCAN: All photos Antonio Martinelli

THE ROYAL MURALS OF RAJASTHAN: D.P.A. Images of India 1; Joachim Bautze 2, 4, 5, 7, 9, 11, 12, 13; Horst Metzger 6, 8, 10, 14; Antonio Martinelli 3

THE MESSAGE OF MISFORTUNE: All photos Chester Beatty Library, Dublin

THE CHISELLED SURFACE: Réunion des Musées Nationaux 6; Yolande Crowe 1, 7, 12, 13, 15, 18, 19, 20

CHINA FOR EUROPE: All photos except 2 Christie's Images

THE PROGRESS OF RAMA: Robert Harding Picture Library 1, 5; Thierry Zéphir 2, 3, 4, 6, 7, 8, 9, 10, 11, 12

RITUAL AND SPLENDOUR: Kalpana Kartik 2, 3, 5, 10, 15, 17, 27; Réunion des Musées Nationaux 1, 4, 6, 7, 8, 11, 14, 16, 18; Dirk Bakker 9, 13; Pierre-Alain Ferrazzini 19, 21, 23, 24, 25, 26, 28; F. Letailleur 20; Musée de l'Homme 22

A FEARFUL SYMMETRY: Steven Cohen 3, 4, 5, 7a & b, 17, 18, 19, 21, 22, 23, 29; Ole Woldbye H; Bildarchiv Preussischer Kulturbesitz 30

MEIBUTSU-GIRE: P. J. Gates 1, 5, 10, 12, 13, 15

THE EMPEROR'S TREASURE HOUSE: Shosoin, Nara City 1

SILK OF THE NORTHERN SONG: Réunion des Musées Nationaux 2; Wendy Maine 10; Map of archaeological sites Shelagh Vainker, 1996

ALL EXCELLENT QUALITIES..: Map after Chinese Jade from the Neolithic to the Qing, Jessica Rawson, 1995.

Nizami of ca.1405-1410 in the Freer Gallery of Art, Washington DC, no.31.34 (Gray, 1961, p.54).

46. Again the scene of Sa'di and the maiden is the obvious example. The lack of interest in depicting shadow in this tradition of painting correspondingly inhibited experiments with shafts of light.

47. For example, the boatmen in f.29v.

48. In the light of this, the generally acceptable dictum of Lentz (*Painting at Herat*, p.100) that "there is little room for individual expression" in the house style of the Baisunghuri atelier may perhaps be modified in the case of the *Gulistan*. The exceptions to this bleakness are the somewhat anodyne scene at the beginning, in which Sa'di converses with a youth in a garden – though even here the atmosphere of regret is palpable – and the tableau of the wrestlers, where virtue narrowly triumphs over vice. Prentice argues that Sa'di himself is the the real subject of these paintings (op.cit., p.42).

49. The problems alluded to earlier, which were consequent on illustrating a text which had not yet acquired a standard repertoire of images, must also be kept in mind here, since this situation might have predisposed the artist to recycle his compositions whenever he could do so.

50. In other words, he is never content baldly to tell the story in the way that Sa'di does. There is always something extra.

51. This use of spectators as chorus is particularly marked in the scenes of the wrestlers and the drowning man.

52. This is not a new device in court painting of the early Timurid period; it can already be seen in such Jala'irid work as a combat scene in the *Kulliyat* of Khwaju Kirmani (see M. Gorelik, 'Oriental Armour of the Near and Middle East from the eighth to the fifteenth Centuries as shown in Works of Art', in *Islamic Arms and Armour*, R. Elgood (ed.), London 1979, p.48) in the British Library *Anthology* (Add.27261), as in the fire ordeal of Siyavush (f.295v: see B.W. Robinson, *Persian Miniatures*, New York n.d., pl.III) and in the same scene from a *Shahnama* in the Chester Beatty Library, Dublin, dated 800AH/1397-8AD, f.14v (R. Hillenbrand, *Imperial Images in Persian Painting*, Edinburgh 1977, colour pl. opposite p.53). Perhaps, though, one might argue that the painter(s) of the *Gulistan* imbued the theme with a poignancy not found in other contemporary manuscripts. The presumably slightly later painters of the Juki *Shahnama* (London, Royal Asiatic Society, MS 239) are constantly using this device, but they do not invest it with the emotional power found in the Dublin *Gulistan*, preferring dramatic effects (Lentz and Lowry, op.cit., pp.127 and 133-134; J.V.S. Wilkinson, *The Shah-Namah of Firdausi. The Book of the Persian Kings*, London 1931, pls.III, V and XV).

53. As there would have been if Bihzad had treated these themes.

54. The comparison with a speech bubble is most relevant when the text panel is reduced to a few verses, as in the Freer *Nizami* (Gray, 1961, p.54; id., *Arts of the Book*, pls.XXXIII and p.68).

55. See O. Grabar and S. Blair, *Epic Images and Contemporary History. The Illustrations of the Great Mongol Shahnama*, Chicago and London 1980, pls.9, 17, 34, 35, 38 and 46.

56. The most spectacular examples of this practice occur in the *Kulliyat* of Khwaju Kirmani, for example the unmasking of Humayun by Humay (Gray, 1961, p.47; see the analysis by T. Fitzherbert, 'Khwaju Kirmani (689-753/1290-1352): an éminence grise of fourteenth century Persian painting', *Iran* XXIX (1991), pp.142-143.

57. Such as the *Divan* of Sultan Ahmad Jala'ir in the Freer Gallery, Washington D.C., datable to the first decade of the 15th century (Gray, 1961, p.49).

58. See Fitzherbert, op.cit., p.143, for a telling example of how and why the text was tampered with by

adding extra verses.

59. Even a full-page illustration could only be inserted at a later stage if it fulfilled two conditions: that its verso also contained a full-page painting, and that neither painting incorporated any of the text to be illustrated. In point of fact there are no full-page paintings in the *Gulistan*, and indeed artists of this period seem to have gone to great lengths to make a picture 'technically' contain text even though it was effectively a full-page illustration.

60. In some cases it is plain that the exact length of the text, down to the number of lines, was calculated, as were the dimensions of each picture. The Dublin *Gulistan* would not have been able to exploit its most teasing devices of suspense without such careful calculation. The text block, too, maintains consistent dimensions, and if these are transgressed, it is only by pictures. See B. Brend, 'Beyond the pale: meaning in the margin', in *Studies in Persian Painting. Festschrift for B.W. Robinson*, in press.

61. In the tale of the wrestlers, the page begins with the quotation which ends the previous tale, namely the verses inscribed on the crown of Kaikhusrau. These stress that no one can hold on to power for ever. And the story which they round off features a king whose dishonest dealings prove his downfall. That is the immediate context for the account of the wrestler who passed on all but one fragment of his professional knowledge to his younger colleague and pupil, and used that against the youth when the latter treacherously challenged him to public combat.

62. In the tale of the amorous prince, the Chinese maiden and the negro, most of the text written on the painted page comprises verses from the previous story; their burden is that fortune bestows wealth upon the ignorant, the foolish and the illiterate. These verses are quoted in the context of the ignorant negro whom Harun al-Rashid appointed to rule over Egypt, and who suggested, in a manner worthy of George III, that wool should be planted instead of cotton so that the Nile should not be able to sweep it away. The following tale is about an unworthy negro on whom Fortune smiles.

63. The story of the king and the beggar is accompanied by a painting whose text panel contains all of the previous tale and the closing verses of the one before that. All three stories are linked by the theme of a ruler who behaves badly.

64. In the story of the wrestlers, the connection with the previous tale, about the king whose dishonesty brings him to grief, is patent – for here too the dishonest apprentice fails of his purpose and is publicly shamed.

65. What do these examples of overlap suggest? At the very least it may be said that in none of them does the text of the earlier stories weaken or obscure the episode that is actually being illustrated. In the cases of the Chinese maiden and of the dervish, a good deal of text from the previous story is included on the painted page. And here the connection is crystal clear. It is as if the presence of the immediately preceding episode (which is of course potentially intrusive) is here intended to drive home the moral which the painting expresses. The incorporation of ostensibly irrelevant text can be seen to play its part after all.

66. For the latter manuscript, see I. Stchoukine, *Les peintures des manuscrits timûrides*, Paris 1954, pp.78-81; Gray, 1961, pp.113-118.

67. See E.J. Grube, 'Two Kalilah wa Dimnah codices made for Baysunghur Mirza: the concept of the "classical style" reconsidered', *Atti del III Convegno Internazionale sull'Arte e sulla Civiltà Islamica. 'Problemi dell'età timuride'*, Venice 1980, pp.115-122 plus Appendix.

68. See E.G. Sims, 'Prince Baysunghur's Chahar Maqaleh', *Sanat Tarihi Yilliği VI*, 1974-5, pp.375-409.

69. E.J. Grube, *The Classical Style in Islamic Painting*, n.p. 1968.

4 FARANGI SAZ
Pages 46-59

An earlier version of this paper was presented at the Institute for Asian Studies in New York in October 1994.

1. John Carswell, *New Julfa: The Armenian Churches and Other Buildings*, Oxford 1968, pp.19-26.
2. Sheila R. Canby, *Rebellious Reformer: The Drawings and Paintings of Riza-yi 'Abbasi of Isfahan*, London 1996.
3. A recent article traces the European prototypes for a group of works by Sadiqi Beg, Riza's somewhat older contemporary, but they appear to be the work of his old age, the first decade of the 17th century. See Gauvin Bailey, 'In the Manner of the Frankish Masters', *Oriental Art*, vol.XL, no.4, Winter 1994/95, pp.29-34.
4. J. Braat, J.P. Filedt Kok, J.H. Hofenk de Graaff, and P. Poldervaart, 'Restauratie, Conservatie en onder-zoek van de op Nova Zembla gevonden zestiende-eeuwse prenten', *Bulletin van het Rijksmuseum*, vol.28, 1980, pp.43ff.
5. This portrait is in the Princeton University Library. See Abolala Soudavar, *Art of the Persian Courts*, New York 1992, p.264, fig.45.
6. Richard Ettinghausen, 'Stylistic tendencies at the time of Shah 'Abbas', *Studies on Isfahan, pt. II, Iranian Studies*, vol. VII, nos 3-4, Summer-Autumn 1974, p.602.
7. Jean Baptiste Tavernier, *The Six Voyages of Jean Baptiste Tavernier*, London 1672, p.63.
8. Sir Thomas Herbert, *Some Years Travels into Africa and Asia*, London 1677, third edn., p.175. R.W. Ferrier, 'The First English Guide Book to Persia: A Discription of the Persian Monarchy', *Iran*, vol.XV, 1977, pp.84-5, no.11, identifies this artist with the painter Giovanni, who came to Iran in 1617 with Pietro della Valle.
9. Adam Olearius, *The Voyages and Travels of the Ambassadors sent by Frederick Duke of Holstein to the Great Duke of Muscovy and the King of Persia (1633-39)*, trans. John Davies, London 1662, p.286.
10. Sussan Babaie, 'Shah 'Abbas II, the Conquest of Qandahar, the Chihil Sutun and its Wall Paintings', *Muqarnas*, vol.11, 1994, pp.125-42.
11. Basil Gray, 'An Album of Designs for Persian Textiles', *Aus der Welt der islamischen Kunst, Festschrift für Ernst Kuhnel*, Berlin 1959, pp.219-25.
12. A.A. Ivanov, 'The Life of Muhammad Zaman: A Reconsideration', *Iran*, vol.XVII, 1979, pp.65-70.
13. Eleanor Sims, 'The European Print Sources of Paintings by the Seventeenth-century Persian Painter, Muhammad-Zaman Ibn Haji Yusuf of Qum', in Henri Zerner (ed.), *Le Stampe e la Diffusione delle Immagini e degli Stili*, Bologna 1983, p.78.
14. Soudavar, op.cit., p.366, no.145, colour repro-duction.

5 THE CHISELLED SURFACE
Pages 60-69

1. *Hunan Sheng po-wu-kuan, Ch'ang-sha Ma-wang-tui i-hao Han-mu* (The Han tomb no.1 at Mawantui, Ch'angsha), 2 vols, Beijing 1974.
2. A. Stein, *Serindia*, vol.4, Oxford 1921, pl.L.
3. J. Hackin, J. Carl and J. Meunié, *Diverses recherches archéologiques en Afghanistan (1933-40) avec des études de J. Girshman et J.C. Gardin*, Paris 1959, *Mémoires de la DAFA*, vol. XVI.
4. These are published in a) Iran Bastan Museum no.8247; b) Iran Bastan Museum no.604; c) J. Kiani, 'Early Lacquer in Iran', in *Lacquerwork in Asia and Beyond, Colloquies on Art and Archaeology in Asia, no.11,* University of London, London 1982, pp.211-224.
5. Sale, Christie's, London, 17 October 1995, lot 269.
6. R.M. Riefstahl, 'A Seljuq Koran Stand with Lacquer-painted Decoration in the Museum of Konya', *The Art Bulletin*, vol.XV, 1933, pp.361-373.
7. Boston Museum of Fine Arts, 22.392.
8. Musée du Louvre, Paris, AO 7096.
9. Chester Beatty library, Dublin, Pers. MSS 111.
10. W.M. Thackston, *A Century of Princes,* Cambridge Massachusetts 1989, p.287.
11. H. Garner, *Chinese Lacquer*, London 1979.
12. T.W. Lentz and G.D. Lowry, *Timur and the Princely Vision*, Los Angeles and Washington DC 1989.
13. J. Rawson, *Chinese Ornament: The Lotus and The Dragon*, London 1984, p.161.
14. M. Medley, 'Imperial Patronage and early Ming Porcelain', *Transactions of the Oriental Ceramic Society 1990-1*, vol.55, 1992, pp.29-42.
15. Isabella Stewart Gardner Museum, Boston.
16. V&A Museum, London, 973-1901, a stone cenotaph from Bukhara, dated 942AH/1535AD.

7 THE PROGRESS OF RAMA
Pages 80-89

1. For example the famous Sanskrit inscription known as Vo-canh C 40, a site in Vietnam dating from the 3rd century AD, see Georges Coédès, *Les Etats hindouisés d'Indochine et d'Indonésie*, Paris 1964, pp.81-82 and p.81, note 3, or the Sanskrit inscrip-tions of King Purnavarman, found in Java and dating to the middle of the 5th century, see Albert Le Bonheur, *La Sculpture Indonesienne au musée Guimet*, Paris 1971, pp.35-36.
2. These two schools of art represent the Buddha in a similar manner: the face is large and smiling, the hair is rendered with tight locks twisted from the left to the right, the pleated monastic coat leaves the right shoulder bare. See P. Dupont, 'Les Bouddha dits d'Amaravatî en Asie du Sud-Est', in *Bulletin de l'Ecole française d'Extrême-Orient*, XLIX 1959, pp.631-636.
3. The kingdom of Funan prospered thanks to the maritime trade routes connecting Southeast Asia to China on the one hand, and to India on the other. The important archaeological site of d'Oc-Eo in southern Vietnam has revealed modest but numerous finds testifying to this trade activity. See L. Malleret, *L'Archéologie du Delta du Mekong*, published by the Ecole Française d'Extrême Orient, 4 vols, Paris 1959-1963.
4. The kingdom of Zhenla originated in the Vat Phu region in the south of present-day Laos.
5. For example the dykes built in the first half of the 7th century at the city of Sambor Prei Kuk, a Khmer capital predating the Angkor period.
6. Compiled at some point between the fourth centuries BC and AD, the *Mahabharata*, the Great (gesture) of Bharata, tells the story of the five Pandava brothers and their hundred cousins, the Kaurava. In 90,000 verses and 18 books, the text explains the reasons for the rivalry between the two clans, culminating in the great battle at Kuruksetra. The *Mahabharata* incorporates numerous digres-sions on Brahman mythology as well as the famous

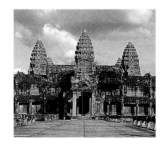

Bhagavadgita, the Song of God, one of the greatest and most beautiful of the Hindu scriptures. The *Bhagavadgita* serves as a founding text on *bhakti* (devotion) so fundamental to the practice and religious thought of the Hindu devotee.

7. The *Harivamsha* or Genealogy of Hari, another name for Vishnu, consisting of 16,374 verses, is a contemporary text to the Mahabharata. Functioning as a complement to the latter, it presents various Vaishnavite myths.

8. See Georges Coédès, 'Les bas-reliefs d'Angkor Vat', *Bulletin de la Commission archéologique de l'Indochine*, 1911, p.50, note 3.

9. See Georges Coédès, op.cit., p.51.

10. See Georges Coédès, *Inscriptions du Cambodge*, vol.1, Hanoi 1937, p.131.

11. For example the myth of the origin of the Linga (*lingodbhavamurti*), found on a 7th century lintel from the monastry of Vat Eng Khna and now in the National Museum of Phnom-Penh. See K. Bahttacharya, 'Les Religions Brahmaniques dans l'ancien Cambodge d'après l'épigraphie et l'iconographie', *Bulletin de l'Ecole Française d'Extrême Orient*, vol.XLIX, Paris 1961, pp. 80-81, pl.I.

12. For example the Hindu god Indra, often found in the centre of the lintel over the eastern sanctuary door.

13. See for example the famous bas-reliefs of the Candi Loro Jonggrang at Prambanan in the centre of the island of Java.

14. It has been suggested that, as Angkor Wat opens to the west, it was built as the king's own mortuary shrine, as were some Indonesian temples such as the Candi Singhosari. According to Indochinese mythology, the west is the direction in which the dead depart. Rectangular stone 'coffins', containing pots that might have functioned as urns, were indeed found in some Khmer temples of the Angkor period, notably at Phnom Bakheng and at Angkor Wat. However, due to looting these are no longer at their original location within each temple. It seems that temples were built first and foremost as religious edifices, but might eventually have housed the remains of the king, not unlike medieval cathedrals in Europe. In the light of current evidence, the theory of Angkor Wat being built as a mortuary shrine cannot be sustained. See Georges Coédès, 'La destination funéraire des grands monuments Khmer', *BEFEO*, vol.XL, pp.315ff.

15. Traces of paint and gilding have been found on the bas-reliefs. However, these have not yet been dated. It is likely that the bas-reliefs were painted at a later period.

9 A FEARFUL SYMMETRY
Pages 104-135

I would like to express my sincere thanks to all those curators and conservators who allowed me to examine their fragments of red- and blue-ground grotesque carpets, as well as all those who offered their advice on this complicated subject: Kjeld von Folsach, Anne-Marie Keblow and Maria Fjeldborg at The David Collection, Copenhagen; Amanda Slavin at St. Louis Art Museum; Cathryn M. Cootner at the M.H. de Young Memorial Museum, San Francisco; Anne E. Wardwell at The Cleveland Museum of Art; Stuart Cary Welch and Julia M. Bailey at the Sackler/Fogg Art Museum, Harvard University; Thérèse Bittar and Maguey Charritat at the Musée du Louvre, Paris; Sylvie Dubois at the Musée des Arts décoratifs, Paris; Elsie Peck at the Detroit Institute of Art; Carol Bier, Julie Evans and Ursula McCracken at The Textile Museum, Washington DC; Jean-Michel Tuchscherer at the Museum of Fine Arts, Boston; Anatol Ivanov at the Hermitage Museum, St Petersburg; Elena Tsareva at the Museum of Ethnography, St Petersburg; Val Blyth, Sophie Younger and Nicholas Pearce at The Burrell Collection, Glasgow; Daniel S. Walker and Nobuko Kajitani at The Metropolitan Musuem of Art, New York; the Director General, Archaeological Survey of India; the Director, National Museum, Delhi; William Robinson and Jeremy Rex-Parkes of Christie's, London; and Rina Indictor in New York. I would especially like to thank both Charles Grant Ellis and Robert Pinner who read the original draft of this article several years ago and who made many constructive comments. Finally I would like to thank the art department at Hali Publications for their patient work on the drawings of the reconstructions of the red-ground grotesque carpets.

1. G. Migeon, *Manuel d'Art musulman*, Paris 1907, vol.II, p.434. Translation by Henry Ginsburg and Bernard Weaver, London.

2. Manuscript border with grotesque heads added to intersections and ends of scrolling stems: *Diwan of Sultan Hosayn Bayqara*, Herat d.1501, MMA, New York 1982.120.1; bottom of manuscript without grotesque features at end of scrolling stems: *Diwan of Mir 'Ali Shir Nawai*, Tabriz or Istanbul ca. 1520-30, British Library, London OR 13061; round bronze dish with grotesque heads at terminals of spiralling scrolls, Khurasan, ca. 1200, see *Treasures of Islam*, p.262 no.268; silver-gilt roundel with leaves at terminals of spiralling scrolls: Sackler Gallery,

Washington, Iran ca. 6th-7th century, see Harpur, *The Royal Hunter*, p.62, no.19; faience tile with grotesque vine scroll, tomb of Madani, Kashmir ca. second quarter of 17th century, V&A, London IM 297-1923; ceramic tiles with vines ending in leaves and flowers: Cordova, Spain, spandrels from Grand Mosque of Hakim II, ca. 965; embroidered or woven cloth seen painted on outer roof of tent, covered with grotesque spiralling scrolls, *Zafarnama*, Herat? ca. 1480, fol.83a, Johns Hopkins U, Baltimore; spiralling scrolls with grotesque heads and Arabic calligraphy on resist-dyed linen fragment, Egypt? ca. early 14th century, Museum of Islamic Art, Cairo 14472; spiralling stems terminating in flowers and leaves from wall tiles and carpets illustrated by Farruk Beg in the *Baburnama*, Lahore ca. 1589, Sackler Gallery S 86.0230. Other well known examples of spiralling scrolls ending in grotesque heads which are unrelated to the *Shahnama's* "talking tree" are: the enamalled glass flask, Egyptian or Syrian, ca. 13th-14th century, BM, London 69 1-20 3; enamelled ivory plaque ca. 12th-13th century, formerly in Kouchakji Collection, published by Pope, *Masterpieces of Persian Art*, London 1945, p.94 pl.58; inlaid brass penbox, Mamluk, dated 1281, British Museum, London, 91 6-23 5; inlaid brass incense burner, Syrian ca. 13th century, Walters Art Gallery, Baltimore 54.451; ceramic vase, Kashan, Iran ca. early 13th century, Musée du Louvre MAO 442; carved stone roundel, Syrian or Egyptian ca. 1250, published in *Propylaen Kunstgeschichte*, fig. 213 no.195, Museum of Islamic Art, Cairo. One could mention hundreds more examples.

3. One small fragment, 65-230 x 102-284mm, in a private collection in London, does share the drafting, exactly, of the elephants from the red-ground grotesque carpets. But this small fragment contains additional decorative features (a baby elephant) not seen on any other red-ground grotesque fragment, and although its structure is approximately the same, the density of knotting (88-98 x 60-62 per dm) is probably sufficiently different to reject this fragment as one which originated from the same pair of carpets.

4. Each block or grid (what on a drawloom would be a pattern unit) is arranged according to a curious vertical and horizontal symmetry. Four patterns are used in each horizontal row (either two different

patterns and their two mirror images or two different patterns, one mirror-image and one variant) to complete the full design from border to border. Four such horizontal pattern units (sixteen in total) follow one another, each displaying either a bilaterally symmetric arrangement of different combinations of two different pattern units and their mirror images or three symmetric units and the addition of the variant block. If required for greater length, a fifth horizontal row identical to the first would begin the original sequence once again. A design of this sort which incorporates non-symmetric variants is unusual in carpet designing but is well known for textiles intended to be woven on drawlooms. The implication is that the designer of the red-ground grotesque carpets was also experienced as a designer of non-knotted pile textiles.

5. F.R. Martin, *A History of Oriental Carpets Before 1800,* I. and R. State and Court Printing Office, Vienna 1908, p.82, fig.192

6. Ibid., p.80.

7. Ibid., p.80.

8. The exploits of the 4th century BC historical figure of Alexander the Great became the subject of an anonymous Alexandrine Greek work of the late 2nd century AD, now known as the *Pseudo-Callesthenes,* and appeared subsequently in most European and Asian languages by the Middle Ages.

9. This is true of the vast majority of the Arabic, Persian, Indian, Turkish and Central Asian illustrations of the 'talking tree', and some of these same features are also found on illustrations of the trees on the fantastic island of Wak-Wak, described and illustrated in works such as ibn Bakhtishu's *Manafi' al-Hayawan,* al Jahiz's *Kitab al-Hayawan,* al Qazvini's *'Aja'ib al-Mukhluqat,* Shadiyabad's *'Miftah al-Fuzala...*etc., and on the trees of hell illustrated in the *Miradj-Nameh.*

10. A.G. Warner and E. Warner, *The Shahnama of Firdausi,* London 1912, pp.167-169.

11. F. Sarre & F.R. Martin, *Die Ausstellung von Meisterwerken muhammadanischer Kunst in München 1910,* Munich 1912, vol.I, pl.84, nos. 180 & 181.

12. K. Erdmann, 'The Art of Carpet Making in Survey of Persian Art, Rezension', *Ars Islamica VIII,* 1941, p.171, fn.161.

13. Special Exhibition Catalogue, *A Collection of Rare Textiles,* City Art Museum of St Louis, Series 1913, no.4, p.17. My thanks to Amanda Slavin, research assistant to the director of the St Louis Art Museum who kindly provided me with a photocopy of this catalogue. As Charles G. Ellis pointed out in personal correspondence 23/8/88, it is always possible that Kouchakji did own this fragment and that he and Bacri might have reached a commercial arrangement for its exhibition.

14. *Oriental Rug Exhibition, December 15, 1919-February 15, 1920,* Supplement to the *Bulletin of the Cleveland Museum of Art,* pp.10 & 15, pl.IV. The author was assisted in locating this catalogue by Anne Wardwell, Curator of Textiles, The Cleveland Museum of Art. The fragment is now in the Fine Arts Museums, San Francisco, inv.no. Sachs 1952.35.

15. G. Migeon, *L'Orient musulman,* Paris 1922, p.29, and pl.28, no.128: "Fragment de Tapis, Art indo-persan, XVIIe siècle".

16. G. Migeon, *Manuel d'Art musulman,* Paris 1927, vol.II, (2nd revised edn.), pp.384-385.

17. J. Orendi, *Das Gesamtwissen über neue Teppiche des Orients,* Vienna 1930, pp.178, 220, ill.892.

18. *Collection Octave Homberg, Catalogue des Tableaux Anciens Objects d'Art...,* Galerie George Petit, Paris, 2 June 1931, p.59 & pl. LIV, no.123 [sales catalogue].

19. M. Aga-Oglu, 'A Fragment of a Rare Indian Carpet', *Bulletin of the Detroit Institute of Arts,* vol.XIII, no.1, Oct. 1931, p.2. No evidence of a central device has yet appeared.

20. Ibid., p.4.

21. Erdmann, 'Rezension', cit., p.171, fn.161.

22. Ibid., ill.16.

23. W. von Bode & E. Kühnel, trans. Charles Grant Ellis, *Antique Rugs from the Near East,* Braunschweig 1958 (4th revised edn.), pp.161-162.

24. Ibid, fig.118.

25. M. Beattie, 'The Burrell Collection of Oriental Rugs', *Oriental Art,* new series, vol.VII, no.4, winter 1961, p.162, fn.4.

26. K. Erdmann, *Der Indische Knüpfteppich,* Göttingen 1959, pp.104-105. My thanks to Maria Schlatter, former German editor of HALI, for her English translation.

27. Beattie, op.cit.

28. Christie's, London, 13 December 1934, lot 286, p.42 and facing illustration: "A fragment of a hunting carpet, woven in colours with fabulous and grotesqued [sic] animals hunting on a red field inset with flower-sprays – 8ft. 7in. square – Indo Persian, 15th Century From the Imperial Collections, Vienna Purchased from the Administration of the Hapsburg Trust". The vendor was Richard Weininger of Augsburg, Bavaria, and the price was 450 guineas. My thanks to Jeremy Rex-Parkes, Christie's London archivist, and Nicholas Pierce, Islamic curator, The Burrell Collection.

29. Beattie, op.cit., p.142.

30. Personal correspondence with Dr Kjeld von Folsach, Director of the David Collection.

31. J.V. McMullan, *Islamic Carpets,* New York 1965, pp.44-45 & col.ill. no.8.

32. K. Chattopadhyaya & J. Dhamija, 'Important Carpets in USSR', (part 4 of 'Historical Carpets'), *Marg,* vol.XVIII no.4, Sept. 1965, p.20, fig.2.

33. My thanks to Robert Pinner for this information.

34. K. Erdmann, *Seven Hundred Years of Oriental Carpets,* London 1970, pp.176-178, 230, fig.221.

35. Correspondence from Mr Sacks arrived at the Museum from 33 rue d'Université in January, 1952, and Hotel St Regis in October of that same year.

36. Colding, Poulsen, Schou-Christensen, Leth & Gelfer-Jørgensen, *C.L. Davids Samling. Fjerde Del Jubilaeumsskrift 1945-1970,* Copenhagen 1970, vol.IV, p.255, no.7.

37. S.C. Welch, *Art of Mughal India,* New York 1976, pl.21 and p.165. His famous quotation comes from the Mughal minister Abu'l-fazl 'Allami's description of the Indian carpet industry in his 1590 *A'in-i Akbari.*

38. Ibid., p.165.

39. Dr Eiland is, of course, correct about their later prevalence but one still does not know when the practice first began.

40. M. Eiland, *Chinese and Exotic Rugs,* Boston 1979, p.143 & colour plate 43 a-c. During subsequent discussions between Dr Eiland and the author, he has confirmed that these opinions may have to be modified in the light of further investigation.

41. R. Crill, in R. Skelton et al., *The Indian Heritage. Court Life and Arts under Mughal Rule,* (exhibition catalogue), London 1982, p.74, nos.191-193.

42. This author agrees with Walker except for two points. Either the dates of his 'Lahore group' must be extended to include the earliest examples, the red-ground grotesque carpets ca. 1600, or the red-ground grotesque carpets should be left out of the group because they were possibly royal commissions with designs distinct from later commercial production.

43. D. Walker, 'Classical Indian Rugs', *Hali,* vol.4, no.3, 1982, pp.255-57, fig.10. The Fogg/Sackler fragment was purchased at the 'F. Adda' auction no.1013-1022, Palais Galliéra, Paris, 3rd Dec. 1965, lot no.1019: "Fragment de Tapis Indo-Persan...Fin du XVIe siècle." The list of related examples was standard except for the addition of "...puis dans la collection Tabbagh (Hôtel Drouot, mai 1935, no. 123 du catalogue, Reproduit pl.LIV. Voir la reproduction)." This is incorrect. There was no Tabbagh

sale in May 1935; it was held on 20-21 June 1935, and did not include any fragments of red-ground grotesque carpets. While it is always possible that Tabbagh may have owned the fragment at one time, we have no supporting evidence for this supposition. The catalogue number (123) and plate number (LIV) mentioned by the auctioneers refer to the earlier Homberg sale in 1931 (see note 18 above). The initial information about the Adda sale and permission to examine the fragment in Cambridge, Mass., were generously provided by the present owner.

44. H. Erdmann, 'Mughal Carpet with Grotesques', *Hali*, vol.4, no.3, 1982, pp.224, 236 & 237, carpet no.3, illustrated on p.225.

45. R. Marks, R. Scott, B. Gasson, J. Thomson & S. Vainker, *The Burrell Collection*, London & Glasgow 1983, pp.81-82 & fig.1.

46. S.C. Welch, *India! Art and Culture. 1300-1900* (exhibition catalogue), New York 1985, p.159 and col.pl.95.

47. Biriukova, Shkoda etc. trans. Smirnov, *Decorative Arts in the Hermitage*, Leningrad 1986, pl.50. The Stieglitz School of Design was known as the 'Muzei Tzentral 'nagho Uchilishcha tekhnicheskagho risovaniya Barona Shtiglitz' in pre-revolutionary Tsarist Russia and its original collection was formed in the late 18th-mid 19th century by Baron Christian Ludwig Stieglitz.

48. Christie's, London, 18 October 1994, lot no.569, p.187. Because of the higher knot count this fragment may have derived from a third carpet.

49. Ex-Ballard, MMA 22.100.67.

50. F. Sindermann, 'A Group of Indian Carpet Fragments with Animal Grotesque Design on a Red Ground', *Oriental Rug Review*, vol.15, no. 5, 1995, pp.21-27. This is an extremely complicated but valuable work. Unlike my efforts to re-create the missing portions of each known fragment, Dr Sindermann had the insight to recognise the four basic pattern units from the beginning and to understand how they were repeated.

51. K. Bharatha Iyer, *Animals in Indian Sculpture*, Bombay 1977, pp.14-15, figs.5-8.

52. E. Mackay, *Further Excavations at Mohenjo-Daro*, pl.LXXXIV, no.75, Mohenjo-Daro DK area G, upper levels; and Iyer, op.cit., p.16, fig.9.

53. The *Tuti-nama* was probably originally illustrated as a Sultanate MS ca. 1500? but much of it was overpainted during the 1560s and it is the style of this overpainting which is under consideration. See: John

Sailer, *Artibus Asiae*, vol.LII, 3/4, 1992, pp.283-318.

54. Examples of this extremely skilled but over-polished style are the animals found within oval cartouches on the border of the Shah Jahan album ca.1650. See: Heramaneck, *Masterpieces of Indian Painting*, p.230, no.210, National Museum, Canada. Though these are of the same species as the animals on the carpet, they are better drawn, but without spirit.

55. A greater sensitivity towards the illustration of plants was always an element of non-Islamic Indian art. Before the 1620s, Indian artists working for Muslim patrons tended to rely upon standard Shirazi conventions, but there are exceptions. The Deccani folio of "three bamboo shoots", dated 1595, is botanically accurate because it is a copy of an Arab *Materia Medica*. See: Topsfield and Beach, *Indian Paintings and Drawings from the Collection of Howard Hodgkin*, London 1992, pl.7, p.33.

56. The Girdlers & Fremlin Carpets are illustrated in R. Pinner & W. Denny (eds.), *Oriental Carpets & Textile Studies*, vol.3, no.2, London 1990, p.108, figs.3, 5; and in D. King & D. Sylvester, *The Eastern Carpet in the Western World: From the 15th to the 17th century*, (exhibition catalogue), London 1983, p.31.

57. One hesitates to cite specific numbers of heads, arms, tusks or trunks for these divine beings as those numbers change, depending on which tradition or which aspect of the being one is referring to.

58. Iyer, op.cit., p.72.

59. Ibid., p.71.

60. A.K. Coomaraswamy, *Yaksas*, Delhi 1980, 2nd edn., pt.II, pl.41, no.2.

61. This is thoroughly explored by Bosch in *The Golden Germ*, 's-Gravenhage 1960; repr. Delhi 1994.

62. An early Jain, as opposed to Hindu or Buddhist, example is the Kushan period fragmented pink sandstone arch from Kankali Tila, Mathura ca. 2nd century. On one side three parallel rows of processing devotees bring gifts to holy beings seated at the apex of the arch; the bodies of the devotees and of their grotesque hybrid mounts (fish-tailed dragons, fish-tailed lions and fish-tailed birds) form the meandering stem which begins at the point where the first devotee kneels and draws a treasure from the open mouth of a huge makara. See: L. Ashton (ed.), *The Art of India & Pakistan*, fig.63, pl.13, National Museum, Delhi 1950, inv.no. J.555.

63. Coomaraswamy, op.cit., pt.2, pp.48-49; Bosch, op.cit., pp.34-39; Vogler, *De Monsterkop*, Leiden 1949; O.C. Gangoly, 'IV.-A Note on Kirtimukha:

Structural analysis of red-ground grotesque carpet fragments, grouped according to orientation of design.
Note: In every case all warps and wefts are cotton; all pile is wool. Warp depression is the degree of difference between alternate warps.

ORIENTATION 1							
PIECE	PL.	WARP DIMENSIONS	WARP COLOUR	WARP STRUCTURE	WARPS/DM	WARP DEPRESSION	WIDTH OF WEFT
Burrell 1934/9/1	G	2700mm	white (lustrous)	Z6-7S	108/109/102/106	75°-80°	2675mm
TM R.63.00.20A	J	1053-1060mm	dull white-beige	Z7S	104/116 108/118/118	58°-65°	1278-1292mm
Harvard 358.1983	N	1416-1420mm	white	Z7S	122/120/122	65°-72°	1004-1010mm
MMA 1971.263.3	K	770-783mm	white	Z7S	118/116/120/124	45°-58°	527-555mm
FAMSF 1952.33	L	658-673mm	white	Z6-7S	126/124/116	-	508-670mm
FAMSF 1952.34	M	647-663mm	ivory white	Z7S	122/112/112	28°-38°	670-675mm
Christie's 1994	O	341-399mm	off white	Z6S	120/110/130	48°-60°	672-675mm
ORIENTATION 2							
Detroit 31.64	C	1912-1930mm	white	Z7S	116/120/120/124	66°-70°	1765-1792mm
Boston 04.1697	D	1905mm	white	Z7S	106/112/110/110	65°-76°	1277mm
Hermitage YT 1017	F	963-970mm	white	Z7S	112	75°	645-670mm
David Coll. text.32	H	785mm	ivory-beige	-7S	116	-	675mm
FAMSF 1952.35	E	718-777mm	white	Z7S	120/116/110	63°-76°	3000-3048mm
Louvre 7255[a]	A	1490-1500mm	white	Z7S	116/112/116/110	65°-70°	586-596mm
Louvre 7255[b]	B	1490-1500mm	white	Z7S	118/112/112	65°-70°	496mm
TM R.63.00.20B		300-305mm	white	Z7S	116	58°-67°	375-378mm

Being the Life-History of an Indian Architectural Ornament', *RUPAM*, vol.1, no.1, 1920, pp.11-19. For the Shaivite text cited, see: *Skandapurana*, Basumat edn., Calcutta, vol.II, pp.1182-1183.

64. Coomaraswamy explained the significance of the water pot most eloquently: "Throughout the history of Indian art the full vessel (*purna kalasa, purnna ghatta*, etc.) is the commonest of all auspicious symbols, employed equally by all sects, and occurring not only in India proper, but also in Farther India and Indonesia." "...As an integral architectural motif it occurs in rich and varied forms as an essential part, generally the capital or sub-capital, of...columns or as the support of a pilaster...The *purna kalasa* is plainly thought of as an inexhaustible vessel, but the actual form [is] always associated with vegetation...Thus the form is essentially that of a flower vase combining a never failing source of water with an ever living vegetation or tree of life." from Coomaraswamy, *Yaksas*, part II, pp.61-62.

65. A note about the use of the terms 'lion', 'tiger', 'leopard' and 'cheetah' within an Indian context might be appropriate. Indian texts often do not clearly distinguish the differences between the various large cats. Therefore, for the sake of convenience, the heavy bodied felines found on the carpet and decorated with stripes will all be referred to as tigers, those with spots will be leopards, those without markings will be lions and the thinner bodied leaping cats will be referred to as cheetahs.

66. Two comparative illustrations are found in Gangoly, op.cit., fig.14, Chalukyan architecture; and in Vogler, op.cit., pl. VI, fig.59, from Balligamve, Mysore.

67. That list would include the *Mahabharata/Razmnama*; *Ramayana*; *Harivamsha* and *Jog Bashisht*.

68. V&A, London IS.122-1984, published in: *Two Thousand Years of Indian Art*, Spink & Son, London 1982, p.75, no.56. Robert Skelton kindly drew my attention to the undated folio from the *Dayavimalaji Kalpasutra* commissioned ca. 1475 by two Jain bankers from Gandhar Bandar near Broach, Gujarat. It contains several drawings of elephants, a horse, and auspicious symbols made up of the distorted bodies of women. See Moti Chandra, *Jain Miniature Paintings from Western India*, Ahmedabad 1949, pp.39 & 42, figs.132-135. An even earlier unpublished stone sculpture is outside the Rani Devi temple, Tala, southern Madhya Pradesh. This 6th century Shaivite image of Rudra/Bhairava contains various animals integrated within its outline.

69. This story is only found in the 'Asvamedhikaparvan' (chapter of the Horse Sacrifice) of the *Jaimini-Bharata*. In the fourteenth book, the 'Asvamedhikaparvan' of the traditional *Mahabharata*, there is no mention of talking trees, encounters with Amazons...etc. According to M. Winternitz (*History of Indian Literature*, University of Calcutta 1927, vol.1, pp.584-586) the version ascribed to Jaimini had to have been composed during or after the 6th century AD at the earliest, because a historical figure, the astrologer Varahamihira, is mentioned and he lived at that time. For both texts in English, see: Karmarkar, *The Asvamedhikaparvan*, Poona 1960, introduction, p.XXXVII.

70. In the folio titled 'Krishna and Pandavas question head of Raja Barbarik', Book XII, Santi Parva, published in T. Hendley, *Jeypore Memorials* IV, pl.LXXI, the artist has simply used the conventional Persian representation of the 'talking tree' from the *Shahnama*.

71. In Rajasthan, *narikunjara*, literally 'ladies & elephants', remains one of the most popular subjects for composite drawings.

72. W. Born, 'Ivory Powder Flasks from the Mughal Period', *Ars Islamica*, vol.IX (1942), pp.93-111.

73. Yang Xiaoneng, *Sculpture of Xia & Shang China*, Hong Kong 1988, pp.47, 58, 166-171, figs.16, 161, and many other examples.

74. E. Bunker, B. Chatwin & A. Farkas, *"Animal Style" Art From East to West*, New York 1970, p.67, no.40: gold armlet from Central Asia or Siberia ca. 4th century BC; p.129, no.112: bronze plaque from Inner Mongolia ca. Warring States period; Lawton, *Chinese Art of the Warring States Period*, Washington DC 1982, p.65, no.26: two bronze fittings ca. 5th-4th century BC and p.123, no.72 and drawing: gilt bronze garment hook, 3rd century BC.

75. Bibliotèque Nationale, Paris MS Lat. 12135, f. IV, Corbie, N. France, ca. 2nd half of the 8th century; published in: O. Pächt, *Book Illumination in the Middle Ages*, London 1986, p.48, no.53. Oxford, Bodleian Lib. MS Douce 176, fol.62, Gospel Lectionary from Chelles, N. France, ca. 800; published in: Pächt, op.cit., p.50, fig.55a.

76. The letter 'A': Salisbury Psalter, Salisbury Cathedral Library MS 150, ca. 975, Anglo Saxon and 12th century Latin, from J. Blackhouse (ed), *The Golden Age of Anglo Saxon Art*, London 1984, p.50, no.29; also in Flavius Josephus, *Jewish Antiquities I-XIV*, Canterbury, ca. 1130, Cambridge University

Weft Colour	Weft Structure	Shoots	Weft bundles/1dm	Pile	Colours	Discontinuous wefting	Kn/dm2
beige	Z spun	3	57/57/54/58	2Z	-	yes	2754-3161
beige	Z twisted	3 some 4	57/59/54	2Z	-	yes, 4 diagonal lines in centre	2828-3481
beige	Z twisted	3	55/54/56	-Z	-	yes	3240-3416
beige	Z twisted	3	61/57/55/52	2Z	-	yes, some very small lines	3016-3782
beige	Z	3	52/57/53	2 or 3Z	-	yes, 4 lines	3016-3591
beige	Z	3	51/51/52	2Z	-	yes, one 175mm diagonal line	2856-3172
light beige	Z	3	65/57/70	2Z	10	yes, one 20mm long	3135-4550
ivory	-Z	3 some 4	67/55/58/59	2Z	11	yes, 8 lines in 3 rows	3190-4154
beige-yellow	2Z	3-4	60/64/62/57	2Z some 3-4Z	11	yes, 150-180mm	3021-3584
beige	3Z	3	64/64/61	Z2S mostly, Z3S red	14	yes	3416-3584
light ochre & dull beige	Z	3	61	-Z	-	yes	3538
ivory beige	Z	3 some 4	66/60/63	2Z	14 or 15	yes, many lines	3300-3960
beige-off white	Z	3 some 4	53/56/64	2Z	10	yes	2915-3712
beige-off white	Z	3	64/58/62	2Z	10	yes	3248-3776
beige	Z	3 some 4	56	2Z	-	no	3248

Library MS Dd.1.4, folio 220; from Zarnecki et al. (eds.), *English Romanesque Art*, London 1984, p.52, no.43.

77. British Museum, London MLA 1870, 8-11, 1, Anglo Saxon pen case, walrus ivory ca. mid 11th century; published in *Golden Age of Anglo Saxon Art*, pl.XXV, no.132.

78. D. Wilson, *Anglo-Saxon Art*, New York 1984, p.144.

79. See *English Romanesque Art*, p.62, no.142.

80. See R. Ghirshman, *Iran*, Paris 1962, p.299, no.388. The tympanum of the Church of Saint-Gilles, Beauvais Museum, ca. 12th century, is a splendid example which also reflects the compositional balance of the red-ground grotesque monster masks with their side features. The inhabited capital of the portal trumeau in the Domkapelle in Goslar, Germany, was sculpted by Hartmanus in ca. 1150. Here a central monster mask with volutes or foliage dropping from its mouth is surrounded on either side by two pairs of 'animated' wings. One pair has bony legs and the other knotted dragon heads. From R. Calkins, *Monuments of Medieval Art*, Oxford 1979, pp.108-109, fig.91.

81. Pächt, op.cit., p.60, fig.77.

82. P. Lewis & G. Darley, *Dictionary of Ornamentation*, London 1986, pp.112-113.

83. Ibid., p.268, "Hugues Sambin. 1) Herm for the Composite Order from Oeuvre de la diversité des termes, 1572."

84. Ibid., p.312.

85. Brand and Lowry have suggested "...that this type of material could have been brought to India from Iran, perhaps as part of an artist's scrap book." From M. Brand and G. Lowry, *Akbar's India*, New York 1986, p.97.

86. Ibid., p.98.

87. See the section on the acquisition and influence of European Renaissance art on Akbari court artists in: Brand & Lowry, op.cit., pp.96-104.

88. The Canning jewel: V&A, London inv. no. M 2697-1931, *The Indian Heritage*, V&A, London 1982, illus. no. 299, p.108. *Jahangir Preferring a Sufi Shaikh to Kings*, The Freer Gallery, Washington DC, 42.15a, Mughal, ca. 1615-18 by Bichitr, published in Beach, *The Imperial Image*, Washigton DC 1981, p.79. See illustration no.31 in text.

89. R. Skelton, 'A Decorative Motif in Mughal Art', P. Pal (ed.), *Aspects of Indian Art*, Leiden 1972, pp.147ff.

10 MEIBUTSU-GIRE
Pages 136-145

I would like to thank Fritz and Kitty Schmidt for their help and encouragement, and for allowing me to illustrate textiles from their collection. Thanks too to Michael Birch, the resident Tea Master at the London Urasenke Foundation for Chanoyu, and to Momoko Tsuchida.

1. Mountings for hanging scrolls of calligraphy or painting, *hyogū nō gire*. Napkins generally are *fukusa*; small square napkins, *kobukusa*; napkins for guests, *dashibukusa*; host's larger napkin, *temaebukusa*.

2. The Toshiba Gallery of Japanese Art, V&A Museum, has an interesting display of tea utensils grouped according to the type of tea gathering.

3. During the 'Age of the Warring States' (1467-1563), Japan was subject to constant civil wars which decimated the weaving industry, resulting in the import of luxury fabrics. The Ashikaga shoguns were significant cultural patrons based in the Higashiyama and Kitayama districts of Kyoto. Ashikaga Yoshimitsu (1358-1408) was a great patron of the Nō theatre and the textile industry. His retirement villa, Kinkakukji, built ca. 1395, included a room set aside for tea gatherings. Ashikaga Yoshimitsu (1435-1490) built the Ginkakuji, ca. 1480 which houses a room, the Dojinsai (completed 1486) considered to be the first especially designed for drinking tea.

4. *Wabicha*, literally 'poverty tea', comes from *wabi*, an aesthetic concept denoting an idealised expression of poverty. A useful discussion of *wabi* traditions can be found in 'The Wabi Aesthetic Throughout the Ages' in Haga Koshiro, *Tea in Japan: Essays on the History of Chanoyu*, Tokyo 1989. Any discussion of the aesthetics of tea-utensils should be considered as a manifestation of and a contradiction of the ideals of frugality sought by exponents of *wabicha*.

5. Translated here by Martin Collcutt in *Haga*, 1989, from the *Nanpōroku* (see note 14 below). Rikyū's four guiding principles governing the use of tea utensils from China, Korea and Japan (and with regard to fabrics from Southeast Asia, India and Europe) were harmony, reverence, purity and tranquillity (*wa, kei, sei, jaku*).

6. The kind of tea drunk at *Chanoyu* is *mattcha*. The thick variety, *koicha*, is made by whisking powdered tea directly in the teabowl resulting in a frothy yellow-green tea with a uniquely bitter taste. *Usucha*, thin tea, is made from an infusion of the leaves as opposed to the powder. The glossy lacquer caddy for *usucha* tea is known as an *usuki* or *natsume*.

7. Gokokuwatari: before 1419; kowatari:1433-1493; nakawatari: 1504-1547; atowatari: 1558-1592; chikawatari: 1603-1652; arawatari: 1652-1711; imawatari: up to 1800.

8. Gold brocade, *kinran*; silver brocade, *ginran*; satin damask, *donsu*.

9. Textile designs of Mogul dynasty origin (1526-1857), *mōru*; striped, checked or thread resist dyed cottons, *kantō* and hand drawn or printed calico and cotton, *sarasa* (chintz).

10. *Nishiki*, multi-coloured brocades.

11. Since the Edo period *meibutsu* have been ranked in three categories: firstly, *O-meibutsu*, covering objects which have been recognised by the time of Sen Rikyū (1521-1591); secondly, *meibutsu*, covering items which had once belonged to Rikyū; thirdly, *chūko-meibutsu*, items recognised by Tea Master, garden designer and architect, Kobori Enshū (1579-1647) who systemised *Chanoyu* under the Edo Shogunate.

12. For this occasion Hideyoshi displayed his collection of named pieces, one of which had a *shifuku* with a design of roundels enclosing paired phoenixes, named 'Futarishizuka Kinran'. This was cut from a piece of Ming dynasty fabric that had been made up into a Nō robe once worn by the Shogun Ashikaga Yoshimasa. In this way Hideyoshi – once a mere footsoldier – established his cultural lineage as well as temporal legitimacy to rule.

13. The three styles were *shoin*: the classical Chinese style practised by the Kyoto and Nara elite; *suki*: the style first practised by the upper class merchants of Shimogyo, the commercial centre of Kyoto, and *sakai*: from where Rikyū came developing *wabicha* after his association with Hideyoshi. For *Wabi* see note 4. Each of the three had its own concept of collecting named pieces, of which *wabi* involved the least interest in the acquisition of expensive antiques.

14. *Nanpōroku*, a treatise on Tea compiled around 1593, discussing the development of an ideal setting of *wabicha* and the contribution of different Tea Masters.

15. Since the classification was allied to the object with which the *shifuku* was used, extant 'named' caddies may be accompanied by several *shifuku*.

16. Also called *sendon*.

17. Many of these patterns had been known in Japan since the Heian period (794-1185) when classified in the Yūsoku repertoire of textiles for the Imperial Court.

18. *Kinran* (gold brocade) and *ginran* (silver brocade) derive from *kin*, meaning gold, *gin*, meaning silver, and *ran* from *ran'e*, the border of a priest's robe.
19. It was Abbot Kokei who gave Tanaka Soeki his lay Buddhist name – Rikyū, in reference to a Zen epithet "Dispense with both fame and wealth."
20. The Omotesenke school members also use orange *fukusa*.
21. Sen Soshitsu XV, 'The Implications of the Fukusa', *Chanoyu Quarterly No. 65*, 1991.

SELECT BIBLIOGRAPHY

Bethe, Monica (trans), 'Meibutsu-gire: Famous Chanoyu Fabrics', *Chanoyu Quarterly No.45*, 1986.
Cort, Louise Allison, 'The Grand Kitano Tea Gathering', in *Chanoyu Quarterly No.31*, 1981.
Harris, Jennifer (ed) *5000 Years of Textiles*, London 1993.
Hayashiya, Tatsusaburo, M. Nakamura & S. Hayashiya, *Japanese Arts and the Tea Ceremony*, New York 1974.
Kitamura, Tokusai. "An Introduction to Weaving" in *Chanoyu Quarterly No. 13*, 1976.
Kitamura, Tokusai, 'An Introduction to Donsu', *Chanoyu Quarterly No. 17*, 1977.
Koga, Takezo. *Cha no Kireji* (Tea Textiles), Kyoto 1980.
Koga, Takezo. *Chaseki no Kire. Ochajin no Tomo* (Tea Ceremony Textiles. The Tea Person's Companion), Tokyo 1986.
Koga, Takezo. *Meike no Kire. Ochajin no Tomo.* (Distinguished Lineage Textiles. The Tea Person's Companion), Tokyo 1980.
Kuwata, Tadachika, *Sado Jiten* (Tea Ceremony Dictionary), Tokyo 1956.
Nezu Institute of Fine Arts, *Chanoyu no Utsuwa* (Tea Ceremony Utensils), Tokyo 1990.
Sen Soshitsu XV, 'The Implications of the Fukusa', *Chanoyu Quarterly No. 65*, 1991.
Shohaku, Tosho, *Iro no Techo* (The Colour Notebook), Tokyo 1986.
Shogaku, Tosho, *Monyo no Techo* (The Pattern Notebook), Tokyo 1987.
Taka, A., 'Sen Rikyū's Tea Utensils', *Chanoyu Quarterly No. 62*, 1990.
Varley, Paul H. and Elison, George, 'The Culture of Tea from its Origins to Sen no Rikyū', *Warlords, Artists and Commoners*, Honolulu 1981.

11 THE EMPEROR'S TREASURE HOUSE
Pages 146-159

1. At that time all the buildings of the Tōdaiji had not yet been completed, but by 756 the Shōsōin was finished.
2. The airing of stored artefacts is an ancient custom in Japan which continues to this day in many households and temples.
3. This theory was advanced by W. Meister in 'Zur Geschichte des Filzteppichs in 1. Jahrtausend n. Chr.', *Ostasiatische Zeitschrift*, N.F., no.12, 1936, pp.56-61.
4. Resist dyeing involves the use of a substance such as wax or paste which, when applied to cloth in order to achieve the desired design, prevents those areas from receiving colour when the textile is dyed. The wax or paste resist substance is traditionally applied either free-hand, or with the aid of stencils, carved wood blocks or metal stamps.
5. This inventory was made at a time when objects in the North Section were re-examined and described in fuller detail than in the 756 inventory.
6. V. Gervers (ed), *Studies in Textile History*, Toronto 1977, p.308. It is incorrect however to claim this group of Shōsōin textiles as Chinese products imported into Japan, as stated by Gao Hanyu, *Soieries de Chine*, Paris 1987, p.28.
7. Ibid., p.27.
8. K. Matsumoto, *Jōdai-Gire: 7th and 8th Century Textiles in Japan from the Shōsō-in and Hōryū-ji*, Kyoto 1984, p.15, pl.12, for a full view of this design in a similar textile.
9. *Exhibition of Shōsō-in Treasures*, Nara National Museum, Nara 1991, p.77, no.48.
10. Kimura, op.cit., pp.20-21, pl.15.
11. Ibid., p.55, fig.86.
12. Ibid., p.132-33, pl.84. The full set of animals appears on a bronze mirror in the Shōsōin. The use of the Chinese zodiac was one of many customs borrowed by the Japanese from China.
13. In a few instances part of the padding material consists of felt, which, as discussed, was not considered to have been a Japanese product.
14. Ibid., p.59, fig.91.
15. At the edges on either side, a small-scale horse, and a peacock are only partially seen. In their original complete form, these motifs probably appeared in mirror-image on either side of a tree, of which only a few leaves appear at the edge of the reduced textile
16. A similar scene, showing a pair of lions and their handlers under a palm tree, is found in roundel form in a textile in the Vatican which is considered Byzantine in origin and is dated variously from as early as the 5th century to as late as the 9th century, see M.F. Lucidi, (ed)., *La Seta e la sua via*, exhibition catalogue, Rome 1994, p.233, pl.60. One of the minor motifs in the joku, the peacock, originated outside of China and was later incorporated into the East Asian design vocabulary. It is found similarly depicted on a painted chest in the Shōsōin, see N. Kimura, op.cit., p.66, pl.47-1.
17. S. Sasaki, *Jodai kinryo tokui giho ko*, vol.5, Kyoto, 1973, pp.9-10, for a closer detail of the textile, a macrophoto and a diagram of the textile's structure. The macrophoto also appears in Matsumoto, op.cit., p.205, fig.9.
18. R. Whitfield, *The Art of Central Asia, Vol.III – Textiles, Sculptures and Other Arts*, Tokyo 1985, pl.27.
19. Matsumoto, op.cit., p.230, pl.29.
20. *Exhibition of Shōsō-in Treasures*, Nara 1995, pp.56-57, no.28. The motifs are in dark brown on a lighter brown background; it is executed in damask weave with same-directional twilling, and the motifs are one-directional.
21. Interestingly enough, there is another *joku* that was part of the same donation in 768, which features a textile woven with an almost identical pattern of horned animals, phoenixes and trees (K. Matsumoto, op.cit., pp.68-69, pl.50.) Instead of having a damask-weave, its pattern was woven with floating wefts. It is probable that these textiles with similar patterns were woven in Japan, using the imported textile in (**12**) as their model in regard to certain colour, technical and design features.
22. Ibid., p.41, pl.29.

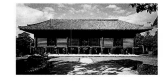

GLOSSARY

asa – a bast fibre, usually either hemp or ramie
Daibutsu – an enormous bronze Buddha commemorated in 752 at Tōdaiji
Emperor Shōmu – under his reign (724-749) construction of Tōdaiji was begun. Many of the objects in the Shōsōin were once his personal belongings.
Hōryūji – an important Buddhist temple complex outside Nara that dates to the 7th century
joku – all-purpose, padded furnishing textile made in varying sizes and shapes, used especially for adorning table tops and as a refined surface for the presentation of precious objects
kasen – floral-patterned felt carpet
kyōkechi – a type of resist-dyeing wherein fabric is pressed between carved boards in order to direct dyes to certain parts of the textile as required by the

pattern. It is commonly know as clamp-resist dyeing.

Nara – the capital of Japan from 710 to 784

rōkechi – a type of resist-dyeing in which paste or wax is applied to fabric to prevent dye penetration in certain areas of the textile as required by the pattern (batik).

Shōsōin – a *shōsō* was originally a generic term for a storehouse. It came to denote the main storehouse at Tōdaiji housing imperial and temple treasures, and was divided into a North, Middle and South Section.

Tōdaiji – Buddhist temple complex dating to the mid 8th century. The Shōsōin stands on its grounds.

SELECT BIBLIOGRAPHY
General Works

Gomotsu jōdai senshokumon (Ancient Imperial Textiles), 2 vols., Tokyo 1927.

Kimura, Norimitsu (ed.), *The Treasures of the Shōsō-in: Furniture and Interior Furnishings*, Kyoto 1992.

Matsumoto, Kaneo, *Jōdai-Gire (Ancient Textiles): 7th and 8th Century Textiles in Japan from the Shōsō-in and Hōryū-ji*, Kyoto 1984.

Mino, Yukata (ed.), *The Great Eastern Temple: Treasures of Japanese Buddhist Art from Tōdai-ji*, Chicago 1986.

Shōsō-in Office (ed.), *Shōsō-in no homotsu: Senshoku* (Treasures in the Shōsō-in: Textiles), 2 vols., Tokyo 1963, 1964.

Simmons, Pauline, 'An Interim Report on Ancient Textiles Collections in Japan', *Bulletin de liaison du Centre International d'Etude des Textiles Anciens*, Lyons, no.15, January 1962, pp.11-31.

Tōyei shukō, (An illustrated catalogue of the Imperial Treasury called Shōsōin), 5 vols., Tokyo 1908-9.

Works on Felt Carpets

Gervers, Michael and Veronika, 'Felt-Making Craftsmen of the Anatolian and Iranian Plateaux', *Textile Museum Journal*, vol.4, no.1, December 1974, pp.15-29.

Gulacsi, Zsuzsanna, 'Felt Rug Representations in Manichaean Miniatures', *Hali* 75, 1994, pp.80-85.

Imperial Household Museum, *Shōsō-in gomotsu zuroku* (Catalogue of the Imperial Treasures in the Shōsō-in), vol.III, Tokyo 1929.

Laufer, Berthold, 'The Early History of Felt', *American Anthropologist*, no.32, 1930, pp.1-18.

Nishimura, Hyobu, 'Shōsō-in no mosen: kasen, shikisen' (Felt Carpets in the Shōsō-in: floral carpets, unpatterned carpets), *The Mingei*, no.194, March 1969, pp.12-17.

Works on Resist-Dyed and Woven Textiles

Buhler, Alfred and Fischer, Eberhard, *Clamp Resist Dyeing of Fabrics*, Ahmedabad 1977.

Sasaki, *Shinzaburo, Jodai kinryo tokui giho ko* (Study of Special Weaving Techniques in Ancient Examples of Nishiki and Aya Textiles), no.5, Kyoto 1973.

12 NORTHERN SONG SILK
Pages 154-169

This article is a version of a paper first given at the Textile Society of Hong Kong conference 'Chinese Textiles: Technique, Design and Patterns of Use', Hong Kong, 24-25 June 1995.

1. *Songshi*, juan 102, Zhonghua shuju edition, pp.2493-2497.

2. *Songshi*, juan 175, Zhonghua shuju edition, pp.4231-4236.

3. See note 1 above.

4. See *Wenwu* 1984.10, pp.31-33.

5. Paintings and poems depicting weaving were the subject of a paper by Lisa Lee Peterson of Purdue University at the Hong Kong Textile Society's conference in June 1995.

6. J. Murray, 'Sung Kao-tsung as Artist and Patron: The Theme of Dynastic Revival', C. Li (ed.), *Artists and Patrons: Some Social and Economic Aspects of Chinese painting*, Kansas 1989, pp.27-36.

7. Joseph Needham, *Science and Civilisation in China*, vol.V:9, D. Kuhn, *Textile Technology: Spinning and Reeling*, London 1988, p.386.

8. Ibid., p.387. The Chengdu Jin Yuan is also mentioned in Meng Yuanlao, *Dongjing mehghua lu*, compiled 1147, Beijing 1962 edition, p.30. See also *Shujin shihua*, Chengdu 1979, p.31 and Lu Dafang (Northern Song), *Jin guan louji*.

9. Chen Weiji (ed.), *History of Textile Technology in Ancient China*, New York 1992, p.457.

10 Peng Xinwei, *Zhongguo huobi shi*, Shanghai 1965; trans. E.H. Kaplan, *A Monetary History of China*, Birmingham WA, 1994, p.359, note 19. The 'cloth' cited here may be taken to include silk.

11. See note 2 above.

12. Hina Kaisaburo, *Gin ken no jukyujo yori mita Godai, Hoku-So no saihei, saishi*, cited in J-S. Tao, *Two Sons of Heaven: studies in Sung-Liao Relations*, Tucson 1988, p.33.

13. *Liaoshi. Shengzong ji*, cited in Li Renpu, *Zhongguo gudai fangzhi shigao*, Changsha 1983, p.135.

14. *Koryosa* chapter 9, Tokyo 1977 edition p.126; see also J-S. Tao, op.cit., p.83.

15. *Avalokitesvara and donors*, ink and colours on silk, British Museum, OA 1919.1-1.052 (Ch.00167). See Whitfield, *The Art of Central Asia: The Stein Collection in the British Museum*, Tokyo 1982-5, vol.2, pl.26, fig.35; also Whitfield and Farrer, *Caves of the Thousand Buddhas: Chinese Art from the Silk Route*, London 1990, no.21.

16. Silk embroidery, 31 x 17.5cm (12" x 7"), British Museum OA 1919.1-1.05, 1919.1-1.052* (Ch.00167). See Whitfield and Farrer, op.cit., no.103.

17. Gao Hanyu, *Zhongguo lidai zhiranxiu tulu*, Hong Kong 1986, pls. 238 and 250. For the pagoda construction see *Wenwu* 1980.3, pp.86-87.

18. Silk embroidery 29 x 8cm (11" x 3"), British Museum OA MAS 912 (Ch.xxvi.003), see Whitfield and Farrer, op.cit., no.100.

19. Gao Hanyu, op.cit., no.234.

20. Monastic robe, 107 x 149cm (42" x 59"), British Museum OA MAS 856 (Ch.lv.0028), see Whitfield and Farrer, op.cit., no.89.

21. Sae Ogasawara, 'Chinese Fabrics of the Song and Yuan Dynasties preserved in Japan', *Orientations*, August 1989, pp.32-34. For a printed gauze and a five-colour polychrome fragment with paired birds see Inoue Yasushi and Tsukamoto Zenryu, comp., *Koji junrei: Kyoto vol.21, Seiryo-ji*, Kyoto 1978, pls.32 and 33.

22. *Wenwu* 1972.8, p.40.

23. The wrapper and the box are displayed in Zhejiang Museum, Hangzhou. For an account of the pagoda see *Wenwu* 1971.3, pp.48-58, pl.8 and inside back cover. The sutra wrapper is illustrated on p.57, fig.14.

24. *Wenwu* 1984.12, pp.73-6, pls.5 and 6.

25. *Wenwu* 1984.12, p.80.

26. See Su Bai (ed.), *Baisha Song mu*, Beijing 1957, p.41, fig.1 for drawings from *Yingzao fashi* which match the painted architecture of Baisha tomb no.1, dated 1099AD. The designs include linked cash.

27. *Wenwu* 1984.12, p.78 and pl.5:4.

28. See Kaneo Matsumoto, *Jodai-Gire: 7th and 8th century Textiles in Japan from the Shoso-in and Horyu-ji*, Kyoto 1984, no.70.

29. *Wenwu* 1995.12, p.1097, fig.17:6.

30. Listed in the site report, *Wenwu* 1972.8 p.46, and illustrated in *Urban Life in the Song, Yuan and Ming*, Singapore 1994, p.65. Now in Dingzhou City Museum.

31. *Wenwu* 1991.6 p. 42-3, fig.12 and pl.4:4.

32. Ibid., p.46, fig.24.

33. Ibid., p.46 fig.23.
34. Y. Mino, *Freedom of Clay and Brush through Seven Centuries in Northern China: Tz'u-chou Type Wares, 960-1600AD*, Indianapolis 1981, pls.25 & 27 and figs.56, 59, 61, 72, 84 and 85. The motif also appears on a *qingbai* porcelain box from south China in the British Museum (OA 1938.5-24.101).
35. *Wenwu* 1984.12, pl.6:3.
36. Unearthed 1976 at Hebei Quyang. See Feng Xianming, *Zhongguo Taoci: Ding yao* (ed.), Shanghai 1983, pl.74. Ibid. pl.76 illustrates a late Northern Song Ding ware pillow incorporating a more elaborate brocade ball, in relief.
37. See Mino, op.cit, 1980, pl.62 and fig.165.
38. Beijing 1962 edn., p.35.
39. Beijing 1962 edn., p.51.
40. *Wenwu* 1984.12, pl.6:5 and 6:6.
41. OA 1947.4-12.62, Oppenheim Bequest. See S.J. Vainker, *Chinese Pottery and Porcelain:from Prehistory to the Present*, p.97, fig.71.
42. For texts on *kesi*, see Amina Malago, 'Kesi, Chinese Literary Sources in the Study of Silk Tapestry', *Annali di ca' Foscari* XXX, 3, 1991, pp.227-261. For a survey of its origins, see Amina Malago, 'The Origin of kesi (1), the Chinese Silk Tapestry', *Annali di ca' Foscari* XXVII, 3, 1988, pp.279-97.
43. As in the Stein Collection, for example, British Museum OA MAS 858 (Ch.xlviii.001), sutra wrapper; OA MAS 905 (Ch.0058), banner heading with *kesi* border; OA MAS 906a,b (Ch.00166), OA MAS 907 (Ch.00300), OA MAS 908a,b (Ch.00301) banner

loop (?) fragments.
44. See *Masterpieces of Chinese Silk Tapestry and Embroidery in the National Palace Museum*, Taipei 1971, pl.2.
45. See Liaoning Sheng Bowuguan (ed.), *Song Yuan Ming Qing kesi*, Beijing 1982, no.1.
46. The pouch is now in Nanjing City Museum. See *Wenwu* 1982.3, pl.3:1.
47. *Kesi* panel, formerly Spink & Son. See R. Krahl, 'Designs on Early Chinese Textiles', *Orientations*, August 1989, pp.62-72, fig.20.
48. Palace Museum, Taipei. See *Gu Gong ming hua*, Taipei 1966, vol.2, pl.33.
49. S. Cammann, 'Notes on the Origin of Chinese Kesi Tapestry', *Artibus Asiae*, vol.XI, 1948, pp.90-110, note 8, Zhou Mi, *Qidong yeyu*, 6.1b (in the Xuejin Taoyuan).
50. See note 45 above.
51. See J-P. Dubosc, 'A Contribution to the Study of Song Tapestries', *Artibus Asiae*, Vol.XI, 1948, pp.73-89, fig.F.
52. Zhuang Zhuo, *Ji lei bian* in *Shuo fu* juan 6.
53. For a gold thread example of *kesi* unearthed in Liao territory, and datable between 959-986, see *Hali* 82, p.99, fig.20.
54. The description of the Uighur ambassadors to Kaifeng, found in *Dongjing Menghualu*, Beijing 1962 edn., p.33, does not imply that they were lavishly attired: they are listed last, and described as having "silk wound round the head, and a robe thrown round the shoulders".

13 ALL EXCELLENT QUALITIES...
Pages 176-185

From June to September 1995 the British Museum exhibited the collection of jades belonging to Sir Joseph Hotung. *Chinese Jades from the Neolithic to the Qing*, a substantial, academic catalogue of the collection by Dr Jessica Rawson, Warden of Merton College, Oxford and formerly Keeper of the Department of Oriental Antiquities, was published by British Museum Publications to coincide with the exhibition. It contains much new research, a great deal of it from Chinese archaeological reports, and I am indebted to Dr Rawson for allowing me to make use of this material and her research in the preparation of this article.

1. For implements with comparable cross-section, found at the Chahai site at Fuxin in Liaoning Province, see *Liaohai Wenwu xuekan*, 1991.1, pp.27-34, fig.3:5.
2. For example those found at Dongshanzui and Niuheliang.
3. Tomb 4, Liaoning, Niuheliang, area II, shows the placing of jades in the tomb with a hoof-shaped jade below the head and a pig-dragon on the chest (*Wenwu*, 1986.8, pp.1-17, col pl.2: 1).
4. Compare Zhejiang Sheng Wenwu Kaogu Yanjiusuo, Shanghai shi Wenwu Guanli Weiyuanhui, Nanjing Bowuyuan (eds), *Liangzhu wenhua yuqi*, Beijing, Wenwu Chubanshe, 1990, no.76.
5. For comparable pieces see *Wenwu* 1984.2, pp.1-5, col. pl. 1 :2.5; *Kaogu* 1984,2, pp.109-129, pl.4:3, *Kaogu* 1981.3, pp.193-200, pl.2:7.
6. A piece with openwork, though not as elaborate as this piece, has been found in Jiangsu Wu xian Zhanglingshan, see *Wenwu*, 1986.10, pp.26-35, fig.9:7
7. The closest comparative excavated examples are found in the Shijiahe culture in Hubei province. See *Kaogu Xuebao*, 1993.2, pp.191-229, though many others, of unprovenanced origin, exist in museums such as The Art Institute of Chicago, the Winthrop Collection at Harvard University, the Gugong Bowuyuan in Beijing and the National Palace Museum, Taipei.

8. Eg. *The Zhou li* and the *Yi li*: for translations see Biot, Edouard, *Le Tcheou-li ou Rites des Tcheou*, 3 vols, Paris: 1851, reprinted Taipei, 1975 and Legge, as per note 11.
9. For archaeological reports on this tomb see: *Yinxu Fu Hao mu*, Beijing, Wenwu Chubanshe, 1980 and the second printing, with additional material at pp.241-88. This material consists of four essays on the Fu Hao tomb reprinted from earlier publications: Xia Nai, 'Shangdai yuqi di fenlei dingming he yongtu', *Kaogu* 1983.5, pp.455-671; Zheng Zhenxiang and Chen Zhida, 'Lun Fu Hao mu dui Yinxu wenhua he buci duandai di yiyi', *Kaogu* 1981.6, pp.511-18; Zhongguo Shehui Kexueyuan Kaogu Yanjiusuo Shiyanshi, 'Fu Hao mu tongqi chengfen di ceding baogao', *Kaoguxue jikan 2*, 1980, pp.181-93; and Zhang Peishan 'Anyang Yinxu Fu Hao mu zhong yuqi baoshi di jianding', *Kaogu* 1982.2, pp.204-61.
10. *Xi Han Nan Yue Wang mu*, 2 vols, Beijing 1991 and Lam, Peter Y.K. *Jades from the Tomb of the King of Nan Yue*, Hong Kong 1991.
11. J. Legge (ed.), *Li Chi, Book of Rites, An Encyclopedia of Ancient Ceremonial Usages, Religious Creeds, and Social Institutions*, 2 vols, New York 1967, vol.II, p.19.
12. This point is proposed and cogently argued by Dr Rawson in the catalogue to the Hotung Collection; *Chinese Jade from the Neolithic to the Qing*, London 1995, pp.60-75
13. *Kaogu* 1984.4, pp.302-32,
14. *Mancheng Han mu fajue baogao*. 2 vols, Beijing: Wenwu Chubanshe, 1980. For a detail of the suit see Rawson, op.cit., p.73, fig.66.
15. Legge, 1967, vol.2, p.464.

AUTHORS

JOACHIM BAUTZE
Joachim K. Bautze received the most valuable part of his art historical training from Prof. Dr. H. Härtel, then Director of the Museum of Indian Art, Berlin. He obtained his doctorate in 1982 for a thesis on Ragamala murals of Bundi, India. Besides contributing to a number of art exhibitions in Germany and the US, he has written extensively on Indian art, which he teaches at the South Asia Institute, University of Heidelberg, Germany. He is currently acting as a consultant to the exhibition 'Kotah: Its Gods, Kings and Tigers', to be held at Asia House, New York, in Autumn 1997.

SUSAN-MARIE BEST
A freelance lecturer and consultant on the history of Japanese art and design, she specialises in the cultural history of textiles, fashion and accessories to dress. Her current research is on the intercultural relationship between Japanese and Western styles of dress. She teaches at the School of Oriental and African Studies, University of London (SOAS) and will be the tutor for the first V&A Asian Arts Course, *China, Korea and Japan*, commencing autumn 1996.

SHEILA CANBY
After receiving her PhD from Harvard in 1981, Sheila Canby worked as Associate Curator of Islamic Collections, first at the Los Angeles County Museum of Art and later at the Brooklyn Museum in New York. In 1991 she came to England to join the Department of Oriental Antiquities at the British Museum, where she is responsible for Islamic art and antiquities. Her recent publications include *Persian Painting, Humayun's Garden Party* and *Rebellious Reformer: the Drawings and Paintings of Riza-yi 'Abbasi of Isfahan*. She is currently working on the book *Safavid Art and Architecture*.

STEVEN COHEN
Dr Steven Cohen travelled widely in Asia before returning to London to work at SOAS on his PhD on Indian floorcoverings in miniature paintings. For a while he joined the editorial team at *Hali*, while continuing his research on Indian textiles. He began work on the red-ground grotesque carpet fragments in 1987, and since 1990 has been preparing a study of Indian complex-woven silks.

YOLANDE CROWE
After graduating from the Sorbonne, a journey to Japan led Dr Crowe back to SOAS and a PhD in Islamic art and archaeology. Since then she has worked as a freelance writer and lecturer, travelling widely across Asia for her research in the field of ceramics, architecture and lately in design, the essence of Islamic art.

ROBERT HILLENBRAND
Educated at the Universities of Cambridge and Oxford, Professor Hillenbrand has been teaching at the Department of Fine Art, University of Edinburgh, since 1971 and was awarded a chair of Islamic Art in 1989. He has held visiting professorships at Princeton, UCLA, Camber and Dartmouth College. His scholarly interests focus on Islamic architecture, painting and iconography. His books include *Imperial Images in Persian Painting*, and most recently, *Islamic Architecture. Form, Function and Meaning* (Edinburgh University Press).

KALPANA KARTIK
Born in Jakarta, Indonesia, Kalpana Kartik has studied in Switzerland, England and France and holds degrees in art history both from the Sorbonne and the Ecole du Louvre in Paris. A freelance writer, photographer and correspondent for Indonesian magazines, she has a special interest in Asian ethnology and tribal arts. She is co-founder and president of the French-Indonesian bilateral association *arkadwipa* (Islands of the Sun), which fosters intercultural exchange.

ALAN KENNEDY
Alan Kennedy has lectured and written extensively on the subject of Japanese costume and textiles. As a student of Schuyler Cammann at the University of Pennsylvania, he learned the importance of a cross-cultural approach in the study of Asian art and culture. He brings this background to an analysis of the Shōsōin textiles, which are the product of one of the most cosmopolitan periods in Asian history.

CAROL MICHAELSON
Carol Michaelson has degrees in European History and Chinese language from London University, and as a postgraduate has studied the Chinese Han dynasty. She has been a curator in the Department of Oriental Antiquities at the British Museum since 1991. She was one of the authors of the *British Museum Book of Chinese Art*, which won the National Art Book prize for the best art book of the year. Most recently she acted as research assistant to Dr Jessica Rawson in her catalogue of Sir Joseph Hotung's jades, *Chinese Jades from the Neolithic to the Qing* (British Museum Press, June 1995).

GEORGE MICHELL
Independent researcher George Michell obtained his PhD from SOAS. He has worked on a number of sites in India, most recently the southern palace-city of Vijayanagara. He was a visiting Rockefeller Research Fellow at the Arthur M. Sackler Gallery in Washington DC in 1988-89. He is co-author with Mark Zebrowski of *Architecture and Art of the Deccan: Sultanate, Mughal and Maratha Periods* to be published by Cambridge University Press in 1997 as part of the *New Cambridge History of India* series.

COLIN SHEAF
Colin Sheaf, an Oxford graduate in Modern History, joined Christie's London in 1974, initially to work with European ceramics. Between 1975 and 1978 he developed a specialist knowledge of oriental ceramics and soon moved to the Chinese Department. Today he is a senior director of Oriental Art for Christie's Europe, and a director of Christie's Hong Kong. He regularly lectures, writes and advises clients worldwide about Chinese art at auction and the international art market. His particular area of interest is Chinese art made for the Western markets. He is the author of a definitive study on Chinese export porcelain recovered from shipwrecks, *The Hatcher Porcelain Cargoes*.

SHELAGH VAINKER
After graduating in Chinese from SOAS, Shelagh Vainker spent a year in the Archaeology Department of Nanjing University. From here she joined the Burrell Collection as Assistant Keeper of Oriental Art, moving from there to the Department of Oriental Antiquities at the British Museum. Since 1991 she has been Curator of Chinese Art at the Ashmolean Museum, Oxford, and University Lecturer in Chinese art. She teaches a university course in oriental art. She is the author of the chapter on textiles in *Caves of the Thousand Buddhas* (Whitfield & Farrer, British Museum Press, 1990) and of *Chinese Pottery and Porcelain: from Prehistory to the Present* (British Museum Press, 1991).

THIERRY ZÉPHIR
Thierry Zéphir received his Doctorate from the Ecole du Louvre, Paris, in 1991. He has been *chargé d'etudes* at the Musée National des Arts asiatiques-Guimet in Paris since 1986, and teaches at the Ecole du Louvre. A specialist in the art of Southeast Asia, he has been a consultant for UNESCO and has taught at the University of Fine Arts in Phnom Penh, Cambodia. His publications cover South and Southeast Asian art from India to Indonesia.

ADVERTISEMENTS

HD

Davide Halevim

I TAPPETI, GLI ARAZZI.

CHINESE EMBROIDERED VELVET, CIRCA 1600 AD

TIBETAN CARPET CIRCA 1880

ZHU WEI (b.1966)

書室堂 PLUM BLOSSOMS

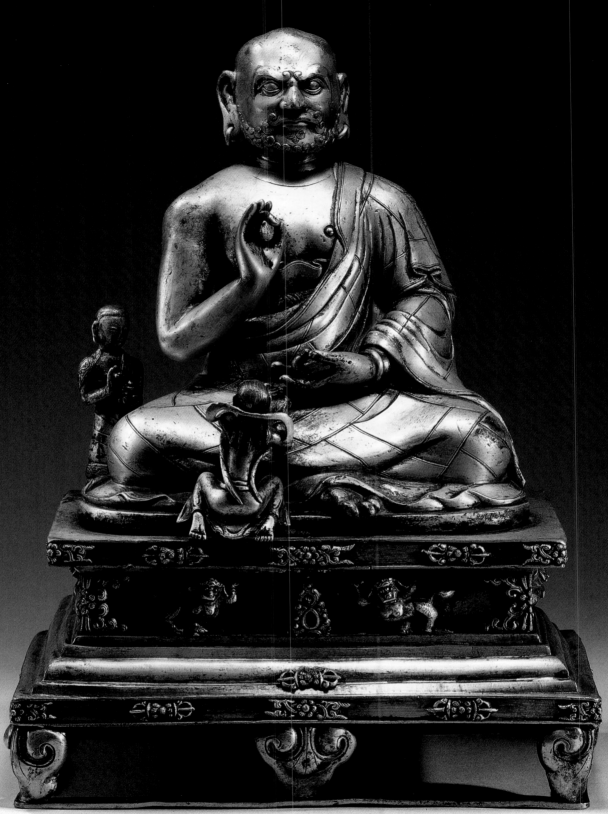

Vajradhara
Cambodia, Khmer, Bayon, from Benteai Chmar (?)
Late 12th or early 13th century
Grey-green sandstone
Height 94 cm

A very rare image of Vajradhara – the spiritual guide of the historic Buddha – shown holding *vajra* (thunderbolt) and *ghanta* (bell). The figure is probably, at the same time, a portrait of King Jayavarman VII (ruled 1181-1219), during whose reign Khmer art enjoyed its last period of splendour. The age of Jayavarman was the heyday of Mahayana Buddhism, which had probably been imported from Sri Lanka. Unlike his predecessor, who had been Hindu *Devaraja* or «god-kings», Jayavarman reigned as a *Buddharaja* or «Buddha King». He built monasteries and hospitals throughout his kingdom, as well as the monumental Bayon complex at Angkor. His physiognomy became the model for a great many of the images created during his reign – both for the monumental stone sculptures made in the service of this state cult and for small bronzes produced for private devotion. In this stone figure, the king is represented in modest attire rather than in his traditional kingly raiments, the intention being to emphasise his spirituality, as Adi Buddha, rather than his grandeur as king.

Judging by similar pieces found in situ, this sculpture's original home was the monastery of Benteai Chmar, which was built in the second half of Jayavarman's reign. Some of the sculptures from that site reveal corresponding stone damage, notably to the base. This damage was probably due in each case to the extreme differences in temperature between night and day.

The Bayon style of sculpture is noted for its simplicity, and the consequent impression of benevolent austerity. One probable reason for this purity of form, suggested by many Bayon inscriptions, is that the figures would have been covered with real jevels and textiles. The artist would accordingly concentrate his skills on perfecting the features of the head, including the famous «Bayon smile», which was intended to convey an impression of cosmic harmony and inner peace.

Related examples

There are three known images of Vajradhara. One is in the storage room at Angkor Thom, another is in the hospital chapel near Prasat Ta Keo in the vicinity of Angkor, and the last – which also comes from Benteai Chmar – is in the Musée Albert Sarraut in Phnom Penh. (See Victor Goloubew, «*Sur quelques images Khmères de Vajradhara*», JISOA, vol. V, 1937).

John Eskenazi

John Eskenazi Ltd	Antique rugs and textiles	Eskenazi & C.
15 Old Bond Street	Oriental art	Via Borgonuovo 5
London W1X 4JL		20121 Milano
Telephone 0171 - 409 3001		Telephone 02 - 86464883
Fax 0171 - 629 2146		Fax 02 - 86465018

EM

Emil Mirzakhanian

Via Bagutta 24, 20121 Milan, Italy
Tel: (02) 76002609 Fax: (02) 783719

Female Torso in Polished Greystone
Khmer, Angkor Wat Style
First Half of 12th Century, 104cm

Announcing the opening of our second gallery:
Palazzo Melzi, Via Montenapoleone 18, 20121 Milan,
Tel: (02) 76006460 Fax: (02) 76007305

TEFAF
BASEL
1996

**Organised by
The European
Fine Art Foundation
+ 31 73 689 00 90**

**Monday - Friday
11 am - 8 pm
Saturday and Sunday
11 am - 6 pm**

**International
Fine Art and Antiques Fair**

**Messe Basel, Switzerland
26 October - 3 November**

ELIKO
Antique & Decorative Rugs

Phone: 212•725•1600
Fax: 212•725•1885

4th Floor

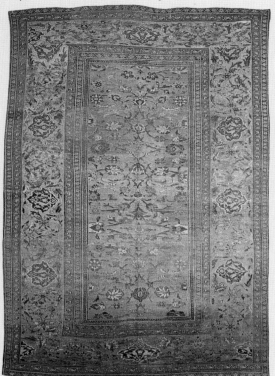

#33952 Sultanabad (circa 1900) 13'4" x 9'2"
406cm x 279cm

HASSID
Oriental Rugs
Antique • Semi Antique Oriental Rugs

Phone: 212•779•7400
N.J.: 201•569•8829
Fax: 212•689•0090

5th Floor

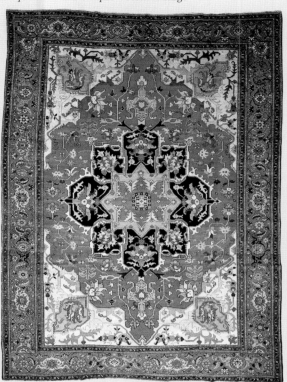

#4389 Serapi (circa 1890) 13' x 10'
396cm x 304cm

**Euro-American
Carpet Traders**

Phone: 212•725•1600
Fax: 212•725•1885
Nat: 800•669•3228

5th Floor

#3582 Hadji Jalili Tabriz (circa 1890) 14'3"x10'4"
434cm x 314cm

 **Rahmanan
Oriental Rugs**

Phone: 212•683•0167
Fax: 212•683•1437

9th Floor

#5650 Amritsar (circa 1890) 12'9" x 10'6"
388cm x 320cm

New York's Antique Oriental Rug Center
102 Madison Avenue
New York, New York 10016

PAINTED POTTERY FIGURE OF A SEMITIC MERCHANT
Tang Dynasty (618-907AD)
Height: 12 ⅝ inches (32.1cm)

PROVENANCE: Mr & Mrs Jerome Krieger, New York
Richard Ravenal, The Asian Gallery, New York

A smaller merchant figure has been exhibited from the
Morse Collection and is illustrated in *Spiritual and Ritual*,
fig. no. 51, by Robert L. Thorpe and Virginia Bower.
Also mentioned is an excavated example of smaller
proportions unearthed at Loyang. Also illustrated are two
other similar examples in figs. 50 & 52.

The Seattle Art Museum has a similar figure, which is
illustrated in *The Westerners Among the Figurines of the
Tang Dynasty of China*, pl. 17b, by Jane Gaston Mahler.

WEISBROD
Chinese Art LTD.

Gisèle Croës

ARTS D'EXTRÊME-ORIENT
54 BOULEVARD DE WATERLOO
1000 BRUSSELS - BELGIUM
TELEPHONE 322/511.82.16

This rare and magnificent dagger
has a rock crystal hilt carved with a
honeycombed pattern on the grip.
The pommel has a design of acanthus
leaves carved on the top edge blooming
into a flower on either side. The blade
is watered steel and the ferrule is
decorated with floral arrangements in
black, cream and yellow enamel.
Mughal
early 18th century
length 37.5 cm
Maharukh Desai
91C Jermyn Street
London SW1Y 6JB
telephone 0171 839 4341
facsimile 0171 321 0546

Reliquary stupa
gilt schist
height 78 cm
diameter 32 cm
Gandhara region
early Kushan period
Kadphises reign, mid-1 st century to A. D. 78
provenance: Private Collection, Switzerland
published: Czuma, *S. Kushan Sculpture:*
Images from Early India, Cleveland, 1985,
pp 165-169, no.82

Anna Maria Rossi
Fabio Rossi
91 C Jermyn Street
London SW1, 6JB
telephone 0171 3210208
facsimile 0171 3210546

214

HEAD OF BUDDHA LIMESTONE TANG DYNASTY H/21CM

GITERLU & LI YIN CO.,LTD

NO.31, SEC.1, HOPING E. RD. TAIPEI,TAIWAN,R.O.C.
TEL:(886-2)3910235/3930605 FAX:(886-2)3914742
138 RUEY YUAN RD.,CHUAN JIN CHIU
KAOHSIUNG,TAIWAN,R.O.C.
TEL:(886-7)2151953/2412198 FAX:(886-7)2154138

ISLAMIC ART

A week of sales of Islamic and Indian Art
is held bi-annually in London in April and October

A Hebrew-inscribed Iznik pottery lamp, circa 1575 A.D.
Sold in London on 25th April 1996 for £65,300.

SOTHEBY'S

LONDON

SOTHEBY'S

LONDON

AUCTION SCHEDULE IN LONDON: 26 SEPTEMBER 1996, 16 OCTOBER 1996

To find out more about buying or selling carpets and textiles at Sotheby's London please call:

Jacqueline Coulter on (44 171) 408 5152. Sotheby's, 34-35 New Bond Street, London W1A 2AA

Carpets are also included in *Colonnade* sales in London.

To order catalogues, please call (44 171) 314 4444

RANGE OF CARPETS & TEXTILES OFFERED AT SOTHEBY'S DURING THE LAST YEAR

SOTHEBY'S
NEW YORK

Western Han, 206BC - 9AD
7" x 6¹/₂" (18 x 16cm)

A Chinese excavated silk pillow with fine embroidery on each end.
One end shows a small playful Dragon; the other (not visible in the photograph) a leaping Tiger.

LISBET HOLMES EARLY TEXTILES

10 NOEL ROAD LONDON N1 8HA
Telephone 0171 226 3149 Fax 0171 226 5812
(By Appointment)

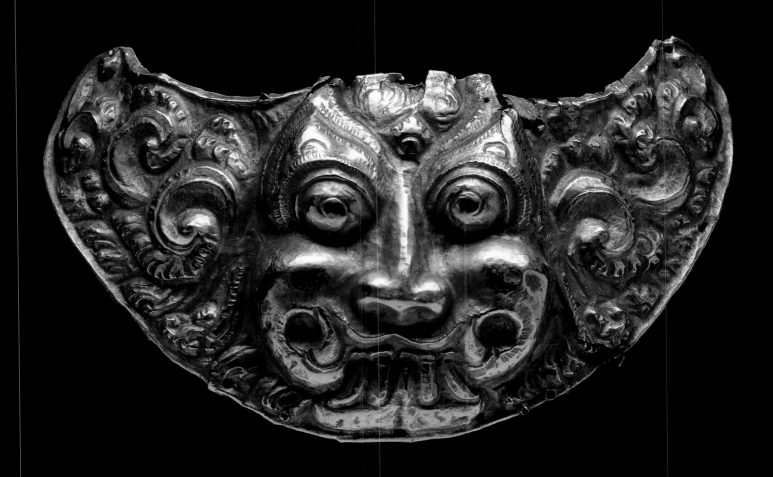

SPECIALIST ART PUBLICATIONS FOR CONNOISSEURS & ENTHUSIASTS

CARPET & TEXTILE ART
THE FIRST HALI ANNUAL

'... an abundance of information on textile traditions and a veritable feast for the eye.'

Livio Hürzeler, Cultural Counsellor
Swiss Embassy, London

REF: HAP94
PRICE: £34 $55 DM87
plus p&p of £5 $10 DM15

ASIAN ART
THE SECOND HALI ANNUAL

'... a most significant contribution to art research.'

Prof. Angelos Delivorrias
Director, Benaki Museum, Athens

REF: HAF95
PRICE: £44 $72 DM113
plus p&p of £5 $10 DM15

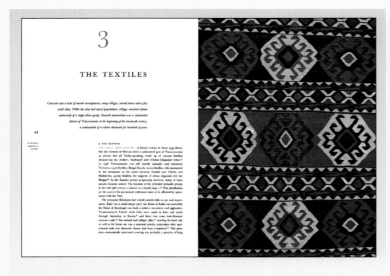

CAUCASIAN CARPETS & COVERS
the weaving culture
by Richard E. Wright & John T. Wertime

'The book should be regarded as one of the most important rug publications of our time.'

Prof. Walter B. Denny, University of Massachusetts at Amherst

REF: BS932
PRICE £44 $80 plus p&p of £5 $10

MOROCCAN CARPETS
by Brooke Pickering,
W. Russell Pickering & Ralph S. Yohe

'... clear and unpretentious style, dramatic, large-scale format, the love-of-subject so apparent throughout the work... add up to a treat.'

James Opie, author of *Tribal Rugs of Southern Persia* & *Tribal Rugs*

REF: BS920
PRICE: £60 $95 plus p&p of £5 $10

Please use the Order Card provided to purchase your copies now or call our HOTLINE on (44) 171 328 1998

J.P. WILLBORG

Antique rugs · Textiles
African Art

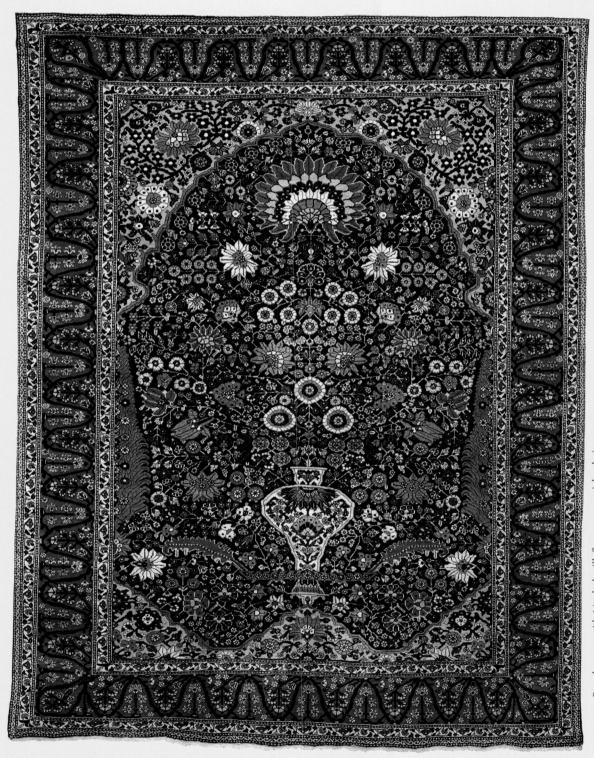

Feraghan rug with Moghul millefleurs prayer-niche design.
129.5 x 172 cm, 1850-1880. Excellent condition.
Provenance: via Russian refugees, 1917 to Finland.
Private Collection in Helsinki thereafter.

ESTABLISHED 1980 · MEMBER OF THE SWEDISH ART & ANTIQUE DEALERS ASSOCIATION

Sibyllegatan 41 S-11442 Stockholm · Sweden Tel. +46 8-783 02 65 Fax. +46 8-783 59 93
Hamngatan 3 S-21122 Malmö · Sweden Tel. +46 40-611 90 20 Fax. +46 40-611 90 30

Address in Iran
Vakil Mosque Ave. 37
Shiraz
Tel. 071-29560

Old Qashqa'i Horse Cover

**The Specialist
for Tribal Rugs
and Kilims of
Southern Persia**

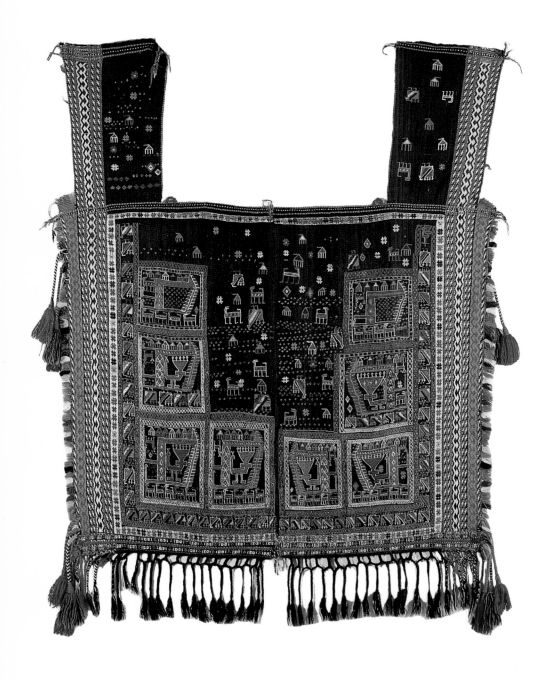

Zollanvari AG
8043 Zurich, Switzerland
Freilagerstrasse 47
Block 4, 5th Floor
Postbox 156
Tel. 01-493 28 29
Fax 01-493 07 73

Zollanvari GmbH
Kehrwieder 4
20457 Hamburg Germany
Telephone (+49) 40- 37 50 05 70
Facsimile (+49) 40- 37 50 05 71

ZOLLANVARI

Silk kesi (detail), China, 14th century
A very fine depiction of a rare subject
128 x 126cms (50.75" x 49.75")

TSERING TASHI

Sakya Arcade, Durbar Marg, Kathmandu, Nepal
Tel: 977-1-223375 (Shop) · 977-1-272901 (Home)

Please contact by fax: 977-1-270465

Do you know **Tribal Arts?**

The World of Tribal Arts is a quarterly collection of highly visual articles on themes ranging from powerful tribal sculpture to Pre-Columbian ceramics and textiles featured in 100 pages of top-quality color reproduction.

Written and curated by acclaimed experts and academics, *The World of Tribal Arts* is both informative and beautiful. With its independent nature and eclectic content, our publication presents a unique insight into little-known worlds full of beauty and history that until now have been understood by only a few enlightened enthusiasts. Whether you are interested in anthropology, art, history or world culture, in the pages of *The World of Tribal Arts* you will find stimulating concepts and beautiful art as well as book reviews, auction results, and profiles of collectors & collections, stunningly illustrated in full color.

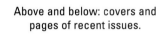
Above and below: covers and pages of recent issues.

Left; Senufo figure, Mali

The readers of our journal include anthropologists, artists, museum curators and historians as well as art enthusiasts and collectors. I hope that you will join this elite group of satisfied subscribers and enjoy the singular mix of cultures and their arts that we showcase with each issue.

A subscription to 4 issues is $53 US or 265FF for the U.S.A. or Europe. To subscribe to this unique publication, simply send a cheque to either of the offices listed below, phone or fax your payment with VISA or Mastercard, or visit our website:

www.tribalarts.com

SUBSCRIPTIONS:

2261 Market Street #644
San Francisco, CA 94114 • USA
Tel: (415) 677-7917 • Fax: (415) 431-8321

29, Rue Saint Amand, 75015 *Paris* • FRANCE
Tel: (1) 48425776 • Fax: (1) 48560854

Photography: Scott McCue / Tribarts Inc.

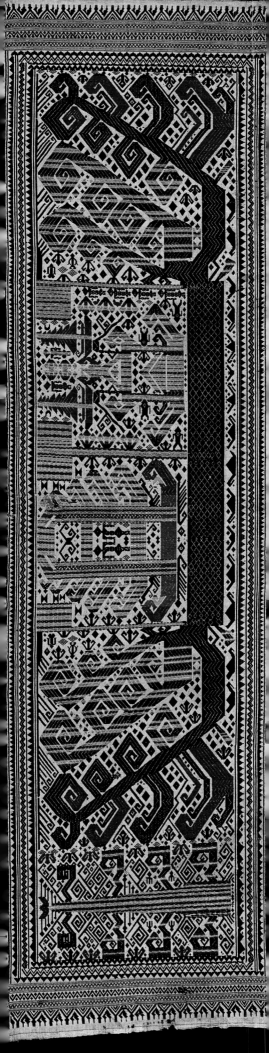

ADVERTISERS INDEX

Whilst every care is taken by the publishers, the descriptions and attributions of pieces advertised are the sole responsibility of individual advertisers